Marjorie Vecchio has curated over 40 art exhib
published numerous authors in exhibition catalogu
tablished and emerging print designers. Before bec
an exhibiting artist for 12 years, president of Artem
the photography faculty at Wright College and Eva
years. From 2006–2012 she was the director of Sheppard Fine Arts Gallery and faculty at the University of Nevada, Reno. In autumn 2009 she was the inaugural scholar-in residence at Columbus State University, Georgia. She is currently a board member of the Signal Fire Artist Residency. She has a BA from Mount Holyoke College, BFA from The School of the Art Institute, Chicago, MFA from Milton Avery Graduate School of Arts at Bard College and a PhD from the European Graduate School, Saas Fee, Switzerland.

'This book compiles insightful essays and interviews concerning the work of one of the most innovative and particular narrative filmmakers of our time—Claire Denis. I feel so lucky to have this remarkable body of films accessible to my consciousness! THANK YOU CLAIRE DENIS.'

Jim Jarmusch, *Film Director*

'Claire Denis's films are unequalled in contemporary cinema in their political rigour, sensitivity, artistic verve and sheer sensuality. This beautiful, exploratory book responds to these films through interviews with the director and her collaborators, photographs and tributes and through a series of coruscating critical essays from the finest writers in the field.'

Emma Wilson, *Professor of French Literature and the Visual Arts, Cambridge University*

'Marjorie Vecchio has put together a stunning volume, full of intellectual verve and breathtaking insight that throws light on the work and critical impact of Claire Denis. Unpretentious yet spot on in terms of philosophical framing, the contributions will occupy a central place in the ever-growing archives of film criticism and the theoretical soundtrack that accompany every screening of our ability to think.'

Avital Ronell, *Professor in the departments of Germanic Languages and Literature and Comparative Literature, New York University*

THE FILMS OF CLAIRE DENIS

INTIMACY ON THE BORDER

EDITED BY MARJORIE VECCHIO

For my parents Joseph and Diane Vecchio

Published in 2014 by I.B.Tauris & Co. Ltd
6 Salem Road, London W2 4BU
175 Fifth Avenue, New York NY 10010
www.ibtauris.com

Distributed in the United States and Canada Exclusively by Palgrave Macmillan
175 Fifth Avenue, New York NY 10010

Copyright Editorial Selection © 2014 Marjorie Vecchio

The right of Marjorie Vecchio to be identified as the editor of this work has been asserted by her in accordance with the Copyright, Designs and Patents Act 1988.

Copyright Individual Chapters © 2014 Martine Beugnet, Firoza Elavia, Sam Ishii-Gonzales, Henrik Gustafsson, Kirsten Johnson, Florence Martin, Laura McMahon, Jean-Luc Nancy, Adam Nayman, Noëlle Rouxel-Cubberly, Cornelia Ruhe, Rafael Ruiz-Pleguezuelos, Andrew Tracy, Marjorie Vecchio, Wim Wenders, Catherine Wheatley and James S. Williams

Every attempt has been made to gain permission for the use of the images in this book. Any omissions will be rectified in future editions.

All rights reserved. Except for brief quotations in a review, this book, or any part thereof, may not be reproduced, stored in or introduced into a retrieval system, or transmitted, in any form or by any means, electronic, mechanical, photocopying, recording or otherwise, without the prior written permission of the publisher.

International Library of the Moving Image 13

ISBN: 978 1 84885 953 1 (HB)
ISBN: 978 1 84885 954 8 (PB)
eISBN: 978 0 85773 599 7

A full CIP record for this book is available from the British Library
A full CIP record is available from the Library of Congress

Library of Congress catalog card: available

Printed and bound in Great Britain by T.J. International, Padstow, Cornwall.

Contents

List of Illustrations	vii
Notes on Contributors	ix
Preface	xiii
Forward: 'Klärchen'	xix

Part I Interviews

1. 'To Let The Image Sing': Conversations with Dickon Hinchliffe and Stuart Staples 3
 Martine Beugnet
2. Interview with Nelly Quettier 13
 Kirsten Johnson
 Interview with Alex Descas 25
 Kirsten Johnson
3. Interview with Claire Denis 41
 Jean-Luc Nancy

Part II Relations

4. La Famille Denis 63
 Catherine Wheatley
5. Reinventing Community, or Non-Relational Relations in Claire Denis's *I Can't Sleep* 79
 Sam Ishii-Gonzales
6. Beyond the Other: Grafting Relations in the Films of Claire Denis 91
 James S. Williams

Part III Global Citizenship

7 Beyond Post-Colonialism? From *Chocolat* to *White Material* 111
 Cornelia Ruhe
8 *Trouble Every Day*: The Neo-Colonialists Bite Back 125
 Florence Martin
9 Foreignness and Employment: A Study of the Role of Work in the Films of Claire Denis 135
 Rafael Ruiz Pleguezuelos
10 *The Intruder* According to Claire Denis 147
 Jean-Luc Nancy

Part IV Within Film

11 Delivering: Claire Denis's Opening Sequences 163
 Noëlle Rouxel-Cubberly
12 Rhythms of Relationality: Denis and Dance 175
 Laura McMahon
13 That Interrupting Feeling: Interstitial Disjunctions in Claire Denis's *L'Intrus* 189
 Firoza Elavia
14 Points of Flight, Lines of Fracture: Claire Denis's Uncanny Landscape 203
 Henrik Gustafsson
15 Arthouse/Grindhouse: Claire Denis and the 'New French Extremity' 215
 Adam Nayman and Andrew Tracy

Bibliography 227
Index 233

List of Illustrations

1. Claire Denis with crew on the set of *White Material* © Zoé Zurstrassen — xvii
2. Claire Denis and Cécile Ducasse on the set of *Chocolat* Orion Classics/Photofest © Orion Classics — xxiii
3. Claire Denis and Stuart Staples © Jean Goldsmith — 11
4. Still from *Beau Travail* New Yorker Films/Photofest © New Yorker Films — 24
5. Alex Descas and Claire Denis on the set of *35 rhums* The Cinema Guild/Photofest © The Cinema Guild — 39
6. From *35 rhums* The Cinema Guild/Photofest © The Cinema Guild — 39
7. Claire Denis and Jean-Luc Nancy at European Graduate School, Saas-Fee, Switzerland 2011 © Hendrik Speck — 59
8. Still from *White Material* © Why Not Productions — 76
9. Still from *Chocolat* Orion Classics/Photofest © Orion Classics — 77
10. Still from *Nénette et Boni* Strand Releasing/Photofest © Strand Releasing — 77
11. Still from *I Can't Sleep* New Yorker Films/Photofest © New Yorker Films — 90
12. Still from *White Material* © Why Not Productions — 107
13. Still from *Chocolat* Orion Classics/Photofest © Orion Classics — 124
14. Still from *White Material* © Why Not Productions — 124
15. Still from *Trouble Every Day* Lot 47 Films/Photofest © Lot 47 Films — 133
16. Still from *35 rhums* The Cinema Guild/Photofest © The Cinema Guild — 145
17. Still from *L'Intrus* © Why Not Productions — 160

18	Still from *L'Intrus* Wellspring Media/Photofest © Wellspring Media	160
19	Still from *Nénette et Boni* Strand Releasing/Photofest © Strand Releasing	173
20	Still from *Friday Night* © Photofest	173
21	Still from *Beau Travail* New Yorker Films/Photofest © New Yorker Films	187
22	Still from *L'Intrus* © Why Not Productions	201
23	Still from *L'Intrus* Wellspring Media/Photofest © Wellspring Media	214
24	Still from *L'Intrus* Pyramide/Photofest © Pyramide International	214
25	Still from *Trouble Every Day* Lot 47 Films/Photofest © Lot 47 Films	226

Notes on Contributors

Martine Beugnet is Professor in Visual Studies at the University of Paris, Diderot. She was previously in post at the University of Edinburgh (1999–2012). She has written articles and essays on a wide range of contemporary cinema topics and published four books: *Sexualité, marginalité, contrôle: Cinéma Français contemporain* (Paris, 2000), *Claire Denis* (Manchester, 2004 & 2012), *Proust at the Movies* (with Marion Schmid) (Surrey, 2005) and *Cinema and Sensation: French Film and the Art of Transgression* (Edinburgh, 2007 & 2012). She also co-edits, with Kriss Ravetto (UC Davis), the EUP series in *Film Studies*.

Firoza Elavia teaches courses in Film and Media Studies and earned her PhD from York University, Toronto. Her current scholarly interest examines difference and repetition in analogue and digital technologies, focusing on memory, perception and the virtual time of media events. She has edited *Cinematic Folds: The Furling and Unfurling of Images* (Toronto, 2008), an anthology on film and digital media.

Henrik Gustafsson is a post-doctoral fellow with the research team 'Border Culture' at the University of Tromsø and a member of the Nomadikon Centre of Visual Culture. His book *Out of Site: Landscape and Cultural Reflexivity in New Hollywood Cinema, 1969–1974* (Saarbrücken, 2008) is an interdisciplinary study on film, fine arts and cultural memory. Together with Asbjørn Grønstad, he has edited the volumes *Cinema and Agamben: Ethics, Biopolitics and the Moving Image* (New York, 2014) and *Ethics and Images of Pain* (New York, 2012). Gustafsson is currently working on a new project entitled 'Crime Scenery: The Art of War and the Afterlife of Landscape'.

Sam Ishii-Gonzales is Assistant Professor of Film in the School of Media Studies at The New School, where he teaches courses on aesthetics, media theory and film production. He is the co-editor of two books on Alfred Hitchcock and has published essays on a variety of artists and philosophers, including Apichatpong Weerasethakul, Francis Bacon,

Henri Bergson, Gilles Deleuze and David Lynch. His writings have been translated into Hungarian and Italian. His current book project, *Being and Immanence, or Non-Acting for the Cinema*, considers the different uses of the non-actor throughout cinema history and the relevance of this figure for understanding the ontology of film. He is also currently developing a collaborative film project inspired by the philosopher Henri Bergson's *Matter and Memory* (1896).

Kirsten Johnson works as a director and a cinematographer. She is currently editing a documentary she shot and directed in Afghanistan called *I Dream Them Always*. In 2010, as the supervising DP on Abby Disney and Gini Reticker's series, *Women, War and Peace*, she travelled to Colombia, Bosnia and Afghanistan. She shared the 2010 Sundance Documentary Competition Cinematography Award with Laura Poitras for *The Oath*. She shot the Tribeca Film Festival 2008 documentary winner, *Pray the Devil Back to Hell* and the Warner Independent/Participant Pictures *Darfur Now*. Her cinematography is featured in *Fahrenheit 9/11*, Academy Award-nominated *Asylum*, Emmy-winning *Ladies First* and Sundance premiere documentaries *This Film is Not Yet Rated*, *American Standoff* and *Derrida*. A chapter on her work as a cinematographer is featured in the book *The Art of the Documentary*. Her feature-film script *My Habibi* was selected for the 2006 Sundance Writer's Lab and Director's Lab and is recipient of an Annenberg Grant. Her previous documentary as a director, *Deadline* (co-directed with Katy Chevigny), premiered at Sundance in 2004, was broadcast on prime time NBC and won the Thurgood Marshall Award.

Florence Martin is Professor of French and Francophone Cinema and Literature at Goucher College, in Baltimore, Maryland. She is Associate Editor of *Studies in French Cinema* and has published articles internationally on cinema. Her books include *Bessie Smith* (Paris, 1994; Marseille, 1996); *De la Guyane à la diaspora Africaine* (co-authored with Isabelle Favre, Paris, 2002); and *Screens and Veils: Maghrebi Women's Cinema* (Indianapolis, 2011). She co-edited, with Patricia Caillé, *Les Cinémas du Maghreb* (Paris, 2012).

Laura McMahon is College Lecturer in French at Gonville and Caius College, Cambridge. She is the author of *Cinema and Contact: The Withdrawal of Touch in Nancy, Bresson, Duras and Denis* (Oxford, 2012) and of various articles on Denis's work. She is also the co-editor, with Michael Lawrence, of *Animal Life and the Moving Image* (forthcoming) and, with Elizabeth Lindley, of *Rhythms: Essays in French Literature, Thought and Culture* (Bern, 2008). Her current research project explores the relations between film, ecology, politics and the nonhuman.

Jean-Luc Nancy is a French philosopher who has published over 40 books since the 1970s and is Professor of Philosophy at the University of Strasbourg, France, and Georg Wilhelm Friedrich Hegel Chair at the European Graduate School, Switzerland. Many

artists have worked with Nancy, such as Claire Denis, Simon Hantaï, Soun-gui Kim and Phillip Warnell. Nancy has written about the filmmaker Abbas Kiarostami and was featured prominently in the film *The Ister*, directed by David Barison and Daniel Ross. Recently Nancy played a role in *Les Chants de Mandrin*, by Rabah Ameur-Zaïmeche, which won the 2011 Jean Vigo Award.

Adam Nayman is a film critic in Toronto for *The Grid* and *Cinema Scope*. He has also contributed articles to *Cineaste*, *Film Comment*, *Reverse Shot* and *LA Weekly*. He has an MA in Cinema Studies from the University of Toronto and teaches on documentary cinema for Ryerson University.

Rafael Ruiz Pleguezuelos was born in Granada, Spain, in 1974. He has a PhD in English and degrees in Spanish Philology and Literary Theory from the University of Granada. His writings on cinema and theatre have been awarded prizes including the Ciudad de Segovia (2011) and Garcia Lorca (2009). In 2011, he published *La Rebelión Nace en el Bosque* (Granada, 2010), a study on Alan Sillitoe.

Noëlle Rouxel-Cubberly teaches French at the Isabelle Kaplan Center for Languages and Cultures at Bennington College, Vermont. She also serves as a co-director of the Master's in Teaching in a Second Language Program. Her research focuses on French films and pedagogy. Her book, *Les titres de film* (Houdiard, 2011), examines the economics and evolution of French film titles since 1968. Her current projects include an article on films as textbooks and the publication of a nineteenth-century correspondence.

Cornelia Ruhe is Professor of Romance Literature and Media Studies at the University of Mannheim. She holds a PhD in French literature. She has published two monographs on the literature and film of Maghrebi immigration in France and co-edited the German translations of Yuri Lotman's late writings on cultural semiotics.

Andrew Tracy is the Managing Editor of *Cinema Scope* and Publications Manager at TIFF Cinematheque (formerly Cinematheque Ontario) in Toronto. His work has appeared in such publications as *Sight & Sound*, *Cineaste*, *Film Comment*, *Reverse Shot*, *Moving Image Source* and *The Auteurs Notebook*, and in the recent anthology *Kazan Revisited* (Middletown, 2011).

Marjorie Vecchio has curated over 40 art exhibitions, shown 250 artists, published numerous authors in exhibition catalogues and commissioned established and emerging print designers. Before becoming a curator, she was an exhibiting artist for 12 years, president of Artemisia Gallery (Chicago) and the photography faculty at Wright College and Evanston Art Center for eight years. From 2006–2012 she was the director of Sheppard Fine Arts Gallery and faculty at the University of Nevada, Reno. In autumn

2009 she was the inaugural scholar-in residence at Columbus State University, Georgia. She is currently a board member of the Signal Fire Artist Residency. She has a BA from Mount Holyoke College, BFA from The School of the Art Institute, Chicago, MFA from Milton Avery Graduate School of Arts at Bard College and a PhD from the European Graduate School, Saas Fee, Switzerland.

Wim Wenders was born in postwar Germany in 1945. One of the most influential figures of the New German Cinema in the seventies, his films – among them *The American Friend* (1978), *Paris, Texas* (1984), *Wings of Desire* (1987) and *Buena Vista Social Club* (1999) – have won numerous prestigious awards, including the Palme d'Or in Cannes, the Golden Lion in Venice and an Academy Award nomination. Several of his soundtracks have acquired cult status. He also works as a photographer. A major survey of his photography, *Pictures from the Surface of the Earth*, has toured museums and art institutions worldwide since 2001. He has published numerous books of essays and photographs and teaches film as a professor at the Hamburg Art School. He is President of the European Film Academy and a member of the order Pour le Mérite.

Catherine Wheatley is a lecturer in Film Studies at King's College, London. Her books include *Je t'aime, moi non plus: Anglo–French Cinematic Relations* (Berghahn, 2010; co-edited with Lucy Mazdon); Michael Haneke's *Cinema: The Ethic of the Image* (Berghahn, 2009); and a short guide to the film *Hidden* for the BFI Film Classics series (2011). Her most recent book, *Sex, Art and Cinephilia: French Cinema in Britain*, was published by Berghahn in 2012. Catherine is also a regular contributor to *Sight & Sound* magazine. She is currently working on a monograph examining iterations of Christianity in contemporary European cinema.

James S. Williams is Professor of Modern French Literature and Film at Royal Holloway, University of London. He is the author of (among others) *The Erotics of Passage: Pleasure, Politics, and Form in the Later Work of Marguerite Duras* (Liverpool/New York, 1997), *The Cinema of Jean Cocteau* (Manchester, 2006) and *Jean Cocteau* (London, 2008). He is also co-editor of *The Cinema Alone: Essays on the Work of Jean-Luc Godard 1985–2000* (Amsterdam, 2000), *Gender and French Cinema* (Oxford, 2001), *For Ever Godard: The Cinema of Jean-Luc Godard* (London, 2004), *Jean-Luc Godard: Documents* (2006; catalogue of the Godard exhibition held at the Centre Pompidou, Paris), and *May '68: Rethinking France's Last Revolution* (London, 2011). In 2011 he recorded an audio commentary for a new DVD edition of *Orphée*, by Criterion, and his latest book is *Space and Being in Contemporary French Cinema* (Manchester, 2013). He is currently working on a new monograph project, entitled *Reclaiming Beauty: Post-Political Aesthetics in Francophone African Cinema*.

Preface

Marjorie Vecchio

> The self is the least of it.
> Let our scars fall in love.
>
> Galway Kinnell
> from *Dear Stranger Extant in Memory by the Blue Juniata*

Since 1988, the year of her first film premiere, filmmaker Claire Denis has grown to become a leader in contemporary cinema. Born in France but raised throughout Africa until the age of fourteen, Denis assisted directors such as Wim Wenders and Jim Jarmusch before writing and directing her own work. However fascinating her personal story, it is through her films that we can imagine the world as uniquely as she does. The best description I have seen of Claire Denis's work is by someone not writing about her at all. American poet Ann Lauterbach wrote two essays describing what she calls the 'whole fragment', first in her 2002 book, *The Night Sky: Writings on the Poetics of Experience*, and in 2007, for the exhibition catalogue *Whole Fragment*, presented by Sheppard Fine Arts Gallery. Combined, these essays present a mindful conceptualisation of Denis's success.

> The whole fragment brings the near into the proximity of *here*...Reason's rapture is the goal, annealed as it always is to curiosity: a kind of following through and around the boundaries of the already known...I like to think that all our experiences are, or can be, whole fragments, in the sense that what happens to you and what happens to me, our voyage of incidents, exposures, conversations, touches, and signals, shared between us but which, in the ensuing episodes of our several lives, are subsequently taken up either as part of our

individual passages, or forgotten: blanks in our separate retrieval systems.... The whole fragment historicizes the intimacy of gesture, the singular node that finds succor in the gesture before and the gesture to come. It finds meaning in the interlocking precision of seams; it attends to the preposition... The whole fragment configures the 'it' into it is.

A film by Claire Denis does not complete into a presumptuous whole but rather exists as gesture and tone – as the type of 'whole fragment' described so elegantly previously by Lauterbach in her exhibition catalogue essay, 'A Blade of Grass: On the Whole Fragment'. The films are akin to the presentation of details rather than the digestion of a finished story simply waiting to end. Characters are not sacrificed or dominated by dialogue or storyline, which means we also never know the whole story because there is not one; the films only end by conjuring more questions. It is not her intention to be illusive but rather to straightforwardly present how life actually works: her films are filled with images of quiet communication and miscommunication between people, stories that are told by tracing the daily life of characters, which in turn expose how relational our movements are. Thus to compare any of her films to wholeness would be the denial of life force: Denis's films are instead about subsistence. In the following pages you will read what makes Lauterbach's notion of the whole fragment so pertinent to Claire Denis's work and so contemporary to our times. A variety of voices will describe why her films matter, covering a broad range of topics from her process to the place of her work in (or out of) film history.

From the beginning, Claire Denis has created film after film that exposes the cracks between identity, circumstance and action. She has a disconcerting skill for telling one story, which in turn tells other stories. With a Chekhovian style, whereby events often happen offstage or somewhere other than within the cinematic narrative, for Denis, each work is a Trojan Horse pushed into the heart of contemporary globalism *and* globalization, eroding the slim barriers between the two concepts. Hidden in the belly of a Claire Denis film is the truth that all the scholarship and governing of identity politics and socialisation is nothing in the face of simple human interaction, regardless of how small those interactions may be – a glance, a gesture, a conversation, a decision. In her work, dynamics change subtly, even if the plot features shocking or grandiose events. In any given film, you will witness the authentic intersection of people, landscape, music, animals, urban space, war, food, work, authority, sex, government and family – this is where the content quietly occurs in her narratives, more than through obvious plot or storyline.

Denis's films are about philosophy and politics as much as they are about film and art. They are not didactic; rather, they present examples for the viewer to witness and question. Through an understanding of cinema's formal potential,

her films prompt us to question how we live, both as individuals and as part of an indefinable social community, where the rules and their scale are not always clear, natural or humane. Her work constantly pushes the concept of personal agency against the boundaries of unquestioned allegiance, nationalism, stupidity, innocence and multi-culturalism. Her images are elegant and tangible, raw and bold, or reserved and frightening – and always passionately expose the most complicated circumstances of being alive: immigration, illness, family life, jealousy and survival.

This book aims to display and challenge the questions presented in the films of Claire Denis. It is divided into two sections: the first part is composed of interviews and the second of essays. The interview section is crucial in order to understand Denis's career model: she continuously collaborates with a regular assortment of actors, editors, cinematographers and composers. The essay section is dedicated to new writings by a diversity of scholars from across the globe, some of whom have written extensively about Denis elsewhere and others by those new to the field. The subtitle of the book, 'Intimacy on the Border', speaks to the content within Denis's filmmaking form. The borders touched upon in her films include intimate ones such as between children and parents, siblings, neighbours, strangers, old friends and lovers – individuals who are always encircled by larger, and oftentimes powerful, borders such as class, race, country, gender, age, politics and land. Being encircled by so many borders is our human plight, yet Denis never falsely assimilates the incongruities between people's experiences; instead her films hint at co-existence within difference – possibly without resolve or surrender but at least with stability and respect.

There are writers missing from this book who ought be here: some were invited but were engaged with other projects; others missed during the book's development. Denis's body of work continues to grow. Her 2013 film *The Bastards* premiered at Cannes Film Festival just before we went to press. In order to cement her importance in cinema history, her films deserve more serious scholarly attention. I would like to thank the following people for making this one possible: all the contributors and interviewees for their utmost patience in a lengthy process, Kirsten Johnson and Alissa Surges for excellent copy-editing, translators Nathalie Le Galloudec and Anna Moschovakis, Martine Beugnet and Judith Mayne for their seminal books, Rémi Fontanel and Sébastien David for their Denis book, Jean-Luc Nancy, Wim Wenders and Heidi Frankl, Stuart Staples, Dickon Hinchliffe, Dan Oggly of Tindersticks Management, Lucie and Pauline of Why Not Productions, Hendrik Speck, Jean Goldsmith, Zoé Zurstrassen, Noël Véry, David Sorfa and Douglas Morrey of Film-Philosophy, Mahen Bonetti of the New York City African Film Festival, Jackie Brookner, Lydia Davis, Avital Ronell, Stefanie Koseff, Jim Jarmusch and Carter Logan, Emma Wilson, Yves Cape, Joan Goldin, William L. Fox, Carina Black,

Sandy Stone, Joy Garnett, Tad Beck and Grant Wahlquist, Larry Engstrom, Wendy Ricco, my former staff at Sheppard Gallery, Wolfgang Schirmacher and the European Graduate School for deeply influencing my life and the initial inspiration for this book, Hannah Israel and Columbus State University's Visiting Artists and Scholars Residency Program, which supported this project from the beginning, Isabelle Favre, my parents Joseph and Diane Vecchio for everything from A to Z, my editors at I.B.Tauris, Philippa Brewster, Anna Coatman, Lisa Goodrum, and of course, Claire Denis.

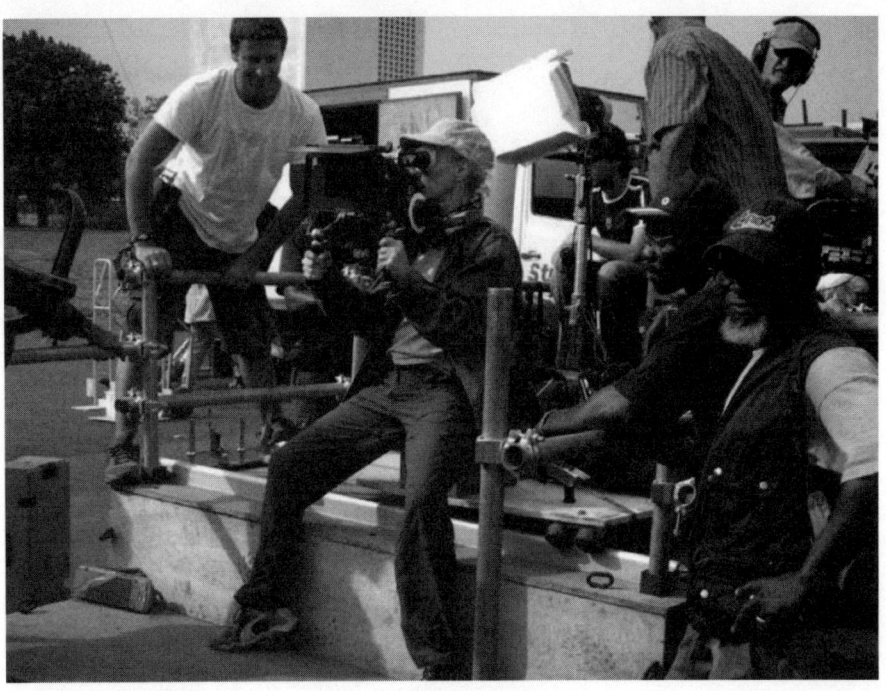
1 Claire Denis with crew on the set of *White Material*

Forward: 'Klärchen'

Wim Wenders

I was waiting for my new assistant in Houston.
I had worked on the script for *Paris, Texas* with Sam Shepard,
(well, it was called *Motel Chronicles* then...)
I had traveled huge parts of the American West on my own
in preparation for the film
and now it was about time to start prepping it for real.
The project was a German–French co-production,
to be shot entirely in the US,
by an almost all-European crew.
An enterprise unheard of at the time.
Some sort of guerilla filmmaking, in hindsight...

My French co-producer had determined
that she had found the perfect assistant for this task
to guide us safely through this journey into unknown territory:
A young woman by the name of Claire Denis...
I had not met her before.
I didn't even know what she looked like.

She showed up one morning at the hotel in downtown Houston.
We walked towards each other, a bit awkwardly.
Were we going to speak French together
or would English be the language of choice here in Texas?
My future assistant was smaller than I had anticipated.
'Frail' would be the right word.

She stared at me
with curious, wide-awake eyes under short blond hair.
Was she up for this tough job?
Maybe my eyes showed what I thought.
She smiled shyly...

Only time would tell.

Well, time did tell!
I can safely say that Claire single-handedly pulled this film through.
She steered it through thick and thin.
When the teamsters discovered us
and found out that most of our European crew members
worked on tourist visas
they forced us to employ a dozen drivers.
Our alternative was terrifying: to be thrown out of the country.
End of the film!
We had to accept the deal they offered
which took a huge chunk out of our budget.
Claire had to shorten the shooting schedule from eight weeks
down to six, then to five...
That alone would have scared the shit out of anybody.
Claire was fearless.

We ran out of script after the first two weeks.
(Sam Shepard was supposed to stay with us during the shoot
and write the second half of the film as we were gong along.
But then he fell in love with Jessica Lange
and decided to play opposite her in a film called *Country*.
That was shot a thousand miles away.
I had lost my writer...)
We had to interrupt the shoot and send the crew home.
Everybody was gone except for Claire.
The two of us sat in a crummy hotel in Hollywood
and tried to figure out how this film could possibly continue.
She got us out of this hole, too.
With Claire's help I managed to write a story and ship it to Sam
who would write dialogue overnight
and dictate it to me way after midnight.
(This was in the age before internet or fax machines...)

We continued the shoot, after all.
Claire was relentless.
When we had actually finished principal photography
we had totally run out of money
but we still needed a few extra scenes and travel shots.
So we shot a last week with a team so reduced
that apart from Robby Müller, my cameraman, and me,
Claire fulfilled practically all other functions.
We paid all the bills on my credit cards until they were busted.
In the end we literally had to stop eating.
(Well, almost.)

Claire was the unsung hero of this whole adventure.
I could not have done *Paris, Texas* without her!
Her strength and perseverance
were in reverse proportion to her physical size.
Little had I known on that first encounter...

She even surpassed the heroic efforts of our first collaboration
when we teamed up a couple of years later
for what was going to become *Wings of Desire*.

To even think about doing an entire film without a script...
I would not have dared approaching a project like that
if I hadn't known I was going to be backed up by Klärchen.
(That was Claire's name by then.)

We actually made this film with the help of a big wall in my office.
One side was covered with photographs
of my favorite places from all over the city.
The other half was a whole bunch of cards
with loosely sketched ideas for all sorts of scenes.
Our heroes were guardian angels
and there were countless story possibilities
that could be explored by our invisible characters.
Well, there wasn't much of a plot, anyway.
We really made this film like you would write a poem:
every day we would add a new line
not knowing what the next day would bring.

Claire and I spent late-night hours in front of this wall,
trying to figure out where this journey was taking us.
One night, deep into our shoot already,
we even dreamed up a new character: an ex-angel.
And the miraculous happened:
that very night we found the actor for it
and he even agreed on the phone to do it,
laughing his heart out about such a preposterous proposition
to come from LA to Berlin to play the unwritten part
of a former guardian angel now turned human: Peter Falk.

My own guardian angel on this film was Claire.
She was both the assistant in the American sense of the profession
that she would lead the shoot like a military operation,
and in a more European tradition
she shared all creative issues, fears and dreams with me.

There was no way to follow up on these two experiences.
And one thing was clear:
Claire was more than ready to make her own films.
It would have been a waste to let her continue
working as an assistant director.

I am proud that I was able to help (a bit)
that she could go (back) to Africa
and start her directing career with the masterpiece
that *Chocolat* turned out to be.

The rest is history.
And this book will hopefully throw many new lights
on the amazing director that Klärchen became,
a path she carved out all on her own,
and that didn't owe much to her first career
as the greatest first assistant (not only) I ever had.

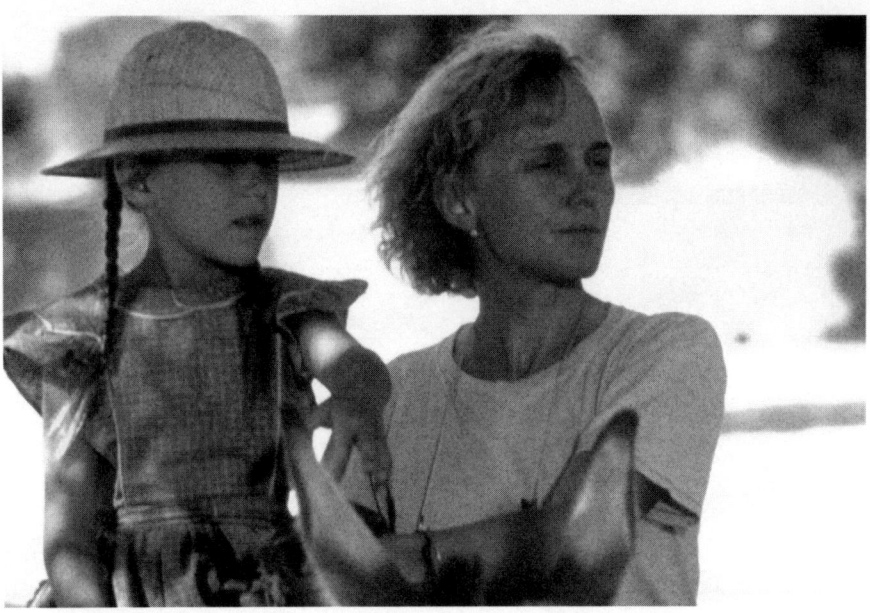

2 Claire Denis and Cécile Ducasse on the set of *Chocolat*

Part I

Interviews

Part 1

Interviews

1

'To Let The Image Sing': Conversations with Dickon Hinchliffe and Stuart Staples

Martine Beugnet

'To Let the Image Sing'

Hearing the song 'My Sister' (1995) for the first time as she was shooting *Nénette et Boni* (1996), her absorbing account of a sister–brother relationship, Claire Denis had an immediate kindred feeling with the Tindersticks' distinctive musical universe: the way Stuart Staples' trembling baritone inhabits the brooding, slightly off-kilter space that the music creates, bringing out its characteristic mood of melancholy fragility. The band's idiosyncratic approach could be described in terms of defamiliarisation and a kind of generic subversion – from ballad to bebop to Bossa Nova, familiar genres are revisited with simple melodic lines that are drawn out, repeated or distorted, alternatively turned into haunting leitmotivs or brought to the brink of dissolution.[1]

Similarly, Denis's film worlds elicit an intangible sense of strangeness, at once intriguing and unsettling. Unconstrained by the requirements of tight plot and dialogues, her films take the form of slow-paced, careful explorations of relationships between characters and between characters and environments where, captured by the camera's attentive gaze and rendered through meticulous sound compositions,[2] even the most mundane of spaces, everyday objects or situations appear as more than mere prop or setting. Denis's cinema is also a cinema of gestures and movements, of the melody drawn out by bodies circling around one another, gradually transforming as they move from one space to another. Together, music, sound and image offer this entrancing quality of

something in suspension, caught between an indefinable sense of threat and a charmed wistfulness.

At the recent series of Tindersticks concerts based on the film scores, the band played beneath a cinema screen on which sequences from the films unravelled throughout. These performances not only beautifully emphasized a rare case of image–music symbiosis, but they also highlighted the remarkable formal achievement of Denis's films – detached from the rest of the film but brought forth by the music, each sequence filled the screen with an inescapable power.

All of Denis's feature films have been scored and performed by renowned musicians, testifying both to the director's love of music and the openness of her filmmaking to heterogeneous references and to the appeal of her work to musicians. The Tindersticks are privileged collaborators, however: six of her films have been scored either by the band or by ex-Tindersticks musician and composer Dickon Hinchliffe. The Tindersticks have signed the scores for Claire Denis's *Nénette et Boni* (1996), *Trouble Every Day* (2001), *L'Intrus* (2004), *35 rhums* (2008) and *White Material* (2009). Hinchliffe wrote the score for *Vendredi soir* (2002). The synergy between their scores and Denis's images and soundtracks (for the music is often incorporated with ambient, diegetic sounds) can hardly be defined in terms of the categories conventionally applied to the study of mainstream film music, where images and score are considered first and foremost in terms of the fulfilment of precise (narrative, expressive or affective) functions. This is not to say that, in Denis's films, the music does not relate to specific elements of the diegesis – characters, setting and atmospheres are indeed shaped by the musical as well as the audiovisual compositions. Such relations, however, are embedded in the deeper, shared sense of musicality of soundtrack, images and music, emphasized by the recurrent overlap of diegetic and non-diegetic music.

In the case of *Nénette et Boni*, the band were introduced to the project as the film was already being shot, and a temp score provided for its editing. The soundtrack the Tindersticks offered was one of great simplicity – with a basis in Bossa Nova, much of the track hangs on binary rhythms and on alternations between a couple of chords. In its very hesitancy, the way it goes back and forth, suspends chords and merely sketches melodic lines into tiny leitmotivs, the music track does perfectly capture the universe of two unanchored youths, the liminal space between childhood and adulthood that they inhabit, and the diffidence of the character of the adolescent Nénette in particular.

In subsequent films – through the low, haunting bass tones of *Trouble Every Day*'s string orchestration or the floating sequences of bell-like chords of *Vendredi soir* – the score sets the dramatic tempo between a sense of spellbound suspension and sudden, irrepressible acceleration. Most crucially, however, the

music effectively concurs with the images in giving a presence to the film's most ubiquitous character: the city of Paris, appearing, respectively, in an unusual, gothic guise or as an enchanted space of potentialities. It is both the city as atmosphere that the music carries across, infusing the filmic space seamlessly and invisibly with an implicit, intangible diegetic presence, but also, as the score fuses with the soundtrack, the city as a profoundly sensual environment, one that appeals to multi-sensory perception – vision, hearing, smell, touch.

In turn, the opening credit sequence of *35 rhums* offers a sketch portrait of Paris, both humorous and melancholy. Simultaneously evocative of the city and of cinema's history, it takes the form of an auditory palimpsest, in which, a sense of location is ostensibly established yet at the same time challenged. The very beginning of the credits, featuring the elongated, floating sound of the ondes Martenot, of which the Tindersticks are fond, prefigures the first images – captured from the vantage point of the driving cabin of a suburban train, the opening sequence gives an impression of floating above the railway tracks. Such images are redolent with the memory of cinema's beginnings, of the train rides that punctuate the city symphonies, bringing workers into the town centres. Yet, as the credit music proper starts, it brings forth something old-fashioned and very 'French', oddly reminiscent of the *bal musette* and of Tati's *Jour de Fête* (1949).[3] The ballad-like plaintiveness of the melodica, however, also evokes an elsewhere, a sense of exile that many of the film's African French characters of the older generation implicitly share. Soon, an *étude*-like piano composition brings with it a more classical register, a different voice that weaves in and out of the existing melody. As the railway tracks unravel in front of us, crossing, merging and separating from other tracks, the music similarly talks of destiny, of encounters and losses, its slightly mournful tune concluding, unexpectedly, on the hopeful sound of a major chord.

Neither *L'Intrus*'s nor *White Material*'s music tracks offer such a hopeful pitch. What they have in common is a radical destructuring of the musical space. *L'Intrus*'s drifting guitar riffs are characteristic of a readiness to create a musical space that wilfully lacks a centre, eschewing a sense of narrative and conclusion that would undermine the films' powerful evocation of post-colonial estrangement. Yet, as in the previous films, the scores in *L'Intrus* and in *White Material* emphasise the sensuous quality of the images – the sparse use of guitar, strings and percussion, bringing out hues, evoking colours, alternatively emphasizing a sense of depth of field or one of physical intimacy.

In the following interviews, both Stuart Staples and Dickon Hinchliffe describe their work with Claire Denis as a fluid, open process of co-creation – a remarkably open collaboration based on a common understanding of cinema and the search for the right 'tone'. Ultimately, as Stuart Staples puts it, the aim is 'to let the image sing'.

5

Conversations with Dickon Hinchliffe and Stuart Staples

Dickon Hinchliffe

Claire Denis is completely unique. Working with her profoundly alters the way one thinks about film music. She connects with music. She is not after conventional film scores – where music primarily emphasizes narrative and emotional development – she is after a *tone*.

'A Form of the Blues'
Nénette et Boni was different from the other films. A temp score was used as the base for the film's final score. We scored after the film was shot, but there is a sense that existing songs shaped part of the film. For the following films, Claire has been sending scripts, and we talk about them. We get to understand on a deep level what she is doing. It develops into a kind of conversation – a space where one is free to explore ideas. Claire Denis is interested in using instruments as well as non-instrumental sounds. There is a big contrast, in that way, between, say, *Chocolat* and *Beau Travail*.

I composed the score for *Vendredi soir* on my own and with a string orchestra while Claire was shooting. Claire Denis always thinks about music as she writes, however. For instance, she insisted that the music in *Vendredi soir* had to be *in the air* of Paris at night – as if coming through the windows of the houses and cars, spreading around. I therefore composed in a high register in piano and strings so that the music carries a lot of air, conveys a dreamy feel. In contrast, for *Trouble Every Day*, there was a powerful bass sound coming from the double bass and cello. As in all the records, Stuart [Staples] wrote the lyrics, and the song helped shape the rest of the film's instrumental music.

I give demos while Claire is editing. It is quite a loose process – there is no crude way of fitting the visuals and the score. Most crucially, there is an avoidance of effects that end up telegraphing emotions as in Hollywood (no 'sad' and 'happy' music). Part of the score can relate to characters, but not in isolation. The music creates relationships between characters and between characters and their environment, in terms of intensities.

In Claire's films, there is friction in music and sound. The score and soundtrack create a third dimension. The music always emerges as a strong voice in the films – even more so because there is little dialogue. Dialogue is less important, and this opens up a poetic space in her films. So music and sound effects play a crucial role in affecting the audience. They become a more direct route to the unconscious than the visuals.

There is a flow in much of the scores rather than a rhythm or a beat: it evokes a state of suspension, or a liminal state. Suspended chords abound, creating a

sense of the unresolved. Cues start and die in a non-conclusive way – it creates an impression of the unfinished.

Rather than melancholia there is intensity, a way of seeing the world, a form of the blues, as well as a lot of tenderness and humour. At the same time, Claire Denis films in a very physical, tactile way, both in terms of images and sounds. The way one hears things and sees colours – that is, what cinema should be about: a multiple engagement of the senses.

Stuart Staples

'A Sense of Space'

What I do know is: we need a space in our music. We have always needed a sense of space to step into rather than be presented with something. Our music always asks you to step into it. And for this you need a sense of space. We don't like to make things obvious or one-dimensional. It's very unsatisfactory. It's always better if you get a feeling of tension or ambiguity within the ideas. It's not *one* thing you can step in. It's the same with Claire's cinema. It is so open; it *makes* you feel as a viewer, it never *tells* you how to feel.

One example, for me, is melody. Melody takes a lot of space. It takes a lot of mental space. I suppose in the film music I encounter, in the actual experience of it, it just takes up so much space. It leads you – I feel I am led in such a heavy-handed way. It seems the new trend is to pack every moment and every frequency. What people do generally leaves me cold. There are certain chords you use at certain moments – to leave people no choice but to feel *this* at that moment. With Claire, it's more about a reaction and a connection, a conversation that has to do with music and images that allows a certain kind of a breath in the film and doesn't try to choke it. Sonically, the grass bristling is as important as the music in the film. With Claire's films, those kinds of details can be just as emotive.

The beauty of music is that there never has to be a reason for it. I cannot say that this particular piece of music is about this, or about that, but it is very much about a particular way of treating music in a film. I could not say exactly what that was, but it is very important to me that it be simple, with momentum and not to make any statement. You can hit something at a certain time, and it can just feel right. Like, you know, to do with a moment. It was very much true with the guitar in *L'Intrus*. There was no reason apart from something just chimed, and it was a starting point for that to chime, for both Claire and me. I believe the music in a film provides a different dimension to the experience.

It's all about space and openness and ambiguity. Cinema, for me, is an experience of so many different senses, something that holds you for a certain period of time. You don't really need to know what it has given you. You

don't really have to walk away with a checklist. If something just holds you there, you are enthralled by it – I think it is far more interesting. But there is kind of a pressure to make people feel what you want them to feel. Claire's films are far away from that.

Working with Claire

Fundamentally, it's about people, and whether it's music or cinema, the media is secondary to the relationship between ourselves and Claire. So, it is just a creative relationship, the only one that we have, and that kind of bounces back and forth and allows things to change and happen and move. The thing about working with a group of people is, if I write a song, I have to make the people around me inspired about it. And if they get inspired, then I trust them, I trust their aesthetic. It's kind of the same with Claire. The first thing she has to do is fascinate and enchant us and inspire us to make something. It's not a given. To us, it's not a job. Hopefully, at the end we make some money and carry on, but so far we've tried to never 'have a job'. To never have to do this because of the money. It's not a job, and you can't treat it as a job. We look at what inspires us. Where will this take us to, which adventure?

That's the kind of thing I feel when people ask, 'Do you want to make music for other films?' And I think about it. I imagine what the process is – you know, without that trust and conversation, I always shy away from it because it's a special thing. It has so much to do with the way Claire works generally, whether it is with her cinematographer, or her editor, or with her actors. She always forms relationships where people have space to bring a part of themselves and surprise her, and she opens her mind and thinks about it. But, at the same time, she is able to do that because she is so strong, so confident inside about what she wants. So she is able to allow people to move, she is not holding on to things ('It has to be like this, it has to be like that'). She wants to get her head around other people's perceptions, understand how people view these things. At the same time, she is immovable, you know – I mean, for the central vision of where she is going. I think that it is a great, rare kind of thing and makes her films unique.

Finding an Entry Point

Every film we have done with Claire, we have had a different approach. It's not been a standard way of 'we now do this and now we do that'. It's always about finding a starting point to enter the film. With our first film score, with *Nénette et Boni*, it was kind of ready-made because Claire was so influenced by our second album, especially the song 'My Sister', that it kind of presented us with this kind of thing to grow from, something that was already inside the film – like the song and the song title were already inside the film and we had

to build around that, and that was great because it was our first film, and it gave us a starting point.

With *Trouble Every Day*, the starting point, for us, was about the romance, connecting with the romance rather than connecting with the horror and creating this feeling that felt so much more powerful – to go with the romance against the violence, the brutality of the pictures felt so much more exciting. We quickly came upon that as a conversation about the film. So it's different every time, how you find a way in.

I think with *35 rhums*, it kind of depended on a certain simplicity. And a certain kind of joy. A certain kind of joy in the mundane. There is very little music, and it is almost used to kind of warm the film. The music for the opening credits of *35 rhums* was an idea of David [Boulter]'s, before we even saw the film, just a little idea we were working on, and when I went to see Claire in Paris, she said, 'I'll just show you the start of the film', and as soon as I saw the train tracks, felt the rhythm, I thought of David's music and could not wait to get home, to put the two together. And I thought, 'Whoa'. And I sent it back to Claire, and it was the last thing she would have expected, but it worked. As soon as you have that you are in the film, you are on your way. That song, or idea of a song, that's David at his most wistful. I imagine him alone in his studio in Prague. Writing this song.

The initial emotion with *White Material* came from totally the opposite place and we had a completely different way of working on it. Before I saw the images I thought: Africa? But as soon as I saw the images...so different from reading the script. The script gives you a kind of intent but so different from seeing the images. Some composers would want to read the script and compose some music to some of the characters and give that to the director to help with the making...maybe that'll happen to us one day. But, generally, it's just a reaction to the images and then starting a conversation about the editing process, and the music affects the editing process and all these decisions.

With *White Material*, to start with, really, it was about colour. It was so much to do with the colour of the landscape, and then finding a palette of sounds. It started off without melody. It just started off with abstract sound sketches really, just to do with the feeling of the landscape. What struck me first were the colours, the palette of oranges and the dark browns of people's skin and the rich greens, with Isabelle dressed in pink, superimposed. It is so beautifully done and even as a five-minute sequence, inspiring enough and powerful enough to make you want to do it.

Then, it felt important to bring together certain feelings and see what kind of collided with them – you know, these feelings about collapsing systems of values and tension. In *Trouble Every Day*, it was the romance, strings, and in *35 rhums*, it was so much more gentle, and light...and delicate...the feeling of

walking down the street, riding a train, that momentum. With *White Material*, it had to do with the heat. The tension, the impending violence. The first time I saw the rushes, it felt like the music was in the trees, surrounding and pulsing, pushing at the centre point. This was mixed in with what I think Claire is so interested in – that kind of innocence that the children hold in *White Material*, and those things altogether created something quite inspiring to work with.

White Material is one of our recent works that I am most proud of. To approach something, not knowing, not having a melody to help you hold this thing together, to start from the smallest cell and to gradually build it up. As with a song. You want to remove all the ideas of 'craft' – you don't want to feel the process, you just want to feel its breathing. With *White Material*, the experimentation gradually moulded itself into the movie.

'The Image is the Melody'

It's a gradual process – there is no enlightenment, it's like a kind of very elongated process of improvisation. It's so much to do with a kind of palette of sounds, to start with, whether it is the orchestral music for *Trouble Every Day* or, as with *White Material*, a bell – the sound of a bell started it. It's a silly thing but you know the Chinese lucky kittens with the moving arm? Claire and I have always shared a love of these things. And we just tried one of these lucky kittens striking a wine glass that was suspended above it. What happens was, you would assume it would create a regular kind of tempo, but because it's so delicate and because, when it gets hit, the wine glass moves slightly, sometimes it misses, sometimes it gets closer and speeds up. It's a minute thing, but just experimenting with that created this abstract rhythm, and it was something that really moved me in a way, to do with *White Material*. It started us working on a music that would have no tempo and no set kind of rhythm. And from there it was finding the harmonium, and from the harmonium, the right sounds for the right feelings.

Ultimately, it's not even music that's composed. It's a kind of music that's built. It's like grown from seeds. When I think of the word 'compose', I think of someone sitting in front of a screen, with a bank of sounds, and picking on themes and characters and putting these things together, whereas, for us, we experiment until it makes us happy. And we kind of learn what's wrong by doing it.

Especially working on the last two films with Claire, I felt the shape you give to the music could be however you want it to be. It does not have to have a strong centre to it because, really, the strong centre is the image. A lot of times, I feel the image is the melody, you don't need to have a melody, you just need a colour, a feeling, to let that image sing.

Notes

1. I am indebted to musician Jean-Noël Bertrand for his illuminating comments and precious insights to this introduction.
2. Jean-Louis Ughetto is in charge of sound on most of Denis's feature films.
3. Just as the sound of traffic in *Vendredi soir* was reminiscent of Tati's *Traffic* (1971) and *Play Time* (1967) – it seems fitting that someone as attentive to sounds as Denis should thus pay homage to Jacques Tati.

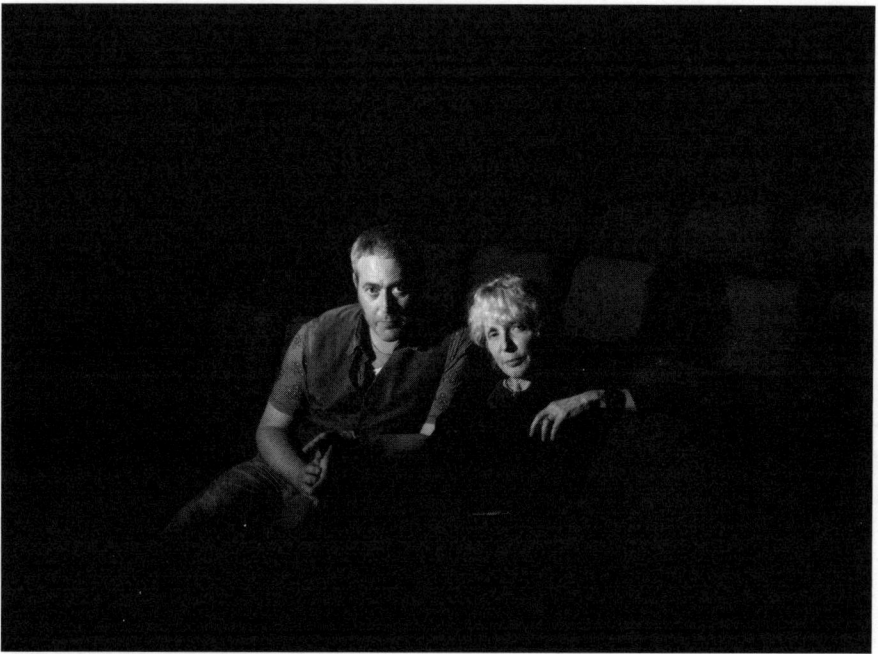

3 Claire Denis and Stuart Staples

2

Interview with Nelly Quettier

Kirsten Johnson
Translated by the author

Nelly Quettier has worked with Claire Denis for more than 15 years, editing *J'ai pas sommeil*, *Beau Travail*, *Trouble Every Day*, *Vendredi soir* and *L'Intrus*. When I met her for the first time, in Paris in July of 2011, she told me that she hadn't seen *Beau Travail* since it came out in theatres over ten years ago. Despite being in the middle of cutting another film, she gamely agreed to re-watch it once on her own and then again with me to talk about the process of editing. I joined her at her edit room one evening and found her chatting with Leos Carax about their upcoming project. One of the great pleasures of screening *Beau Travail* with her was to see her incredible relish for every aspect of the film and great appreciation of everyone who had been a part of it. At one point in our conversation, I brought up Leni Riefenstahl and the way she filmed athletes in Olympia. This was Nelly's response:

> **NQ:** There is an absolute and huge difference between the Olympic films of Leni Riefensthal and Claire's work in *Beau Travail*. The difference is that, in Claire's film, every person is an individual; you can always see the person, always discern the personality of each person. In the work of Leni Riefenstahl, it's man, whether with a capital 'M' or lowercase 'm', but without the personality. I think that's the big difference between them. Because Claire really loves the actors she films. The actors and the non-actors, whether it's the people in the streets or the young women dancing in the club, she really loves them. In each film it's like that. In all of her films. She really has love for everything that she films, and I think that the love and attention she gives comes through.

KJ: And Agnès Godard must share that, because we see it through the camera. Alex Descas told me, 'I know that she loves me, but when I'm on set, I realize that she loves everybody!'

NQ: Everybody! (laughs) I think she would be incapable of filming someone she didn't love.

KJ: She's not interested in that, is she?

NQ: No, that's not what she wants to do. And I think it's palpable. I don't know how she does it, but there it is. I think it is Claire's great strength. The great strength of Claire.

It was clear to me, watching *Beau Travail* with her, that Nelly too shared what she described in the work of Claire and Agnès – a great love for the image, the sound, the music and the people in the film she had so brilliantly edited. One of the first things she said was, 'This film really is a UFO! I don't know how it ever got made!' But she was clearly delighted that it had.

NQ: It was made for a series on ARTE, commissioned by Pierre Chevalier, who was a man who's helped a lot of films come into being. I think the fact that it was a commission helped Claire be a lot freer with it. If she was making it as a film for the cinema, I don't think she would have felt the same kind of liberty. It really is a UFO of a film. It's quite a striking film about memory, about the internal pressures someone experiences – rather mind-blowing. It's also the first film Claire edited digitally on Avid,[1] as opposed to cutting film on a flatbed like she'd done for all of her other films. It was also my first film on Avid. At the time, when we cut on film, because it was 35mm, you would have to conform the image and then watch it projected. This was the first film we'd cut together where we couldn't do that. The budget was really small. The budget was miniscule in fact, and since we couldn't initially watch it projected, we were really worried about the picture except that what we could see of the images was that they were exceptionally beautiful. Agnès was worried about how they would look projected. At the time there wasn't digital colour correction, so you had to do the colour correction at the film lab later, and any special effects that you did digitally had to be blown up to film before you could be sure about how they would turn out. I remember that we were all really worried about it. It really was a moment in film history, in editing history. We were all really anxious, because we'd never done it before and, with the effects and the blow up, we realized that the edge of the frame moved. When you worked in film, a frame was a frame. And here we were with digital and the frame could change, or we couldn't figure out where the edge of the frame was, and that was all supposed to be normal!

So we were running around like chickens with our heads cut off. (laughs) It really worked us up.

KJ: Did cutting in Avid change your approach to the film?

NQ: It would have been very difficult to cut the way we did on a flatbed because we used a lot of different effects that were really important for the film. Trying to do anything like that, a dissolve or a fade, is really laborious when you are cutting on film. Avid is an incredibly versatile tool when it comes to doing things like dissolves or cropping the image just a little. The one thing you lose with it is your perception of the image. When you were cutting actual film on a flatbed, you could feel the image. You could just feel it; you made your cuts in relation to the light in a shot. Now that can be a bit more difficult.

KJ: And there is such incredible luminosity and transparency in *Beau Travail*; I can imagine that you had your moments of wishing you were cutting on film.

NQ: Well, things change and that's what allows you to do this kind of film. *Beau Travail* was very much a film that was constructed in the edit room. Unfortunately, I couldn't find the screenplay when I looked for it this weekend; I would have loved to find it. It didn't look like a traditional screenplay at all. It started with a long poem, and then there were a series of scenes and descriptions of places. What I did find were the lists of scene order in each reel. They're amazing. Completely out of the original order, which makes me think that working on Avid really did make the construction of the film a lot faster and a lot more easy than it would have been.

KJ: You must have been knocked out when you first saw the dailies.

NQ: It was really incredibly beautiful. At the time I was still editing *Pola X* with Leos Carax, and I couldn't look at the dailies until really late at night after I'd finished editing. Sometimes it would be eleven o'clock, midnight, one in the morning. The producers came and we would all sit there going, 'Ooh! Ah!' But, at the same time, it wasn't obvious how it was all going to work as a story, not clear at all. There were some beautiful scenes in and of themselves but, in relation to the overall story, it really wasn't clear how it might all add up. *Beau Travail* really expresses the confidence Claire has in cinematic language, which is certainly a belief I share. Claire has great confidence in cinema. And this film in particular reflects that – because the meaning in it is almost completely created through picture and sound. That's how meaning emerges in the film. And that's what it really is, truly a great confidence in the power of images and the impact of sound. The sound is particularly interesting in it. Jean-Paul Mugel was the sound

engineer, and he did a lot of stereo recording on location. Especially the music. The major musical themes in the film were from Benjamin Britten's music for his opera, *Billy Budd*, and those were broadcast in playback while they were shooting the scenes. The recordings were incredibly beautiful. We used those recordings in the sound mix of the film because you have the sound of the music interwoven with the sound of the wind. It was magnificent. If you tried to layer a recording of the wind over a recording of the music, you could never get to the recording Mugel had made on site, and that's why we used it in the sound mix. He recorded a huge amount in stereo on location, and that's why I think we only had two or three weeks of sound editing. It really was a very simple sound edit on this film because so much sound already existed in the original location recording.

KJ: The music was being played when the Legionnaires did their exercises?

NQ: Yes, Mugel played the music over loudspeakers, and in certain places there was a lot of wind. When the men are out marching, which was filmed in a tracking shot, they are playing the Neil Young music over loudspeakers, and there's the sound of the wind and the camera car. So it made for a pretty unique sound. So much was thought out. Claire and Agnès had seen those dry little bushes shaking and blowing in the desert, and they told the choreographer, Bruno Montet, about them. So he choreographed the Legionnaires' movements to create shadows like the way those bushes moved. Agnès had figured out the time of day for the shadows to be the right length. And then Mugel blasted that music while the Legionnaires moved in the sun. So you hear all of the atmosphere of the place in the music.

KJ: I was sure that the sound mix was quite complicated for the film.

NQ: Not at all actually. And when you have great sound from the very beginning with a film like this, it's an incredible pleasure, a true pleasure. I really think that this is a very strange film. I was truly happy to see it again. It made me remember how the hardest part was in the beginning, when we had all of those little fragments of scenes and we really didn't know how to move forward. We didn't have much of a story – just the idea of betrayal, and we had to put it together in a way that all of these incredible images would speak to each other. I believe that the shoot in Marseille didn't happen until about a month and a half after we'd started editing. Meaning that we were editing, but we didn't have the footage from Marseille, which really was the anchor of the whole film. They only shot two days in Marseille, but those two days were critically important. We used almost everything they shot. And then after that was the voice-over. Claire really had a hard time writing the voice-over – voice-overs are incredibly difficult to do!

KJ: Impossible! (laughs)

NQ: It really is impossibly hard. The voice-over was recorded a day or two before the sound mix, and even though I would have loved to have gone back in and readjusted the edit to the voice-over, there wasn't any time, and it didn't happen. It was frustrating for me because there are moments that play a little longer than they need to because we had left too much space for the voice-over. When you edit without knowing what the words will be, knowing the idea of course, but without really knowing the words, it changes everything.

KJ: That's incredible that the voice-over was the last element to come in!

NQ: That's right.

KJ: It's such the heart of it all; I imagined that the voice-over existed in the screenplay.

NQ: No, I know, that's what's really crazy about this film. But, on the other hand, it's wonderful, because you have these floating images; it's really as if it's all floating in water. And that's because the image came first.

KJ: It works the way memory can work.

NQ: Exactly. One image conjures another, and eventually all of the images speak to each other. A sound might bring you back into reality, back from the desert to the steam coming out of Galoup's iron. I especially love the long dissolve between Galoup's notebook and the flowing water. It's really beautiful. There are a lot of things like that which were created in the edit. The scenes of the young women dancing, for example, were all supposed to happen at once but, instead, they are peppered throughout the film, which end up being important. So it reads as a story of foreign Legionnaires in a place called Djibouti, but it also is a story full of the presence of the people who really live there. The people are there, watching the Legionnaires. One of the great strengths of both Claire and Agnès is to capture moments, like the woman who throws the rock or the shot of moonlight on the water. It's one thing to film scenes that you've already thought of, but it's another to be able to capture moments on the fly, which are as meaningful or as beautiful as that shot of the water, which was only lit by moonlight. They just grab shots like that in the moment without knowing where they will be used, and it's wonderful. It's really valuable to have shots like that.

KJ: And that shot of the woman throwing the rock says it all: 'Get out of here, this place doesn't belong to you'.

NQ: When I saw that shot in the dailies I knew I had to use it. But where? It had to find its place.

KJ: But you know when you see a shot like that that there must be a place for it! That kind of 'catching it on the fly' shot that's the trademark of

documentary camerawork, would you say that Agnès and Claire do a lot of that within the scenes that are completely directed?

NQ: Often. For example, when the men are exercising or at the birthday party, those are really lived moments that are being captured with the eye of a documentary camera. All of those young men really completely lived the film.

KJ: I can believe it! How long was the shoot?

NQ: It wasn't very long: I think only five or six weeks.

KJ: You were saying that all of the club dancing shots were supposed to be grouped in one scene?

NQ: That's what I saw as I went through my notes. Look, here's the order of scenes in the first reel: 8, 39, 1, 2, 68, 11, 104, 112, 22! (laughs) No, it's really something to look at it. With Reel 2, it goes 36, 41, 42, 44, more or less in order, and then it goes 48, 120, 39, 39 – the nightclub again, 56.

KJ: Everything completely out of order!

NQ: Here's Reel 2 – there's a little bit of continuity from scene 26 through to the end. Twenty is the chess match, then you have Marseille 66, you see, 92, 68, you can see that those are the scenes related to places that we return to, but it's amazing to look back at this list...

KJ: When you began editing and you didn't yet have any material from Marseille, did you just start assembling scenes?

NQ: Yes, we started putting scenes together without much of an idea how anything would come together. I remember that we had a lot of scenes of the men marching at sunset that we were going to put together with a poem of Aimé Césaire at the beginning of the film. I didn't think it worked, but Claire was attached to the idea. It seemed like a tough thing to pull off – starting a film with a poem. So we really didn't figure any of it out right away. We had little units of scenes that we put together bit-by-bit and once it started to make any kind of sense, we just kept moving forward like that.

KJ: Was it all intuitive?

NQ: At times the work of editing is all about reflection and at other moments it's all about intuition.

KJ: And the back and forth between the two.

NQ: That's right, you have both, and then there are things that just don't come together immediately, and then perhaps something comes together that's completely obvious – it's very difficult to describe how editing functions. Claire rarely speaks directly about things, at least in relation to the editing, but she feeds you. She tells you things, things that don't necessarily have to do with the film, but her thoughts feed you and guide you in the editing.

KJ: When you've put together a few scenes or an assembly, does she react to the material with clarity?

NQ: It depends. When I show her scenes she might say, 'Oh that's great, that's great', or she might just move on to the next problem and sometimes she doesn't have a reaction right away. She is not at all someone who says, 'No, that doesn't work, that works, that doesn't work' like some directors. She's not like that at all.

KJ: Does she let you work a lot by yourself?

NQ: At certain times, yes, because she is doing so many things. There are times when I am just working by myself. I edit, I edit, I edit, and well, then... That's what's great about editing. It's not irreversible. At the early stage at least. You can try something, and if it doesn't work, it doesn't work.

KJ: And you feel the freedom to try new things?

NQ: That's what I love about it. And you have to try to understand the film. When you are editing, sometimes the film slips through your fingers. You don't understand it right away. You can't just, it's not, how can I say it... it's a lot of work. Nothing's clear. There's nothing certain. Once in a while, yes, there will be a scene or two that comes together without any questions, more or less right away. But the whole is never a given. There are gorgeous things that you know will find their place in the film, but you have no idea how, you just have to find the way to bring them in.

KJ: The thing that I love in *Beau Travail*, like in the shots of the young women dancing in the nightclub, is that sometimes you show us things just for the pure pleasure. There's a lot of confidence in that. To set out just to create pleasure for its own sake.

NQ: Yes.

KJ: A lot of people try to make every scene serve the story in this very utilitarian way, but pleasure has its purpose.

NQ: Well, this is a film full of visual pleasure. You have other films that don't have that. The pleasure isn't there, or there isn't enough of it, so it just wanes. It can't sustain itself.

KJ: There's that incredible moment when one of the Legionnaires is spider-walking under the wire, and it has such a gorgeous and violent impact. It comes out of nowhere. I can imagine that you had lots of material of the men exercising, but different moments like that began to take on different emotional weight.

NQ: Absolutely. Those little pings of sound that the wire makes as he's crawling under it are really something.

KJ: It seems like the beginning of a film is often the most difficult and the last to be edited. Was that the case with this film?

NQ: I think it was. There were some last touches at the end. We had the songs; they had recorded the Legionnaire songs that the men sang. I don't remember exactly, but I think there was a scene where they were sleeping that's no longer in the film and one where they were singing, but we just kept the sound, which was really quite beautiful. We took that singing and put it over another shot, the painting on the rock. Without a doubt, we found that idea at the very end; it took until the very end to find the beginning. (laughs) That's always the way with beginning and endings...

KJ: They always elude us! (laughs)

NQ: Absolutely!

KJ: But from the beginning of the edit you had the music, which wasn't going to change and which really was vital to the energy of the film.

NQ: That's right, we had the two main pieces by Britten, the Legionnaire songs and the nightclub songs, and of course the incredible dance to 'The Rhythm of the Night' at the end, where Denis Lavant is completely mind-blowing.

KJ: Now was that always the end of the film? It's a breathtaking ending.

NQ: I think that Claire knew right away that it would be the ending because it's so strong. You had to finish with that.

KJ: How did that scene ever come into being?

NQ: You'll have to ask Claire. It's all a part of the 'man in black' side of Galoup, like his black double or his shadow side. The end really is mind-blowing. It's an explosion. It's like some breathtaking interior violence that just has to get out. I have such admiration for Denis Lavant. I've worked on many of his films, and he always completely takes my breath away by how precise and surprising he is.

KJ: His dance scene comes as such a shock that it's stayed with me for years. I love that Claire knew it had to be the ending of the film immediately.

NQ: Yes, we had it there from the beginning.

KJ: There was no way around it really.

NQ: There were two takes. I remember it well: there were two takes, and we couldn't bear not to use both of them. We separated them by the card with the actors' names on it. That way we could start with one take and finish with the other and use them both! (laughs)

KJ: It's as if you couldn't deprive yourselves of the pleasure to be found in each take. Just when we think it's over, bam! The card goes, and he's off again!

NQ: That's it. You think it's the end, but no! (laughs). By the way, in watching the film last night, I was also really struck by the shot of the compass. It's a simple close-up of just the compass, and it totally works. I really found that shot surprisingly powerful. It carries such weight of story.

KJ: It's a great metaphor – losing your true North.

NQ: Yes, and I think what's amazing in cinema, what's remarkable in Claire's films, is just that kind of belief. The belief that so many things can be said in one shot, in this case, just a close-up. And it works – with that one shot of compass, so much is said. And that's really something.

KJ: Where does Claire get her confidence to not explain things? It's a rare thing in films. Not so rare when it comes to great filmmakers, but most everyone else seems to be trying to explain too much...

NQ: I think Claire really hates that. She detests films that try to explain psychology. I think what she loves in cinema is when things are felt but not said. As for the way she believes in the power of cinema, I have no idea where that comes from, but it's really wonderful! (laughs) Truly, truly wonderful. She believes in the images, she believes in the sound, she believes in the editing.

KJ: Do you share her belief?

NQ: I do, but then I have my moments of doubt with certain films which are much more dependent on the storytelling. With that kind of film, you can have your doubts about the strength of an individual shot. But, with Claire's films, if you are going to watch one of Claire's films, you have to be ready to go on a voyage. It's a completely different mindset. We know that there won't be any explanations, we know that it will be up to us to make the connections, it's up to us to go for the ride. And, at the same time, she always creates an incredible mood. The music is always incredibly strong emotionally. She does it every time. For that, I really have to take my hat off! (laughs)

KJ: Our hats are off! (laughs) It would be so easy to completely lose your viewers with *Beau Travail* and, yet, I feel like you have succeeded in making a film that is incredibly free but in which the viewer is not lost.

NQ: That's good. (laughs) In any event, I really don't know how...I have a hard time talking about Claire's films. It's really very, very hard to talk about her films. I don't know – for me, this was one of the easier ones to do. I think because it was so free. It's really pretty simple – we know from the beginning that we are in someone's memories, that we're in Marseille, with Galoup, who's writing in his notebook about the past, so we know where we are and how it will work.

KJ: He's your guide.

NQ: And I feel like that's really well established at the start of the film.

KJ: Yes, but there's a great freedom even in that. Clearly you know when you're with him in Marseille, but there are plenty of moments when you wonder if that really was the past. Did they really carry a man on their shoulders? Did Galoup really wear that black outfit?

NQ: No, that's a fantasy.

KJ: But you're not sure. Maybe he wore that when they went to the nightclub. Yes, he's your guide, and, yes, there's a present and a past, but it's a lot more complicated than that.

NQ: Claire really pushed for the cut to stand on its own without the voice-over. I think she was right to do that, because, probably, we wouldn't have created moments like the sequence where the woman is dancing in slow motion and the guys are carrying each other through the streets, where it just works with picture and sound and it doesn't need any voice-over. That wouldn't have happened if we had the voice-over from the beginning. Sometimes voice-over can be a crutch. Picture and sound can do so much without words. It's not a classic construction, but you can understand everything. I know that there were a lot of moments in the edit when we were really lost without the voice-over: it really wasn't clear what we should do. At the same time that we had no idea how it would come together, I felt confident about it. I had confidence in Claire, too. There are always moments of doubt when editing a film, when you really say, 'What have we gotten ourselves into and how are we going to get out of it?' But what you're missing is just the layers, you have to keep bringing in the layers.

KJ: Despite what you said about the sound mix being relatively quick, sound in this film is very complex.

NQ: It goes with the picture.

KJ: You're bold, though! You do some bold things with the sound!

NQ: I love playing with sounds during the picture edit. I like looking for sound ideas.

KJ: But you don't spend as much time on it as you do the picture...

NQ: I love sound engineers who give me lots of wild sound to play with. I like to just listen to the distinct recordings and start to play with the sound and see what it can do.

KJ: You think of it as much your material as the picture is?

NQ: Of course.

KJ: Plenty of people bring in sound once they've already cut picture.

NQ: No, no, not me. Especially with this kind of film. This film is picture and sound.

KJ: Lots of people say that's what their film is, but it's not so often the case.

NQ: That's the way I always think about it.

KJ: The sound is completely integrated to the way you think about picture.

NQ: Sounds give you ideas.... Just a little sound or a noise that you take away can count for a huge amount. It's really important. I don't do sound editing, but I am always working on sound during the picture edit. And

especially when you are working on a film that deals with memory like this one does, it can be really wonderful to take away the direct sound. You can't be too realistic. When I re-watched the film, I really noticed how little direct sound there is. I think that it's a wonderful choice. For example, when you hear the direct recording of the Legionnaires talking amongst themselves, which only happens a few times, it can quickly become something a little banal. But when the direct sound is pulled away, it allows the film to be more atmospheric, sometimes epic.

KJ: You fight against literalism.

NQ: When it's too literal it doesn't interest me. But when music or sound appear and disappear, that's how you create emotions in film. That's what makes the picture really take off.

KJ: It's been really interesting to me to see how much you pay attention to sound as we've watched the film. It's almost like you hear it before you see the images.

NQ: It's also great to see the film after so many years, because you don't know how it's going to hold up; it's been 12 years, and there are lots of things I don't remember. There are things in the edit that I no longer have any idea whether they came from Claire or whether it was me. But it doesn't matter. It's the film that matters. I know that there was a whole process and that it wasn't easy, but then you just forget it. I really love that.

KJ: Real collaborations are like that.

NQ: Yes, and it's the film that's important.

KJ: It must be great to see it after all this time and be able to say it holds up.

NQ: Especially to be able to say that it holds up after ten years! It really is a timeless film. It's strange, isn't it? I think ten or 20 years from now it will still work. It won't be dated. It's outside of time. It really is a UFO, isn't it? In the good sense of the term! I remember once when we screened it for Pierre Chevalier, and we finished watching it and talked about it, and then he said he wanted to see it again just for the pleasure of it. It was very moving, that man asking to see it a second time.

Notes

1 The Avid Media Composer is a non-linear digital editing system that was introduced in 1989. The first Academy Award for editing for a film cut on Avid went to Walter Murch for his work on *The English Patient* in 1996, which heralded the beginning of widespread adoption of the Avid system by editors in the late 1990s.

4 Still from *Beau Travail*

Interview with Alex Descas

Kirsten Johnson
Translated by the author

I met Alex Descas in a café near Montparnasse in July 2011, to talk about his collaboration with Claire Denis. Alex has had roles in six of Claire's films over the course of the last 20 years. I'd been put in contact with Alex by Raoul Peck, a director with whom we've both had the great pleasure of working. Born in Haiti and raised in the Congo, Raoul Peck, like Denis, has incorporated an in-depth inquiry of colonialism in his filmmaking. Alex Descas played the role of Mobutu Sese Seko in Peck's 2000 film, *Lumumba*. Alex described both Raoul and Claire as those rare directors who are not only able to see people and situations on multiple levels, but who are also remarkably able to communicate the complexity of their gaze to the rest of us. Alex began our conversation by telling me how he first met Claire:

> **AD:** There's a great complicity between us. We've known each other for many years now, since... it's simple, our first film together was *S'en Fou la Mort* in 1989. We met each other a little before that. At the time I was barely working. You could even say I wasn't working, because what I was being offered really wasn't great. I was trying to do my best with the terrible roles I was getting, but when we met I wasn't working much, and I had just about decided to quit acting altogether because the things I was being offered were so degrading. I said to myself I've already done all of these roles – the drug dealers, the low-lifes. But that's what I kept being offered, as if there was no end in sight. It was tiring. So I had decided to stop. I was getting the reputation of someone who was difficult because I

wanted roles in which I could enjoy myself and stretch just a little bit. I just wanted to play a normal person instead of the caricatures I was being offered. So I met Claire at this time, I think through Isaach de Bankolé, who was my best friend at the time, though now he lives in New York.

Now that I think about it, I think the first time I heard of her it wasn't through Isaach but through an actor named Mireille Perrier. She did a lot of films in the Eighties. I remember one night when I was at her house and she left the room and I saw a screenplay on a table called *Chocolat* by Claire Denis. I hadn't heard of Claire, she hadn't made any films yet. When Mireille came back into the room she said that I was welcome to read the script. When I flipped through it, I realized immediately that there was something special about the way the characters were handled, and I wanted to meet the person who had written it. I wanted to be in the film. I did something that I never did – I found a way to contact Claire so that I could tell her that I'd heard she was preparing a film. I didn't tell her that I had already read her screenplay! She told me that the role that I might be right for was in fact written for an African-American, whom she'd already met, who lived in Cameroon. So she didn't see how it could happen, she said, but she'd think about it. She explained that she was on her way to Marseilles to work with her co-writer, Jean-Pôl Fargeau, and that, when she got back to Paris in a few weeks, she'd call me. A few weeks passed, and she hadn't called. So, I decided I should call her. And she told me 'No', that it wasn't going to work. The role was for a former GI, so it really had to be an African-American. And obviously, I was quite disappointed, but I understood, and that was it. Time passed, and Isaach got the lead role in *Chocolat*.

I don't think it was until after he'd shot the film, that I met Claire with him, somewhere, no doubt in an African restaurant near Belleville. And still nothing. Then, months and months later I was out with Isaach, and Claire was there, and I noticed that she was really watching the way Isaach and I interacted. She watched us with a way of seeing that only few directors have, like what I said about Raoul [Peck] – it's a dimensional way of seeing the many meanings and layers present in a person or a situation. A little while later, Claire called both of us and said that she had an idea for a film about two friends that she thought the two of us might be right for. She told us a few things and then said she'd say no more but would send us a synopsis in two weeks. Two weeks later we read the synopsis and were incredibly happy because it was quite wonderful, and she asked us whether we were interested in collaborating on the project. If we were, she'd write the screenplay. Are you up for it? Of course we were, we were two young actors barely working. Isaach had finished *Chocolat*, and I wasn't

doing much and we said, 'yes'. On top of that, we had never really worked together before. Especially with great roles. And a little while later we had the screenplay for *S'en Fou la Mort*. It was truly an incredible adventure. Really, really incredible.

KJ: Do you think part of her inspiration for the film was seeing you two together as friends?

AD: There was definitely a connection. I think that it mattered, the fact that we really were close friends, similar in the way we were leading our Parisian lives.

KJ: But you were so different.

AD: We really were different. We each came from different worlds, Isaach from the Ivory Coast, me from the Antilles. So close and so different at the same time. There were a lot of things that brought us together, the way history was, all of it, and I think that Claire and her sharp sense of things, her incredibly quick intellect, she really picked up on something interesting.

KJ: Of course Isaach is exceptional in *Chocolat*.

AD: Completely.

KJ: But it seems that something Claire is attuned to is how the idea of the 'exceptional' person has been a part of racism. I can imagine that when she saw both of you together as good friends, she could see what it would mean to cast someone as strong as Isaach in a role next to him. It could be a way of defeating the idea that there can only be one 'special one'.

AD: Yes, absolutely. And we really are different. I think that's part of why it's interesting to watch us together. Isaach is like the sun. He is completely radiant, when he walks into a room you have to look at him, because of his laugh, just the way he carries himself, he really becomes the centre of things like the sun. When it comes to me, and I've gotten to know myself a little as the years have gone by (laughs), that's not me at all. I love the light, but I think I'm a lot happier in the shadows. That can cause some trouble when you are always in the shadows and you look out into the light. But I think, in terms of the roles we had, it was a really interesting relationship because it's two people with completely different interior states. One looks inward, the other looks outward. One had a madness that pushed him towards death, while the other one was always talking about business. Isaach's character had that kind of energy, which I think my character, Jocelyn, couldn't really handle, he was more trapped in his way of being.

It was a shoot that we did on an incredibly low budget, and it almost fell apart several times – I was told that a long time after the film was finished, I didn't know it at the time. One of the times was when I was on my way to

Martinique, where I was going to spend time with some people involved in cockfighting, because I had never even seen cockfighting and had no idea how it worked. I had never been a part of it in the Antilles. I'd never gone to the rings where they throw the cocks in and watch them fight. I'd heard about it, but for me it was a little disturbing. So it was thanks to the film that I was able to connect with a part of my culture I'd never known. So, later, Claire told me that it was right before I was supposed to leave for a month in Martinique that the producer had called her saying that the film wasn't going to happen. But she didn't have the heart to tell me, and so I went. She just decided that she would find a way to make it work. And I think that happened many times during the film. But she never told us because she really believed it had to happen, and it did, but with a very low budget. I know that I went into a deep state while making the film. It had a great urgency for me, and it was as if I became another person. There was an incredible energy on the set, I would almost say 'magic'.

KJ: I would think that must have felt like it was your big chance, and you were giving it everything you had.

AD: It was my big chance. It was my great opportunity, and everything that's happened since is because of it. It's all thanks to Claire, really. She laid the first stone for all of the rest of it.

KJ: I don't know if you were aware of it when you first acted in *S'en Fou la Mort*, but what always strikes me about your presence as an actor is the way we can read what's happening inside of you on your face. Did you know that's what you were capable of before you did the film?

AD: No.

KJ: Did that film show you how much you convey by your silence?

AD: I had no idea. I think I had never seen myself in such a significant role. So I had no idea of what I was capable of. Like you mentioned earlier, I think Claire did see something in my friendship with Isaach. It's the kind of thing you can't often see in yourself, and I certainly didn't see any of it in myself. And even now, though I've done so many more films, maybe I can see myself for a moment, but even then I'll forget it immediately. You have to forget it when you act. You can't get caught up in that. I think you can't really see those qualities in yourself. And, in lots of ways, it's just something you are. It's outside of the work. It probably has to do with a lot of things, my childhood, where I come from, my education, it's just about who I am. Inside. So I don't understand it. So it's just a gift or something outside of myself. It's your own energy. It's like Isaach, who is just incredibly radiant. I'm nothing like that. And it's nothing you can change, it's just the way it is.

KJ: When you say that *S'en Fou la Mort* was like the first stone in the foundation of your film career, I think to myself of all the films you've done with Claire, and it seems like both of you share a very particular form of patience. I get the impression that you have been feeding off of each other ever since you started working together. The great calm in your character in *S'en Fou la Mort* is so riveting that I wonder if your presence helped Claire realize that she could linger even longer on people's faces with the camera. In *35 rhums*, the camera just takes its time watching the changes that happen in your face.

AD: It makes sense to me what you're saying about time and patience. Every actor should be so lucky to work with Claire Denis. Without imposing on you in any way, without generating any stress, she takes her time to listen to you and to really see you. And then the camera's there with her and she's able to capture your presence. In *35 rhums* there's an incredible relationship to time. It's not cut, cut, cut from shot to shot. There's a sense that there's all the time in the world to be with the characters. That the film understands time for the characters in relation to life, in relation to their own lives, the time that life takes, that's what really struck me when I saw the film. I said to myself, 'What an eye she has! What confidence'. It's incredible to have such a way of seeing the world.

KJ: It's a confidence in what can be seen in a person.

AD: It's really an extraordinary way of seeing. It's also true that I have complete confidence in her and what she wants to film, so when we're shooting, I'm not doubting myself, no matter what she asks me to do. I don't ask myself, 'Did that work? Is it any good?' I believe it. I don't believe it. I don't have any doubt.

KJ: So you feel secure when she films you.

AD: Completely, because she's there, and Agnès Godard, with whom we've done so many of the films, is there too. I feel incredibly secure in the presence of these two women. They let me follow my instincts, they can ask me to do whatever they need me to, they have confidence in me and where I'm taking things. And once I've thrown myself into it, they leave me the choice to stop if I need to, or to just keep going, or to take something apart, to find my way, however it works for me – because we all know where we're trying to go more or less, but they let me find my own way, which is just a remarkable form of trust. And that's the way Claire sees me, and that's how the camera sees me. And I'm not the only one she treats like that. She's like that with all of the actors, all the way from the person who has the main role to the extras, and that's what's really fantastic.

KJ: And what's that like on set? I know that shoots are always short on time and money, so how does she do it?

AD: Of course, there's never enough time on set, but somehow in spite of that, she won't stop until she gets what she wants. She just keeps going. If it doesn't work, then maybe she'll change the set-up, but she'll keep going. If the actor isn't coming through in the way she needs, then she'll find a way, whether it's through talking to the actor or through the camera.

KJ: But how does she do that without making the actor lose confidence? When an actor knows that the director still isn't satisfied with what he or she is doing, it can really destabilize a performance.

AD: (Long silence) I don't know how she does it. Because it's true that you can really start to doubt yourself as an actor when a director is doing take after take and it's clear that it's not working. So, when Claire keeps doing takes, I could start to get paranoid and think to myself, 'I'm terrible'. But that's not what happens. That's where she's really exceptional – she'll never give you the feeling that you're no good, she'll just keep giving you notes and direction until she gets what she's looking for. Sometimes I do think to myself, 'It's me. I'm blowing this'. But then, at the end of the day, we always find it, because something happens when you keep searching, when it doesn't feel right, but you keep trying, and then you break through, I don't know quite how to say it, but suddenly you feel like you're in something real. I can get really caught up in my head trying to find solutions, but I have to say, the best way to work isn't to have it all churning in your mind. Sometimes you have to go to that agitated mental state to find your footing again, but then you have to let your mind be still and let yourself go back out into this other dimension, I don't really know how to say it...

I know this is going to sound completely ridiculous, but it's like there's a dimension where everything is happening only in relation to sensations. In relation to what you feel. In the same way that you might feel the wind on your face or the sun shining on you or whatever else. In those kinds of moments you enter into this dimension – I mean, that's the way I experience it, that I enter into a dimension of pure feeling with everyone who's around me, the other actors, all of it. The only thing that exists is sensation and touch, even if you aren't really touching a person. People touch you and you touch them in your own way, that's how it works. So, it's no longer a case of understanding things with your mind in an intellectual way. You're just present, you're just there. I think I'm... it's strange because this is the first time I'm saying all of this, but I think that most of the time when I'm acting, I'm in this dimension, and so I don't have the feeling that I'm being false or that I'm acting. I've always felt

like using the word 'acting' is a little pejorative. It's like saying that you do something and then you do it again, like it's a mechanical thing. As if you are mechanically doing the same thing over and over and someone is saying stop and go – that doesn't interest me.

I think I get into this state of waiting before each take, looking for the way to get at something that feels true or profound, and each time I do it, it's different, but it's always coming from the same source. That's the way it is for me. And it's really what's saved me in my work. That's how it is: there's nothing but a world of feelings. Once you've learned your lines, once you know where you're headed, you just have to go. It's as if you were headed down a staircase and it's completely dark at the bottom and someone tells you to start walking down. That's a little crazy as an example. And you have no idea what's at the bottom of the staircase. Because it's completely dark after the first step. You can be afraid, saying to yourself, I can't do it, I can't go down there, but you have to trust. And once you start walking you have to use all of your senses. It's like being an insect or a dragonfly with really sensitive antennae that can pick up everything. Or maybe it's like a passport that allows you to go anywhere without being afraid. It doesn't help anyway to be afraid, you just have to go to the heart of yourself, down into the darkness, where you will find your source. I think it's more or less the same source for everyone. Except that there are some who are afraid and others who aren't, and we don't know why. There are plenty of reasons to be afraid. So some have the gift of being fearless, almost all of the time, which is fascinating, so they can just go up and down the stairs as if it's a game. And that's what being an actor is all about; being an actor is so strange because it's always been work that's more philosophical or spiritual than mechanical. It's a relationship to the body in the same way it's a relationship to the senses – the way you touch someone, so it is always connected to something spiritual and it has a way of bettering you as a person. If you can't get something in life, when you are engaged in this journey up and down the stairs whether you make it or you wipe out, you have the opportunity to have what you can't have in life. You have to have the interiority necessary to go into something that's real. You can't fake it. There's nothing flashy. And that's important.

Last night, before falling asleep, I was watching television, and I saw an actor I really love. And I saw him in a couple of scenes, and I realized he wasn't very good in them. And he's a great actor. But he wasn't good in this at all. I thought of myself, and I thought, I hope I won't be like that in the next thing I do, that I won't fall into the trap of becoming mechanical. That I'll have to really give myself over to it. It's complicated. And I do get afraid.

KJ: Claire puts you in danger as an actor.

AD: We're always in danger. That's what's great!

KJ: That's what's so moving.

AD: Yes. That's what I tell young actors when they see me in something and tell me about how nervous they are when they act. And I tell them, I'm just as nervous as you are. And they say, But you've done lots of films, and I tell them, I promise you every time I hear, 'Camera!', I am as nervous as ever. And I have the feeling that everything I've ever done before can't help me. So, even though there's all this fear and emotional charge and it's always there when I'm about to do a film with a director and the first day of shooting is coming and I'm a mess... but then I get to the set, and I start to find everything – my relationship with the other actors, with the director, I start to get into it and then I remember that the camera is this extraordinary thing and all it needs me to do is be the best I can, to be as true as possible. It's such a strange eye, they say it's an objective eye, but it's really an eye that takes you in... (laughs), oh, I don't know how it works!

KJ: One of the moments that really struck me was when your character dances with his mother in *J'ai pas sommeil*. Often, Claire puts you in positions where there's a lot happening simultaneously...

AD: True.

KJ: In that moment, you are conveying so many emotions – how you feel about your mother and your brother, but you do it all physically and with such clarity that we can see the emotions as they change. Your brother cuts in on your dance with your mother...

AD: Yes!

KJ: We can see the way you see that he's a little out of it and how it affects you. How do you do it? It's like you are inside the person.

AD: Yes, that's it. What's your question?

KJ: (laughs) Does it help you inhabit the person more when Claire puts you in these situations where there is so much going on – like in *35 rhums* when you're in the restaurant and you're exasperated with your neighbour the taxi driver, you're watching your daughter dance with the upstairs neighbour and you're attracted to the owner of the place?

AD: I had this strange feeling, thinking, you're with your daughter and with this woman who has feelings for you, who's been waiting for you forever and you know it, and then there's this woman from the restaurant, how can he do that? Claire puts my character in a situation like that where he has to do something, all the while knowing that his daughter is there and that taxi driver who has these really strong feelings for him is watching him, but he's going to choose the woman he doesn't know... But that's life!

KJ: That sure is life. And it also works as a great gesture by the father to the daughter, showing her that she has to live her life for herself, the way he does in that moment.

AD: Exactly. And I said to myself, He has to free his daughter, to show her that you have to do what you want to do, that's the most important thing, to follow the energy that leads you. And I did it in that spirit.

KJ: Maybe that's the strength of your collaboration...

AD: I think you're right, though I don't know what you mean. (laughs) I also think that even when we know people well, we don't know them at all. In *J'ai pas sommeil*, you never know people well, even if it's your husband or wife, even if you've spent lots of time together, like your brother, your father, your mother, there are so many surprises. Claire's strength is that she understands that, and now I share that with her. Because of all the time I've known Claire and what we've shared on a professional level as well as a personal level over all these years, we've built that together. And even if I don't see her that often, because it's always complicated to find her, she's always doing something and she never has enough time...She's such a hard worker that, even if we're talking regularly, a year can go by before we actually manage to see each other. She's working on so many different projects simultaneously. Sometimes I yell at her, 'This is crazy! We never see each other!' Before she left for Brazil, I thought the same thing to myself. Every time I call her it's always the same thing: 'I'm on my way out of town'. To Germany, to London, to Switzerland. It's a joke between us; every time I call her she says, 'I'm leaving town'. But what I'm trying to say is that this friendship that we share is very strong – when you love people it's not just friendship. When you really love someone, you might call it a friendship because you don't live together or you don't sleep together, but in some ways Claire and I have brought many things into being together. Not just in the films we've made together but in the reality that we share – there's a lot we've created together. That exists.

KJ: You said that she was in Brazil doing research on her grandfather. I know that *35 Shots of Rum* is based on the relationship between her mother and her grandfather. It seems significant that she would give the role of the father, her grandfather, to you.

AD: Yes, the father. I don't think I can say much more after being given such an incredible gift.

KJ: It's an honour.

AD: Truly. Her relationship with her grandfather was so important to her and for her to give me the role...it's very moving to me. It's very powerful. Somebody else might have thought, but my grandfather was

33

white, he was Brazilian...but this goes beyond colour, beyond the facts of reality, or the way we're represented in reality, it's beyond all that.

KJ: When I look at Claire's work and I see her working with many of the same people again and again, it makes me think that she's really interested in seeing people through time, as they age.

AD: Through our different ages, through the time that passes, she's interested in all of it. Her relationship to time is an important part of her work. And it's always complicated because every film of hers is complicated. Obviously, it's always complicated by how hard it is to raise money. Despite her immense talent and the body of work she's built, she's only just starting to be recognized in France. It always seems like she's more recognized abroad than she is here. She still hasn't had a retrospective in France, even though they did one in Berlin, in other places, all over the place. I really can't believe it.

KJ: Me either.

AD: She's not a part of the French film-production world the way some people are, and it's always hard for her to get a film made. I'm not saying that she should have it easier than anyone else, but it shouldn't be that she has to start from zero every time, that it's always impossible to get financing, as if she's never made anything before. I just find it...it's sad in a certain way, that's all.

KJ: We were talking about time.

AD: Right, about her building work with people that she knows and also with people she doesn't know but who will be there for the next film. There's always someone new on set as well as those of us who've been there before, and that's pretty wonderful. She is very loyal.

KJ: It must inspire a lot of confidence in you as an actor that she's so deeply interested in you as a person.

AD: It does. And I think she has that kind of relationship with every person she encounters. With reality, with each person. When she talks to you, when she's sitting across from you, she does inspire a deep trust, something...I don't know, something that's true, somehow she radiates this intensity, and suddenly you're completely taken with her. You're taken with her and you trust her, that's how it is.

KJ: Taken? Captivated?

AD: Captivated. And on a human level, you just trust her immediately. She really connects. That's not to say she isn't complicated – she can be difficult. I've met people who've said to me, 'Claire Denis, she's too complicated'. Producers. Producers have told me that. As if everyone isn't...

KJ: Films are complicated.

AD: Films are complicated. Very, very complicated. And then with the body of work she's trying to create, that she has created, there's nothing easy. She's always had a very personal way of looking at things, she's never chosen simple entertainment. She's never gone for the easy way out. She's never compromised what she's trying to do so that she might have a bit more success or make things easier on herself. She always goes for what's complicated, what's difficult. Her choices, even the way she films, her subject matter, everything. Even *35 rhums* – who's interested in *35 rhums*? Some crazy producer. But who else is going to support *35 rhums* with unknown actors, with lots of black actors, in the context of French film production as we know it? It's really a bold thing to do, there's no box office stars... The producer, Bruno Pésery, really had to be brave. You have to give him credit for producing a film with so many unknown actors and a subject matter that I would say is a little dark, it's not completely dark – there are many rays of light in it, but still. It's like actors. They can be so dark and so luminous at the same time. But it's not a glamorous film, that's for sure.

KJ: I would think that the emotions that come across in the film weren't necessarily obvious in the script. The love that exists between father and daughter, the grief at the end. Every time I see the scene in the cemetery I cry.

AD: Oh, that cemetery scene, oh yes. We really were lucky because that part of the film was what we shot first. It was really wonderful for everyone – the actors and the crew. We shot the first scenes in Lubec, which is a place I'd never been, but what an extraordinary place. The light there is beautiful. The first scene was when we go to meet the sister of his wife who's dead, his daughter's aunt. It was very special. And we all spent this great week together there, and it gave everyone this incredible energy for the whole rest of the film. The great idea was to start with this scene. It was really incredible. We started with this, meaning we started with a trip, everyone went on a trip together. Because the film takes place in Paris and we all went on a trip to do these scenes, we started with a party. Even the work we did in that little cemetery was special. Just two weeks ago, I went to the funeral for Jean-Louis Ughetto, who did the sound for quite a few of Claire's films. He'd lived a long time. So, Claire was there, and lots of people, and it was in a cemetery in Montmartre that I'd never been to before. I'd gone down that street many times and never seen it. It wasn't too big, and I said to myself that it would be nice to be buried there. It was a special place like the cemetery in Lubec. There was beautiful light. There was such a pleasant energy there that we were all able to share. That's also what films are about. You don't know why, but sometimes

magical things happen. Between people. To a great extent, the film went on in that vein. All of us behind Queen Claire. To help her, all of us, all of us, it was incredible.

KJ: It really surprises me that those are the scenes you shot first. It's such surprising, uncomfortable energy in the scene with the aunt.

AD: I'm telling you, there was incredible energy with everyone there. It's like the scene with the father and daughter at the beach. They were singing, and I remember this moment because it was a moment of pure feeling, of pure truth between Mati Diop and me. It felt like there was no one else in the world except the two of us under a sky full of stars. The sound of the waves. The wind in the grass. Just the two of us. It's something very special to feel like there's nothing else in the world but the person you're with. Obviously, we're shooting and she's going to say 'Cut!' and you shoot something else, but it was like that all the time, where you had these moments where the feeling of reality was so strong that you just wanted to stay in the moment and have it be the only thing you felt.

KJ: The situation describes their relationship perfectly. Both of them want to stay in the moment, but they both know they need to move on. They just want it to last forever.

AD: It's a wonderful thing to have been given such a role. I'm not speaking as an actor but as a person. What better gift can you give to another person, to give the feeling that you're giving love? It's the most beautiful thing you can give a child. All the love that you have. When you have a role like this, you can make it through anything. It's an incredible feeling to give. So, we're back to the spiritual that I talked about earlier.

KJ: It seems to me that, often in the characters you play in Claire's films, your presence is one of a person who is ethical, someone who is trying to be decent despite the complications that surround you.

AD: What comes to mind is that I've always tried to work in relation to a set of ethics, trying to work on things I'm not ashamed to be in. I've only had one time in my career when I agreed to do something I didn't want to do and it was the only thing I've regretted. It's true that in general, I'm operating with a certain ethic. I will decide to do something if I think it's worth it. And it doesn't have be an important role. It can be a minor role.

KJ: It seems like it's something that's present in you as an individual. So, one of the things I find interesting in Claire's films is that she highlights this quality in you – for example, when you are the father of the small child with Béatrice Dalle, when you are the father to Mati Diop, or your role as a son in *J'ai pas sommeil*, but then she puts those characters in direct confrontation with the impossibility of remaining a decent person who puts up with the situation, like when your brother is arrested, or in *Trouble*

Every Day when Beatrice kills another person and sets the house on fire. A moment comes where your character can no longer continue to be patient.

AD: No longer take everything on my shoulders.

KJ: And that's what's so interesting – Claire gives your characters a lot of time to express the depth of their patience and then puts them in conflict with it.

AD: Because that's also life. It's very complicated to move through the world when you are trying to live with a certain kind of... how should I say it?

KJ: Dignity.

AD: Yes. Sometimes life slaps that person in the face. (laughs)

KJ: (Laughs)

AD: And it can really hurt. You have to react to it. She does give me characters who try to understand others, who try to understand or try to find a way to handle great difficulty, the amount of love in all of it... (long silence) ... It's just that it gives me a lot. Claire and I talk all the time, what's interesting is that we are always... nothing ever stays the same. When we get together, we always talk with a certain intensity – sometimes we're in conflict, it's not always easy. But we know each other well enough that we're both ready to forgive each other no matter what.

KJ: There's love.

AD: Whatever mood each of us can be in, because neither of us are saints – but you have to take the time to move towards the other person. See the person, if you can.

KJ: It seems like, between the two of you, both of you are doing that.

AD: Yes, yes, yes.

KJ: How much do you talk about a character before you start a film, or do you talk about other things instead?

AD: We talk about everything. Well, maybe we don't talk that much about my character before a film. Because the screenplay is so clear.

KJ: Claire's screenplays are clear?

AD: To me they are. But that's not to say what's in the screenplay is what it's going to be. Once it's a film it will be something else again, something even more clear, something that you've never seen before, that you couldn't have imagined. Or her way of handling it, the way she positions it, or what she asks of an actor. I am always surprised. Obviously. But, before a film starts, she'll say to me, 'Let's go see a film', and I'll know it's not just a casual thing but that she really needs me to see it. She does the same thing with her cinematographer. I've seen lots of Ozu's films with her. At one time, I didn't know Ozu's films, so one summer we saw as many of them as we could. And then before *35 rhums* she talked to me about a film

of his that I hadn't seen, which was the story of a father and son. So we went and saw it, and you'd have to be a fool to not get the connection. So that's how she does it. She talks to you about the film. I say, 'Yes, there are extraordinary things in the film'. She talks some more about the film. We talk about the film. And she keeps talking about the film and I listen. And then I say to myself, what she's saying there is important. I understand. I get it. That's how she does it. Or sometimes she'll just call me up and say, 'I was thinking about something...' She might do that on set too. But that's very rare. It happens though.

KJ: So when she's on set...

AD: She's in an incredible state of concentration. And in general everything goes really well with the way she relates to actors. She asks a lot technically of Agnès. Those are two very strong women. Each of them really needs the other. They are very complementary. They can really struggle together, sometimes fighting, because Claire really wants what she wants and Agnès understands what she wants, but sometimes she sees something different.

KJ: Is that kind of a struggle happening when actors are there?

AD: Not when the actors are there.

KJ: But you've seen it!

AD: Maybe we're all there. But it's subtle. It's a back and forth between what one wants and what the other is proposing. Since I know them both so well, I can see when that kind of a struggle is happening. So I won't say anything at all. I'll just try to be as good as I can as quickly as I can, just trying to stay as open to both of them as I possibly can. Sometimes Agnès will want me to do something for a technical reason and Claire will be concerned that it doesn't work for my character, but I'll just try it. Sometimes you are faced by both of them and you just try to respond to each of their needs.

KJ: I would imagine in those moments both of them have great reasons, even if they're in contradiction.

AD: Both of them are so brilliant. You can't say that either of them is wrong.

KJ: It's just the work of how to figure out how to move forward.

AD: I just try to not take sides. I try to stay exactly in the middle! (laughs)

KJ: Do you and Claire have a project that you hope to do together someday?

AD: You know, I never know if I'm going to work on the next Claire Denis film. I might know that she's in the middle of preparing a film, sometimes she'll talk to me about it, or someone else might tell me that she's getting ready to make another film, and I'll say, 'Oh, really!' But I just don't know if I will be in it or not!

5 Alex Descas and Claire Denis on the set of *35 rhums*

6 From *35 rhums*

3

Interview with Claire Denis

Jean-Luc Nancy
Video interview filmed by Hendrik Speck, translation by
Nathalie Le Galloudec

Switzerland, Summer 2011

Jean-Luc Nancy: The first time I interviewed you, I asked you how you came to the film business – you answered with a story from your childhood in Africa. You were in a dangerous situation, so your parents put you in a closed metal container and had you repeat your name so that you would stay in it because there were lions around the car and the car would not start. You said that, in this black closed box, you had a feeling of security and then of a certain happiness, a certain well-being. However, the second time, when I had you tell the story to other people, you said that you were very afraid.

Claire Denis: I was afraid of suffocating.

JLN: Yes, and to you it is not contradictory to be afraid of suffocating and then be somewhat reclusive from the world and thus safe.

CD: No, it's not. I was living in a country where there wasn't a cinema. People weren't going to the cinema, there was no VCR, no videos, so what I knew about films – since we lived in the bush in South and North Cameroon – was from my mother. She talked to me about films or talked about them with my father as if they were extraordinary memories. She talked about the films they saw or the ones she saw when she was a teenager. And, really, I did not understand at all what they were. For me, [films] were something that seemed to be – from their words, maybe – the only thing they missed. They weren't missing much. They were young and happy. They had been teenagers during the war [so they knew hardship],

and [in Africa] they had enough to eat. They lived outside, where money was not very important – a little like Robinson Crusoe. They didn't miss anything from Europe. Maybe a little, though, since they had a few vinyl records and books. I think that if there was one thing my mother missed, it was films. I was very curious about them.

JLN: What connection do you see between film and the story of the container that protected you from the lions?

CD: Well, actually, it's a connection I made when you asked the question many years later – this story of me being locked in the container and the lions circling the car that would not start became a legend in the white community in North Cameroon: 'Ohhh, you're the girl who was locked in the container with the lions and all that'. It became something of an extraordinary story that, year after year, when I went back to Cameroon, became more and more magical, you see. In the end, I was allegedly trapped for fifteen days! So, after all that, it became sort of a legend, though it was completely untrue. And years later, when I went to the cinema, when I knew what a film was, I thought, 'Really, what a drama...what a drama we created at that time'. But, still, I realized something: that I was not afraid of the lions – I think I was way too young to be afraid of the lions and imagine that they could eat us – but that I had a feeling of being isolated, of being in a different time frame, isolated from the stress in the car, from my mother's fear and that I was in peace somewhere shielded from the stress of others and, thus, my own stress. And time did not have the same dimension. I am going to say this in a crude way: it was like all of a sudden, time only belonged to me, to my dreams. I could interpret the sounds I was hearing, and I did not have to obey the group anymore.

JLN: So, at the same time, there is a film scene, but you never thought of filming it?

CD: No.

JLN: You never thought of using it in a film or...?

CD: No. When I made my first film, *Chocolat*, and I was checking locations in Cameroon, that's what people were telling me: 'Oh, but it's you – the girl with the lions', and I was telling myself, 'No' – this story can't be told because it would require special effects I didn't have, like putting the film camera inside a dark box. And finding beautiful lions like those ones, which aren't easy to find. No. I had the impression that this scene was much better as just an anecdotal story. And by the way, was the lion episode really the anecdotal seed for what would become cinema in my life? I'm not sure.

JLN: And it was a scene. It was a film scene, as if someone filmed it, but it was also a scene like you were...

CD: ... Yes, like a spectator, sort of a listener.

JLN: ... At least... like years later when you're asked [about cinema], you answer with this story. And here you just gave all the key elements of your position as a director.

CD: Mmm....

JLN: ... Who can interpret but who at the same time stays in the background.

CD: Yes.

JLN: So your answer bears the mark of a cinéaste who is able to interpret and, at the same time, takes a certain distance in adopting the position of the subject responsible for organising the whole film and finds in that distance some kind of tranquillity.

CD: Yes.

JLN: Is there a link for you – besides the story of the lions – between the fact that you became a film director and a certain distance towards the world in general that you developed during your childhood?

CD: Oh, yes, certainly, yes. I think it is easy to understand, that we were living a little away from the cities, in isolated areas where there were no roads. My father got around on a horse or in an old truck. My mother was a little like a woman on a ranch in cowboy movies, making bread, killing pigs, making 'rillettes' and birthday cakes. It was a little idealistic with the kids, the mother, the father and all that.

JLN: Kids? How many of you were there?

CD: Three at the time. My brother hadn't been born yet. There was – as we say in English – a *flaw*, a stain on this diamond, a defect. It was not the ranch of pioneers. It was the house of a French family at the end of the colonisation of Africa, so there was a gardener, a cook, a servant who came to take care of the clothes, clean the house, the floor, change the sheets, etc. So there was something abnormal, slightly abnormal. And my parents were very young – they had never had servants. We all felt like it was the norm, but it always made us uneasy. For example, my mother would only let the servant clean tablecloths, dishtowels and bath towels. Anything more personal she would wash herself. She would never leave her bedroom disorderly; she made her own bed, for example. There was uneasiness [towards servants] that I think showed how they felt there. Then later, when I returned to France, I had had, at the same time, a different life experience than other kids had. It was rougher, more adventurous. I had seen many countries. I think I was somewhat envied a little by the other kids in my extended family because I had seen animals like giraffes, elephants, lions, crocodiles. But, at the same time, they were a little contemptuous because we didn't own a house nor had much

dough. When we came back to France, we were poor. But maybe we experienced something they didn't know. We were enriched because of that knowledge, the knowledge that we were experiencing the end of a historical period and that independence was coming.

JLN: What year did you come back to France?

CD: I came back to France after the independence occurred, but when I talk about Cameroon at the end of the fifties, the Independent movements already existed. My dad always talked about them at home. You see, the war started in '57, so it was a part of us. We were returning to France as a family that ignored all this and didn't really care. We still talked about the war in East Asia, you see. Not at all what was going on in Africa, but we knew something was about to change radically. The French Empire was... was... nothing... was finished.

JLN: In addition, your family members were not settlers...

CD: ...No, they were government employees.

JLN: Your father was a government employee – that's right. And, thus, the second link to film...

CD: The second link to film was to actually go to the cinema. In France, my grandparents took me to Walt Disney films – cartoons – and I had the feeling that I was cheated. From what my mom told me, the films she told me about were stories of humans, stories about men and women, with the problems of men and women, and not cartoons. And I didn't like [the cartoons]. I have terrible memories of being taken by my grandparents to see cartoons. And I think the first time I saw a film with actors, only then did I understand what a film was. It was *War and Peace* with Audrey Hepburn.

JLN: What year was that?

CD: I don't know. It must have been in the Fifties. It was under the biggest tent in the world. But back then we did not see films when they came out. There were second and third showings, so a film like *War and Peace*, I suppose, must have been shown often and under the biggest tent in the world, too.

JLN: I understand very well what you are saying. Funny, I never realized it, but I had the same experience but younger, just around D-Day. I remember my grandfather took me to see *Dumbo* and a little later going to see *Tarzan*. I found [the experience] really was not comparable.

CD: Exactly, yes.

JLN: Because cartoons, I would say, were sending me back more to the books that I knew already at the image level.

CD: Yes, and, you know, I had a subscription to *Tintin* paid for by my grandfather. So comic books like those by Hergé were important in my

life, but I didn't want to go to the cinema to see cartoons that were even sillier.

JLN: Yes! And, also, I think not sillier, they may not be sillier but rather that it's another image. It's a drawing, I think; it's not an image. I don't know how to characterize it. You have to admit there is something like the illusion of reality.

CD: Yes, but they're not serious. In *Tintin*, even if we laugh with Professor Tournesol and the Duponts, and even if the situations are really outlandish, there is a capacity to follow, to accept that everybody has a personality, that Haddock is grumpy and needs whisky, that the Duponts are cops. It is at least something that looks a little more like life, where each person is unfortunately not simple – they have a past. You feel, for Haddock, that life was not always simple, or he would not need to be gulping down whisky all the time. I found that nice.

JLN: Yes, ok, yes, right... but we misunderstood each other there, because I meant that in the real film image, we believe in this reality, at least I think we do.

CD: Yes, we believe.

JLN: Even if it's *Tarzan*, for me it was...

CD: Of course...

JLN: ...It was *Tarzan*, maybe the first film... There are real trees, and it's a real guy that hangs from the vines, it's a real monkey...

CD: ...And when there's a man and a woman. For me, films were more troubling in that regard. They touch each other – they have adult attitudes – even if the films are not rated. Even a kiss, a stroke, a hand that takes an arm, or a hand that takes another hand. It becomes something that is addressed to me and not just something I hide and dream about, but it's exposed there, on the big screen, and it's addressed to me, and I can see it. I can see a kiss; I can see a man taking a woman in his arms. I can also tell that they are going to remove their clothes even if it doesn't show that at the end of the scene.

JLN: ...Especially in the Fifties...

CD: Yes, but the idea is there, the sexuality is there and [the idea] that there will be something more because, often in films, like in cowboy movies, there's a kiss, the hug, and then there's suddenly a kid after that. There is a sort of strange ellipse that exists in films for a young viewer. It is less puritan than the familial unspoken, I think.

JLN: So, for you, this dimension of the film is important, like seeing something that was forbidden.

CD: Yes, to see men and women in intimate situations was even more troubling than seeing someone kill someone else.

45

JLN: I was going to ask if it was similar or if it wasn't the same?

CD: No, because when I saw someone killing someone I figured it out – like everybody else – that it was fake, that nobody was killed. With death, there are people whose death or whose departure I remember – like something that impacted me for life. But what I felt was more powerful because in a film there is no death – when someone died in a film, it was not real. What was more powerful in a film for me was separation. It was the fact that two people who loved each other, or could have loved each other, would not see each other anymore or would lose each other or would go their own way because of a misunderstanding. And when the film ends, there is no proof that the misunderstanding will be resolved, you see . . . no . . . and that they separated . . . separation . . .

JLN: Is *Brève rencontre* an archetype for you?

CD: Yes, yes of course. *Brève rencontre* is a film that I saw late – a film my mother told me about. It didn't belong to me, if you like. For example, in *Doctor Zhivago* – the end of *Doctor Zhivago* – there are two characters who don't see each other any longer, she on the tram, he on the Rue de Lee Christie – that was agonizing for me. Something had happened. I know in the end they are killed in each other's arms. They really kissed in the film. Because in spite of everything a kiss is a kiss in the cinema, no matter what one says. There's a contract that even if this separation is fiction there are real tears in one's eyes and perhaps even a bit of glycerine. Personally I don't care. In any case there is something that is very, very close to a real separation.

JLN: Would you say there is now, in that way, a separation in your films? Do you think about that when you make a film? I can think of several of your films where I saw that all of a sudden. I see it in *35 rhums*, I see it in *Trouble Every Day*, I see it in *L'Intrus* and of course I see it in *White Material*. Would you say that you think about that when you're making a film?

CD: How can I explain it? I remember when I was a student and Jacques Rivette told me, 'So, think really hard about something. We can't kill without thinking about this character in two different ways'. I told myself I'm not going to be killing all the time. I realized that it's true that writing a plot is not that simple – that is to say, this one here we're going to knock off. It's not that simple. For example, I was almost able to find a romantic necessity for the death in *À bout de souffle*. The death of a young man who runs down the street to escape from police and who's shot in the back. He puts his hands on his back. And there's the face of this young woman who knows that she betrayed him. But if we end with the man's death there wouldn't be any meaning; what has meaning is when we end on

Jean Seberg's face as she realizes she's responsible for her lover's death. So there, yes, I agree with that. It's crucial that the death not just be [Denis snaps her fingers] macabre but that it has an immense echo in the film – that it be justified. The separation touches me more if I don't say, 'We're going to make a film about separation. Come on, let's make another film about separation'. For me it rises like carbonation in a bottle. It rises, rises, rises. It puts pressure on the plot. Often I notice without completely realizing it that it was really *that* that interested me; it was practically the heart of the film. For example I remember when I made *S'en fout la mort* there are two friends – one played by Isaach de Bankolé, the other by Alex Descas. Their friendship in real life touched me enormously. It was a very beautiful friendship because Alex was shy and didn't talk. He was quite proud but he said nothing and smoked his cigarettes in silence. And Isaach, he felt completely at home – he was open to the world. He introduced Alex and spoke for both of them. I loved the relationship between these two men. So the plot was written around that friendship. At the end of the film – which was the first time for me there was a death in a plot... the first time it was necessary to kill off a character – I realized afterwards it was just so one character could tell the other goodbye. When Alex's character is killed with his fighting cock – he's stabbed and then killed – Isaach's character takes him into his arms, takes him into this hut where they live, very gently lays him on a bed they have there, takes a wash basin and a sponge – (that's really strange, this sponge and this wash basin with the clean water) – and cleans his wounds even though Alex's character is dead at this point. He washes him and talks to him. It's a monologue since the other character is dead. He tells him about how they met: they were at his mother's place, Ray Charles music was playing and they made *gratin de christophine* – one of Martinique's national dishes. That moment was a lot stronger for me than the actual death of Jocelyn, Alex's character: it was a goodbye between two friends. I remember we all had tears in our eyes to a certain extent though perhaps that was naïve because we felt it was a moment stronger than death: it was a separation.

JLN: I'm going to back up a bit – you said, 'I was a student and Rivette told me...' How did you end up going to film school? Why?

CD: Two things happened with my mother. First was her presence, the strength of my mother, and the other, perhaps, was the fact that I had very bad asthma. I still do but a lot less than I used to. Because of asthma I often escaped my father's watchfulness since he monitored the children and their activities. He made sure that we got up early, that we were active, that we could take care of ourselves, that we never got sick, that we walked to school, that we played sports and all that. To teach us how to swim he'd

throw us into the ocean where we couldn't put our feet down. It was best to be a bit like that. He was a loving father who also loved to punish us. But he loved me a lot – and disciplined us a bit anyway.

JLN: Yes, because it was a bit the model of the time.

CD: Exactly. So as he didn't have an oldest son – I was the eldest – I had to be both swimming champion and a champion runner. My father had been a champion runner of the 110-metre hurdle. I had no choice but to run and of course I had asthma. Eventually it was my mother who more or less took me to her breast. She said to my father, 'Oh no, you're completely crazy. She can't do that. Look, she can barely breathe'. So that protected me. With my mother I could either read – because I didn't go to school and all that – or she would tell me about the films she'd seen. I wasn't allowed to watch them because at the time there were restrictions. So she told me the story of *Hiroshima mon amour* – that's one of my memories. She must have told me about it 20 or 30 times. My father thought it was weird and unhealthy to talk about films. He didn't like the film and he had already seen it with my mother. It left him totally indifferent, without a doubt. And my mother not only talked to me about the film but she said, 'I've never seen a film like that, told like that'. I find an interesting parallel between the young French woman falling in love with a German during World War II in Nevers and her later love story with the Japanese architect in Hiroshima with my mother's past during the German occupation. During her youth one was evidently forbidden to look at a German. My mother always told me that when she took the metro to secondary school she had to avoid meeting the gaze of any Germans. And at the same time, because my mother is a reasonable enough person, she understood very well the story of the *Le Silence de la Mer* [a war novel]: that one could fall in love with a German. So *Hiroshima* was part of her past as well. I imagined the actress Emmanuelle Riva perhaps resembled my mother and even might still. As my mother described this Japanese man to me, it was the first time she spoke to me about a man who was a fantasy for her. It was the first time she confided in me that she thought he was a sexy man. She had two children – we didn't talk like that. But suddenly she told me, 'This man, wow, really, if I met him tomorrow I'd leave your father'.

So after having spent all of my life being protected this way, in a cocoon in the heart of which were cinema and books, when I graduated I felt the tragedy was about to begin, meaning that I had to finally answer to my father and take my studies seriously. I had to escape from this protection of asthma where I could watch movies, read books and all that because making a career out of the cinema wasn't even something that I could imagine. My mother spoke to me about Alain Resnais and Jean-Luc

Godard, but they were superhuman to me. I had to find a place to escape to after graduation. As soon as I graduated (and thanks to my literature teacher I succeeded in figuring out how to do so), I managed more or less behind my parents' backs to prepare myself for film school, without fully realizing myself what I was doing. The lit. professor thought I should do literature. He didn't think the cinema was a good thing for me. For one thing, I was a woman and for another I was thin and fragile. No, he thought I should do literature.

JLN: And so for your preparatory studies in film, which school did you go to?

CD: Marie la Lune. At that time there was the Lycée Voltaire on the other side of Paris. I lived in the suburbs. I went to the Lycée Voltaire's exit and there were a lot of boys. It was also a very political school. I discovered the real boys – the Marxists, Leninists, the cinephiles – I discovered everything. Because up to that point there had just been my mother but now there were boys. Deep down that pleased me even more. And then I met a boy who told me, 'Yeah, come on let's make a date for noon'. Little by little I found myself getting led along like that but without being sure of myself at all. It feels stupid to say this but I did something that was in essence romantic – I got married. Not with a boy from the Lycée Voltaire. I got married to someone who I met elsewhere, who was a photographer and who, knowing my family, wanted to take a photo of me. He thought I was pretty. I didn't even understand; for me, it was abstract, except one day he came to pick me up at the Lycée's exit in a car. I say 'in a car' because he had a driver's licence, which meant he was from another generation.

JLN: At that time that meant something – a car...

CD: And he went to the cinema a lot. So he came to pick me up at the Lycée's exit. We went to the 'Cinoche' in the Latin Quarter, which I had never been to. And the 'Cinémathèque', which I had never been to. And so it wasn't a coincidence, huh? And he took me home one evening and said, 'Go to film school'. It was he who... well, first, we were married...

JLN: And how old were you?

CD: Seventeen. It was a little shocking for my parents because he was over 30 years old.

JLN: Were they opposed to this? You were only 17...

CD: No, because I think they had more or less given up. I no longer had a brilliant future [in their eyes], so they said, 'Oh well, at least she's married so she can't get into too much mischief'. I'm not mad at my parents for that. Since I was a good student and loved literature, I think my parents had this idea of a brilliant future for me, being a professor or something. My parents said, 'She's physically fragile but she'll make it'. And suddenly

I also gave up on the only part of me that they'd counted on: my studies.

JLN: But you didn't necessarily abandon your studies?

CD: Well, I didn't know that there was such a thing as film school. I didn't even know what that was. I got married so they ticked the box that said the literature thing is not going to happen! But nevertheless I found some small jobs in a company that made institutional films for a school in Mali. These were films about learning how to avoid mosquito bites, how to avoid catching malaria – institutional films like that. I still saw some guys from Lycée Voltaire who were going to Nanterre and who made it to L'IDHEC,[1] which had become a completely revolutionary school: there were Maoists, there were Situs; they fired the faculties, they did not want any more faculties, they only wanted people from film to teach.

JLN: When was that?

CD: At the beginning of the Seventies.

JLN: After '68 then.

CD: They told me to take the entrance exam! But instead of a formal entrance exam like it was before, it was given by professionals, professionals like chief operators who were active in '68. They were still heroes of the film business who were giving the exam, like operators working with Bresson.

JLN: Still, they were professionals.

CD: Yes! But you know when Jean-Luc Godard talks about the professionals of the film business it is somewhat of a general comment. I was told, 'Look, he is from Belgium; this is Bresson's chief operator, maybe you'll have him on your jury'. For me it was very, very impressive because all of a sudden I was in touch with the other side. It was not the bla-bla, 'the film this, the film that'. They were people who knew the film directors, people who participated in the making of the films. There was Jean Eustache, for example. All of a sudden it was like a curtain lifting, I was entering a different world! So I gave in under the pressure from two friends and I took the exam, but the exam was something extraordinary because we were put in a dorm for one week isolated from the world. We were 500.

JLN: Five hundred?!

CD: Yes, 500 because after '68, L'IDHEC had an aura. Today they ask for five years of college education. Back then it was an open house: 'Come make film!' There was no little fence at the entrance.

JLN: Well, it was still an exam.

CD: Yes but now you can only take the exam if you have five or six years of college education.

JLN: At L'IDHEC you mean?

CD: Yes, today it's called Femis. Now if you do not have any diploma and you want to get into Femis, you have to go to summer school and you are put in a specific category. You do not take the same exam as the others. Back then everybody was taking the same exam. There were people who were professional photographers, for example. I knew how to take photographs since I was married to a photographer; I liked it, but I wasn't a film bum. There was a guy who was a film critic. I was mesmerized. I thought to myself, 'This guy takes the entrance exam? But I am nothing'. So I took the exam and forgot about it! I went to Hamburg because my husband was hired by a German magazine to shoot a whole series of pictures in Germany. We lived near Hamburg next to the Baltic Sea (the context for *35 rhums*, actually). We had a car, a tape recorder, and since Germany was ahead of France I bought a Rolling Stones album that had not come out in France yet. We lived isolated from the world. My husband was taking pictures and I loaded the cameras. In November he was done with his work and we returned to Paris. One of my friends from Lycée Voltaire tells me, 'Claire! We've been looking for you all over the place! (No cell phone then.) Where were you?!' I said, 'Huh, I don't know, I was in Germany'. He tells me, 'You made it!' Only 20 people were accepted and if I didn't go now they'd give my spot to somebody else since the deadline for acceptance was the next day. To be accepted and not go would be really shameful, so I met with Louis Daquin, the new director of the school (it was his first year), who lectures me and I tell him the truth, that I do not believe it, that I forgot! The exam was extraordinary but being accepted didn't cross my mind at all! Especially because parallel to this my husband had taken pictures of Peter Brook and his wife, and then Brook invited me to take his classes.

JLN: Theatre classes?

CD: Yes, so I was a student of Peter Brook's but I didn't really know why I was there. So when Daquin all of a sudden told me that L'IDHEC was serious, it's everyday, you get out with a diploma, I went. It was then that I met Rivette. My first teacher was Pierre-William Glenn who was the chief operator for Rivette. He said, 'Yeah right I work with Rivette, so what'. Juliet Berto was also taking classes. All of a sudden I made it – I was in, in a world where maybe I was going to meet Jacques Rivette.

JLN: So Rivette was already a first-class director?

CD: Yes. For the record in the *Cahiers du Cinéma* he was from the group of four, he was considered like the Saint-Just. We referred to him as Saint-Just: *The* absolute critic. Even if Truffaut, Godard and Chabrol had started making films, for Rivette it was more difficult. He was respected as 'the pure thought'. But Jacques Rivette was a very seductive man, very curious

of others. He is still like that. So he spotted me in Glenn's class one day. He said, 'If you ever want to work you could do an internship with us. We would not be opposed if you wanted to come work a little with us'. Suzanne Shiffman was also there. One said 'we', there was always this majestic 'we', you see, nobody was playing games.

JLN: And so you became an assistant.

CD: No, I finished school thanks to Louis Daquin because he required I finish. That counted a lot for me, but Peter Brook thought I was going to play in King Lear, the role of Cordelia and all that. I knew that it was Peter Brook I was interested in, not becoming an actress. So I got my diploma and then Louis Daquin told me, 'When you have a diploma from L'IDHEC you can go directly to the Office de Radiodiffusion-Télévision Française [ORTF], you'll be salaried, you'll be part of ORTF until you die, you will probably be a director, I trust you. But you will have a regular income'. Daquin wasn't crazy; he saw that my husband and I had financial ups and downs. We had issues with rent, for example, Daquin kept an eye on his students. I think he saw a little bit further too, he saw that this marriage was not on track, so sometimes he would say, 'If you want to come sleep at my home, you can.' I asked him, 'What if I don't go to ORTF? What's the other option?' He said, 'Well, there's nothing else. You'll have to wait to get internships in the film business, meet film people. I know some but since I am a Communist, and a part of the Communist clique with Sacha Vierny, we're a bit excluded. I can help you find internships of course but it will be one, then maybe another one, nothing regular. There won't be any job security'. And yet he also told me, in a way you know, I could not really go to ORTF. I really had no desire to go, he also made me understand that there would always be food at his place, you see, whatever happened. Little by little I had internships that Daquin found, he found me jobs, sometime for a week sometimes two weeks, they were always good things. He also helped me to become self-sufficient. And that's when I met Rivette again and became his assistant.

JLN: And all this time you told yourself that you wanted to direct a film yourself?

CD: Yes, because I was making little films that Daquin sent me, for example he said, 'Alain Cavalier is putting together something for EDF, won't you give him a hand?' And around Jacques Rivette there was no hierarchy, there was no 'being an assistant' for life, we were all making films together. What counted around Jacques was the film; it was not like an army with officers and rank and all that. There was a group who took care of the film. I think it de-inhibited me a lot. I thought, 'Yes, this was not at all what

I imagined of the '"elite", way above us'. But I have to tell you: it was not shyness – I was so quiet and even though I was capable of wanting, I had will power – I was incapable of representing myself outside of the others. For example, when I worked with Jacques Rivette I became a little bit Jacques Rivette. I am exaggerating, but I became the film, and I told myself, 'How sad it's going to be when I can't fusion [sic] with this whole, but I'll have to be initiating it'. I thought, 'How lonely I'm going to become'. And I was a little scared of that.

JLN: But still, you wanted to do it.

CD: I wanted to do it. But that's something that today's young Femis people forget: that I was living on my own without my parents. After being married, divorced and in the film business, I could not go see them and ask for food. It was impossible.

JLN: When you said married, divorced...

CD: No, I was separated. I divorced years later. We did not have enough money to divorce. Back then you had to pay to get a divorce.

JLN: You still do.

CD: We did not have an address either. My husband was not paying his taxes so the collectors were after us.

JLN: You couldn't go back to your parents.

CD: Ah no!

JLN: Today the young can't do this because they have not even left their parents.

CD: But it was not because I was stronger or anything, it was just impossible. I could imagine the snarling from my dad. I would rather have died, sincerely, when I say die, it's true. I remember a summer I had nowhere to go; I had no more money. My parents were in Brittany. I went to Brittany for one week and I told them I wanted to see them, but it was not true. I went there to be fed twice a day. My brothers and sisters knew it; they were spoiling me. And Daquin always knew it. People from this generation don't realize that back then when you didn't work, you didn't eat, you didn't pay your rent, and so assisting jobs for me were really marvellous! I worked with people I admired and I made money, so before taking the jump and making a film on my own somebody had to tell me, 'Yes, I will produce your film'. Back then we did not have the little HD film cameras, you see, so I found this producer...

JLN: ... the cameras do not guarantee...

CD: No, but I found the producer, though I did not find this producer right away because the producer, Stéphane, who was the producer for Rivette and Marguerite Duras, went out of business so I did not find a producer right away who told me, 'OK, let's go'.

JLN: But you found him. So unless you want to continue to tell the story, I want to switch gears and come back to what you said earlier that you and the crew had tears in your eyes during the death of...?

CD: When Jocelyn died [while shooting *S'en fout la mort*].

JLN: That's it. Another time I remember you said that in *Trouble Every Day* in the scene where Béatrice Dalle...uh...devours...

CD: Devours...

JLN: ...you told me that the whole crew was taken by a sort of...

CD: Stupor...

JLN: Ah...and they were also frantic when you started throwing blood all over. Blood, well...paint.

CD: Yes. It was not a trance.

JLN: I am not saying it was a trance. I did not interpret this as a trance at all, but is there a certain crossing of the distance of the one who represents – something into which he does not take part – a transition from mimesis to methexis? Does this play an important role? Do you find this in every film?

CD: Yes. In *Trouble Every Day* it was obviously a lot more troubling because it's one thing to write a scene like that on paper. I did not rehearse it because we knew we could not do several takes, so I told Béatrice and Nicolas Duvauchelle about how it was going to happen, how it needed to be prepared. We explained how the special effects guy would put the little blood pump on her neck, that everything had to be installed including the little piece of flesh there, etc. There were two cameras and we did one take. I had no experience. I had the word 'devour' in my head but I knew nothing and I think we shared this unknown with the actors. We had a tube of blood, a little piece of flesh. As long as we followed the stroke of Béatrice's hand on his body we could accompany that scene as a crew, but then there was the first bite – even when you read it in the script there was the feeling that we were trespassing, going over a forbidden line, and I believe I was not the only one who felt that way. It was not funny at all. Not funny like in a horror film where a vampire comes to a girl and sucks her neck. There was something about the 'devouring' of the young man; yesterday we spoke about the English word 'surrender'. He surrendered, he did not defend himself anymore, this is a strong guy and all of a sudden he surrenders. I do not make any comparisons of course, but that is what was most exceptional in the film *Realm of the Senses,* by Nagisa Oshima, when the man tells the woman to continue strangling him, to go until the end of the strangling because he can't stand her to stop and start anymore.

JLN: Yes, it's true but the case of *Trouble Every Day* is particular because there is this transgression. To take another scene...when Michel Subor

[from *L'Intrus*] was pulled through the snow by horses; that is quite a tough scene.

CD: Yes, it hurts.

JLN: Yes, it really hurts. When you did it, did it hurt you too?

CD: Yes.

JLN: I was wondering how you shot the scene? Do you tell yourself you can cheat a little bit but not completely?

CD: No, you can't cheat too much. In addition, we did not have any stuntmen; we did not have trained horses. They were horses from a little ranch nearby. Katia [Yekaterina Golubeva] rides well but pulling two is difficult and we didn't want to hurt Michel, so we had to be on soft snow not hard-packed snow. Only in the faraway background scene did we use a young man from the ranch with a piece of foam in his back. He volunteered and did it so Michel did not have to do all the takes. But it hurt everybody. It hurt Katia too because it's heavy. It hurt because of the scraped back. Also in *Trouble Every Day* when the young maid is grabbed by Vincent Gallo's character in the maids' changing room, she is stripped of her clothes already in front of the door and he puts her down on the concrete – in this hotel it's rough concrete – he rapes her on the concrete. I asked Florence Loiret, 'Do you want to try to have foam on the floor?' She said, 'No, no, no, no, I don't want to think about these things, I'd rather we don't do too many takes, only one take'. So she was really hurt, her back was scraped and the crew knew it, and there was the rape, sure, but there was this position lying on her back with a heavy man on top of her, spreading her legs apart, he was moving on top of her, so her back was hurt. These are terrible, terrible things; we physically felt them.

JLN: And when it's not physical, it's more psychological, like in *35 rhums* when...

CD: ...the father and daughter tell each other goodbye.

JLN: Yes, or when he watches her dance with the boy.

CD: I don't know, I am in Alex Descas's gaze and I am also in Grégoire Colin's uneasiness...

JLN: Yes that's it...there are two...

CD: More than in the young girl because I know that she knows she is in the converging point of these two gazes, the father's and the neighbour's. So I think I am more in the perspective of their gazes and not that of the young girl, that's what I feel. It's there, what they both feel and what is so hard for them to tell her.

JLN: But when I watch the film, I wonder what she feels, what she thinks. She remains indecisive to me.

CD: Yes.

JLN: Indecisive or extremely complicated.

CD: She is indecisive and I think maybe she doesn't want this kiss while her father is looking. I think I would not like a boy to kiss me knowing my father is looking. So she doesn't want it but she doesn't meanly push him away.

JLN: Yes, but then she sits down farther away.

CD: Then she pulls him back but it is unbearable for her that her father watches this one kiss because it is a real love kiss not a little kissy.

JLN: But I have the feeling that she knows this but she tells herself she has to go for it.

CD: Yes, but I think for a lot of teenage girls, until what age I don't know, there is a long time of something that is like a 'give in'. I think this is for boys as well, but I always felt for a long time that there's this first step, you have to give in and it's not funny. You can't always refuse because you have to have a really good reason to say no. And it's not obvious to accept intimacy even from someone you're attracted to; I think it's still a shock. And in addition, if your father is there you might as well go hide.

JLN: I'd like to say one more thing about this and link it to what you are saying about the girl who has to go for it, who has to separate: there is a long thread of separation that runs in everything you are saying, and then there's a sort of succession in the way you tell things. There's the kitchen, then your mother, then finding yourself all alone. It's like at each step – childhood, teenage years, then adulthood – there is something that brings you back to isolation and separation. And at the same time you are looking.

CD: Maybe from early on I realized that the idea of family – living with a man to have kids with him – wasn't out of the question in my head, and to have a man I loved wasn't out of the question, but my preference was toward a sort of nomadism. (But something that wasn't nomadism. 'Nomadism' is a word in fashion, I hate it.) But also that love stories were portable into work, into films, even passion, even what tears you apart the most in love stories includes the bad times. And to create a family requires that you come home and be a somewhat stable person. I did not know how to do this. I am either passionate or depressed. For me to accept to have kids I would have had to meet someone so balanced that they were capable of being balanced for two, however I could not take on that responsibility. I was fine not being the one who makes films but the one who tries film after film to make a better one, not always with good success. But life with a family wasn't up to me.

JLN: I understand that very well. I think that we could stay a long time on this subject because I've always been fascinated by people around me who

never created a family. I always told myself in comparison to some boys around me: how did these young guys manage to know, while I never knew. I just jumped in and then later thought maybe I wasn't really made for this. So that is a very complex thing.

CD: For a woman the question is slightly different because a father is one thing, but to be a very bad mother... it's... you see what I mean... whew!

JLN: Yes, OK it's different.

CD: And there's pregnancy...

JLN: Yes, yes absolutely but I still felt the possibility of a conflict with what I wanted to do and what I had already started.

CD: Making films made a lot of things simpler because making films puts your family at a distance. To make films you sleep in hotels, etc...

JLN: You just said something in passing about making films one after the other with different – more or less – successes. Do you make a difference between your films?

CD: No.

JLN: Do you tell yourself, 'No, this one it's not as good as...'

CD: No, it's a continuum, but when a film is done the frustration is such that you feel like you screwed up or that I didn't do what I should have. You immediately have to tell yourself, 'Let's go to the next, one more'.

JLN: I wonder if it's the same experience for everybody who has created something. For me it's the same thing, when a book is finished I am not interested in it at all anymore. It's not that I think it's bad, I'm just past it and I don't want to come back to it.

CD: It bothers me; I need to let it go.

JLN: Yes it's true. And then that's what makes it so we can do it again. And also so that we somewhat keep doing the same thing.

CD: Of course, yes. When I hear people say they recognize my films, I go, 'Really?' Why? When people tell me this I don't even know what they are talking about.

JLN: I know. The day before yesterday after having seen *35 rhums* again, pretty quickly I thought, 'Yes, it's true, that's the way it is in Claire's films' – a certain slowness, a certain stillness, almost like the camera stopped. And maybe what differentiates you from others is that you throw several lines, several leads in, if you will.

CD: Yes, maybe.

JLN: Like at the beginning of *35 rhums*. There's him, there's the girl, there are the trains, there's René, a man who is going to retire and...

CD: ... it comes together little by little.

JLN: Yes, it comes together but we feel left behind. There is you: someone who wants to open this array of leads on purpose, each of them... and let them go for a while...

CD: In books and films there are things that move me a lot, they are life's rituals: people sharing breakfast, people taking off their shoes when they come in, people who make their beds when they get up in the morning, those who don't, those that open the window to let fresh air come in, etc. Rituals. I am always told we can't film rituals; that they are boring because they happen again and again, but specifically that's what I love.

Notes

1 L'IDHEC (L'Institut des hautes études cinématographiques). The Institute for Advanced Cinematographic Studies is a French film school. It was reorganized in 1985 and renamed La Femis (FEMIS is an acronym for *Fondation Européenne pour les Métiers de l'Image et du Son*).

7 Claire Denis and Jean-Luc Nancy at European Graduate School, Saas-Fee, Switzerland 2011

Part II

Relations

4

La Famille Denis

Catherine Wheatley

In the introduction to her 2005 overview of Clare Denis's body of work, Judith Mayne claims that 'virtually all of Denis's films demonstrate a preoccupation with kinship, with family ties, and, more often, with what takes the place of family ties'.[1] It is curious, though, that in the light of the unobtrusive yet omnipresent place of family within these films, the subject remains critically neglected in studies of Denis and her work. Historically, academics have tended to focus instead on either the socio-political or formal aspects of Denis's oeuvre. More recently, there has emerged a tendency (which has arguably arisen in the wake of *Trouble Every Day*'s release) to read the director's work within the context of what has been dubbed 'The New French [or European] Extreme', paying particular attention to features that might be deemed transgressive, provocative or outright nihilistic.[2] While Martine Beugnet's recent work on Denis's films takes a different approach, examining the films' sensual evocation of the forging of human connections, it is the sexual encounter, rather than the platonic or familial, that she focuses on.[3]

The scholarly writing that does engage with the place of the family group within Denis's films, meanwhile, is both restricted and restrictive in its focus. Despite the grand claims she makes for its significance within the oeuvre, Mayne's analysis of family remains limited to Denis's sibling-oriented diptych, *US Go Home* and *Nénette et Boni*. Mia Carter subordinates the family dynamic to questions of post-colonialism, reducing Denis's intimate studies of kinship to the status of analogy,[4] while for Laura McMahon, family is subsumed by the wider category of community.[5] Adrian Martin acknowledges that 'Denis often asks in her work: what does it mean, how does it feel, to be a sibling, a parent or child, the member of a family?' but leaves the question hanging, turning his attention to broader questions of the body.[6]

This chapter thus attempts to provide a corrective to the marginalisation of family within the writing that surrounds Denis's films, investigating its significance within each work, examining the various forms that these familial groups take and speculating on their deeper significance within Denis's cinematic project as a whole. It is my contention that, by tracing the thread of family through her films, we can open up new ways of seeing them.

Family and Friends: *Chocolat, S'en fout la mort, J'ai pas sommeil*

Family within the films of Claire Denis is a complex, ever-shifting category. The director never presents us with the stereotypical '2.4 kids' family unit, but in some cases the familial connection is, superficially at least, a conventional one – one might think of *Chocolat*'s triad of father, mother, daughter; *Nénette et Boni*'s paired siblings; or the father–daughter relationship that dominates the narrative of *35 Rhums*. Elsewhere, the family is fractured or fragmented: *L'Intrus*'s protagonist searches endlessly for a connection with an absent and perhaps non-existent son (ignoring the flesh and blood son with whom he is in contact), while *White Material* sees two sets of mothers and sons sharing one paternal figure and all hopelessly thwarted in any attempt at communication or connection. On still other occasions, the 'family' in question is a group bonded not by blood but by experience or institutionalism. For Mayne, 'the child France's closest companion, in *Chocolat*, is the Cameroonian family servant, and while the two male leads of *S'en fout la mort* have few visible family ties, the brotherly bond between them is far stronger than the other family connections we see in the film'.[7]

Mia Carter's examination of what she terms Denis's 'metropolitan films' – *S'en fout la mort* (1990), *J'ai pas sommeil* (1994) and *Nénette et Boni* (1996) – views the family units within these films as symbolic representations of the democratic state. Within these tattered families,

> some members cling desperately to memories of what was, could or should have been, while others are sacrificed or cast out. Denis's father figures insist upon a narrative of paternal-egalitarian protection and care, even while their behaviours brutally conflict with their narratives of rescue and uplift. Ardennes in *S'en fout la mort*, and Monsieur Luminaire (the father) in *Nénette et Boni* expect loyalty and fidelity, even though they have betrayed and abandoned their 'dependents'.... The only father figure in *J'ai pas sommeil* is desperately trying to escape the alienation of the European metropole in order to return to Martinique, which he remembers quite consciously as an impossible dream.[8]

Carter herself admits that 'these allegorical narratives are represented far more subtly and elliptically than they have just been described here; in Denis' corpus,

human and social relationships are presented as puzzles to be deciphered and reconfigured'.[9] Nonetheless, there is something to be said for her understanding of the family unit as a site of dystopia within her early works. Certainly, within both *S'en fout la mort* and *J'ai pas sommeil*, biological bonds are configured as either too tight or else so slack as to be rendered meaningless.

In *S'en fout la mort*, the family unit of gangster Ardennes, his son Michel, and wife Toni (the latter two are involved in a quasi-incestuous relationship) self-destructs, taking Jocelyn, who may or may not be Ardennes's illegitimate child, with it. In *J'ai pas sommeil*, immigrant Théo, desperate to return to his motherland of Martinique, is trapped in France by his ties to his white wife Mona and their son but alienated from the mother and brother who share his links to the Caribbean – as he himself puts it, 'My brother is a stranger'. In both films, it is the characters who are free to form bonds with whom they will and who are born (into these films at least) free, who survive to walk away from their terrible events. Martine Beugnet asserts that the fact that Dah (in *S'en fout la mort*) and Daiga (in *J'ai pas sommeil*) are the only characters who escape the downward pull of the events that surround them can be attributed to their 'outsider' status – that is, the fact that neither is French, that their histories and presents are not as closely embroiled with those of that country as their counterparts;[10] yet we might equally see them as 'outside' the bonds of family and therefore free from its destructive force.

If the family unit is an alienating structure in these early films, though, the positive alternative might at first seem to be found in the notion of *kinship* and most clearly in the relationship between Dah and Jocelyn of *S'en fout la mort*. During the film's opening scene, the men's friendship expresses itself through a sense of wordless complicity as they silently smile and nod in a series of alternating close-ups set to the beats of Bob Marley's 'Buffalo Soldier'. At its end, their fraternity is emphasized once more, when Dah lays out the corpse of his dead friend and washes it clean. However, to view the relationships of family and friendship as diametrically opposed (one determined and destructive, the other freely chosen and full of hope) is to overlook the nuances and background details that provide so much of the richness of these films. *J'ai pas sommeil*, for example, offers one lovely instance of filial communion in the shape of the energetic Ninon, who runs the boarding house where both Daiga and Ninon's elderly mother stay. In a scene that at once emphasizes generational heritage and the female line, as well as the formation of non-genetic kinship, Daiga and Ninon dance together while the older lady looks on, creating a moment of warmth and respite from the harsh, blue-lit, Parisian backdrop.

This ambiguous configuration of kinship and blood ties is present, too, in Denis's first film, *Chocolat (1988)*, which contrasts the relationships within a biological family – French colonialists Marc and Aimée Dalens and their

daughter, France – with those that extend between the members of this family and their 'boy', Protée. France's interactions with her parents are given as affectionate if somewhat automatic. In a matched pair of moments, we see Marc swing her high in his arms and Aimee welcome the child without pause into her lap, where she cradles her, absentmindedly stroking her flaxen braid as she chats with a house guest. Nonetheless, Judith Mayne is amongst many critics who have argued that the thread that runs throughout the film's central flashback is the complex form of companionship shared by France and Protée. Pointing to the fairy tale nature of the friendship, for example, Martine Beugnet writes that:

> The man and the child share an arcane complicity sealed by mysterious rituals that skirt the prescriptions and rules imposed in the adult world. Protée tells riddles and garnishes France's buttered bread with live ants, and, when he waits at the table while she eats, France forces him to kneel down to taste her soup and spoon-feeds him. In one episode, the pair even go on a nightly hunt, Protée brandishing a useless rifle and carrying France perched on his shoulders. As he walks into the darkness that surrounds the house, repelling the hyena's laughter with his loud incantations, the two bodies merge, becoming one tall silhouette.[11]

Theirs is by no means a 'pure' relationship, however – the closeness that unites the pair is based on the so-called boy's inferior status to the white, Western adults that control the world the two both inhabit and are excluded from. Perched at the entrance to this adult world, France tests out its power when she feels her friend's devotion momentarily waning, literally commanding his attention. For his part, Protée abuses his influence over the child at the film's climax, in an act of revenge upon the adults who have wronged him.

In both *S'en fout la mort* and *Chocolat*, kinship can be understood as contingent on exclusion from other groups: the adult world, the white world, French nationhood. As Denis told Aimé Ancian, 'You can only feel yourself an outsider if you are part of a community'.[12] Subject to the shifting dynamics of these larger forces, kinship does not exist in isolation, nor does it offer a utopian alternative to the fragmented and fractious family groups that these films present us with. It is all too fragile, ethereal and ephemeral for that. Time and again the white colonialists in *Chocolat* attempt to forge bonds of kinship – based largely on their mutual expatriation and concomitant alienation from the African landscape and its people. However, personal politics consistently get in the way, as their divergent views on the black locals fracture any sense of community.

Conversely, family is not presented as an entirely negative structure within either film. In fact, *Chocolat* opens with an idyllic depiction of filial communion. As its credits begin to roll, an opening still of a vast, empty ocean comes gradually to life as a young boy and his father emerge from the surf, with what Beugnet

calls 'joyous carelessness'.[13] The camera pans to what will be revealed as the adult France, looking on, and we sense her isolation, her exclusion from their self-contained contentment. Moments later, France will accept a lift from another (or perhaps the same?) father and son, stepping into the intimate enclosure of their car. While the boy dozes, trustingly, next to his father on the front seat, she sits in the back of the car, once again separated by the image's frame from the linked pair. At the film's close, having told the man – whose name is revealed to be Mungo Park – that all that is left for her in Cameroon is a place she once knew, not the people who lived there, she makes an attempt to enter their world by inviting him for a drink. Her offer is rebuffed; there is no room for her in their private universe. One suspects that the childhood home she is seeking may likewise have ceased to exist, at least as she imagines it, without the presence of Proteé and her parents.

Brothers and Sisters: *US Go Home, Nénette et Boni, Beau Travail*

Predicated as they are on the exclusion of their participants from other, more privileged, worlds, the bonds of kinship formed between France and Protée, and between Jocelyn and Dah, might be seen, in certain lights, as iterations on the sibling relationship, which is so often defined by its distinction from the rights and rules of parental figures. However, their fellowship stands in stark contrast to the estrangement of Théo and Camille, the two blood brothers who are not even shown onscreen together in *J'ai pas sommeil*. It is made clear in Denis's films that to be genetically linked does not automatically entail a sense of communion.

In the short film *US Go Home* and its feature-length follow-up, *Nénette et Boni*, Denis turns her attention to the relationship between a brother and sister, played by the same actors in both films, Alice Houri and Grégoire Colin.[14] In both films, the brother–sister relationship is presented as fraught and fond by turns. The fact that the siblings in question are in the moment of libidinal discovery (*US Go Home*'s protagonists, Martine and Alain, are teenagers, as is Nénette; Boni seems to be around 20 years of age) lends an erotic aspect to their relationship while keeping the explicit question of incest at bay. These characters are tied to a member of the opposite sex by birth: a phenomenon that renders the other both fascinating and repulsive. The two films allow for an exploration and evocation of male–female relations in which sex is not absent but neither is it in the foreground.

Indeed, as if to underline the contrast between sexual and sibling relations, in each film the central brother–sister relationship is juxtaposed with a series of more overt heterosexual rapports and liaisons. This strategy of counterpoint

finds its most graphic outlet in a central dance sequence set during a party in *US Go Home*. Martine and her best friend, Marlene, arrive at a party where they discover Martine's older brother, Alain. Their reactions are telling: Martine is delighted to find her brother, while Marlene's gaze suggests desire and jealousy. Marlene and Alain quickly find partners to dance with and, in a shadowy scene during which a whirling camera connects a network of looks and glances, we realize there is a sexual tension between the pair. But, when Martine and Alain subsequently share a dance, the camera observes their movements with a still, watchful eye while the heightened lighting picks them out from the shadowy mass of intertwined bodies in the background, their tender gestures towards each other clearly distinguishable. The frantic violence of desire is contrasted with the calm, still intimacy of family. This intimacy will be fractured when Martine surprises her brother in bed with her best friend, and will fall apart entirely when she later berates him for his treatment of Marlene. Still, as the film closes, we are left with the image of Alain waiting for Martine while Marlene looks on from the periphery – herself excluded from this family relationship but without one of her own to console her. Earlier, in the introductory voice-over to *US Go Home*, Martine casts the familial relationship as one of (over)protection: 'I feel sheltered', she tells us. 'My mother protects me, my brother protects me, Marlene protects me'. And, yet, this final relationship (of kinship rather than family) seems to be displaced, marginalised, by the primacy of the sibling's bond.

A quasi-absent presence, Martine and Alain's mother appears only briefly in *US Go Home*, shot in the kitchen, dealing with domestic chores such as the washing up and the family finances. Thus glimpsed, she forms part of a banal and claustrophobic home, in which Alain 'can never be alone'. It is no coincidence that the teens' relationships unravel and reform in a space apart, free of the infantilising atmosphere of the flat that they share with their parents, where they can flex the muscles of their burgeoning adult identities. In *Nénette et Boni*, however, the parents are properly absent. Boni occupies the house he has inherited from his deceased mother, keeping her perfectly preserved bedroom as a kind of shrine to her; Nénette, having been exiled from the flat she shares with her father to a boarding school (where teachers assume pseudo-parental authority), flees the restraints of both to join her brother. The space the two occupy for the majority of the film's running time is thus a kind of limbo, perched between the world of parental rigour and that of independent adulthood. Within it, they play at being adults. While Nénette prepares for the birth of her unplanned and unwanted child, Boni keeps house, engages in onanistic (re)iterations of graphic sexual fantasies, and runs a makeshift pizza business.

Initially, it is the young men with whom Boni spends most of his time that serve as his 'family'; the boisterous gang who occasionally share Boni's home

are portrayed as physically close, if not emotionally intimate, and at ease with each other's presence. The arrival of Nénette into their universe once more pushes the bond of kinship to one side, as Boni throws out the friends who are leering over his younger sister. He is clearly not pleased to see her – in an extraordinary scene, Boni and Nénette first appear onscreen together as Boni, masturbating, stretches out a hand to discover his sister in bed next to him; the verbal fight that follows is mirrored in a physical fight the next day. As they scrabble and grab half-heartedly, without passion or self-consciousness, Denis paradoxically evokes their physical intimacy – this is, it seems, a well-rehearsed routine. Despite their apparent loathing of one another, Boni remains his sister's protector, ejecting their father when he arrives to take her home. Nénette, meanwhile, is disgusted by the smell of Boni's unwashed sheets but takes every opportunity to crawl into his bed, and at one point we see her tenderly spooning mashed banana into his mouth. As Denis explains, 'There is something extremely weird in that [sibling] relationship as you get older...I think brothers and sisters – they have a kind of pact, even if they are separate in their life'.[15]

The back-and-forth, love–hate cross-gender dynamic has shades of the screwball comedy to it, with the male and female leads played against one another as opposites: she closed off, smart-mouthed; he sensuous, live wired. The contrastive pairing is repeated, to a certain extent, in Denis's *Beau Travail*, although here the sibling relationship is metaphorical rather than literal, and focuses on two 'brothers': the golden-skinned, clear-eyed and calm young recruit Sentain (Grégoire Colin) and the craggy, haggard, bitter and explosive Galoup. Jean-Luc Nancy has pointed out that, within the film and the Herman Melville novel that inspired it, Sentain/Billy Budd figures as a Christ figure: benign, beneficent, shrouded in innocence, he is forced out into the desert to wander before ultimately being martyred.[16] However, the story, and its realization, seems to have greater resonances with the tale of Cain and Abel. Their fight is for the affections of the father figure, Bruno Forestier (Michel Subor); the incumbent Galoup's (attempted) disposal of the younger newcomer a fratricidal act brought on by his perceived supplanting in Forestier's esteem. His banishment from the Legion transforms him into the biblical 'restless wanderer on the earth', forbidden from fighting for the good cause and then dying, condemned to a choice between eternal limbo and suicide.

Boni's betrayal of his sister is less severe. At the film's end, he storms the hospital where she has just given birth and abducts her infant child, intended for adoption. Is this a gesture of sibling solidarity, as Boni protects his sister from what he perceives as a poor decision? Or does it undermine Nénette's freedom to make her own choices? As the film closes with a shot of the young girl alone and outside, her expression unreadable, it is impossible to gauge the

impact of Boni's actions on her. But, in its final moments, the film shifts away from the sibling relationship and towards the filial. The tempestuous, frustrated Boni is reborn as a tender father to the tiny infant, cradling him in his lap as he watches television. The father that Boni and Nénette share is a man whose feelings about his daughter seem overzealous and frightening and who accuses his son of having usurped his place in his wife's affections. The biological father of Nénette's child is an anonymous non-entity. Boni, a single parent to a child that he has 'conceived' immaculately, seems by contrast a wholly committed father, one who is liberated from the conflicting emotions and relationships that make up a wider family. As Martine Beugnet sees it, 'The yearning for a relation with the world that would not be an experience of alienation but one of sensory plenitude incarnates itself literally in the body of the newborn baby'.[17]

Parents and Children: *L'Intrus, 35 rhums, White Material*

Beugnet reads *US Go Home* and *Nénette et Boni* as part of a progression within Denis's filmmaking towards the centrality of physical love, which culminates in *Trouble Every Day* – the first of her films to include sex scenes – and *Vendredi soir*, the first of her pictures to present a story of fulfilled sexual desire.[18] It might, however, be just as valid to view the latter two films as something of a hiatus within the filmmaker's *oeuvre*, dedicated to an overt exploration of heterosexual desire. This seems particularly true when one considers that in her two subsequent films, *L'Intrus* and *Trouble Every Day*, Grégoire Colin reappears as a twinned pair of variations on the character of Boni, caught once more in a network of familial relations.

The elliptical narrative of *L'Intrus* implicitly revolves around questions of fatherhood. Louis Trébor (Michel Subor) has two sons: one named Sidney (Colin), whom he neglects and hardly knows, and another whom he abandoned years ago in Tahiti. Like the fathers in *S'en fout la mort* and *Nénette et Boni*, Trébor is a sinister figure, whose relationships with his children seem self-interested at best and at worst horrific (it is suggested at one point that Sidney has been murdered in order to provide his father with the illegal heart transplant he so desires). Amidst the film's surreal, nightmarish imagery there appears, however, one striking moment of peace and communion, which sees Sidney carrying his infant son through a forest. As Sidney walks purposefully through the grass, the child strapped to his waist, the camera lingers on the tiny face until he opens his eyes. Immediately following a chance encounter and brutal exchange between Trébor and Sidney, the scene provides a startling contrast. Discussing the scene with Damon Smith, Denis explains its motivation:

This was in a way the most important scene in the film. It's a father looking down at his son and giving him the warm breath of his love without saying a word – in his gaze, and the way he is carrying him, so they are face to face. And I thought this was exactly what the main character had missed. He could have beautiful landscapes, money, everything except that single moment of holding your child and making eye contact and seeing the smile of trust coming to his lips.[19]

Trébor's only other encounter with Sidney in the film makes explicit exactly what it is he has missed. In a morgue, the son's corpse lies on a slab, his body bearing a deep wound in the vicinity of his heart. Trebor's hand hovers near him, not quite touching. No eye contact, no communication, is possible.

In *L'Intrus*, the father–child dynamic is thus constructed along binary lines: good father and bad father, love and hate, life and death. In *35 Rhums*, however, Denis constructs a single parent–child relationship that is much more ambiguous although generally presented in a positive light. Here, Colin appears as Noé, a young man, seemingly in his mid-twenties, who, like Boni, occupies the apartment of his deceased parent(s), keeping it just as they left it. Both he and the space he inhabits are stuck in suspended animation. His only friends are Lionel and Jo, the father and daughter who share an apartment below. But Noé is one more character who is kept at the edges of a central familial relationship. At one point, he pauses in the darkened corridor outside Lionel and Jo's home, apparently drawn to the soft music and diffuse light that emanate from behind their door. A tracking shot seems to beckon him forward, yet he turns and mounts the stairs – this space is not open to outsiders, as another neighbour, Gabrielle (Lionel's ex-lover), will discover when Jo literally squeezes her out of the door. Noé and Gabrielle not only make up a sort of surrogate extended family for the single father and only daughter, but also represent a potential intrusion into their close-knit and closeted world.

Carrie Tarr and Brigitte Rollet have argued that 'the patriarchal father is most frequently represented by [French] women in films [as] a problematic figure whose unacceptable behaviour, ranging from absent and neglectful to uncaring, autocratic and cruel, accounts for the child's trauma or propels the adolescent daughter into the arms of a lover'.[20] Such is the closeness between Lionel and Jo, however, that they could easily be mistaken for lovers during the film's opening scenes, as they perform a delicate *pas-de-deux* around their kitchen. Their exclusive rituals have quasi-erotic undertones, which bubble to the surface in an episode during which Jo tends to her hungover father in bed. As he lies splay legged and clad in soft-jersey garments that cling suggestively to his powerful frame, she curls herself submissively on the floor before him, winding her hands and arms through his, teasingly telling him that he no longer

loves her. But, as she does so, Lionel half-heartedly urges Jo to move on with her life. Implicit in his insistence that she should 'be free' is the knowledge that she is swiftly becoming an adult – to remain in the flat would be to cling to the same state of perpetual childhood in which Noé is stagnating.

It is in yet another dance scene – and one that takes place outside of the home – that Jo takes her first step away from her father, or perhaps that he first pushes her away. In a café bathed in flickering orange candlelight, a wordless dance unfurls, over the course of which Jo is passed from Lionel to Noé, while the father asserts his own independence by seducing the café's owner. In a neat reversal of *US Go Home*'s central dance scene, the tender, delicate calm of the familial pair's dance is transformed into a highly charged sequence of sexual tension, which seems as much a struggle as an embrace. The pale, gleaming skin of Jo's shoulders, lovingly caressed by Lionel, becomes a landscape to be fought for in Noé's hands.

Following this scene, the film's final third documents the split between father and daughter. A journey to Josephine's German grandparents signals a part of her life that exists apart from her father. The trip to Germany, according to Denis, is how Lionel indicates to Jo that, although she is still his daughter, she is no longer his child.[21] And yet theirs is the gentlest of partings, for the dance sequence foreshadows the film's denouement, in which Jo is glimpsed marrying Noé. A marriage to the boy next door keeps her within the confines of the community in which she and Lionel have built their home.

The dynamic of mutual alienation that characterised kinship and community within Denis's early films is thus turned on its head in *35 Rhums*. At the film's end, Jo is both part of French culture and outside (or at least both within and beyond) it; she is part of her father's family as well as her husband's. Exclusivity becomes inclusivity, and it is remarkable that the film is one of Denis's most warm and optimistic works as a result. At the opposite pole, however, lies *White Material*, which sees a colonialist family spectacularly implode against a backdrop of political unrest. From the outset, the internal dynamic is cast as a complex and highly volatile one: coffee farmer Maria Vial (Isabelle Huppert) shares a plantation with her ex-husband André, their son Manuel, André's father Michel, second wife Adèle, and their child José (the complicated nature of the set-up is made strikingly clear when Maria attempts to explain it to José's schoolteacher). Relationships are strained, but pockets of tenderness still exist: we see both Maria and André carefully, painstakingly reaching out to Manuel, stroking his hair, clothing him and attempting to protect him from harm. Indeed, it seems that their parental concern for their son is their one point of accord. Otherwise, the pair – and the family as a whole – constantly fail to connect.

At the centre of this failure of communication is Maria herself, whose 'stubborn wilfulness and blindness to the social situation around her', as Adrian

Martin puts it, 'create a bubble around her'.[22] Maria is not only blind to the wider political climate, but also to what is happening within her own family. She even refuses to acknowledge the increasingly psychotic behaviour of her son, which results from a combination of her own tendency to mollycoddle him and his concomitant desire to seek community and kinship with a tribe of deadly child soldiers[23] as well as his refusal to heed André's warnings that the atmosphere on the plantation is becoming toxic. By the film's end, Adèle and José have fled, Manuel and André are dead, and Maria herself murders Henri, her father-in-law, by bashing his head in. The matriarch has destroyed the family from within and is left alone. In both its overall structure and its incidental details, *White Material* offers a vision of a family in disarray, flying apart at every seam, and of maternal zeal as a frightening and destructive force.

People and Places

For both Maria and her father-in-law, the possibility of leaving Africa – the only 'true' home they have ever known – is unthinkable. Indeed, as Adrian Martin incisively reveals, 'all references to France in the film conjure it as some ghostly, unimaginable, lost point of origin for these "white materials"'.[24] The same could be said for the Dalens family in *Chocolat*, too. However, the reverse is also true, as is made clear in France's failed attempts to return to Cameroon and her African childhood, or in Theo's romantic dream *J'ai pas sommeil* of a return to a Martinique that he has never really known. The impossible notion of 'home' and 'homeland' is made most clear, perhaps, in the closing moments of *S'en fout la mort*, when Dah conjures a utopian vision for the dying Jocelyn:

> From the porch under the breadfruit tree, I see rolling waves of banana plants. It's all green and cool. Down below there's a brook. In the shade, there's a big tree. There are coconuts and a machete. They're so good after a morning's work. They're heavy and full of milk. The cocks are crowing, but I can't see them. Your mother is there doing a little dance to her Stevie Wonder tape. She looks calm. She cooked you some rice and beans. She lives alone now. Your brothers and sisters help her out. She's happy without a husband. She scolds you when you say you are going to France: 'What'll you do there, son?' Your grandpa's shack is nearby. He also lives on his own. Your mother brings him his meals. He's hard to please. He lives amongst his cocks. They're all he has now.

Home is an idealised fantasy: unattainable or unsustainable. Just as Jocelyn will never return to his land of coconuts and banana trees, so Jo must eventually leave her father's flat, and Maria must face the inevitable destruction of her African plantation. In much the same manner, there is no perfect familial

communion with Denis's films: the categories of family and kinship are ever shifting, dynamic. Moments of purity can be glimpsed – Boni's embrace of his newborn nephew; Lionel and Jo's tightly interlocked hands – but these too must pass. And more often than not, the prompt for this change is sexual desire.

As Denis has repeatedly told interviewers, desire and sexuality are destructive forces within her films. She claims that 'there must be violence for there to be desire.... Sexuality isn't gentle, nor is desire. Desire is violence'.[25] To some extent, it is this association of the two that has led critics to place her work in the tradition of a new European cinema of extremism, in which human connection is all but impossible and relationships are fraught with danger. However, her depiction of familial relationships offers a way around an understanding of these relationships as always wrought with violence. This is not to claim that family is given as straightforwardly positive within the filmmaker's *oeuvre*. Denis's films repeatedly caution against attempts to 'possess' another. The families in which duty, obligation and ownership play central roles are doomed to destruction, as the fates of Maria in *White Material*, M. Luminaire in *Nénette et Boni* and Michel in *S'en fout la mort* make all too clear. Denis's comments on her own relationship with her collaborators are, in this respect, telling: 'It's not a family, in a way.... Because I would hate people to feel that we are the family and they cannot say no to the next project. I want everyone to be free, but the ritual is "are you ready for this one? Are you in?"'[26]

When family presents itself not as bondage, though, but as a choice, and as a gift, it presents an alternative vision of human connection, one that stands apart from the themes that are so often seen to structure Denis's work. An examination of family and kinship allows us to zoom in from a wide-angle vision of large-scale politics to the close-up intimacy of personal relationships. It allows us to extend studies of touch, sensuality and sensation beyond the sexual to other forms of cross-gender and inter-gender relations. Most significantly, however, paying attention to Denis's portrayal of kinship and family allows us to notice a surprising strain of optimism in her work. That is, if society and the colonial experience offer only exile and alienation, and desire is a divisive, violent experience, then mutual love (familial, platonic) has the potential to anneal the divided self – not into an unproblematic whole but into a joyful hybrid, drawing strength from contradiction.

Notes

1 Mayne, Judith, *Claire Denis* (Urbana, 2005), p. xii.
2 See, for example, Horeck, Tanya, and Kendall, Tina, *The New Extremism in Cinema: From France to Europe* (Edinburgh, 2011).

3 Beugnet, Martine, *Claire Denis* (Manchester: Manchester University Press, 2004); and *Cinema and Sensation: French Film and the Art of Transgression* (Edinburgh, 2007).
4 Carter, Mia, 'Acknowledged absences: Claire Denis's cinema of longing', *Studies in European Cinema* iii/1 (2006), pp. 67–81.
5 McMahon, Laura, 'Deconstructing community and Christianity: "A-religion" in Nancy's reading of *Beau travail*', *Film-Philosophy* xii/1 (2008b), pp. 63–78.
6 Martin, Adrian, (2006), 'Ticket to ride: Claire Denis and the cinema of the body', *Screening the Past*. Retrieved February 6, 2009, from: http:www.latrobe.edu.au/screeningthepast/20/claire-denis.html
7 Mayne: *Claire Denis*, p. xii.
8 Carter: 'Acknowledged absences', pp. 71–2.
9 Ibid: p. 72.
10 Beugnet: *Claire Denis*, p. 78.
11 Ibid: p. 60.
12 Ancian, Aime, 'Claire Denis: An interview', *Senses of* Cinema 23 (2002). Available at: http: archive.sensesofcinema.com/contents/02/23/denis_interview.html (accessed June 2, 2009).
13 Beugnet: *Claire Denis*, p. 54.
14 Since in both of these films the sibling relationship is in the movie's foreground, much has been written about the diptych in relation to my interests here. It is not my intention (nor could it be!) to reiterate all of the lucid insights that have been offered. Some will be repeated, however, in order to elucidate how they might fit into broader patterns within Denis's *oeuvre* as a whole.
15 Sachs, Ira, 'Awakenings', *Filmmaker* vi/1 (2006), pp. 36–8, 77–81 (p. 78).
16 Nancy, Jean-Luc, 'A-religion', *Journal of European Studies* xxxiv/1&2 (2004), pp. 14–8.
17 Beugnet: *Cinema and Sensation*, p. 80.
18 Ibid: *Claire Denis*, p. 137.
19 Smith, Damon, 'L'Intrus: An Interview with Claire Denis', *Senses of* Cinema, 35 (2005).
20 Tarr, Carrie, with Brigitte Rollet, *Cinema and the second sex: Women's filmmaking in France in the 1980s and 1990s* (London and New York, 2001).
21 Bell, James, 'All in the family', *Sight and Sound* xix/8 (2009), p. 44.
22 Martin, Adrian, 'In a foreign land', *Sight and Sound* xx/7 (2010), pp. 50–1 (p. 50).
23 Isabelle Huppert describes the mother–daughter relationship as follows:

> 'Speaking of him, she says, 'You are soft.' And she is everything but not soft. She is hard, she's determined, she's stubborn. So she cannot bear to see that soft boy.... Of course, she's a mother so she has to accept it. But what's beautiful about it is that her son's character is attracted to something that he thinks is going to be good for him, but in fact it's going to be evil. There's a strange sense of something... it does not know what it is exactly. Like orphaned children, they have an instinctive sense of something. He goes to children, because, being

children like him – even though they are younger than him – he can find some kind of community with them. He is a bit like his mother, actually. Her being stubborn and he being idealistic and being attracted by something that attracts him – this violence, this childish violence – but he does not understand that it will be against him.... So, in a way they are equal, in that sense. A totally different way, but in a way they are the ... two components of the same behavior.'

Shephard, Alex, (2010), 'Isabelle Huppert, beloved actress', *Planet Magazine*. Available at: http://www.planet-mag.com/2010/features/alex-shephard/isabelle-huppert-interview/

24 Martin: 'In a foreign land', p. 50.
25 Darke, Chris, 'Desire is violence', *Sight and Sound*, x/7 (2000) pp.16–8 (p. 18).
26 Davis, Robert, 'Interview: Claire Denis on *35 Shots of Rum*', *Daily Plastic*. Retrieved February 6, 2009, from: http://www.dailyplastic.com/2009/03/interview-claire-denis-on-35-shots-of-rum/

8 Still from *White Material*

9 Still from *Chocolat*

10 Still from *Nénette et Boni*

5

Reinventing Community, or Non-Relational Relations in Claire Denis's *I Can't Sleep*

Sam Ishii-Gonzales

This chapter will focus on Claire Denis's complex, expressive use of montage. I'm particularly interested in how Denis uses montage to rethink relationality, which is to say the way people and events enter into relations with one another. Her experimentation with montage allows us not only to conceptualize new models of relationality, but also to qualify, or disqualify, previous ideas about what it means to form a relation, what it means to perceive ourselves as being-in-common. Although the most striking examples of montage in Denis come in her later films – for example, *Beau Travail*, *L'Intrus* and *White Material* – my focus here will be on Denis's remarkable third feature film, *I Can't Sleep*. My reasons for this will, I trust, become clear through the course of the essay. My interest in montage *vis-à-vis* Denis is twofold. First, I'm interested in discussing Denis's work as one particularly rich and fascinating manifestation of the transformations that montage goes through in the shift from 'classical' to 'modern' cinema. Second, I'm interested in the way Denis's work intersects with recent discussions of community and the various attempts of contemporary artists and theorists to reconfigure artistic production as an experimental practice of relations. Here, I will focus in particular on the philosopher Jacques Rancière's arguments about the relevance of art for the production not of consensus but of dissensus. It is dissensus that allows for the emergence of a true politics, or what we might call a true political community, a community that preserves 'the solitude of being together'.[1] As I will demonstrate, and through an analysis of *I Can't Sleep*, the

second topic (art as a practice of relations) is a natural extension of the first (cinema as montage). After all, could we not say that cinema, as a form of montage, is precisely based in a principle of relations? As Michael Witt observes, there are a number of different forms of montage found in the cinema: 'within the image, between images, between the viewer and the screen, between the subject and society, and between the individual and the world'.[2] In other words, cinematic montage is not strictly related to diegesis, the fiction contained on the screen; it also has ramifications that extend beyond the frame, as the relational structures at work within the film require an affective response from the viewer, a being-in-relation.

Let me start with a brief historical sketch of the relevance of cinematic montage to modern cinema. There is a common confusion in the critical literature that equates developments in modern film with a rejection of the techniques of montage. This is the case whether the critic's starting point is André Bazin and Roberto Rossellini, with their battle cry of 'no more montage', or Gilles Deleuze and his equation of modern cinema with the 'time-image'. On the contrary, what we find in modern cinema is not a denial of montage *tout court* but rather an attempt to create an alternative mode to the coercive or closed form that characterizes montage in Hollywood and Soviet film. In Hollywood films, this closed form is the result of an adherence to certain formal techniques developed in continuity editing that allow the filmmaker to guide the viewer through the narrative fiction through an arrangement of shots that focuses the attention of the spectator first on *this* detail then on *that* one. Despite the extreme fragmentation employed in mainstream cinema, the viewer, acclimated to the conventions of classical decoupage, experiences the scene as though it were a continuous action, as though the sequence of shots were a manifestation or extension of their own interests, their own thoughts and desires, as though they were choosing what to look at within a particular scene and at which moment in time. Continuity editing works not only because viewers become habituated to such techniques; it also works because it affirms common-sense notions of human behaviour, psychology and causation, among others. The viewer passively absorbs the material, precisely because it seems to conform to their preformed ways of seeing and understanding the world, even if said seeing and understanding are themselves by-products of previous encounters with films and other media objects. The coercive nature of classical film is thus all the more effective for appearing to be something else: the non-coercive affirmation of our 'natural' beliefs and habits.

This is clear enough, but what about Soviet montage, which is typically seen as the antithesis of continuity editing? Here, it might be useful to recall the contrast that Deleuze himself makes between Sergei Eisenstein, one of the key figures of Soviet montage, and one of his cinematic heirs, Jean-Luc

Godard.[3] Despite their shared interest in the properties of montage, Deleuze argues that Eisenstein belongs to the classical paradigm, while Godard can be considered a modern filmmaker. Why? The distinction has to do with their understanding of thought and the nature of the thought engendered by montage. Eisenstein argues, like Godard and Deleuze, that cinema has the ability to stimulate thought. For Eisenstein, this occurs through the strategic deployment of montage. Indeed, montage, as the juxtaposition of heterogeneous images, *requires* thought. Eisenstein thus makes explicit the demand that the viewer think. This already distinguishes him from mainstream narrative cinema, which masks the necessity of thought, encouraging the viewer to believe that 'no thought is required' to enjoy this film. But what is the nature of this thought? Although his ideas on this matter are by no means simple, Eisenstein is unable to completely abandon the belief that the thought engendered by cinematic montage is the thought placed there by the filmmaker.[4] A filmmaker has a thought, an idea and transmits this thought, this idea to the viewer through the precise arrangement of shots in conflict or collision. But, we might ask, to what extent is the viewer thinking – thinking in the true sense of the word – if all that occurs in the viewing of a film is that the viewer thinks the same thoughts as the filmmaker?

Eisenstein's presumption of a natural inclination or destination for thought can be explained in part through his allegiance to Hegelian dialectics, and this, Deleuze argues, is one of the problems with his theory of montage. For Deleuze, the problem with Hegel's dialectical process – which, for all its seeming innovation, remains what Deleuze would call a classical 'image of thought' – is that Hegel proposes a *telos*, an end to process, which occurs when *geist* (mind or spirit) attains Absolute Knowledge. It is here that all antinomies, all contradictions, are supposedly resolved or reconciled. (This is why Marx, adopting Hegel's system, proposes Communism as the completion and resolution of dialectical struggle. It is here that the master–slave dialectic allegedly concludes once and for all.) Deleuze rejects the notion that process comes to a conclusion, that process concludes, as well as the suggestion that process naturally gravitates towards rational synthesis or higher forms of truth. For Eisenstein, who believed in the truth of Marxism, there was an inevitable direction to which thought and knowledge progressed. Deleuze, on the contrary, insists that process is ongoing; it continues, with or without us, and there is no way to predict in advance how it will develop and in what direction. Equally problematic for Deleuze is the will to homogeneity that characterizes Hegelian synthesis and that allows us to discover an affinity between Eisenstein's theories of montage and the logic of continuity editing – for, whatever their differences, they both presume that the goal is coherence and completeness and that this coherence and completeness is achieved by a filmmaker who controls

the distribution of shots and extracts a unity from them (this is what allows Deleuze to speak of both Eisenstein and Hitchcock as exemplars of classical cinema). In both forms of editing, what is assumed is that there is a higher principle at work that allows the part (the shot) to achieve a unity in relation to a whole (the film) that both verifies and assimilates it. By contrast, modern cinema no longer subsumes part to whole, difference is affirmed for itself, and montage becomes heterogeneous and open rather than homogenous and closed.

Here, we might also recall Brian Henderson's argument that montage proper gives way, in filmmakers like Godard, to what he calls *collage*. In montage, Henderson writes, the parts are subsumed to the whole. In collage, the parts remain autonomous. Collage does not allow for an overriding formal principle, a principle of organisation, to determine part to whole, as is the case with montage. 'It seems clear that the difference between montage and collage', he says, 'is to be found in the divergent ways in which we associate and order images, not in the length and or nature of the images themselves'. Whereas montage wishes to organize or synthesize its fragments into 'emotional and intellectual patterns', collage does not attempt to overcome fragmentation. 'It seeks to recover its fragments *as fragments*'. Collage is thus 'polycentric' or 'decentralized': 'it relates parts primarily towards each other and only secondarily toward a whole, or ideal unity'.[5] The parts retain their difference, their resistance to assimilation or sublation; the work affirms its heterogeneous status, with multiple entrance *and* exit points.

Published in 1970, Henderson's essay is just one of a number of articles published in this period that address the renewed interest in montage in modern cinema. A few months earlier, in spring 1969, an issue of *Cahiers du Cinéma* included a roundtable conversation between Jean Narboni, Sylvie Pierre and Jacques Rivette, in which the authors discuss the outcome of a three-day event at the Centre Dramatique du Sud-Est on the subject of montage that involved screenings of a number of works (by such filmmakers as Cassavetes, Garrel, Godard, Solanis and Straub) and discussion with the audience. In the course of their roundtable, Rivette proposes four key developments in the history of montage: (1) the invention of montage by such figures as Griffith and Eisenstein; (2) the codification of montage for purposes of entertainment and propaganda; (3) the rejection of montage and its techniques of coercion; and (4) the rediscovery of montage, which Rivette describes as 'the attempt to "salvage", to re-inject into contemporary methods the spirit and the *theory* of the first period, though without rejecting the contribution made by the third [... trying to cultivate one through the other, to dialectise them and, in a sense, to *edit* them'.[6] Through a renewed engagement with montage, modern filmmakers develop a new logic of relations liberated from a strict adherence to narrative causality as well as Hegelian synthesis. As Rivette says, montage

in modern cinema is understood not simply in terms of connection but also in terms of *multiplication*.[7]

The principal editing technique utilized in *I Can't Sleep* is parallel editing. Parallel editing means cutting between characters or events that are understood, in some sense, as being comparable to one another. It is also known as cross-cutting. Typically, parallel editing is used as a means to link contiguous events, events whose co-presence in time is premised on their eventual convergence in a single spatial continuum (which is why it is a typical strategy of suspense films, where the promise of a future meeting or contact is what the spectator anxiously waits for, in longing and dread). One of the first forms of editing invented for the cinema, parallel editing first made an appearance around 1906, when the medium was slightly more than a decade old. A device that is commonly employed for the purposes of creating a pleasurable tension, a momentary disequilibrium, it is also used in more complex ways to create, as the term itself suggests, thematic parallels between characters and events, such as in D. W. Griffith's *Intolerance* (1916), which offers us parallel stories of injustice and betrayal separated by thousands of years, from ancient Babylon to modern-day America, but which are made to resonate within one another through the deployment of crosscutting. In *I Can't Sleep*, parallel editing is both affirmed and transformed, as it is used neither to generate suspense nor to create a thematic unity. It is used instead to proliferate difference, to sensitise us to the solitude that adheres in all people and things.

Denis's specific use of parallel editing is even more remarkable when we consider that the film takes as its inspiration or point of departure the 'true crime' exploits of Thierry Paulin. Born in 1963, Paulin was an immigrant from Martinique – a young, gay black man with platinum-blond hair who discovered in 1986, at the age of 23, that he was HIV positive. In December 1987, he was arrested for killing 18 elderly women over a three-year period with the assistance of his white lover, Jean-Thierry (a drug addict born in French Guyana). Paulin would eventually confess to 21 killings. In the press, he was described as a 'beach-blond mulatto, a gay drag queen and a drug addict' and referred to as the 'Monster of Montmartre', even though his friends and family described him as a 'pleasant, engaging and charming young man'.[8] He died in prison of AIDS, at the age of 25, while waiting for his case to come to trial. When Denis's film premiered at the Cannes Film Festival in 1994, the French press 'received it as a scandalous resuscitation of the crimes', and the headlines read '[Thierry] Paulin, the Killer, a Star at Cannes'.[9] However, *I Can't Sleep* is far from sensationalistic or exploitative. Denis has said that what interested her in the case was the different perspective on the murderer that his friends and family had, compared with that of the press and general public, who labelled him a 'monster'. 'When I agreed to use the Paulin case as the inspiration for the film', Denis explains, 'I said

that I would focus on the people who knew him. I wouldn't focus on him. So I made a film about the people who knew him without knowing what he did'.[10] This is already an interesting, and less exploitative, approach to the material, but Denis goes even further than this; it is not that she focuses on 'the people who knew' a man (renamed Camille for the film) who turned out to be a serial killer.[11] Camille's story is now just one of three, along with the story of Théo his brother, an immigrant musician from Martinique who does odd jobs to support his family, and Daiga, an immigrant from Lithuania, who travels to Paris to meet up with a theatrical director who has promised to give her work as an actress.

Both Théo and Daiga serve as parallel figures to Camille, and they give us some insight into his character, but only indirectly or obliquely. Daiga's story, for example, has rough parallels with Camille: they are both outsiders to French society; they are both would-be actors or performers and objects of attraction for a number of different men, as well as objects of attraction for the camera. How we are to understand this parallel, though, is never stated. Nothing is overstressed or insisted upon, and none of the stories are given priority over the other. Martine Beugnet, in her 2004 monograph on Claire Denis for Manchester University Press, argues that the characters' trajectories 'cross till they form a kind of pattern, a circular movement that leads to the central figure of the criminal'.[12] We might call this a circular movement, but, if so, it is a movement without a centre or, to borrow a concept from Bruno Latour, a 'heterarchy' – a heterogeneous structure without a centre (a heterarchy may exhibit hierarchies at a local level, but these centres do not hold at a global level).[13] However, it could be argued that the central figure is Daiga rather than Camille; after all, the film begins and ends with her. Yet, neither claim is entirely convincing since the work finally resists such attempts to create a unity. As Beugnet also states, the story 'does not invest one character as reference and anchorage',[14] adding that Denis's use of parallel editing neither follows 'the rule of strict cause and effect structure' nor 'the necessity of bringing all the elements and loose ends to a logical conclusion'.[15] Denis thwarts our expectation that the parallel lives of these, and other characters, will come together in some meaningful sense. Not only is the encounter between Camille and Daiga momentary and fleeting,[16] but also the final encounter between brothers is, in an important sense, a non-encounter: Camille is taken away by a pair of police office while Théo stands off to the side, neither one attempting to make contact with the other; Théo watches Camille as he is escorted out the door. Camille looks in his direction but without making eye contact. A couple of scenes prior to this a detective sitting in a room with Camille's family says in a recriminatory tone to Théo, 'If it was my brother... I don't know, you notice things'. Théo replies, 'My brother's a stranger to me, just like you'.

Beugnet's commentary highlights a challenge faced by all Denis scholars, which is the conflict between the openness of Denis's structure and the interpretation that this structure seems to encourage or necessitate. This is not a negligible point, since it would be equally wrong, in my view, to suggest that the absence of a definitive meaning to the character's actions or behaviour should lead us to conclude that the work is meaningless. Instead, what is needed is a critical-reading practice that openly acknowledges and explores the productive tension between sense and meaning that is the peculiar strength of cinema – a strength that Denis exploits so well. The complex affective response one has to *I can't sleep* does not occur in spite of this tension *but because of it*. It is what allows us to be drawn towards a character even as their action repels us. It is plausible, for example, to explain Camille's behaviour in psychosocial terms: to say that his actions are the result of his internalization of societal norms, an internalization that leads him to devalue himself while also devaluing the lives of other outsiders or outcasts. There is nothing in the film that disallows such an explanation, but does it really succeed in communicating the emotional richness of the finished work? And if not, why? In what way does such a reading fail to account for the filmmaker's strategic use of ambiguity? In what way does such a reading lose sight of the potential ethical and political ramifications of equivocation?

I do not think it would be an exaggeration to say that Denis's interest in montage, and cinema more generally, is related to its ability to show without telling. Montage shows us something without telling us what it means, or, if it tells us something, it does so with images rather than words, and images do not simply house meaning, but also proliferate its possibilities – and through a meaningful abstinence, through a withdrawal of sense that stimulates the search for meaning, a search that is not futile so much as ongoing; it is renewed with every encounter with the work of art. Denis makes this point in her own way in the interview 'Cinema is not made to give a psychological explanation... For me, cinema is montage, editing... I think that making films for me is to get rid of explanation'.[17] This is the strength of cinema: its ability to withdraw meaning, even as it affirms the mysterious presence of things and the ability of each and every entity to enter into a momentary and fleeting contact, a contact that evades our attempt to impose a meaning or affix an explanation based on a priori notions of morality and truth. This absence of judgement is, no doubt, troubling for some audiences, but Denis neither sentimentalizes her Camille nor does she excuse his behaviour (by blaming it on larger social causes). Nor does she glamorize him. Camille is simply human, a stranger to his brother and to us, just as we are to one another. 'Without reducing or fully explaining the violence, [Denis] takes away the mysterious attraction it holds and

thereby gives to the character of Camille all the desolation and sadness that he possesses'.[18]

We are asked primarily to observe these people – and not only the three main characters. Each and every character in the film, however small their role, is accorded the same full and autonomous existence. Denis's 'extraordinary achievement', as Robin Wood writes, is to offer 'a *way of looking*, which takes precedence over (and encompasses) any definable thematic'. The result is a 'sympathetic but impartial viewer: There is [a] *distance* from all [the] characters . . . a seemingly impartial, all-encompassing distance that the spectator is encouraged to share'. This distance should not be mistaken for indifference, Wood adds, since there is at all times 'an implicit and equally pervasive sympathy and generosity' in the way Denis films these people and the world they inhabit.[19] With Denis, characters are never merely conduits for a larger narrative purpose; they are not used simply to facilitate the movement from one plot point to the next. The chance encounters between characters don't 'add up' in the way they would be required to in a more classically structured text. People meet, cross paths and carry on with their lives. Each character is allowed to assert his or her autonomy of interests, concerns and motivations (such as they are aware themselves of what drives them to action or renders them impassive or incapacitated). They remain other to the solicitations of the viewer or the camera. 'Behaviour, gesture, movement are precisely rendered, yet all explanatory information is withheld'.[20] The characters, and the actors who embody them, pass in and out of Denis's world with their mysteries intact.

The reader may be wondering how this emphasis on non-relations and solitude might lead to a discussion of community, but it is in these terms, or in very similar ones, that the philosopher Jacques Rancière has asked us to understand politics and art. Rancière critiques the notion of the ideal community, which, as he reminds us, is derived from Plato and which people mistakenly view as the goal of modern forms of democracy. For Rancière, the ideal community proposed by Plato signals the end of democracy and politics because it posits a 'distribution of the sensible', in which everyone has their rightful place within a system or organisation. In an ideal community, there is a hierarchy and a fixed distribution of parts. The ideal community is a homogenous community. The ideal community is totalitarian, by which I don't mean totalitarian, though totalitarianism can be understood as one manifestation of this ideal community. Politics occurs when this distribution of sense is called into question or subverted. This is what politics is, according to Rancière: a *dissensus*, 'a confrontation between opposite common senses or opposite ways of framing what is common'.[21] It occurs when an individual or group of individuals comes to see the limits of the contemporary distribution of the sensible and argues for a re-distribution or re-partitioning of sense, and

it is precisely because politics requires a re-distribution or re-partitioning that we can see the aesthetic dimension of politics as well as the political dimension of art – for what is the latter but a field or terrain that makes imaginable, that makes tangible, the re-distribution or re-partition of sense? This does not render politics and art interchangeable. Politics requires action in a way that art does not, while art requires a receptivity, an openness, a responsiveness to alternative forms of thinking and being, which may serve as the impetus for political action but cannot be mistaken for this action itself.

Art allows us to re-imagine the principles whereby we form a bond or enter a relation, and it does so not simply by offering us an alternative image of the community, as this would already be another way of positing an ideal community. Art stimulates the viewer or reader to imagine these new bonds or relations for himself or herself, and it does so as much by indirection as by representation – it does so by leaving an opening, installing an interval or gap, which allows the spectator to participate in the re-imagining of what it means to exist, what it means to belong. To exist and belong: are these not the central problems addressed in Denis's work? By eliminating the standard psychological or common-sense meanings that guide parallel editing or crosscutting, we are asked to re-imagine the principles whereby the entities on screen exist in relation with one another. One can only draw a negative conclusion from this if one's starting point is an ideal community or consensus, reading her non-relations as a symptom of late capitalism, neo-colonialism, globalization, and so on. But this negative emphasis hardly accounts for the affective power of her films or the moments of pleasure or joy that one experiences in all of her works (even when these moments are accompanied by other emotions, such as sadness or melancholy, which do not cancel out the pleasure and joy so much as complement and complicate them). Moreover, the absence of relations should be understood as an invitation to re-imagine our world and the links that join one to another. The absence of relations is an invitation to create new ones. Far from arguing for the futility of such actions, Denis films are themselves demonstrations of this ability to rethink the nature of relations, to create new communities of sense, communities based in dissensus rather than consensus, communities that affirm the necessity of leaving open the question of what it might mean to exist in relation, to exist in common, in the present and as our future.

Notes

1 Rancière, Jacques, 'Aesthetic separation, aesthetic community', in Gregory Elliott (trans.), *The Emancipated Spectator* (New York and London, 2009), p. 52.

2 Witt, Michael, 'Montage, my beautiful care, or histories of the cinematograph', in Michael Temple and James S. Williams (eds.), *The Cinema Alone: Essays on the Work of Jean-Luc Godard* (Amsterdam, 2000), p. 46.

3 For Deleuze's discussion of Eisenstein and Godard see Deleuze, Gilles, *Cinema 2: The Time-Image*, trans. Hugh Tomlinson and Robert Galeta (Minneapolis, 1989), pp. 156–88.

4 See, for example, an essay like 'Methods of montage,' where Eisenstein proposes ever more complex notions of montage (including what he calls *overtonal montage*) but without being able to entirely relinquish the belief that it all of it remains within the filmmaker's grasp or control. See Eisenstein, Sergei, 'Methods of montage', in Jay Leyda (ed. and trans.), *Film Form: Essays in Film Theory* (San Diego, 1949), pp. 72–83.

5 Henderson, Brian, 'Towards a non-bourgeois camera style', in Bill Nichols (ed.), *Movies and Methods: An Anthology*, vol. I (Berkeley, 1976), p. 428; emphasis in original.

6 Rivette, Jacques, 'Montage', in Nick Browne (ed.), *Cahiers du Cinéma Vol. 3, 1969–1972: The Politics of Representation*, trans. Tom Milne (London, 1990), pp. 32–3. In 1990, Denis would direct a feature-length documentary about Rivette, entitled *Jacques Rivette, Le veilleur* (Jacques Rivette, The Night Watchman).

7 Rivette: 'Montage', p. 26; emphasis in original.

8 Mayne, Judith, *Claire Denis* (Urbana and Chicago, 2005), p. 81.

9 Mayne: *Claire Denis*, p. 82.

10 'Interview with Claire Denis', in Mayne: *Claire Denis*, p. 142. Denis tells Mayne that she remained uncertain about the material even after working on it for a couple of years. It was only while shooting the film that she realized that it could work, and this was a result of the contribution of the actors and the way they embodied their roles. 'Jean-Pôl and I worked on the screenplay, but when it was embodied by the actors...Béatrice Dalle said it better than I could: "What was written on paper became flesh". All of a sudden, the violence on paper became something else' (143).

11 The film does not claim to be the 'Thierry Paulin Story'. Parts of it are clearly fictional, such as the introduction of the Daiga character, but it is also clear that Denis and her screenwriting collaborator, Jean-Pôl Fargeau, used a number of details from Paulin's life, however obliquely.

12 Beugnet: *Claire Denis*, p. 87.

13 Latour, Bruno, 'Some experiments in art and politics,' in *E-Flux* xxiii (2011), para 7. Available at: http://www.e-flux.com/journal.

14 Beugnet: *Claire Denis*, p. 93.

15 Beugnet: *Claire Denis*, p. 90.

16 As Nikolaj Lübecker writes, the one encounter between Camille and Daiga seems to indicate 'a real complicity between the two characters', but 'at the same time there is no relation between them...It is a moment of tenderness, but the tenderness does not presuppose a relation'. 'The dedramatization of violence in Claire Denis's *I Can't Sleep*', *Paragraph* xxx/2 (2007), p. 22.

17 Denis qt. in Beugnet: *Claire Denis*, p. 20.

18 In Lübecker: 'The dedramatization of violence'. Lübecker adds, 'To some extent viewers can only draw the same conclusion as the one Denis reached when commenting upon the Paulin case: the opacity remains' (p. 25).
19 Wood, Robin, 'Only (dis)connect and never relaxez-vous, or *I Can't Sleep*'. *Film International*, para 9. Available at: http://filmint.nu/?p=243.
20 Wood: 'Only (dis)connect', para 6.
21 Rancière, Jacques, 'The method of equality: An answer to some questions', in Gabriel Rockwell and Philip Watts (eds.), *Jacques Rancière: History, Politics, Aesthetics* (Durham and London, 2009), p. 277.

11 Still from *I Can't Sleep*

6

Beyond the Other: Grafting Relations in the Films of Claire Denis

James S. Williams

'The Horror, the Horror'

When, in the penultimate scene of *White Material* (2010), Maria (Isabelle Huppert) leans forward over the open hatch and strikes her ailing ex-father-in-law, Henri (Michel Subor), on the back of the head, repeatedly and mercilessly, she is doing more than simply taking revenge on someone who failed to help save her beloved son, Manuel (Nicolas Duvauchelle), whose charred remains are visible. As the culmination of a virtual case study of female obsession and hysteria, Maria's destruction of the wicked father – gruesomely literal in its deadly closing off of screen space – might best be explained in psychoanalytical terms as a form of psychosis. In Lacanian terms, the Real suddenly erupts and takes over in a graphic and highly literal psychotic *foreclosure* of the Symbolic.[1] Indeed, throughout the film Maria has been frequently delusional, consistently downplaying the signs of impending civil war and stubbornly blind to the fact that the Africa she loves does not love her and that she is simply disposable 'white material'. The only European woman in the film, she displays a naive, misguided wish to forget that she is white in order to fuse with the native blacks while castigating all French as *nouveaux riches*. Trapped, moreover, in a regressive and impossible relationship with her spoilt and indolent son, who would destroy all that she stands for by going 'native' and pillaging the plantation on behalf of the rebels, she is ultimately stripped of her sole means of belonging and identity – that of managing the Vial coffee plantation.

The filmic style of *White Material* encourages such a clinical reading, so often does it seem to run counter to Denis's standard de-psychologising approach founded on gaps and ellipses, narrative indeterminacies and speculative possibilities. If her cinema normally lifts dramatically away from the scene of psychoanalysis in order to emphasize the aesthetic potential of being present in the world and open to the Other, this film fatally closes off such a possibility. The final image does nothing to dispel this impression. By means of a simple yet decisive act of montage, a last formal move by Denis almost *in extremis*, we pass abruptly from a low-angle view of Maria's blood-spattered face to an image of the young patriot glimpsed earlier in the film, adulating the fatally wounded rebel leader called the Boxer (Isaach de Bankolé) as a living legend of resistance. Alone in the bush and on the run, stuffing the Boxer's mascot red scarf down his pants, this new Boxer is, in the final seconds, a phoenix risen from the ashes. Yet this is no positive moment of regeneration or futurity. Instead, this sudden resurgence of masculinity in a film littered with weak, wasted men and lost boys – the delinquent Manuel already gone to seed (*avachi*); Henri '*le vieux*'; the expiring Boxer; Maria's scheming ex-husband, André (Christophe Lambert); and the marauding child soldiers (silently slaughtered while drugged and clutching their stolen teddy bears) – offers only the utterly bleak promise of an endless reproduction of the same. Just as the white plantation family has imploded in violence, so, too, the new Boxer will find new children to manipulate in an endless cycle of bloodshed. Doomed to kill and be killed, he represents nothing more than a warped image of rebellion and liberation.

How has it come to this? Photographed by Yves Cape rather than Denis's usual director of photography, Agnès Godard, *White Material* is arguably Denis's first action thriller, yet it appears, paradoxically, to void the cinematic that is always conceived by Denis in terms of relationality. The processes of fragmentation and violence intrinsic in her work have been taken here to a contagious, de-humanising level. It is not simply that this is a film where all human bonds are progressively broken and new or genuine relations impossible (other than a false and corrupt brotherhood of lost boys sustained by fear, idolatry and vengeance). Even when Maria chooses to protect the Boxer, allowing him to hide out in her son's room and even cooking for him on the grounds that his uncle, Jean-Marc, is one of her senior plantation hands (though uncle and nephew are never seen together), she is wilfully ignoring her responsibilities, putting both herself and the workers in her care in certain danger. This one momentary connection across gender and race, which seems more like narcissistic identification on her part, is casually passed off by the film as an impossible association that is over almost before it can be formed. *White Material* ends, in fact, where it began, with the mayor, Chérif (William Nadylam), leading his private militia by torchlight through the plantation and

burning everything. Which is to say, the beginning is already the end, and the film does no more than record a countdown in reverse, the final minutes extending a little further into the unfolding horror. Although the narrative is punctuated by shards that may be embedded flashbacks or, just as credibly, menacing flash-forwards and possibly hallucinations – Maria simultaneously fleeing from, and returning to, the place she calls 'home'; Maria smoking dope with Chérif against parodically romantic backlighting – the effect of a pre-set stopwatch ticking down to apocalypse remains constant. With fluid jump cuts increasing the feeling of urgency and immediacy, space seems bleached out and flattened like a haunted, non-zone. One of the key features of Godard's cinematographic style – the gentle pans combing and teasing out the Real that traces new material forms and contours beyond fixed symbolic and ideological structures and narratives (familial, Oedipal or otherwise) – cannot take root here and is replaced by the regular speed of Cape's urgent tracking shots alternating with intense close-ups. All the while the instrumental theme, 'Opening', by Tindersticks, is heard: a wheezing squeezebox that, with its mournful viola and portentously plucked strings, imposes an oppressive, trance-like mood.

It is the particular absence of intertextual direction in *White Material*, however, that makes the film so strikingly different from Denis's usual cinematic method. This directly reflects the portrayal of profound masculine crisis and malaise. For, despite the obvious echoes of Doris Lessing's psychological tale, *The Grass Is Singing* (1950), set in colonial Rhodesia and featuring a white heroine/victim called Mary, it engages meaningfully with no major intertext as such, a key feature of Denis's practice. The black-and-white postcard image of Lessing in the 1950s, briefly glimpsed on the dressing table in Maria's room, only confirms the absence of anything more sustained. It is a fixed image and casually offered like an obscure personal memento or just some other generic 'white material', like the miniature toy animals and artefacts alongside it. If Denis's films are generated organically by the heat of intertextual energy, here there is simply no clear generative textual nucleus for development and, thus, no real possibility for intertextual fantasmatics or poetics.[2] This seems all the more surprising in the light of the film's pre-eminent literary origins as a script co-written not by her usual scriptwriter, Jean-Pôl Fargeau, but by the important Franco-Senegalese novelist Marie NDiaye, a writer who places the family at the heart of her work, as the focus of all tensions and a means of (self-)destruction. In interviews, Denis has spoken somewhat vaguely of the influence of Simenon, Faulkner and Conrad, as well as of the Congolese writer Sony Labou Tansi, to whom she dedicated the film in her director's statement at Cannes.[3] One might be tempted here to make a link between Labou Tansi, who died of AIDS in 1995, and Subor's character in the film, who is dying of a mysterious disease. Yet again, the connection is too tangential to convince and produces instead

an over-literal identification between text, intertext and real person. Similarly, when Denis talks of Maria as inheriting the same force as Marie NDiaye (whom she claims the film resembles in the sense that the 'small yet unflagging' Marie has an unflinching quality that she [Denis] wanted to steal and give to Maria [2010a: 20]), she is over determining the links between reality and fiction. A loose haphazardness thus defines the creation of *White Material*, which divides its dedication at the end between co-writer 'Marie' (NDiaye) and 'the fearless young rascals'.[4] In short, this is far from a typical Denis film about the cinema or authorship, still less about film in relation to other forms and media.

If *White Material* thus represents stylistically an extreme outer limit of Denis's cinema, it is also ironically the first time in her work that the sheer energy and incandescent power of its star (Huppert) propels the narrative flow. It is not an understatement to say that Huppert's supremely theatrical performance (in many respects an archetypal Huppert performance – resilient, resolved, courageous, wiry – but pushed here to a new level) outshines virtually every other element, cinematic or intertextual.[5] In fact, the extraordinary way that Denis talks of Huppert's active contribution and addictive force ('She [Huppert] doesn't suffer. It's like a rapture, work ravishes her . . . I wanted everything, I never had enough' (2010a: 22)) suggests that the real story of *White Material* may actually be that which took place between director and actor during the film's production. It was, after all, originally Huppert who asked Denis to adapt *The Grass Is Singing*, although both Denis and NDiaye quickly realized that Lessing's novel bespoke a particular historical (and sadomasochistic) tradition between white woman and black worker that Denis had already negotiated in her first film, *Chocolat* (1988) – one that also referenced Ferdinand Oyono's 1956 novel, *Une Vie de Boy/House-boy*, about colonial relations and physical and ideological enslavement. While his character is alive in the film, Subor's queasy, half-naked presence is just enough to provide an intertextual filter or buffer to prevent the film from drowning completely in the unstoppable tide of narrative action and performance. Yet his 'cinematic' potency is progressively depleted, and once he is finally decapitated the film is all but over – a lacerating vision of a world scorched of human love and kinship, where human relations have been reduced literally to ash.

Let us be absolutely precise about this: by finally clubbing Henri to death Maria is also voiding the particular creative value and heft of the actor Subor within Denis's work. In his previous roles as Forestier in *Beau Travail* (2000) and Louis in *L'Intrus* (2004), he had appeared the very incarnation of cinema itself due to the remarkable male cinematic imaginary he embodies. As I have shown at length elsewhere, *Beau Travail*, which revolves around Herman Melville's novella *Billy Budd, Sailor* and Benjamin Britten's opera *Billy Budd* on the same

theme, is sustained by concrete references to Jean-Luc Godard's *Le Petit Soldat* (1961), starring a young Subor (including even publicity shots), part of the film's rich trans-historical and cinematic weave (see Williams 2004). Denis sees the brooding, magisterial Subor as a filter and 'transformer' within the film since he carries cinema history within him and has the force to replace Melville (Denis 2000: 51). In fact, the artistic process is generally conceived by Denis in terms of a direct engagement with the cinematic screen itself, which is always sexual and intrinsically masculine. Indeed, a Denis film usually proceeds organically by positing a tough, masculine-identified nexus of intertextual influence that must be actively unbound, defused and sublimated via new forms. In strictly formal terms, it must start in abstraction (lines, patterns, networks), proceed to literality and then choreograph itself into a lyrical poetics of sounds, gestures and patterns in space by means of an ongoing process of authorial translation and theoretical mediation. This is a meditation *on* and *of* film that offers the possibility for intertextual relay and release from the violence of desire.

This complex rhetorical and textual method is further developed in *L'Intrus*, an epic haul across continents and oceans that constantly threatens to veer off into abstraction. It is directly inspired by Jean-Luc Nancy's autobiographical text from 2000 of the same name (*L'Intrus*), about the process of undergoing a heart transplant and living with a grafted organ. Nancy figures the act of receiving an alien heart as an encounter with the Other as Intruder, suggesting that an ethical response to the arrival of the stranger can take place only when one welcomes intrusion without trying to absorb, assimilate or master it (Nancy 2000: 11–12). Denis pursues explicitly here the creative idea of 'grafting' (*greffage*), and, like *Beau Travail*, *L'Intrus* illustrates her success in working textually through accreted layers of male influence, melancholy and crisis. Indeed, the grafting process would appear to be endless and infinite, like the perpetually unresolved score by Tindersticks lead singer Stuart Staples, which allows us to experience the porosity and spatiality of cinematic time. Yet the narrative is ultimately crystallised through the fragments of an aborted 1961 film by Paul Gégauff, *Le Reflux*, which appears in the last stages set in Tahiti as so much tissue transplanted on to a strange cinematic body and only imperfectly integrated within it. In fact, *Le Reflux* (later released in 1965 with an ending by Roger Vadim and Jacques Poitrenaud) is extracted four times in progressively more intricate and involved fashion – enough to present tangible memories of a much younger and swarthier Subor, almost the same age as Louis's 'lost son'.[6] The link between Nancy's text and Denis's film is essentially one of creative filiation and kinship, and Nancy has himself stated that Denis 'adopts' rather than 'adapts' his essay, suggesting a 'backwash movement' (*reflux*) between the two works and also beyond itself.[7]

The Open Frame: New Grafts, New Relations

It would require a long and separate study to describe in detail the many different ways Denis 'grafts' a specifically male imaginary that can range from the strictly cinematic, as in *Trouble Every Day* (2001) – references during the Notre Dame sequence to the screen character of Quasimodo (played notably by Charles Laughton in 1939) and Robert Bresson's *Une Femme Douce* (1969) (among many others) vie with extracts from two anthropological films about Guyana – to the more musico-cinematic tensions of *Vendredi soir* (2002), which begins with Jeff Mills's *Entry to Metropolis* from his 2000 score for Fritz Lang's *Metropolis* (1927) and is ignited by a stunning encounter between Shostakovich and Benjamin Britten.[8] If Grégoire Colin, a regular in Denis's films, is right that Denis films men intimately as if she were herself a gay man, it is also the case that she has a consuming attraction for male authors, composers and filmmakers and an equal fascination in bringing them together in new and original formations and textures. Indeed, Denis talks compulsively of male artistic influence and male relations, producing through interviews and director's statements a dense paratextual discourse about inter-male creativity and authorship – part of an extended *hors-champ* that encompasses, too, the family of male actors criss-crossing the corpus like Subor, Colin, de Bankolé and Descas. Denis actively draws on this seductive male otherness (including her chosen artists'/actors' rich back histories), creating as a female *auteur* a vast textual and theoretical space of male kinship as potent and far reaching as the 'invisible human fluids' fantasised by the wondrously feminine bakery owner in *Nénette et Boni* (1996). This supremely homosocial (and sometimes homoerotic) aesthetic space – a space of intensive graft and desire (Denis 'corrects' a male intertext precisely out of love) – pre-empts any over-identification with the feminine (something Denis acknowledged as a major risk in her direction of Dalle in *Trouble Every Day*).

With the notable exception of *White Material*, all of Denis's films strive to attain the right mix of intertextual otherness, and the forms of filiation such grafting produces suggest a new and vital relational mode. Indeed, the intertextual *is* the relational in Denis. That is to say, familial and filial relations are part of a larger set of relations (or interrelations) in her work that are fundamentally textual and performative in nature. Any study of Otherness in Denis's work, however sophisticated and ethically informed, that does not take into full account these internal textual landscapes will remain, I think, incomplete. Andrew Asibong, for instance, has recently celebrated Denis's 'flickering spaces of intimacy' and solidarity in his account of her post-colonial subjects trying against the odds to create familial, sexual and other intimacies and communities. He emphasises in particular the unexpected, ephemeral moments of unnameable

intimacy between (normally white) women and (usually black) men, which produce an inarticulate, physically expressed, vaguely post-social transformation of the oppressive social space they both inhabit – a space that becomes a new womb-like shelter of protection and hospitality, with the woman reborn as a new daughter and acceptable guest and the man 're-embroidered' as nurturing, post-colonial mother-father (or sometimes the reverse) (see Asibong 2009 and 2011). Examples include the love scene between outcast scientist Léo (Descas) and his cannibal wife Coré (Béatrice Dalle) in *Trouble Every Day*, when Léo washes the blood from Coré's limp body ('an act that bears witness to the couple's unbearably generous kinship' [Asibong 2009: 110]) and that of the 'quasi-mystical' café scene in *I Can't Sleep* (1994), when the Lithuanian Daiga (Katerina Golubeva) erotically grazes the fingers of the Martinican Camille (Richard Courcet) in shadowed close-up as he reaches across the bar before then paying and leaving. While in broad agreement with Asibong's ultimately guarded embrace of such 'unspeakable' pseudo-parental intimacy through and across otherness[9] – one that produces arguably an intercultural miscegenation – I believe, for the reasons just enumerated, that they form part of a much larger engagement by Denis with alterity that must be understood within the transformative frame of cinematic and textual relations.

In all of Denis's films featuring different kinds of social 'misfits', there is a clear recognition that one must break out of fixed or 'natural' family bonds and move beyond blood ties precisely in order to construct new forms of relations and community. *White Material*'s inability to instantiate any new or genuine fraternity and commonality, either real or formal, out of the familial horror and thus circumvent Maria's misplaced fixation on belonging, serves only to throw into sharper relief the delicate lines and stakes of Denis's project where potentially all is grafted. Indeed, *greffer/greffage* is the term Denis naturally employs whenever she wishes to oppose identity and belonging with something inherently fluid and provisional, and that includes her own conception of France as a shifting set of territories, formed while growing up within an itinerant family (see Denis 2011). Identity for Denis can only ever be an experience of exile and marginality – an open frame of permanent strangeness – and the true family is always diasporic. In her video trailer for the exhibition entitled *Diaspora*, which she mounted in 2007 at the new Musée du Quai Branly in Paris, Denis formulated 'diaspora' in the following terms: 'as etymological dispersion and the attempt to remain connected'. What this implies is always a double movement, one that serves also to define her own work, which attempts to balance two conflicting movements: one centrifugal (its nomadic intensities and cosmic pull), the other centripetal (its internal, intertextual graftings). One thinks of the many partial, fractured and unconventional families and dysfunctional family relations in her work, too numerous to mention,

which bespeak the precariousness of human relations and the breakdown of conventional structures. Yet there are also the many reversals, metaphorisations, quasi-approximations, reinventions and transformations of filial and family relations films that confound the standard lines and borders of filial, social, racial and generational difference (brother/sister, colonizer/colonized, black/white, child/adult, etc). In the spectacular ending to *Nénette et Boni*, Boni (Grégoire Colin) suddenly steals his sister's newborn baby from the confines of the hospital (with her tacit approval) in the hope of forming a new and very different kind of family still to be conceived.

At the root of Denis's project of intertextual grafting lies, I would argue, a wish to move beyond the discourse of the Other (i.e., those who are perceived as different and positioned as other, to be feared, excluded, fetishized) in order precisely to re-engage with these same others on more mutual and progressive terms. Indeed, for Denis meaning in the cinema always comes down to the desire for a relationship with others *beyond the frame*. As she powerfully put it around the time of *I Can't Sleep*: 'Even the pleasure of framing the image isn't sufficient. Desire for the cinema ought to go beyond the frame, towards meaning. It should be a desire for a relationship with others' (1994: 74). *White Material* is no different in this respect; yet, as we've seen, the usual Denisian intertextual tools are signally lacking, and the cinematic frame itself, far from pointing towards new inclusive spaces, is, by the end, graphically closed up, only to be reopened by a shot that repositions the new black rebel leader in the middle of the frame simply as Other – a spectre of terror forever to haunt the frame after he exits it from the right. Narrative closure may have been avoided here, but nothing of a more fundamental nature has changed. Compare this with the ending of *Chocolat*, a film that, from the beginning, with its highly stylised framings and compositions, powerfully critiques the racist politics of colonial space and de-essentialises racial difference. After leaving the protagonist, France, in the airport lounge, the camera offers finally a new vision of black identity and brotherhood. To the jaunty beats of the South African musician and composer Abdullah Ibrahim, it motions slowly towards the three black luggage handlers on their break, one of whom is Isaach de Bankolé, earlier the household 'boy' Protée, who played both a maternal and paternal role for the young France in the colonial story. The camera frames the trio first within the columns of the overpass, then, once these same columns have been stripped back to the edges of the frame and the field ahead (both literal and figurative) has been opened up, stops at a respectful distance simply to record the gestures of three men in the middle distance enjoying just being together, smiling, chatting, gesticulating, tapping each other, even casually urinating, as the rain and light come and go in front and behind them. They remain sheltered under the now invisible overpass, which provides a natural stage set for their performance of

male camaraderie. Yet during this entire extended long take, we hear nothing of their intimate conversation. These present-day Cameroonians exist together beyond the ideological frame of the Other – a set of power relations in which the European spectator, interpellated by the cinematic apparatus, is necessarily implicated.

It is not, in fact, until *35 Rhums* (2009), a film set in the Caribbean community of Paris and made in tandem with *White Material*, that Denis fully develops the potential of *Chocolat*'s beautiful open ending where shared public space is envisioned as a threshold to new (provisional) forms of human relationality and male intimacy. This is a film composed almost entirely of black characters, but where race is rarely made an issue. On the face of it, it is Denis's most classical and hetero-normative work to date, offering a complete portrayal not just of a tight family unit, but also of a 'real' and present father. I would like, however, to explore the film within the specific context of grafting to show precisely how Denis's evolving, multi-layered work on the frame and intertextual relations reinvents the family within an expanded notion of kinship that helps to redefine the very nature of human relations.

Romancing the Father: The Nightshift

The relations between the four proto-family members of *35 rhums* – the young, mixed-race student, Jo(séphine) (Mati Diop); her Caribbean father and train driver, Lionel (Descas); her young white suitor, Noé (Colin); and her pseudo-mother, the taxi driver Gabrielle (Nicole Dogué), who still holds a torch for Lionel – come to a head in the brilliant set-piece sequence, where an unexpected surge of physical desire is peremptorily cut short before it can explode into being. I am referring to the sudden moment of mutual seduction between Lionel and the beautiful African restaurant owner (Adèle Ado), who has eyed him up and down, and he her, from the moment she opened the closed door and he crossed the threshold, followed by Jo, Noé and Gabrielle, after Gabrielle's car broke down in the rain while ferrying them all to a concert. The two dance together to the Commodores' 1985 hit, 'Nightshift', a tribute song to the memory of the soul singers Jackie Wilson and Marvin Gaye, which swells the frame and establishes a mood at once resigned and celebratory, cheerful and sentimental. This is a perfect illustration of Denis's cinema of the senses: a precise choreography of movements and bodily rhythms, of silent looks and touches, at once sensuous and spontaneous, shot for the first time in the film in emotive close-up, with facial expressions, glances and feelings running from anxiety to jealousy under the orange candlelight. Everything seems to flow here – a mobile camera opens up the frame and traces the movement of desire, which Lionel sets in motion through a subtle yet decisive act of agency: he gently hands his

daughter to Noé and shifts out of the frame that he has occupied. Then, as if improvising a ritual, Lionel and the owner exchange looks in a magnetising shot/countershot before he suddenly takes her hand and erotic contact is made. Jo is now witness to her father's desire for another. Meanwhile, cast in the role of spectator, Gabrielle is left to rue her earlier wish to loudly play, solely for Lionel's benefit, a slow reggae ballad by the Jamaican female singer Sophia George, entitled 'Can't Live Without You'. The song 'Nightshift' tells instead of leaving the 'dayshift' (i.e., life on earth) and starting the 'nightshift' in heaven, where the departed will remain 'forevermore, evermore' in close contact with the living (the chorus ends in each case with the words: 'You found another home / I know you're not alone / On the nightshift').

Again, what is being conceptualised here is a typical Denis space of male bonding and play across both form and culture that not simply opens up the French context to the sounds of American culture, but also creates a kinship across different forms of black experience: French-Antillean, African, African-American and, if we add the song that precedes 'Nightshift' on the jukebox, 'Siboney' (a cover by the Martinican crooner Ralph Thamar of a Cuban ballad by Ernesto Lacouna), Spanish West-Indian. Such transcultural shifting determines the very structure and function of this scene, where relationships are reconfigured and desire safely re-channelled. There is a strong sense here that things have been quietly and efficiently worked out and through. Earlier, following the suicide of his work friend, René, who was consumed by fear of the sudden 'deliverance' of his retirement as well as regret for missed opportunities (he may even have harboured desire for Lionel in the past), Lionel had been confronted with the fact of time's inexorable passing. Now, due to his clear signals and actions, he, Jo and Noé are able to start a fresh chapter in their interconnected lives. He does not return to the nest that night, perhaps for the first time ever, and, as Noé says to Jo the next morning when he finds his cat dead and thus the last material link with his own parents suddenly dissolved, 'Everything's going to change now'.

35 rhums is a film about opening up a circumscribed physical space at the decisive moment so that the protagonists can enter a new, 'other' intersubjective and figurative space and thus become unfamiliar and 'other' to themselves. Already, father and daughter had prepared for this moment with their trip to Lübeck to visit Jo's mother's grave and also meet her white aunt (Ingrid Caven) – a foreign space where they look and feel 'other' (though not completely so, since Jo still enjoys a connection with German culture, having retained the language). Unlike *White Material*, where the frame is brutally closed up, here it is opened out and fully spatialised, allowing for a moment of emotional blossoming and an erotic crossing over to the Other.[10] Although Noé is finally able to express his love for her, Jo instinctively draws away from his kiss. However,

she will eventually make up her own mind about marriage upon discovering his decision to leave unless she declares her hand. Here, no one is the property of the other: everything comes down to mutual love and respect. Lionel does not tell his daughter what to do or allow anyone else to arrange her affairs, and the consistently jilted Gabrielle exerts no influence in the end, though she is still there in the last scene with Lionel and still smiling. Crucially, on the day of the marriage, when Jo arrives at Noé's apartment, the door is closed on the viewer. The marriage ceremony doesn't need to be shown because it is irrelevant to the deeper processes of kinship and community recorded in the film, such as when the middle-aged, Caribbean René silently observes on the RER commuter train a white woman his age returning home from a long day's work: an implicit understanding and empathy is struck beyond the evident differences of race and sex. The message here is quintessential Denis: not only to rise beyond the immediate 'natural' family structure, but also to rise up to the challenge of forging new affective forms of human connectedness and creating other kinds of home (i.e., 'another home'). What Jo achieves with her father is an exemplary negotiation of otherness, between self and other, and self and self, which safeguards and expands trust, friendship and intimacy. It is a moment of modulating and crafting the right degree of otherness: by marrying the 'boy next door', she will also ensure continued close physical and emotional proximity with her father.

What is remarkable about Denis's figuration of the father in *35 rhums* is that it remains so benign and affirmative. If, as Denis often states, desire operates within the realms of death and violence, she would appear here to be feeling her way towards a new artistic territory beyond aggression and subversion by means of the purposeful accommodation of social forms and laws. Jo chooses to work creatively within existing social norms in order to safeguard her love for her father. Such accommodation is experienced here as a measure of autonomy rather than conformism. By deregulating and romancing the Father, and hence assuming the risk of sentimentality, *35 rhums* successfully renegotiates and reinvests familial structures and social prohibitions. Again, all this is possible because of the transformative moment of the male-identified 'Nightshift', suggesting that 'unnatural' kinship represents in Denis the best chance of working through and sublimating the intrinsic violence of sexuality and passion.

The unique status and importance of this moment is increased still further by the fact that the film also represents Denis's personal correction and decisive *shifting* of the 1949 classic *Late Spring* by Yasujiro Ozu, the turning point of which is the uninterrupted, eight-minute performance of a Noh drama, during which the daughter Noriko suddenly becomes aware of her father's apparent interest in an attractive widow and realizes he may not need her after

all. According to Denis, Ozu, a filmmaker with whom she feels a particular 'kinship', offers an ambivalent figuration of the 'familial yet secretive' father that corresponds to the myth of her own grandfather.[11] I have demonstrated elsewhere that if *35 rhums* provides an intensely personal story of authorial respect and transcultural admiration for Ozu under the transgenerational sign of the Father – one that also honours the universal and revelatory aspects of cinema itself – it does so precisely by reconfiguring *Late Spring*, in particular by truncating the 'Nightshift' scene to prevent the risk of unnecessary Ozu-like melodrama.[12] Denis's account of a relationship where neither daughter nor father gives anything up as such directly reverses Ozu's tragedy of enforced separation and emotional confusion based on strict adherence to the patriarchal law and social obligations. Indeed, *35 rhums* begins as if already on the other side of trauma, and beyond questions of morality, passion or recrimination, on track toward a new level of understanding and joyful resignation. Lionel's casual revelation near the end that he may have made up the eponymous drinking legend himself, followed by the last shot of him unpacking another rice cooker (the cooker that Jo had purchased at the start but kept secret due to the potential embarrassment of duplication), suggests a deliberate textual openness that carries faith in the active powers of authorial invention.[13] Denis's grafting of Ozu, working *with* and *through* and ultimately *beyond* the Other, could not be more self-reflexive, the intertextual relays perceptible in every shunting back and forth of the intersecting trains Lionel either drives or observes.

What *35 rhums* brilliantly shows is how, by grafting intertextual others, Denis actually makes the Other representable aesthetically. She works through the opacity of otherness precisely by negotiating it at a formal level as textual matter that can be reframed and potentially resolved. Such investment in intertextual relations – an affective mode of kinship through and across texts – offers a *textual beyond of the Other*, that is to say, beyond the limits of the discourse of the Other, and it gestures towards a new commonality and solidarity beyond difference. Moreover, by grafting for the viewer/listener new, intimate, aesthetic spaces – at once transitional, liminal, hybrid, open – beyond the standard terms and conditions of spectatorial identification, Denis powerfully resists the idea of difference as threat.

The Glare of the Other

I want to return again finally to *White Material*, which, in the light of our discussion, would seem even more tragically self-enclosed and apart within Denis's *oeuvre*. It is a fatal, univocal narrative about power, death and survival, where no time or space exists to trace and enjoy the materiality of matter and human and textual relations. Yet it would be a grave mistake to consider the

film as somehow deficient or 'half-baked' like Maria's wayward son, Manuel, simply because it lacks a starting plug for textual ignition and thus the aesthetic means by which to work in and through otherness by intertextual grafting. Indeed, the underlying assumption here – that the feminine (the all-female collaboration between Denis, Huppert and NDiaye) is essentially the negative to the masculine in Denis's creative method – would be woefully simplistic and off the mark. We would do better surely to view the approach of *White Material* as evidence more of a political *parti pris* than symptom of blocked creativity. For, unlike Maria, while Denis may romanticise herself ironically in interviews as *une fille d'Afrique* (a daughter of Africa), she is far from unaware of the limitations and contradictions of her position as a white European filmmaker working in contemporary Africa (the film was shot, in fact, in one of the African countries where she spent her childhood, Cameroon). From the outset, as in the partly autobiographical *Chocolat*, the narrative is centred on, and nearly always mediated by, its white French protagonist, since, according to Denis, it would be presumptuous to attempt otherwise. Moreover, in both films she deliberately avoids what she calls the 'compassionate' clichés of all blacks as victims (2010a: 21). Yet what makes *White Material* so different from *Chocolat* is precisely that its ambiguous 'flashbacks' do not transport us back to the well-defined issues of the colonial era but rather force us to engage with the contingent here and now. The intertextual void in the film is no doubt a response – perhaps the only one possible – to a specific contemporary context: an independent African state in a period of violent transition confronting the enormity of child abduction by rebel movements and where the opportunities for education are literally cut dead. Of little or no currency here are the type of fluid textual networks and intersecting lines of cultural reference that can be immediately accessed and elaborated upon, for instance, in the comfortable black Parisian milieu of *35 rhums* or even in the exceptional case of the Foreign Legion in *Beau Travail*, a film where the voice-over narrator is, after all, positioned 'back home' in Marseilles.

Focused entirely on the accrued symbolic weight of Black versus White and the power relations of Us versus Them, there can be little possibility in *White Material* of working through the 'Otherness' of the world and grafting it intertextually. Like the darting animals caught in the headlights of the car at the start, the film is trapped within – yet is also rigorously faithful to – the unrelenting glare and shock of the Other. There is no beyond to the Other here; that is to say, there is no beyond of the frame except the spectacle of more fear and violence. The foreignness of the external world remains absolute and non-negotiable. In one of the film's highly self-conscious and explicit warnings about the Other as the foreigner within, the soldier who questions Maria at the start declares, 'It's because of [white] people like you that this country is

filthy' (compare this with the African housekeeper Lucie's defiant retort to the abusive Manuel: 'This is not your home. The patriots will kill you'). The white man will always be regarded as 'white material' because of the colonial legacy; years of influence cannot simply be wished away and washed clean. Indeed, it is made abundantly clear that the inevitable outcome of all-out civil war is part of the inglorious legacy of colonialism and its reiterations through different degrees of neo-colonialism with new elites and new militias. Towards the end, when the corrupt and power-hungry Mayor Chérif drives Maria 'home' to her plantation, he declares that blue eyes are trouble and that extreme blondness brings bad luck and cries out to be pillaged. Interracial desire thus emerges as an irreducible metaphor for irreconcilability, and it is entirely symptomatic that the mixed-race child, José, born of André's relationship with Lucie (who herself leaves to join the rebels after being cruelly humiliated by Manuel), makes a resolute decision to sabotage the white plantation from within by cutting the electric cables.

In short, post-colonial black African society cannot be easily transumed aesthetically or opened up culturally, and no textual blurring of borders is realistically possible. Even the model of diaspora is not really appropriate here, since, in Denis's definition, it would seem to presuppose a European perspective. *White Material* will thus remain a realistic – and unflinching – study of ideological, political and economic 'material' or production in the post-colonial era. It is as if to convey accurately the current state of black Africa required a certain authorial sacrifice, or at least major self-re-evaluation on the part of a white filmmaker. The Martinican-born psychoanalyst and revolutionary theorist Frantz Fanon is never cited directly in the film, as he is rather gratuitously in *35 rhums* during the sequence at Jo's university seminar, which includes a strangely stilted discussion on the North–South divide, Third World debt and Joseph Stiglitz. Yet Fanon's lucid thinking is implicit in every frame, specifically his idea that the perverted psychology of colonial (and neo-colonial) relations is the result of a unique context, the colonial system in Africa, which cannot be equated with other forms of oppression. In the penultimate chapter of *Black Skin, White Masks* (1952), which addresses the impossibility for French blacks to gain genuine recognition from whites without radical struggle, Fanon suggests that Hegel's model of the master–slave relationship is ultimately irrelevant to a proper understanding of the colonial system, which is based on racism and not just European-style feudalism and class hierarchy. Whereas for Hegel there will always remain a basis for reciprocity through a mutual sense of independent self-consciousness and human value, 'here [in the colonial system] the master laughs at the consciousness of the slave. What he wants from the slave is not recognition but work' (Fanon 1952: 179n). Put a little differently, in Hegel the slave finds in the object (i.e., work) a possible source of liberation;

in colonialism, however, the black wants so much to be like the master (and possess, we might say, 'white material') that he soon abandons the object. For Fanon, there can be no *beyond* of the Other in the colonial system. Indeed, in his later work, *The Wretched of the Earth* (1962), written during the Algerian War, Fanon insists that national and revolutionary violence is the only way to transform the colonized from 'things' to 'men' and so create the desired new forms of collective being and kinship. On the strength of *White Material*, Denis would seem to be arguing that nothing has fundamentally changed.

In the final analysis, *White Material* should be viewed, I think, as an impressively honest and uncompromising film by Denis that works against her own natural authorial inclinations and bravely acknowledges the limits of her textual practice – limits that reflect perhaps the position of any white intellectual working within the contemporary black African context. Recognizing the continuing legacy of exploitation, where all is symbolically charged and comes down to either white or black, she has defiantly disregarded, like Maria at the start of the film, her standard safety kit. The film's apparent aesthetic 'weakness' (its lack of an intertextual framework and failure to surpass the cinematic and ideological frame of the Other) is perhaps paradoxically the very sign of its political strength. For this reason, *White Material* works with – rather than against – *35 rhums*. Denis herself proposes a kind of dialogue between the two films such that they balance each other out. Following the lines of our discussion, we might formalise such complementarity not just in terms of extremes (i.e., between one intertextually bereft film and another intertextually replete) but rather as itself a creative *kinship* between texts that extends Denis's general project of relationality. Together they help us, like all of Denis's work, to conceive how the very boundaries and barriers of human proximity might be positively remapped, pointing the way towards potential new spaces for social/cultural intimacy and the grounds for common mutuality.

Notes

1 For Lacan, of course, it is as if the foreclosure of the Name-of-the-Father made present in the Real a malevolent authority desiring to commit a crime or inflict damage (sexual abuse, homicide, etc.).

2 Compare this level of non-engagement with Lessing's novel, where the heroine turns to her black cook, Moses, for kindness and understanding, to that already undertaken in *Chocolat*. For Azalbert (2010), the links between *Chocolat* and *White Material* around Lessing and de Bankolé create a vertiginous fascination and spiral *mise en abyme*.

3 Denis concedes there is something Conradian about the way Huppert's character refuses to give up 'even after it's too late' (though she finds Conrad's novels 'too much of a man's world') and also something akin to Faulkner due to 'the way he deals with territory, with the farm' (2010b).

4 In one interview, Denis refers to a television news item she saw about the French army rescuing White farmers from Ivory Coast, including one lonely old man who refused to leave (2010c). NDiaye herself says of the experience of working with Denis that it was a genuine process of co-writing. See NDiaye 2010.

5 Huppert plays the colonial mother in Rithy Panh's 2008 adaptation of Marguerite Duras's novel *The Sea Wall* (1950).

6 Shot in the same Polynesian region as *L'Intrus* and based on Robert Louis Stevenson's adventure story *The Ebb-Tide*, *Le Reflux* was given an ending where Subor explains in a voice-over recording that his character fell in love with a Polynesian woman but decided not to stay because he felt a 'doomed man'.

7 For a fine account of the relations between Nancy's text and Denis's film as a narrative of sacrifice and resurrection with Christian undertones, see Morrey 2008, McMahon 2008a and McMahon 2008b.

8 The turning point in *Vendredi soir*, when it literally changes gear and Jean takes over the wheel from Laure, occurs when the prevailing quiet, sombre, unison strings in Britten's *The Bitter Withy* (Opus 90) are superseded and transformed as the car surges forward to the pounding modernist chords and rapid strings of Shostakovich's string quartet *Chamber Symphony Opus 110a*.

9 Asibong has addressed the problematic aspects of Denis's obsessive flirtation with moments of apparently post-colonial transcendence in *White Material*. He argues convincingly that Maria, 'the archetypal Claire Denis fantasist...longs to dwell in the space of an African–European cradle in which she could be both mother and infant...[Maria] wishes simply to dissolve the struggle at the heart of the hostile neo-colonial space within which she finds herself' (2011: 161–2).

10 In her commentary with Denis on the French DVD, Agnès Godard presents the moment of the dance as akin to alchemy, since it is a highly charged and loaded shot that has the force of real time while incorporating fragments of the past and 'the future in the process of becoming'.

11 Denis has presented the film explicitly as 'a variation on the theme of my grandfather while thinking of Ozu'.

12 See Williams 2009–10, which includes analysis of composition, *mise en scène* and framing.

13 Another inter-textual in-joke is created when René (played by Julieth Mars-Toussaint) hands back to Lionel a book that is just visible as Fritz Zorn's *Mars* (1976), an autobiographical essay about being diagnosed with cancer and feeling a social misfit, depressed and alone.

12 Still from *White Material*

Part III
Global Citizenship

7

Beyond Post-Colonialism? From *Chocolat* to *White Material*

Cornelia Ruhe

Claire Denis's first feature film, *Chocolat* (1988), set in colonial Cameroon, is a reflection on colonialism and its effects on personal relations. With *White Material* (2009), filmed 20 years and 12 films later, Denis literally returns to Africa and to questions of (post-)colonialism that are central to many of her films. The critics writing about the more recent film have thus naturally pointed to the parallel, while Denis herself sees it as a mere coincidence (Ratner 2010: 37). It is another, albeit interesting, coincidence that post-colonialism as an academic term was coined in the very same year that *Chocolat* was released in festivals and cinemas across Europe,[1] whereas *White Material* is usually discussed as clearly addressing post-colonial issues. While Denis's focus in her first film can thus be said to have been post-colonial *avant la lettre*, both movies embrace the rise of the term through its formalisation as an academic discipline, and shed an interesting light on the changes not only of times but also of scientific thinking about First and Third World relations.

Although *White Material* seems to be the post-colonial response to *Chocolat* – proof that the debate about the politics of race and belonging is still ongoing – it can also be read as the rising of new identities that go beyond simple racial ascriptions. The main character of *White Material*, Maria Vial, is a white coffee farmer in post-colonial Africa who refuses to leave the land she feels is rightly hers in spite of an oncoming army of rebels. Whereas France, the aptly named protagonist of Claire Denis's first film, is obviously in search of an identity that she senses she has lost (or never had) somewhere between France and Cameroon, Maria Vial is resolute in her sense of belonging – she sees herself as part of the land she owns, no matter what colour her skin might be.

In this chapter, I will argue that both films centre around questions of race and belonging in ways that academic post-colonialism often fails to address. *White Material* is, as I will show, a more pointed continuation of *Chocolat*, not only acknowledging the historical evolution that has taken place since, but also emphasizing aspects that had hitherto been overlooked.

Denis's co-author for *White Material* is the renowned French novelist Marie NDiaye. NDiaye grew up in suburban France with her mother and brother, while her Senegalese father left the family shortly after her birth. Her texts – 12 novels and six plays up to now – trigger questions of identity and race in a subtle but insistent way. Her novel *Trois Femmes Puissantes* (2009) is her first text set mostly in Africa, a continent whose culture means nothing to NDiaye, who sees herself as '100 per cent Française' (Raya 2009: 14). Setting parts of the novel in Africa is, as the author herself put it, more of a 'musical theme', but it could much more easily be interpreted as a carefully set trap for the critics, who, for the most part, have chosen to get caught up in it and to interpret it as the late acknowledgment of her indebtedness to Africa, awarding NDiaye the prestigious Prix Goncourt for the novel that happens to be the least typical example of her talent.

What may be seen as a return to her roots for Claire Denis, who grew up in colonial Cameroon, is the exploration of a territory that NDiaye has always been linked to by virtue of her skin colour, despite the land being virtually unknown to her. The necessity to transcend colonial practice both on a personal and an aesthetic level is a central issue to the filmmaker Denis and to the author NDiaye. Their collaboration makes *White Material* a poignant statement that goes beyond the established scope of post-colonialism.

Like Maria Vial, the protagonists of NDiaye's novels and plays would like to feel at home in their country and in their respective bodies, but the often hostile gaze of others does not allow them to put the question of belonging to rest. As for the characters of Denis's first and (at time of writing) latest films, their identities are not so much marked by post-colonialism as are their bodies, which seem to utter a truth that they themselves would never dream of expressing – were it not for the others.

Transcending Models

A considerable amount of critical writing exists on the subject of *Chocolat*, nearly always focusing on questions of colonialism, nostalgia and the expression of female desire. Nevertheless, some aspects have hardly been touched upon, though they might lend interesting insight not only into the movie itself but also to its relation to Denis's later film *White Material*.[2] In this chapter, I would like to argue that Claire Denis's two films challenge the problematic equation

between colonizer and colonized and put the dichotomic and somewhat easy representations of the colonial and post-colonial world under a microscope.

Claire Denis never made a secret of the texts that influenced her while writing the screenplay for *Chocolat*: Doris Lessing's first novel *The Grass Is Singing* (1950) and *Une Vie de Boy* (1956) by the Cameroonian author Ferdinand Oyono. Interestingly enough, many critics mention them in passing, but there is no closer examination of the intertextual relation the film bears to the two novels.[3]

Une Vie de Boy is the bleak account of the humiliating life of Toundi, a mission boy working in the house of a French commander. The commander's wife cheats on her husband with another French government official. When the truth about that the affair comes to light, Toundi, having witnessed the affair, becomes a *persona non grata*, for his presence keeps reminding the commander of his wife's infidelity. Toundi is accused of theft and is beaten so badly by the local police that he dies from his injuries after having escaped over the border to Spanish Guinea. The interest of this short novel lies in the reversal of roles that it shows — although their intimacy seems to be far better protected than that of their domestics, the colonizers are subject to the constant gaze of many onlookers, and their every move is noticed. Their staff knows everything about their lives, habits and morals, and their most intimate secrets are discussed and judged without them being able to prohibit it despite the colonial power relations.

Denis stages the same situation in *Chocolat* and the visualisation makes it all the more tangible: Aimée, her husband and their guests are literally framed by their domestic staff; Denis's camera shows them and little France as spectators of their masters' lives. Unlike Oyono's novel, which is largely concerned with the racist and petty morals of a small African town, what Denis emphasizes is the artificiality of the colonial situation — the house is a stage on which the tragicomedy of colonialism is playing out its last act, faithfully watched and commented upon by the colonized. Aimée's attempts to keep up the facade of mimicking French social life are shown to be nothing more than the impersonation of a script inadequate to represent the reality of Africa.

Also set in the 1950s, Lessing's novel depicts the Turners, a couple who are trying to run a farm in Rhodesia. Having no farming skills or experience, Dick and Mary live in poverty, which makes their lives little better than those of the natives they are exploiting; Mary quietly loses her mind over their lonely existence. Moses, their black houseboy, gains power over her because he understands her utter destitution and sees her pain and her weaknesses. When he realizes that the Turners are about to leave him and the farm, he kills Mary. The novel is a bleak analysis of the consequences of the colour bar and has often been interpreted as a political allegory of colonialism.

Lessing's novel is alluded to subtly in Denis's film when Aimée tells her English visitor that the former (German) owner of their house was killed by

his black houseboy. However, the relationship between Aimée and Protée is different from that of Mary and Moses in that it is not only one of power, but first and foremost one of unfulfilled mutual desire. Mary's desire is so unthinkable, the colour bar so absolute, that she can express it only through her dreams. She fears it – and him – so much that she can finally free herself from Moses's influence only with the help of an intermediary. A transgression of the racial limits is deemed impossible by all the protagonists, and it is in uttering its imperative refusal that Lessing allows her readers to think the unthinkable.[4]

More than a generation later, interracial relations have evolved only slightly. While in a reversal of the colonial relations, Moses gains power over Mary by invading the little privacy she has, in *Chocolat*, Denis puts Protée in similar situations but has him silently rebuke the closeness that Aimée forces upon him.[5] Denis is careful to translate the upcoming movement of independence into a failing love affair: it is not so much France but her mother, Aimée, who stands for the mother country; Denis drafts her as a rather indolent character, whose only active move will be to silently offer herself to Protée, immediately assuming the passive role again. Protée refuses Aimée's sexual advances, literally putting her in her rightful place. (In an inversion of the situation depicted by Lessing, it is no longer the colonizer but instead the colonized subject who refuses the unwanted intimacy, who refuses to be further objectified and thus assumes an active, self-conscious role.)

Denis subtly introduces a comment on the colour bar that gives the film's main theme analytical depth: Luc, a rather ambiguous character, reads a text to Aimée that some critics take to be her husband's diary.[6] It is, however, not his text, but the account that Curt von Morgen, a German traveller in Cameroon, gave of the country in 1893:

> Au milieu des visages africains d'un noir bronzé, la couleur blanche de la peau évoque décidément quelque chose de pareil à la mort. Moi même, en 1891, après n'avoir vu pendant des mois que des gens de couleur, j'aperçus à nouveau, près de la Bénoué les premiers Européens. Je trouvais la peau blanche anti-naturelle à côté de la plénitude savoureuse de la noire. Peut-on alors blâmer les sauvages autochtones de prendre l'homme blanc comme quelque chose de contre nature ou une créature surnaturelle ou démoniaque? (01:11:00).[7]

What appears to be an absolute distinction develops into relativism, and this is not the progressive opinion of a post-colonial mind but rather the idea of a nineteenth-century explorer who does not have the general reputation of a liberal. At an intradiegetic level, this may serve as an explanation for Aimée's behaviour, for, like von Morgen, she has lived among the natives of Cameroon long enough to be able to see their beauty and therefore develop a sexual interest

in Protée. What is deemed impossible by Lessing's protagonists is possible for those of Denis, and this is authenticated by von Morgen's statement, which serves to sanction Aimée's decision.

In one of the film's crucial scenes, Marc, Aimée's husband and France's father, comments upon the elusive nature of the colour bar in a metaphorical way. Just after Protée's refusal of Aimée's advances, we see a visibly preoccupied Marc at France's bedside, explaining to her what the horizon is:

> ...quand la terre touche le ciel, exactement, c'est l'horizon....Plus tu t'approches de cette ligne, plus elle s'éloigne. Si tu marches vers elle, elle s'éloigne. Elle te fuit....Tu vois cette ligne. Tu la vois, elle n'existe pas (01:26:45).[8]

There are two ways to interpret this statement. The fact that the scene immediately follows Aimée's and Protée's encounter implies that the horizon serves as a metaphor for the impossibility of a real connection between Africans and Europeans. In the felicitous words of Adam Muller: 'The horizon, after all, and particularly as Marc explains it, is the site at which the land and the air reconcile; it is a site in principle only, remaining forever unreachable, lying at the very limit of our ability to perceive it' (2006: 746). As with land and air, a reconciliation of (ex-)colonizer and (ex-)colonized is conceivable only on a theoretical level.

In my opinion, however, there is still another interpretation that takes into account the film's contemporary framework. The horizon, as Marc explains it, is an optical illusion that pretends to be a (geographical) reality. The encounter between the adult France and William 'Mungo' Park, the man who offers her a ride in his car, shows that the notion of race linked to ideas of culture and national belonging is itself an illusion. What France sees in Mungo is an illusion based on the colour of his skin, just as his reaction to France ones much to the same delusion. What they believe they have seen serves as a characterization that does not match the actual person. It is, in my opinion, not the impossibility of a union between Europe and Africa that the metaphor of the horizon stands for, but rather the elusive nature of race and identity itself.

Broken Lines

The filming of the colonial past in *Chocolat* is framed by a contemporary setting, in which the now grown-up France, whose name is a reference to the mother country that remains unknown to her during her childhood, has come back to Cameroon to look for her childhood home. Denis has pointed out that, when preparing the film, she was told to abandon this frame;[9] the fact that she kept

it thus indicates the importance of the framework for the understanding of the film as a whole. The opening scene of *Chocolat* – where we see the man later identified as William 'Mungo' Park and Sawa, his approximately eight-year-old son, both black, bathing in the ocean – has already been much commented upon. Oddly enough, an important aspect seems to have been overlooked in all these readings: after having jumped around in the water, both father and son lie on the sand, in the breakers. We see a close-up of a hand, presumably the boy's. The water washes away, and we get a clear vision of the lines on his palm (00:02:58).

This scene corresponds to another one at the end of the film's intradiegetic narration: Protée, the black servant who is young France's companion, has already been banned from the house for having refused the sexual advances of her mother, Aimée. He now works in the garage where France comes to find him. She asks him if an iron tube belonging to the generator he is working on is hot, and he indicates that it is not by putting his hand on it. She follows his example and immediately draws back her hand in pain – the tube is red hot, and she has scarred her hand for life (01:32:45). Both move away from the tube and from each other silently before Protée walks away into the darkness of the night.

This scene, which has rightly been seen as one of the film's crucial moments, is often misinterpreted. In E. Ann Kaplan's (1997) opinion, Protée punishes France 'for being part of colonialism';[10] Janice Morgan thinks that 'he is deliberately breaking the tie of friendship and trust between them' (2003: 150). For France, who was born and raised in Cameroon, Africa had been her home up to that moment. She even takes it for granted that they will eventually be buried there, a remark her mother fails even to understand. It is thus appropriate to read the scene as the painful realization of her non-belonging, the beginning of what could be termed her 'diasporic identity' (Sandars 2001: 17). However, it is important to note that the scar is inflicted not only on France, but also on Protée himself. From that point on, they share a scar that, on the one hand, marks the impossibility of a real and durable union between the two of them but, on the other, creates a lifelong bond between them that lasts longer than the relationship they actually had. The scar shows both their identities as marked by the experience of colonialism. Despite colonial policy, although they are profoundly influenced by it, France and Protée are united far beyond familial attachments or racial ties by a mutual understanding transgressing the laws of the colour bar. The loss of innocence in the relationship between Aimée and Protée, as well as in that of Protée and France, does, however, impede the further development of these promising bonds.

The scene's symbolism is further developed within the contemporary frame of the film. France is given a lift by William 'Mungo' Park, the man from

the opening scene, who offers to read her hand. His reaction to her scarred palm is telling: 'Elle est drôle, ta main. On ne voit rien, no past, no future' (01:39:06).[11] On a symbolic scale, this can be interpreted as a clear statement regarding France's – the country's as well as the protagonist's – relation to the ex-colonies, to Africa and to the Africans: their shared (and violent) past has been ended in an act of violence that has scarred both sides of the conflict. There is no room for France in Cameroon, no common future for the two of them – Mungo turns down France's offer to go for a drink just as Protée had rejected her mother.

What must be kept in mind, however, is the fact that the scar is shared – that it marks both France and Protée. Both of their lifelines are burnt, leaving their palms a blank that resists interpretation. Nobody can know what the future holds for them, neither together nor individually. Protée's name, however, at least points to a possible solution for him: he is protean, he can change his shape. While France's name suggests that she will remain as monolithic as her mother country, he is adaptable and can learn to conform to new, post-colonial situations.[12]

The density of the scene, however, has not yet been exhausted: William 'Mungo' Park,[13] the black man who gives the grown-up France a lift and is unable to read her hand, is revealed to be other than what the viewer expected – instead of being a Cameroon native, he turns out to be a black American who has come to Cameroon because he thought that, as an African-American, this would be his home. But what he believed to be a brotherhood of Africans, whether born in America or Africa, turned out to be an idealized fabrication. Even after several years in Cameroon he feels that dying there would make him disappear completely.

Post-colonialism as a theoretical paradigm expresses the idea of hybridization, of hybrid people, trapped between one or more cultures, confronted with problems of alienation and non-belonging. Created before the actual constitution of the post-colonial toolbox, *Chocolat* gives a somewhat less optimistic response to those issues. The lifelines that Protée takes away from both himself and the young France can be seen as the literal, bodily expression of the roots one has in a place and culture. Thus, France and Protée are virtually cut off from these roots, and the environment they grow up in alienates them both from their culture and from the place to which they feel they belong in a simplistic perspective of the world. They've been forced (or allowed?) to step beyond the simple assignation of race, nation and culture. This experience enriches their lives, but at the same time burdens them with feelings of alienation and displacement. Hybrid beings they may be, but they are not allowed to savour the riches of their double identity, to find a third space where they will be allowed to live up to their hybridity. On the contrary, France is always depicted in transitory

spaces – on the road, at the bus station and, finally, at the airport. Moreover, there is no lasting bond between the different diasporic identities – France and Protée, Aimée and Protée, France and Mungo all end up observing the rules of the colour bar, be it colonial or post-colonial. Only the following generation, represented in Sawa, the son Mungo has with his Cameroonian ex-wife, has again grown roots strong enough to free him from the problematic hybridity of his parents' generation; as shown in the first sequence, Sawa's palm lines are strong and clear.

However, the final images of the film seem to offer a way out – not for France, whose fate as a displaced and alienated victim of colonialism is set, but instead for post-colonial Africa or at least for Cameroon. In the last sequence, France watches three men working on a conveyor belt that takes the luggage into the plane, presumably the one that will take her back to France. What they very carefully load onto the plane are the different parts of a large indigenous artefact. The country's riches, its history, one could interpret, are being taken away in another neo-colonial gesture. But maybe this interpretation misses the point; a new, modern Africa is emerging, one that does not wish to be seen just as a source for handicraft that may serve to enlarge the collection of European museums. Once needed to form the old, largely Eurocentric image of an ethnologically interesting Africa, these artefacts have now become obsolete. There are new images to come.

Colonialism, Capitalism and Coffee

At first sight, France and Mungo are unable to really see whom they have met: he believes her to be a tourist, and she thinks that he is a native of Cameroon. Their respective colours still define the way they perceive and are perceived. France's and William's stories intersect, as do, years later, the stories of Claire Denis and Marie NDiaye – while one of them shares a common history with Africa, having lived there and therefore feeling part of it, the other is a stranger. In our post-colonial times, however, this is not a question of race anymore; it is due to the coincidences not so much of history but of very personal stories.

The collaboration between Claire Denis and Marie NDiaye does not, at first, seem an ideal match. Denis is a filmmaker who does not shy away from academic discussions, who teaches at the European Film Academy and who, through friendships with contemporary philosophers such as Jean-Luc Nancy, is well aware of ongoing debates. NDiaye is, on the contrary, a rather secluded author who shies away from academic contexts in which she says she does not feel at home; even in interviews, she is rather reserved.

However, as has already been hinted at, both share a common interest in questions of race, belonging and displacement. As a novelist, NDiaye chooses

never to spell out her subjects explicitly, and her novels and plays are not hyper-realistic accounts of France's shortcomings concerning racial policy but rather enigmatic, haunting accounts of troubled identities. The step into filmmaking is thus a new experience for her and her readers, and her aesthetic reserve, the allusions the reader is asked to grasp and the blanks to be filled, while already making her texts unwieldy, would appear even more intriguing when brought to the screen.

The work of both author and filmmaker shows that the advent of post-colonialism and the widespread discussion about its key concepts have not necessarily led to the global acceptance of these issues, neither on an aesthetic level nor in life. Both women challenge notions of hybridity or third space, which might work well in theory but are hard to live with on a daily basis. Denis and NDiaye tackle post-colonialism by basing their novels, plays and films in real spaces, in real histories, thus showing the shortcomings of the theoretical paradigms. On an aesthetic level, their texts and films do not follow the well-trodden path of identity narratives but rather choose to question it by undermining it subtly.

Together with NDiaye as her co-author, Denis takes up the subject begun in *Chocolat* and further elaborates on it in *White Material*. It is as if we see France, the protagonist of her first movie, reborn in Maria Vial, but a France who has never left Africa and thus has never had the experience of displacement. Maria feels that Africa is her home and the home of her family. She does not question the fact that this is the place where she rightly belongs. The Africans she deals with, though, show her that they view her differently, that they see her as an intruder, as *la blanche* (01:28:30).[14] Yet again, what NDiaye and Denis stage here is another political allegory; not, this time, one of colonialism but of the political ideology that has always been associated with it and which, in many African countries, has come to replace it in the public imagination – capitalism.

It is no accident that Maria, her husband and her father-in-law are coffee farmers, with coffee being one of the main products of colonial exploitation. Next to sugar and cocoa (from which chocolate is made, incidentally), it is coffee that is usually held accountable for the rapid development of the slave trade.[15] As a 'cash crop', it was introduced to many regions of Africa – including, for example, to the grasslands of Cameroon – but its cultivation was restricted to a lucky few: 'It was the aim of the colonial administration that coffee cultivation should be left in the hands of a small "elite," made up for the most part of European settlers, African chiefs, and notables' (Mbapndah 1994: 43). Since the end of colonialism, many Africans have started or continued to cultivate coffee; however, instead of depending on the colonial administration, they now depend on capitalist patterns or, at best, on the laws of the 'fair trade' businesses.

Maria and her family thus continue a business that has its roots in structures of colonialism, inequality and oppression, and the way Maria employs and treats her personnel speaks volumes about it. Though her comments about the farm she runs, but does not own, are a rational, approach of her situation they can also be interpreted as a metaphor for the whole country, presumably for many African countries: 'Rien n'est à moi, mais c'est moi qui dirige' (00:43:59).[16] Although the colonial empires lost their territorial power over Africa long ago, their leading role in the world economy is still strong enough to pull the strings.

What Maria clings to, despite the raging civil war surrounding her, is the country she feels at home in: 'Je ne pourrais plus m'habituer à un autre endroit' (01:14:42),[17] even though this very country does not welcome her and threatens her with imminent death. As with the passengers on the bus that she manages to catch on the way 'home' to her farm, the country as a whole ostracizes her leaving her desperately clinging on to the exterior. Compared to her antecedent Aimée in *Chocolat*, she is a very active and resolute person, yet her frantic activity cannot change the fact that she will have to leave.

Denis and NDiaye give a grim account of an Africa whose modes of acceptance are still based on racial terms. Not being black accounts for Maria's and her family's dismissal, a displacement that can be seen as a late revenge taken out not on the colonialists themselves but on their legal and ideological successors. As the young black official puts it at the end of *White Material*, speaking of Maria's son Manuel:

> L'extrême blondeur attire une forme de valeur, c'est quelque chose qu'on désire saccager. Les yeux bleus sont gênants. C'est pourtant son pays, il est né ici, mais le pays ne l'aime pas (01:34:43).[18]

Yet again, the crop that Maria and her family have been growing sheds an interesting light on the question of identity. The harvesting and manufacturing of the coffee is shown at great length in *White Material* – a process in which the bean is turned from a greenish white into a dark, brownish black. What may work for the crop does not, however, for the skin tone of a human being. Manuel, Maria's son, who has been visibly struggling with his blurred identity, ultimately shaving off his fair hair and then joining the rebellious troops, is burned alive in the coffee factory, which is now diligently guarded by the government soldiers. His corpse, burned beyond recognition, is now, in a cynical comment on the issue of race, undeniably black, a state that was inaccessible to him in life. In her utter despair, Maria turns against her father-in-law, who, with his African affiliations and properties, seems to be the author of all of these alienated, unhappy identities.

While *Chocolat* can be seen as an account of identities broken and displaced as a result of colonialism, *White Material* takes up the subject more than 20 years later to explore it in much bleaker tones. To France and William 'Mungo' Park, third spaces that would allow their hybrid identities to develop freely do not exist, but they still have the possibility of returning to a motherland – the United States or France – that would welcome them. For Maria and her family, France does not seem an option anymore; instead, it is considered an exile that would not allow them the same individual freedom that Africa has. Yet again, and in spite of Maria's presumably strong palm lines, there seems to be no past, no future – and no present. The post-colonial world seems to have become an even more hostile place.

Notes

1 The discipline of post-colonial studies is generally considered to have started a good twenty years ago, with the publication in 1989 of Bill Ashcroft, Gareth Griffith and Helen Tiffin's *The Empire Writes Back. Theory and Practice in Post-Colonial Literatures*, which quickly became the standard work of reference. The title alludes to Salman Rushdie's epigraph, '... the Empire writes back to the Centre...', Rushdie, Salman, 'The Empire Writes Back with a Vengeance', *The New York Times* (3 July 1982): 8.

2 Although *Chocolat* came out as early as 1988, most of the critical writing devoted to the film has been published since the year 2000. It seems that especially those film critics interested in questions of colonialism and post-colonialism rediscovered it as an early example of a film concerned with these issues. However, in reading the film along those lines, many interpretations get caught up in the same dichotomic views that they mean to criticize, making both the colonizer and the colonized a monolithic block that allows for no individual position within this fixed framework. It is significant that nostalgia comes to be a key term for at least three of the articles written about *Chocolat*, and it is even more significant that what they mean by nostalgia is the longing for the lost Africa of the protagonist's youth, which is strongly reprehended by the critics as a neo-colonial attitude. The fact that the African countryside and the male protagonist, both undeniably beautiful, are shown to be beautiful by Denis's camera is not assigned to the artistic mastery of the filmmaker but denounced as unduly Orientalistic representations that 'diminish... the historical value of *Chocolat*' (Watson, 'Beholding the colonial past in Claire Denis's *Chocolat*', in V. Bickford-Smith (ed), *Black and White in Colour: African History on Screen* (Oxford, 2007), p. 188). Alison Murray goes a step further, stating, 'It is possible to conclude that all three films [*Indochine, Outremer* and *Chocolat*] aestheticise the colonial past without giving it serious critical consideration' ('Women, nostalgia, memory: *Chocolat, Outremer*, and *Indochine*', *Research in African Literature* xxxiii/2 (2002): 241). Apart from the fact that it is at least questionable to look for historic truth in a feature film (or to deny beauty any critical potential), it is as if these critics had willfully overlooked the careful

framework of the film that marks its intradiegetic narration as a childhood record and thus as a very personal recollection.

3. Ruth Watson is the only one to take a closer look at the two novels; the conclusions she draws are, however, somewhat unsatisfying inasmuch as they focus largely on the question of realism, making Lessing's novel 'a more sophisticated depiction of the tension in the colonial household' ('Beholding the colonial past', p. 198).

4. The possibility of unions between white women and black men is alluded to by Lessing, only to be refuted vehemently: '[Tony] had met a doctor on the boat coming out, with years of experience in a country district, who had told him he would be surprised to know the number of white women who had relations with black men. Tony felt at the time that he would be surprised; he felt it would be rather like having a relation with an animal, in spite of his "progressiveness"' (*The Grass Is Singing* (London: Harper Collins, 1950/2007), p. 186).

5. Denis relies on Lessing's novel to depict this conflict, restaging the dressing scene (*The Grass*, p. 186; *Chocolat*, 00:36:12) and the shower sequence (*The Grass*, p. 143, Denis: 00:45:54).

6. Durham, Carolyn, 'More than meets the eye: Meandering metaphor in Claire Denis's *Chocolat*', in E. Rueschmann (ed), *Moving Pictures, Migrating Identities* (Jackson: University Press of Mississippi, 2003), p. 133; and Philibert, Céline, 'From betrayal to inclusion: The work of the white woman's gaze in Claire Denis's *Chocolat*', in S. Najmi and R. Srikanth (eds), *White Women in Racialized Spaces: Imaginative Transformation and Ethical Action in Literature* (Albany: State University of New York, 2002), p. 214. Homler rightly identifies the text as 'the travel diaries of a white explorer', without citing von Morgen's name. His analysis of the ensuing scene is quite accurate: 'Protée approaches and a pained silence ensues, for the intractable difference of race is objectified as if it had no real effect on the interpersonal relations of those whose lives center around the commandant's house' ('Love child: Mimesis and paternity in Claire Denis's *Chocolat*', in A. Tcheuyap (ed), *Cinema and Social Discourse in Cameroon* (Bayreuth: Bayreuth African Studies, 2005), p. 316.

7. 'Amidst bronzed black African faces the white skin colour evokes something akin to death. In 1891, I, myself, having seen only coloured people for months, once again saw Europeans near the Benoué. I found the white skin unnatural next to the fullness of black skin. Then why blame the natives for considering the white man as something contrary to nature as a supernatural or fiendish creature?' The original German version can be found in Curt von Morgen: *Durch Kamerun von Süd nach Nord. Reisen und Forschungen im Hinterlande, 1889-1891*. Leipzig: F. A. Brockhaus, 1893, p. 114.

8. '…where the earth touches the sky that's the horizon.… The closer you get to that line, the farther it moves. If you walk towards it, it moves away. It flees from you.… You see the line. You see it, but it doesn't exist'.

9. Quoted in Durham: 'More than meets the eye', p. 125.

10. Kaplan, E. Ann, '"Can one know the other?" The ambivalence of post-colonialism, in *Chocolat*, *Warrior Marks* and *Mississippi Masala*' (London, Routledge, 1997a), p. 162. For Robin Wood, it is a punishment, because France 'embodies the

oppression under which he has lived' ('Claire Denis and Nadine Gordimer', *Film International* ii–iii (2004), pp. 8–13).
11 'Your palm is strange. Can't see anything, no past, no future'.
12 William 'Mungo' Park can be identified as a new version of Protée, who, by virtue of his name, is able to foretell the future. Greek mythology has it that Proteus changes his shape to avoid having to do so, and it can be seen as a twist on his ancient name that it is only the contemporary version of Protée who is finally willing to give a glimpse of the future.
13 Carolyn Durham points out that the name Denis chose for her protagonist makes him a distant relative of the Scottish explorer whose writings about Africa established a model for sentimental writing about the continent ('More than meets the eye', p. 126).
14 'The White woman'.
15 See Wild, Anthony, *Coffee. A Dark History* (New York: W. W. Norton & Company, 2005); Pendergrast, Mark, *Uncommon Grounds. The History of Coffee and How It Transformed Our World* (New York: Basic Books, 2010).
16 'Nothing's mine, but I'm in charge'.
17 'I could no longer get used to anywhere else'.
18 'There is a value put on extreme blondness. It cries out to be pillaged. Blue eyes are troublesome. This is his country. He was born here. But it doesn't like him'.

13 Still from *Chocolat*

14 Still from *White Material*

8

Trouble Every Day: The Neo-Colonialists Bite Back

Florence Martin

For starters, let's look at a rave review of the film *Trouble Every Day* when it was released in France in 2001:

> A carnal filmmaker, Claire Denis takes one more decisive step in her exploration of the body, towards a sophisticated vision of the organic. Everyday sexuality no longer suffices for the lovers of *Trouble Everyday*, and the intensity of their love now goes through the inside of the Other, the taste of his or her blood and innards. That leaves us with two sublime takes of graphic horror, in which coitus becomes an act of unprecedented savagery, in which victims scream out their pain and agony while the executioners savour new taste and tactile sensations (e.g., slide one's finger beneath the skin of one's partner, feel his/her nerves and muscles).[1]

I'll spare you the details of the numerous negative reviews that were bound to pop up – it is easy to imagine how a film by Claire Denis that ties sex and mortal bites, that deals with both cannibalism and vampirism, could be greeted with reactions ranging from the most stunned form of surprise to plain rejection. In short, the film does not leave viewers and/or critics indifferent. What I wish to do here is to analyse what is said through the aggressive graphic violence on screen, and to understand what this violence means.[2]

Flashback: I saw the film when it came out, one afternoon, in an almost empty Parisian movie theatre. I was by myself. The ferocity of its images so terrified me that it directly affected my entire body, which crumpled from a regular seated position (at the opening credits) to a foetal one, seeking shelter

behind the seat in front of me (by the closing credits). This is a film whose forceful, astonishing brutality has been haunting me ever since. In some ways, writing this chapter offers me the chance to exorcize these demons and perhaps, in the process, to try to define this new form of 'cannibalism', which was so difficult to watch. In other words, I wish to overcome my initial superficial reaction to this film – literally a form of physical repulsion – and understand how it makes sense in Claire Denis's overall oeuvre.

How, then, do we construct meaning out of a film that departs so drastically from the rest of French cinema and, in many ways, from the rest of Claire Denis's productions? Denis often films the post-colonial world (*Chocolat*, *I Can't Sleep*, *White Material*), focusing on its dispossessed and disenfranchised populations, and here, for *Trouble Every Day*, she suddenly turns her camera on cannibals in Paris? She denies it vehemently. She insists that she does not film cannibalism but, rather, the continuum between love and violence, between the amorous 'I could eat you up' and a form of vampirism that is never a rape (both partners are always consenting adults) but that, nonetheless, ends up in a murder. And a murder that takes its time, to boot. Furthermore, with Claire Denis filming with her customary, acute attention to visual and aural details, we are spared very little, if anything at all. The whimpers of hurt flesh, the sniffles of the sick eater-lover, the pleasure moans of the she-vampire as she reaches climax, all fill your ears relentlessly – especially, say, when this viewer shuts her eyes to avoid seeing the worst of it.

Narrative Holes or Palimpsest?

Meet two couples: French Coré and Léo, who live in a little house in the suburb of Paris; and American Shane and June, who have just landed in downtown Paris on their honeymoon. Coré is white, married to Léo, a black doctor originally from Guiana. Every morning, before he leaves to go work in a clinic, he locks Coré up at home, taking a thousand precautions to prevent her from being able to get out. But she often succeeds in escaping the house, seducing her prey, making love to men who follow her and then killing them (Béatrice Dalle is sublime in her steamy, man-devouring role). In the evening, Léo looks for her, finds her dripping with blood and brings her back home. He washes her, hugs her, reassures her, and then leaves to bury the corpses of his wife's victims. At night, he conducts research in the lab he has set up in his basement – it looks like a greenhouse, with plants growing in glass jars of all sizes.

Meanwhile, Shane and June (both of them white) are not really having the honeymoon we would all wish for them. Shane, a medical doctor (Dr. Brown), suffers from the same ailment as Coré. He is so afraid of his own desire for his young new bride that he avoids consummating the marriage and finds

compensatory satisfactions elsewhere. The extradiegetic viewer (by that time no longer sitting straight up) is, however, privy to Shane's amorous escapades, which contain about the same quantity of blood letting as Coré's scenes of sexual fulfilment. We quickly discover that Shane came to Paris to find a remedy to cure his disorder and is looking for Dr. Léo Simoneau, who has disappeared from the Parisian medical research circles and is nowhere to be found. Dr. Simoneau's research was deemed to be closer to witchcraft than to science; thus, the research project and protocol were abandoned. Leading his own investigation, Shane eventually finds Coré and Léo.

At first sight, then, we are dealing with a narrative that introduces terrifying characters and situations. On the one hand, an insane male cannibal-vampire free to roam around in the city, and on the other, an insane female cannibal-vampire, who escapes her prison-home and operates in the suburbs of the capital. We know that these two characters are linked somehow, but the filmic narrative contains more narrative blanks than are usually present in Claire Denis's films. I will detail a few examples.

It is suggested that Shane and Coré first became sick in Guiana. Since their sexual pathology is fatal to their partners, their ailment could be interpreted as a symbolic representation of AIDS, with which it shares a number of characteristics: for instance, both are sexually transmitted, and both have a source located elsewhere, far away from the West (Haiti, Gabon for the AIDS virus; Guiana for the cannibal-vampire one).[3] So the question becomes: why join both legendary, dreaded phenomena into an über angst-producing pathology that would come to find a host in Paris, France?

Why was Léo banned from the Parisian laboratories of biomedical research? One of the doctors provides the following answer to Shane's question: 'I don't buy that stuff. His discoveries? Don't make me laugh! Simoneau is no longer part of the scientific community. Try the talk-show circuit?' Ironically, the native doctor from Guiana who has been studying plants and antidotes from Guiana and who, therefore, seems to take an interest in alternative forms of medicine is written off as a travelling medicine man good for itinerant shows, away from the rarefied atmosphere of the Parisian scientific microcosm, his discoveries reduced to laughable medical quackery. His research is thus peripheral (it is practiced in distant Guiana or in the basement of a suburban dwelling). Why? It seems that his research follows not the Western scientific-establishment route but, rather, a methodology that is steeped in sub-altern knowledge. In the wake of traditional healers, he is looking for clues in the natural environment that has produced the disorder in order to fight it. Seen from this angle, the film would then offer a post-colonial discourse on Western and alternative medicine and power play.

What kind of relationship existed in the past between Shane and Léo on the one hand, and Shane and Coré on the other? Here, too, the narrative is

replete with ellipses – we know that Shane and Léo were together in Guiana at some point, probably doing research together there. We know that Shane likes money; could he have betrayed his colleague and made a deal with a pharmaceutical company before the product was fully developed, thus depriving Léo of all future research opportunities? If so, the film would then put on trial Big Business and globalization, two evil bacteria joined at the hip that put profit ahead of health and become serial killers. Shane would then embody a deadly capitalist.

We are also led to believe that Shane and Coré were lovers at some point, although that hypothetical sub-narrative is far from clear. What we do know is that, whether they have been lovers or not, there is a powerful link between these two characters who are both victims and killers. Why create this devouring Franco–American couple in a French (woman's) film? And why does Denis's tale remain so sibylline?

American Vampires and French Cannibals

Whence do these hybrid characters – at once vampires and cannibals – emerge? French horror films do not include the vampires that haunt their British or American counterparts. Apart from the famous Louis Feuillade silent series (1915–6) and Olivier Assayas's recent riff on (and homage to) Feuillade's protagonist, *Irma Vep* (an anagram on 'vampire'), there is not a vampire to be seen on French screens, whereas Dracula, first written by the Irish Bram Stoker[4] in the late nineteenth century, continued to haunt the Anglophone screens almost obsessively during the 1980 and 1990s. To wit: there were 37 variations on Dracula in the 1980s and 43 in the 1990s.[5] John Allen Stevenson[6] sees this upsurge of multiple vampire figures as a parallel to the birth of vampires in 1897. At the end of the nineteenth century, when British colonial expansion was in full swing, Dracula embodied the British fear of contact, the fear that the foreigner might rape British women, and that the white blood of the United Kingdom could become tainted with the brown blood of the colonized. Dracula, the alien count, sucks blood, kills and/or contaminates. When, almost a century later, the AIDS virus starts to propagate, a similar dread starts to emerge, and Dracula is called upon once again, this time to crystallize the figure of the contagious alien:

> ...the novel insistently – indeed, obsessively – defines the vampire not as a monstrous father but as a foreigner, as someone who threatens and terrifies precisely because he is an outsider. In other words, it may be fruitful to reconsider Stoker's compelling and frequently retold story in terms of inter *racial* sexual competition rather than as intra-familial strife.... Although the old count has women of his own, he is exclusively interested in the women who belong to someone else. This reconsideration can yield a fresh appreciation of the appeal of

Stoker's story and can suggest ways in which the novel embodies a quite powerful imagining of the nature of cultural and racial difference.[7]

If cultural and racial differences are significant in the colonial world and in the AIDS-contaminated world of the 1980s and 1990s, then what is their significance in the post-colonial context in which the AIDS virus has been losing some ground, at least in the First World (although, tragically, not necessarily elsewhere) in the beginning of the twenty-first century? The xenophobia that is an inherent component of the vampire theme remains intact in a society that perceives itself as invaded, occupied by hosts of immigrating aliens.

In France, if the vampire vogue never really took off, representations of cannibalism have, however, recurred throughout its cultural history via fairy tales (most notably, perhaps, in the tales by Charles Perrault – see the ogre in *Little Tom Thumb* and the wolf in *Little Red Riding Hood*[8]), short stories (e.g., Alexandre Dumas's *Les Drames de la mer*[9]), novels (e.g., Jules Vernes's *The Survivors of the Chancellor*[10]) or films (such as Marc Caro's and Jean-Pierre Jeunet's *Delicatessen*, 1991). But why shoot a film about aggressive cannibal/vampire lovers at the dawn of the third millennium? Simply because, as Judith Mayne explains, Claire Denis was offered an attractive deal.

In 1992, producer James Schamus asked Denis to be part of a project, consisting in six horror films, each film to be made by a different, non-mainstream auteur. Denis mulled it over and then decided she was willing to make a horror movie but not as part of a series. No problem: the series became a triptych to be shot in a hotel – the horror movie locus par excellence (think of the motel in Hitchcock's *Psycho* (1960) or the hotel in Stanley Kubrick's *The Shining* (1980), for instance). The other two filmmakers were supposed to be Atom Egoyan and Olivier Assayas. Although the tripartite project was never completed, it nonetheless led to the making of two films: Olivier Assayas's *Irma Vep* (1996) and Claire Denis's *Trouble Every Day* (2001).

Hence, after a series of serendipitous happenings, Claire Denis decided to work on her original script idea and turn it into a screenplay for a one-hour-and-40-minute-long film. Meanwhile, as Judith Mayne underscores in her introduction,[11] Claire Denis's overall work has to do with the violence of the colonial encounter and its repercussions in the post-colonial era: 'while not all of Denis's films are so directly centred on the colonial encounter, her cinema reflects a world where people live through the complex legacies of colonialism' (p. xi). We may then see June and Shane as post-colonial, cannibalistic vampires, with the added bonus of an ironic take on the Anglophone cinema (as the presence of Shane, the American, cannibalistic vampire, would illustrate) and on the French cinema (as the presence of sexy Coré, the French, cannibalistic femme fatale, would indicate).

The New Cannibals or: How the Neo-Colonialists Bite Back

In these post-colonial times, a lot of the power play has changed: the black continent is no longer the unexplored heart of darkness it once was, colonies no longer exist, and, most important, the Other is not elsewhere (on the periphery) but is rather here (at the centre). At the same time, however, globalization keeps exploiting the resources and working bodies of the Other, here and elsewhere. Churned out by the gluttonous machine of capitalism, the Other from the 'developing' world remains subjected to the First World neo-colonialist eager to frenetically produce and consume.

In this regard, the insatiable Coré and Shane constitute monstrous representations of extreme consumption, for the latter quickly becomes obsessive compulsive and reaches global, greedy dimensions (although it starts from the amorous vantage point of sensual desire: I want you so badly that I want to literally absorb you within me). Coré's repetitive consumption can be read as a hyperbolic illustration of Baudrillard's definition of consumption:

> If [consumption] were what we naively take it to be – an absorption, an act of devouring, we should reach saturation. If it were related to the order of needs, we should be moving towards satisfaction. But we know that this is not the case: we want to consume more and more. This compulsion to consume is due neither to some psychological fatality (once a thief always a thief and so on) nor to a mere prestige constraint. If consumption seems irrepressible, it is precisely because it is a totally idealistic practice that has no longer anything to do (beyond a certain threshold) with satisfying needs or with the reality principle. It is because its dynamics derive from the project that is always thwarted and unspoken in the object. The object is *sign*. [Consumption] can therefore only overdo itself or continuously reiterate its process in order to remain what it is – a reason for living (Baudrillard's emphasis).[12]

In Coré's and Shane's consuming *modus operandi*, though the amorous literal consumption quickly morphs into an anthropophagic one, the aim is not to consume the Other completely but rather to taste, savour him or her. The victim, therefore, not only becomes an object that incites consumption, but also never provides full, definitive satisfaction. This irrepressible mode of consumption targets its objects without absorbing them fully and then kills them, thus negating them as objects of consumption, before it goes on to select new objects to consume. Shane is a white man from the United States, that is, from the first economic power in the North that drains the blood of the Global South, and Coré is a white woman from France, a neo-colonial nation that keeps on sucking the blood of its former colonies. The colonial clichés on cannibalism

find themselves inverted here: the fear that the Other might devour me has been transmogrified into the fear that I might excessively consume others abroad and at home (after all, Coré's and Shane's victims are French throughout the filmic narrative). The neo-colonial empire bites back: now that the fabled cannibals of the old colonized world no longer exist, they are replaced by new, avid cannibals that appear even more monstrous to a northern audience because of their power and proximity as the global consumers of the North, whites and Hollywood, for example.

This would explain why Denis imports an American character in her film – not only would it highlight a reference to American B horror movies, but also would it hint at supersized Hollywood relentlessly eating up the market of other cinemas (such as French) with big-budget, formulaic films. The rest of the film becomes clearer then, in terms of the answers to such questions as: why are Shane and June beautifully filmed smack in the centre of Paris, in a magnificent shot of Notre Dame? Because, just like its old gargoyles, they have been there a long time, busy devouring others; previously, their prey were the colonized people, whereas now they feast on everyone, indiscriminately, everywhere. Decolonization did not put a halt to their greediness: these "new" cannibals turn out to be the age-old cannibals who have been busy devouring people from the colonial times on.

Hence, under the guise of shooting a horror movie (with all of the graphic violence such a project entails), Denis ends up shooting a film about the horrific world that the enormous brutality of the colonial encounter has created. If the fear of fabled cannibals in the colonies has deserted both the screens and the collective unconscious of France, then the fear of cannibals remains, nonetheless, very real. It now takes as its objects the American and English vampires that haunt the global screens and televisions and comes home to roost in the North: it is not the people who were subjected to the colonial empire(s) that should have been feared but rather the former colonizers who continue to cannibalize an unfortunate world. Even if the cannibals look new to us, they have always been here, stirring up trouble every day...

Notes

1 Gonzalez, Yann (Cinema critic for Arte France). 2001. (my translation) Available at: http://archives.arte.tv/cinema/cannes2001/ftext/1505.htm#b.
2 This is the adapted and updated translation of a paper given at NEMLA (North Eastern Modern Language Association), Baltimore, in March 2007.
3 Similarly, the West locates the origin and existence of cannibalism elsewhere – in Sub-Saharan Africa preferably.
4 Stoker, Bram (1847–1912), *Dracula* (London, 1897).

5. For a complete list of these vampire movies, please consult: http://public.wsu.edu/~delahoyd/vampirefilms.html
6. Stevenson, Allen Johnson, "A vampire in the mirror: The sexuality of Dracula". *Publications of the Modern Languages Association*, ciii/2 (1988): 139–49.
7. *Ibid.*: 139.
8. Perrault, Charles, *Histoires et contes du temps passé, avec des moralités*/Tales and Stories of the Past with Morals (Paris, 1697).
9. Dumas, Alexandre, *Les drames de la mer*/The Dramas of the Sea (Paris, 1860).
10. Vernes, Jules, *Le Chancellor*, first published as a series in the Parisian daily *Le Temps*, 1874.
11. Mayne, Judith, *Claire Denis* (Urbana, Illinois, 2005), pp. 108–9.
12. Baudrillard, Jean, *Le système des objets. La consommation des signes/The System of Objects* (Paris, 1968), p. 238 (my translation).

15 Still from *Trouble Every Day*

9

Foreignness and Employment: A Study of the Role of Work in the Films of Claire Denis

Rafael Ruiz Pleguezuelos

Claire Denis's legacy to date deals with the problems of post-colonial life in a complex and very often surreal fashion, as well as showing a permanent concern with the representation and interpretation of the body. Her particular – yet very artistic – treatment of these contemporary worries has gained a great deal of recognition in the profession for her films, to the point that it has become clear that very few directors' work can more deservedly receive the label of 'cinéma d'auteur'. Since her debut in 1988 with *Chocolat*, Claire Denis has produced unforgettable characters and memorable sequences, even though, for some critics, her work is considered too erratic and extravagant. The supporters of Denis's cinema cite the importance of her contribution concerning the filmic representation of foreignness of the individual as constituting the real message beneath an undeniably heterogeneous production.

Having already enjoyed very precise critical accounts of the importance of her portrait of the separation from society that characters undergo, the idea of this chapter comes from the surprising experience of having reviewed the best-known bibliography[1] on the works of Claire Denis without finding sufficient references to the importance of the role of work and employment in her films. This neglect may be due to the fact that critics have been too busy exploiting the treatment given to the issues of foreignness and community in her films, which is of course undeniable and is a very rich territory in terms of interpretation. I am particularly interested in discussing Claire Denis's films in reference to the

mimetic function of the cinema and as a vehicle for ideological transmission. Her attention to customs and the ability to re-create *real* spaces explains why her cinema has always held a great deal of interest for historians and anthropologists. Following Roland Barthes and his theories on mass-media production, I want to highlight that Denis's cinema is mainly *connoted*, even if the director makes every effort possible to pretend that her image is *denoted* – both terms are used in the Barthean sense.[2]

The first impression left by a Claire Denis film might be that the construction of sense is naive and rudimentary, sometimes even falling into unintelligibility. However, adequate knowledge of her work shows, instead, that the significations and interpretations are as rich as they are unlimited. A patient contemplation of her filmography reveals that the apparently denoted, simple images and the erratic dialogues hide thoughtful and artistically commendable films.

Furthermore, I feel that the presence of work and employment in her cinema plays an important role in the creation of the ideological discourse and the connoted image the director is interested in. It is well understood that Denis likes toying with the public as much as she does with the rules of fictional and artistic creation, but I am convinced that the French director never forgets that she is ultimately interested in a social and philosophical use of cinema. Therefore, the director's intention is not a casual, random look into some individuals' lives but a well-defined artistic proposal. The secret of the quality of the message that the director is trying to convey lies in how carefully – and intentionally – Claire Denis chooses the individuals whose lives we witness. In *Chocolat*, we get a *voyeuristic* vision of the life of Aimée (Giulia Boschi) and Protée (Isaach De Bankolé), but the scenes of domestic life and sexual tension are nevertheless writing a clever reflection of the effect of colonialism on both Europeans and Africans. In *J'ai pas sommeil* (1994), Denis changes the scenery and transports her reflections to an urban, post-colonial environment, as we enter the life of the newcomer Daiga (Yekaterina Golubeva), a Lithuanian immigrant. The observation of the life of Lionel (Alex Descas) in *35 rhums* (2008) transmits a deep concern for the problem of a personality isolated from the community as well as being a superb study of the relationship of the individual within the group to which he or she belongs.

All of the films mentioned previously include long sequences in which we can see the characters as they work, depicted with the surreal, ethereal vision that is typical of Claire Denis. I interpret the presence of work in her films as a powerful mechanism for building the viewer's understanding of the Other. Therefore, the role of employment in Claire Denis's films reinforces the representation of her well-known favourite topics: strangeness, foreignness, community dislocation and the consequences of post-colonialism. Work constitutes the real means to

achieve her social discourse, as it provides her production with an extra charge of social sensitivity and, at the same time, enhances our familiarity with the characters.

Work is often used to highlight the condition of the foreigner, or of the outcast. We feel pity for Daiga in *J'ai pas sommeil* because she hates her job as a cleaner and is deceived by the fake promise of a job in the theatre. Dah (Isaach de Bankolé) and Jocelyn (Alex Descas) from *S'en fout la mort* turn to crime once they are not able to find honest jobs in the restaurant.

Moreover, the technique used by Claire Denis for portraying work is identical to the one that she uses for narrating other aspects of the characters' lives. The image of work in Claire Denis's filmography seems so close and real (there are numerous close-up shots) that the spectators suddenly have the illusion of being part of the action. This observation is not only valid for her fiction; if we analyse documentaries such as *Man No Run* (1989) and, more particularly, *Vers Mathilde* (2005), they are nothing but a *voyeur's* vision of the lives of professionals at work.

The presence of work in Claire Denis's cinema is part of the great sensorial puzzle of her *oeuvre*. It is particularly interesting that, though it is sometimes hard to know whether some of the scenes in Denis's cinema are real or not within the context of the film, the sequences related to the variety of odd jobs at which her characters work can always be considered real, as if this particular topic escaped Denis's strategies of dislocation and narrative rupture. The world of employment is the only one that seems to break away from subjectivity. Work remains by far the most realistic feature in her films. In them, the employment situation is very often the only agent of 'real-life feeling'. From the professional dancer to the singer, from the pizza baker to the military officer, Denis's filmography constitutes a gallery of odd and regular jobs that deeply signify and provide ethics to the whole of the production. The characters shape a close relationship between work and their behaviour in society, and this affects the way they act and feel.

In a cinema in which the original intention is not producing a film of 'story and characters' but rather a philosophical piece of cinematic work, it is particularly significant that very often the only realistic passages of the film are devoted to job routines. Denis's depiction of job routines as performed by the characters very often remains as their only remaining link to real life. *Beau Travail* (1999) is perhaps the best example of this consideration; in a filmography like Denis's, in which sequences are constantly mutilated, very often producing a lack of understanding, *Beau Travail* spends much running time showing the characters' military and domestic routines with detail and no sense of rush at all. Much has been written on Denis's re-creation of the bodies of the soldiers, and the fascist-like military discipline has been constantly reinterpreted. But

we cannot forget that Denis's vision of the work of the soldiers seems far more realistic – from the perspective of the depiction of the real routines of the profession – than in films that are commonly considered war movies. The examples are endless; for example, we see these soldiers from the French Foreign Legion marching, practising, ironing, washing their clothes, making their beds, and so forth.

Beau Travail can be interpreted – starting with its very title – as a highly philosophical, artistically biased study of the military profession. The character of Galoup represents an existentialist version of these ideas; for him, the French Legion and the routines of military work have been everything in his life. He has spent his whole existence in the profession and, once he is expelled from the army for his plan to discredit Sentain (Grégoire Colin), his life becomes nothing but a constant roaming around the suburbs of Marseille – a neighbourhood of delinquency and marginal work.

In the case of Claire Denis, the topic, just like any other element in her films, is so subtly defined that the viewer may not be very sure at what point he was surrounded by this feeling of social concern for the Other. The *invisibility* of the social message – how work affects the individual's life – is made as imperceptible as possible by a director who knows very well how to hide the structure of the product. In other words, Claire Denis is not portraying work conditions in reference to the individual in the straightforward manner of Ken Loach, for example. However, this does not mean that she is unable to produce a very similar message in a more subtle, less narrative and apparently invisible way – so undetectable that it has very often been neglected by certain critics of her work.[3]

One could say that the depiction of work in Denis's films is made present in three very separate, often conflicting ways of representation, according to the status that they provide to the individual. I classify them as: *jobs for Europeans*, *jobs for foreigners,* and *the world of delinquency and illegal activities*. Many films include an exemplification of all three of them, and even the same character can move from one status to another, according to his or her personal circumstances and the development of the plot. In *Beau Travail*, for example, Galoup is demoted and expelled from the army, which means going directly to the third part of the classification (delinquency and illegal activities) after having moved between the first two, as a Frenchman in an army filled with first- or second-generation immigrants. However, the point is that Galoup, once he becomes the cause of Sentain's difficulties, is downgraded to the realm of marginal work and delinquency.

Denis's production is also rich in background representation of work (whatever happens behind the scenes, portrayed while the main characters act, or by anecdotal events), which is most frequently used when Denis wants to characterize Third World working conditions. One of the most remarkable

sequences of this background representation is again found in *Beau Travail* when a taciturn Galoup (Denis Lavant) is approached in the street by a boy who sells trinkets. He tries to refuse with a slight gesture of the hand but ends up buying something.

In *Chocolat,* White people's professional activities in Africa are almost caricatured. This aspect is best shown in the sequences concerning the arrival of the survivors of the plane wreck, who become guests in the Dalens' home until the replacement parts for the plane arrive. Their presence transmits an almost humorous representation of Europeans as arrogant, boastful people. When depicting the Europeans, Denis creates a scale of stupidity that starts with the naive Machinard (Laurent Arnal) and reaches its highest point in Joseph Delpich (Jacques Denis), the epitome of the worst of colonization, a caricature of European greed, and a very interesting character from the perspective of this article. Delpich is introduced as a "sympathique planteur" (friendly farmer) – the Maria of *White Material* is a coffee *planteur* as well, equally obsessed with time and full of pride – and his arrival on the scene could not be more significant, with the character shouting with all his strength that he is losing money 'à chaque minute' (every minute).

It is well understood that Denis loves playing with the idea of strangeness and the concept of the intruder.In the representation of work in *Chocolat*, Denis introduces a very interesting character: Luc Segalen (Jean-Claude Adelin). Denis leads the audience to think that he is better than the other visitors because he chooses to live closer to the Africans – just like Aimée Dalens would like to do if she felt she was capable of doing so. The French director introduces the matter in three different scenes that transgress social convention: the first one is the moment when Luc is among the African workers that get off the truck. We are first shocked by the fact that this white man travels in the back of the truck, surrounded by Africans – just as Isabelle Huppert will travel, clinging to the railing outside of the bus in *White Material*; another similarity between the two films, a surprising scene in a society where the separation between Europeans and Africans is well defined. We are shown that Luc is not afraid of living amongst the Africans, and Denis orchestrates everything in the film so that the viewer immediately sympathises with the character. In this case, work is, once more, helping Denis's intentions.

The second transgression comes when Segalen seems to be more interested in joining the rest of the African workers than in meeting the Frenchmen. The third transgression is purely visual: the Africans work under a blazing sun. Luc, a white man, works with them, sweats among them, has his shirt off like any of them. By contrast, in the meantime, the rest of the Europeans lunch under a tent, served by Protée. The scene is repeated later in the film, when Luc has dinner on the floor with some of the servants of the house.

The character of Protée is equally interesting from a work perspective. He is a servant and, therefore, a 24-hours-a-day man at work. In her later films, Denis offers a more subtle representation of work as an engine of social reference, largely abandoning the cartoonish side that she shows in *Chocolat*, in order to depict the consequences of colonization in a more mature and symbolically worked fashion. However, in *Chocolat*, symbols have not yet reached the levels of subtlety that Claire Denis finds later, and the interpretation is simply made evident. The sexual tension between Protée and Aimée is a typical product of the cultural clash of colonization and a central part of post-colonial studies. From the perspective of this article, we can explain Protée and Aimée's distance because Protée cares about his job, and he is afraid of losing it. Protée can be seen as the *normalized* African, a character that will be reproduced in future films and that is depicted as having embraced colonization.

The fight scene between Protée and Luc is not only about force and male rivalry; it is also about the clash of the European who wants to be African and the African who wants to be European. In his job, Protée is constantly portrayed as the perfect servant, presented with an intelligent mixture of dignity and servility. His work as a servant brings him so close to the Europeans that he becomes a substitute for Marc Dalens when the latter leaves the house.

The non-dialogued, background representation of work is equally rich in *Chocolat*; throughout the film we see Africans working the land, selling trinkets or cooking. The portrayal of these daily actions constitutes a privileged showroom of the years of African colonialism. The film is filled with representations of marginal jobs, very often performed by children. They constitute an evident social construction in her filmography, as the director consciously spends some of the running time of the film showing the public the hard conditions they live and work in, both concepts constantly interrelated.

J'ai pas sommeil is perhaps the film that best shows the three-part division of the representation of work in the films of Claire Denis that have been defined previously; the *jobs for Europeans* are represented by the working context of the theatre and the world of art. In the context of the distance between Europeans and Foreigners, art can easily be understood as the epitome of the most stylish and sublimated activity and is of course made visible as an object of desire for the foreigner coming to the country, in this case embodied by the character of Daiga (Yekaterina Golubeva). In the film, Daiga desperately wants to leave behind the second layer in the pyramid of employment – *jobs for foreigners* – and attain a first-class job. Claire Denis devotes some sequences to representing Daiga's derision for his job as a cleaner. Daiga's desire for a change of layer is so strong that it may even be one of the possible explanations for her rude, sour personality as well as for her pessimistic attitude towards life. A similar situation is present in the lives of the characters of Dah and Jocelyn in *S'en fout la mort*

(1990); they begin working at a restaurant and end up organizing clandestine cockfights in the basement of the establishment, going from layer two to layer three. In *J'ai pas sommeil*, working at the kind of jobs that are left to foreigners, we find Daiga's aunt and Theo (Alex Descas). The third group, the one that includes marginal, odd jobs and delinquency, is made present in *J'ai pas sommeil* by the character of Camille (Richard Courcet) and the presence of the odd jobs that Camille performs help to communicate the image of the outcast that Denis has designed for this character.

Claire Denis seems to be very interested in showing how humiliating this *work for foreigners* can be. We find a good example of this idea in *J'ai pas sommeil*, in the long sequence when Alex Descas patiently puts up with the constant changes of opinion by the woman to whose house he has gone to assemble a cabinet. Eventually, the woman wants to pay less than was agreed upon. They argue about the money, and the complete humiliation comes with the final words of the French lady: 'I could have had a professional for that price'.

Trouble Every Day (2001) includes the presence of the *jobs for Europeans* that I mentioned previously: these qualified jobs are represented by the work of the scientists that Shane Brown is in contact with. As in *Chocolat*, Denis' portrayal seems to be closer to parody and caricature than to a factual, literal portrayal of science. The work done there seems to be anything but serious research, and the consequences, as we discover, are more than disastrous. Moreover, we cannot forget that the fatal malady that constitutes the core of the story is a by-product of the cutting-edge studies that are conducted in the lab. This fact immediately motivates the audience to have a poor opinion of the work done there.

Of special interest is the representation of the unskilled job, embodied by Christelle (Florence Loiret-Caille) as the maid who attends to the hotel room in the hotel where Shane (Vincent Gallo) and June Brown (Tricia Vessey) stay. Denis spends much running time of the film following Christelle's routine work at the hotel – again we witness the director's passion for a voyeuristic vision of the characters. With the camera literally following her, we visit every corner of the hotel, and some of the scenes are shot in the staff-only rooms, including Shane Brown's attack on Christelle. The visit to the staff facilities provides the audience with a privileged view of the everyday tasks of hotel work, offering the director the possibility of re-creating a very personal poetic of bodies in action, with repetition of the usual imagery of inconsistent, zombie-like figures with erratic eyes that is so typical of her cinema.

In this particular feature, Denis makes a clever joke that (again) has to do with social status: when we first meet Christelle, she attempts to make the bed as the Browns ignore her completely and start kissing passionately. In a later scene, Christelle smokes in a room while she is comfortably lying on one of the hotel's beds, which could be interpreted as a quiet, soft rebellion and desire

for reaching the status of the first layer. The main difference between *Trouble Every Day* and previous Claire Denis films is that in this case Denis does not make use of racial differences and post-colonial stereotypes. Léo (Alex Descas), an African, is a doctor, and the hotel maid is not racially marked either.

If *Nénette et Boni* (1996), *Vendredi Soir* (2002) and *L'Intrus* (2004) offer no real material for this study, *35 rhums* is perhaps the most interesting film by Claire Denis in this regard. The film deals mainly with the bond between father and daughter – Lionel (Alex Descas) and Josephine (Mati Diop) – who see their relationship complicated by the presence of a young man, Noé (Grégoire Colin). The main characters are well-established immigrants and Denis is absolutely superb in her portrayal of the scenes of domestic life.

Once more, employment circumstances play a leading role in the film's imagery. *35 rhums* is, among other things, about how disappointing the life of a foreigner can be, even if he has embraced a traditional role in the community he now lives in. Lionel works for – and this is an important fact – one of France's great public services: the RER.[4] From this perspective, he seems an apparently normalized worker and an immigrant who has found his place in the colonial metropolis. Lionel apparently leads a satisfying life, and Denis seems eager to define him as a conformist. To force the contrast and show a person who is not happy at all with the status that Lionel has reached, Denis offers the interesting character of René, one of Lionel's older co-workers (the Martinique-born painter and occasional actor Julieth Mars Toussaint), who is suicidally depressed when he retires from the RER. The scene of the retirement party is one of the most memorable in Denis's production. The party is anything but happy; significantly, all the attendees of the party are immigrants, and the two first presents given to the honouree have a symbolic meaning: they are pieces of art that refer to his roots. But the third present is an MP3 player, a humorous contrast on Denis's part. The director is cleverly toying with the past and the present, the roots and the future, traditional art and technology, the local and globalized world. Denis focuses – to the point of almost falling into repetition and being overly didactic this time – on showing in detail that, after so many years of work, this person is nothing but a pointless, dislocated, unhappy figure who roams around with no particular interest in anything. A good number of sequences in *35 rhums* are devoted to highlighting this, but the perfect summary comes with the words of René, once the presents have been given, referring to his retirement: 'C'est une deliverance, vous savez' (It's a relief, you know).

In *35 rhums*, we see how characters with jobs that go from the first to the third layer share the same building, a fact that emphasizes the contrast. Noé is a businessman and lives in the penthouse. Thus, the person who has a first-class job lives in the top of the building, a fact that is obviously not a coincidence. Gabrielle is a taxi driver, and Joséphine is a student. As I have

suggested before, in this particular film Denis seems to try to be more didactic than in her previous films, introducing a scene (the one with Joséphine in class), in which immigration and Third World problems are discussed in an unusually long dialogue for a Claire Denis film. The whole scene reminds us of *Vers Nancy* (2002), the short film that shows the dialogue between the philosopher Jean-Luc Nancy and an immigrant.

White Material (2009) can in many ways be considered a return to the departure point of *Chocolat*. The photography shares a very similar sandy texture. In *White Material*, work and the plantation constitute the real battlefield of the main character, Maria Vial (Isabelle Huppert). The director revisits Africa, this time shaken by a racial conflict. And, on this occasion, the *intruder* is the member of a white French family attempting by any means to save its coffee plantation. Right from the synopsis, we again meet a French colonial family and a work situation. Of special interest is Maria's constant preoccupation with getting the crop of beans harvested; no matter what risks she or her family might run. There is a memorable scene where the plantation workers leave the plantation riding their bikes, and Maria tries to convince them to go back to work.

If *Chocolat* introduces the work of colonialism, *White Material* represents the unstable conditions of post-colonialism, and, concerning the particular issues reviewed in this article, the latter constitutes a kind of thematic second part of her debut film. The definition of employment in the colonies has changed a lot from the time it was portrayed in *Chocolat*, where power was exclusively in the hands of the whites. In *White Material*, the Africans make their own decisions – they can disobey the reasoning of the boss, as in the scene of the workers quitting and leaving on their bikes. However, Denis is not naive about the social and political situation of post-colonial life of Africa and accurately portrays the genuine, terrifying menace of this new order. In this film, the rules are now so different to those of *Chocolat* that Maria Vial, out of desperation, constantly invades the working space of Africans, in her attempts to gain control of the situation. We see her (in an astonishing performance by Isabelle Huppert) desperately trying to save the crop, obsessed with completing her work. The images of Isabelle Huppert frantically working with her own hands makes the viewer guess that all his power and wealth in the region will soon come to an end. We can interpret the whole scene as a powerful symbol of the Europeans as colonizers who are gradually and inevitably losing control of their power and economic interests in the colonies.

All of this leads us to the conclusion that the presence of work and employment accounts for a major part of Claire Denis's representation of the social element. Being a director of subtleties and not one to spoon-feed her public, Denis is well aware that seduction and artistic creation can be far more powerful in conveying ideas than basic, straightforward transmission. Clearly,

the treatment that the French director gives to this particular issue is *sui generis*, just like any other aspect of her production. This implies that, just because there is a constant, fully intentional presence of the world of employment and sub-employment in her filmography, this does not mean we will be able to easily interpret this subtext. We cannot expect an easily interpretable presence of the issue in her films. Furthermore, the director's representation of employment shows the least philosophical or speculative side of the filmmaker, being realistic, but without the self-evident didacticism of some of her contemporaries. I started this article by stating that there seems to be a critical consensus on the idea that Claire Denis's films are a precise study of other people's actions through the eyes of those who are different, and I hope that I have provided enough clues to convince about the importance of the role of work to convey the great values that enrich her filmography.

Notes

1. This particular topic is absent or simply mentioned in passing in the most popular books on the director: Martine Beugnet's (Manchester, 2004) and Judith Mayne's (Champaign, Illinois, 2005). *Claire Denis, Fusión Fría* (Festival Internacional de Cine de Gijón, 2005), a book with a very limited distribution but very interesting content, is not explicit about the importance of work in her films either.
2. 'Since it is both evictive and sufficient, it will be understood that from an aesthetic point of view the denoted image can appear as a kind of Edenic state of the image; cleared utopianically of its connotations, the image would become radically objective or, in the last analysis, innocent' (Barthes, Roland, *Image Music Text*, (London, 1977), p. 42).
3. Again, excellent studies such as those of Judith Mayne and Martine Beugnet seem to sidestep the issue.
4. French: *Réseau Express Régional*, the Regional Express Network.

16 Still from *35 rhums*

10

The Intruder According to Claire Denis

by Jean-Luc Nancy

Translated by Anna Moschovakis

1.

It would be fair to expect the author of the book *The Intruder* to speak to the effect made on him by the film that claims to have found 'an inspiration' in the said book. But that is not what I am going to do. Or, rather, I will do so only as part of an attempt to untangle something of what this film has, in turn, inspired in me. Moreover, I will not be analyzing whatever relationship Claire Denis may have established with my book. That relationship, that reading, must remain her secret and hers alone – even as the film constitutes its irreducible transmission.

Let us clarify right away for those who don't already know: the book contains no story that the film could have adapted (except by transforming itself into a medical documentary, which would not really have preserved any 'inspiration' from the book). As I once put it – struck by the assonance between words – Claire Denis did not adapt my book; she adopted it. (And in fact, her film does address adoption.) The relationship between us is not the relatively 'natural' one presumed of an adaptation (a simple change of register or instrument) but the kind of extra-natural relationship that, without evidence of kinship, depends solely on its symbolic elaboration. That this, in the final analysis, is the truth behind all kinship is perhaps one of the lessons of the film, just as my book suggests that in the end there is no 'real body' – and this 'just as' is already enough to engage the complex and delicate system of correspondences, of 'inspirations', or contagions between us.

The book merely records a brief reflection on what a heart transplant might represent in the context of a contemporary understanding of identity. The 'intruder' here designates an irreducible, and yet incorporated, alterity for which the transplant itself is only a figure – the central piece of a more general process of transformation that affects everything we believe to be 'natural', entering the realm of what I have elsewhere termed our *écotechnie*. A far cry from the complex, if not labyrinthine, plot of a film in which a persecuted man with a damaged heart seeks a transplant so that he can pursue his search for an abandoned son.

A far cry, and yet. . . . It's enough to juxtapose the arguments, thus condensed, of the book and the film to reveal a glimmer: if filiation can be considered an image (metaphor and metonymy at once) of naturalness (*la naturalité*) in general, then the film undeniably questions, complicates and suspends the very idea or hypothesis of this naturalness. One might even ask if naturalness isn't its primary subject. The breadth and beauty of the landscapes of two hemispheres lend their images a force apart from the aesthetic: the question is asked – for example, in a long static shot of dawn rising over the violet sea of the islands – of the nature of nature (if you will) for us today and of the possibility or impossibility of continuing to inhabit the earth (an attempt at inhabitation, at returning home, comprises the penultimate movement of the film, no less ambiguously than the others).

I suspect that what I have encountered here is – at least from one angle, one approach – the invisible source of the 'inspiration' of this film; and that I will be able to understand how, in spite of the indisputable, irreducible, and welcome heterogeneity that separates the film from the book, the former doubles back on the latter, pulling it into its ebb tide, beyond itself.

Let us follow the thread that has already been identified, that of a 'denaturation'. We will see that it is actually a braid, woven from several strands. I'll just mention those I have identified, which fall into three pairings: 'father and son', 'Christ and Dionysus', 'woman and dogs'. In each of these registers, perhaps (for I am only making gestures here, sketches really), a form of intrusion will occur that will unravel or frustrate the 'naturalness' that we expect (that of 'father', of 'god', of 'woman'). The braided strands are also echoed in the film's editing, full of ellipses and its photography, the wide shots and cut-up sequences. It is the rhythm of a startled, syncopated thinking – a thinking occupied less with its 'ideas' than with its movement, with its pace and its displacement. As is said in the film by the merchant of an expensive watch with a transparent casing: you can appreciate the beauty of the mechanism. This watch, completely extraneous to the plot, is the film itself; as much as the dogsled driver in the final shots, laughing while she tears through the icy forest on a race without a destination, is also the film. As is the woman who is shooting the film and who runs with it;

the woman who runs in the film until she is outside it, until she takes it outside of itself, with a compounding pleasure that turns out to be the real star.

2.

The idea of simple, biological filiation is staged conspicuously closely to the film's beginning, in which Trébor's son is shown in his function of father (of two very young children), of domestic man (he paints a ceiling) and of progenitor (he makes love to his young wife, whose breasts in turn serve as a reminder, by way of a droll juxtaposition with baby bottles, of the parent–infant relationship). One could argue that the father is purposely shown playing a *role*, beginning with the shot in which he is cropped between the frames of two windows. Now this son, we will learn, is decidedly not the 'favourite son': the latter is the one Trébor abandoned in Tahiti, where he will later go to look for him. For this other son, Trébor will have a boat made, because 'my son is a good sailor': *a good sailor*, without a doubt what Trébor himself had been or wanted to be in his youth, when he set off for the Marquesas Islands, as we will see in a flashback (which incorporates an old, unfinished film by Paul Gégauff with a rather ominous title – *The Ebb Tide* – starring a young Michel Subor).

The basic premise is, then, a disturbance that affects filiation – or rather, is effected on filiation – by way of an inexplicable, unmotivated preference between two sons of one, who represents youth (idealized of course) but who also is abandoned, presumably because his mother was a foreigner, from the Far East, a Marquesan, the love of a particular place and time, no more. It's also why the theme of family is introduced only after another theme that opens the film, that of crossing borders and the illegal transport of goods – by way of the young mother, in her role as a customs canine enforcement officer who inspects suspicious cargo. Right away, via this young couple and the double theme they embody, an order is established, of legitimate lineage and authorized passage, which might justifiably be called a natural political economy. In these terms, Trébor's heart transplant is but a restoration of integrity, a renewal of vigour that will allow him to move ahead. But the transplant itself, as well as the purchase of the boat, involves large sums of money, manifestly illegal and no less manifestly stolen from the first son (a double illegality of sorts: in the end, Trébor robs everyone, including, finally, himself).

We learn that the abandoned son has become the lamented son. Trébor would like to retrieve him – *le retrouver*, from *trouver* (to find). And doesn't the fact that *trouver* evokes his name – even in English, by way of *trover*, which comes from *trouvere* (therefore from *trober*) – lend a poetic touch to what we might call 'the invention of the son'? (In French it's used as a first name, while in English it signifies 'skill'; but the French also have the nautical term *tribord*).

Trébor wants to uncover – or, rather, discover for the first time – this image, this idea of successful filiation; this would be something like a return home. 'I want to welcome my son home', he says as he settles into the hut that he has rediscovered. It's a meagre, dilapidated shack, where a fragment of mosquito netting flutters in the breeze like a ghost. Trébor's desire is to follow the ghosts, to make manifest the true face of his son – of himself, of love, of the natural order restored. At the closing of the boat purchase, the Korean ship owner lifts his glass and says, 'Let us celebrate the love between a father and his son'. Trébor toasts and drinks, but the strength of the alcohol makes him hiccup. He says, 'It's strong!' – as if responding, with absolute ambiguity, to the ship-owner's words.

Henri, Trébor's Marquesan friend and onetime cohort, begins the search for a substitute son, arranging for a village council to interview candidates. This highly irregular casting call illuminates the subject's complexity: a social structure of the 'archaic' world easily assumes the task of providing an invented son for a man who had, for a brief moment long ago, been one of their own. The scene operates both as a theatricalisation of the work of the imagination or of idealization and as dramaturgy of the art and artefacts structuring kinship. None of the young people meets the requirement of physical resemblance, the only requirement possible in the absence of all other criteria; in lieu of the real son, a boy who resembles the father and whose skin tone is consistent with having mixed blood would be enough to imitate nature.

But this art of discovery fails. Resemblance, the sign and signature of nature, refuses to be found. In the state of nature, Trébor can only be the big white body sunbathing naked in the forest, asleep with his dogs, at the beginning of the film; or the swimmer, the cycler, the athletic body occupied only with itself. Could he have only one legitimate son? Does he himself know? The boy who ends up taking the son's place does so purely on his own initiative, by his own insistence: he opposes himself to Trébor before imposing himself on him (but by then Trébor, weakened, isn't at home anymore, has had to be hospitalised). The boy refuses money; he will not enter into the cycle of (false) common value. And he is a surfer: a wholly different species, of a different era, practicing a different kind of 'seafaring'.

And this son, who has not been adopted, who has in a sense transplanted himself into Trébor's life (he comes to the hospital, he puts on scrubs), is also the one who will locate the trace of the first son and who will allow for the origin of the transplanted heart – taken from this murdered first son – to be revealed.

In a way, the familial buckle closes with this terrible return of the heart of the son into the chest of the father. A terrible return with implications of murder and revenge, of the complex cruelty used by Trébor's creditors to get him to

pay (they tell him his debt is inextinguishable). Possibly this horror is also, in whole or in part, a product of Trébor's delusion: he could have imagined the consequences of the misdeed (the crime, to be accurate) from which he has benefited and/or the familial provenance of the heart (how could he not have created a fantasy, even a fleeting one, about the provenance of his transplanted heart, about his paternity?).

Trébor leaves on a boat, accompanied by the coffin of the dead son whose heart lives inside him and by Toni, who pampers him with care. We might think he is returning to the island where he had hoped to wait for his son – toward the island, toward solitude, nature, the immemorial. But really, he is returning to nothing but his own death, at least that is the best we can deduce from his condition. Or maybe to a life hanging from a thread.... The return will not bring him back to a point of departure, to an origin; and the Polynesian 'paradise' escapes into the night – making way for a snowy finale in the Northern Hemisphere.

Genealogies are vague and distant, improbable or at least uncertain. That's what we are told by the photographs of the Chinese ancestors of the businessmen Trébor talks to in Papeete. It's not about generations or heritage: it's about departure, passage, drift and the law that the voyager will never come home the same. The Other will always intrude. If there is a hidden political message to this film, it's one that refuses any assumption of identity or 'naturalness', including – and this is the key point – identities labelled 'mixed' or 'Creole'. Intrusion is stronger, less reducible and more troubling than any mixture, for it goes from like to like; here, from Trébor to Trébor.

3.

Travel, displacement, change of place via intrusion and escape; displacement across countries or oceans (the label 'Wild Pacific' sewn on a pair of jeans); the friction between languages (we hear French, Russian, Korean, Tahitian, dogs); and the movement of time both measured (a precious watch) and without measure (we are given no temporal reference for the transplant, the convalescence, or the healing of the scar, a period of time conspicuously subtracted from the film's duration) – this mobile whole, fluid and shifting, forms the basis of the film's directorial schematic. The sliding motions of swimming or biking; the movement of cars, dog races, planes and boats; a walker's wanderings, a surfer's glide: the movement of the film, its *kinaesthesia*, is a movement made up of movements and of sensations of movements, culminating in the fierce momentum of the dog sled and the driver's whip.

This isn't to say that time counts; rather, that it counts in every way: it is precious (like the watch), like the time of return and the time of the quest, like

the time of memory and time of waiting, like the time of tension and the time of release. As with the watch purchased in Geneva, home to the industries of precise timekeeping and unified banking, time counts both absolutely and not at all: every instant is precious, but all instants sink into the general equivalence of their own displacement.

In a parallel fashion, time is mechanical, adjusted, counted – like the regular pulsing of a heart, a machine defined by the fact of beating – and *at the same time* it is continuous and fluid, variable, elastic and unpredictable. That is how we must 'appreciate the beauty of the movement'. Duration perseveres and pauses at the same time; it is continuously shot through with holes or outmanoeuvred by ellipses, by mystifying flashbacks or uncertain simultaneities. To look at just one example and not the least: the burial that takes place fairly early in the film, and that isn't very specifically located (probably in Papeete), could be that of Trébor himself, or of his son, or could even be an anonymous burial with symbolic value. We are not to know anything with certainty; all we have are the slow advance of the coffin, the wide shot and the words of the priest.

The mutual intrusion of time and place, along with that of persons, is quite literally the idea most central to the film. Almost every image is imprinted with a strong sign, a mark of intrusion similar to the scar – the bumps and craters on Trébor's skin, the beauty marks on his lover's body or on the dog-trainer's breasts, the eyes of the blind masseuse, themselves scars; or a clock in the sky in Geneva, furtive shadows in the forest, the miniscule light glimmering in the distance on the banks of the violet sea. Like Trébor's scar and the surface of the sea, all skins are marked by experience, damaged, pitted and marred, sensitive, exposed.

Likewise, when the young couple – the son and the customs guard – encounter a group of hikers in the forest, she says, 'They don't have the right shoes', and he responds, 'You notice everything'. It could be that they are poorly equipped hikers or perhaps phony hikers or other fugitives trying to make it through the day. We won't find out which, and this isolated scene inscribes itself on the film like a stroke of doubt, an intrusion into the story as much as into the mountainous frontier.

At the temporal centre of the film is an explosive image: the release of a cascade of multi-coloured ribbons, marking the Korean ritual of a boat's baptism. It's like an effusion of shimmering celluloid unspooling from a paper balloon – as if from the film's heart – in a mixture of joy, festivity and irony.

4.

Another possible interpretive thread – which, if followed, yields almost a different film – hovers just beneath the surface of the first; it's a vision, like

the bodies filmed through a surface of ice, as plausible as it is unreal, dreamlike. Who is dead? Who has killed? Who is left over, shot through the ice? Whose heart do the dogs seize in their jaws? These questions can be answered. But the answers are designed to be clouded, unclear – as is death; as is life, too. The intrusion, then, may be that of each possible answer into the others.

The foreign body, in this second interpretation, could be identified as that of Christ or at least that of a Christ-like figure. This proposition may seem outlandish; perhaps it is. However, it can't be brushed aside without first looking at a series of clues (the limited number of which is no reason to deny their importance). Any one of these clues is enough to establish the reference to Christ. It doesn't matter if Claire Denis and her co-writer are conscious of it or not; recall that the reference was present, too, in *Beau Travail* (and is, of course, at the very heart of the text that inspired that film, Melville's *Billy Budd*.)

To begin with, there is the series of crosses, of which the first, at least, is very deliberately foregrounded in the frame: a wooden cross, unadorned, planted in the forest in Jura and filmed in such a manner that it occupies nearly the whole screen, 'crossing' it and creating a double emblem – one signifying both the act of crossing and the window of a viewfinder through which we are invited to look.

This image is not accidental, and it is hard not to see a connection to the ones that follow: a cross etched on a clock in Geneva amidst the falling snow; a small iron cross taking up much of the frame; and another, even smaller and more discreet cross embroidered into the pattern of a curtain in Papeete. Then there is the solemn advance – during a tumultuous lightning storm, no less – of the gold crucifix adorning the coffin carried by four men into a church where a priest, touching it, delivers a homily that will be revisited later in the film. And finally, there is the scar of the transplant itself: are we not to notice it is in the shape of a half-cross?

Add to this series of crosses another set of clues, less immediately resonant but even more powerfully Christian, and it becomes impossible not to pursue the interpretation – even though arriving at a conclusion is out of the question.

The 'real' son (whether real or imaginary) is called the 'beloved son' in a letter that Trébor leaves half-burned (as if it's meant to be found), which gets deciphered by the 'real' son once he has become worried about his father's absence. 'Beloved son' is, according to the common translations, how a 'celestial voice' designates Jesus during his baptism in the River Jordan. Later, in Tahiti, as we begin to understand that the beloved son is possibly not of this world (to put it in evangelical terms!), we are shown the digging of a grave. We do not know for whom the grave is intended, any more than we knew who was in the coffin or if the coffin is going to go into the grave (the constant reign of indecision between life and death, the living and the dead). The grave-digging

scene ends with a deliberately strange freeze-frame, like a posed photo, in which the motionless workers, leaning on their spades, frame the empty pit as if giving it centre stage. The empty grave, of course, makes a symbolic gesture toward resurrection. Clearly, the trope of homecoming described previously could double as a trope of resurrection: not only that of Trébor, thanks to the transplant (it is banal to say that a heart transplant is a 'raising from the dead'), but also that of the 'real' son, whose heart lives on, survives, in his father, or even that of the 'actual' son, who is (re)-incarnated by the grace of Toni.

Christ's resurrection is followed by his ascension. Here, the body of the tortured son (it is his torture that is on display at the morgue, in his badly stitched-up chest) is hoisted into the air by a pallet elevator and put on board the boat for what will be the final voyage of Trébor and his 'son'. The camera films this ascension from the ground, in a long low-angle shot that serves to glorify the body, encased in its waxed holster. A heavy ascension, yes; a mechanical and conspicuously filmic one – but for all that, still distinguished from religious phantasmagoria by way of the elevation of the gaze.

From the cross to ascension the connection is clear; we need say no more. I have no desire to string together a Christology for no purpose. I will only point out that according to a certain, fairly common, tradition – let us say from the epistles of Jacques to Nietzsche – Christ is portrayed as an intruder, a disturbing presence bringing trouble and a fear of foreignness to the world.

Of course, explicit scriptural reference is not wholly absent from the film. What we hear from the priest during the burial is a passage from Revelation that contains three salient points: on the one hand, God says that he is 'Alpha and Omega' and that he is the one who dispenses from 'the spring of the water of life'; on the other hand, he proclaims an heir who 'will be His son' in this life; finally, he places in opposition to this son of 'renewed' life (within the context of the passage) all the 'dogs, and sorcerers, and whoremongers, and murderers, and idolaters, and whosoever loveth and maketh a lie' who are headed toward the 'second death' – that is, who will not be resurrected. Thus, the themes of life and the son are joined by the less explicit theme of possible damnation for Trébor (who has certainly murdered) and, perhaps, for everyone else...

For all this, the point is not simply to identify religious references in the film per se. What is really at play here is a relationship of intrusion – of life into death, death into life (Claire Denis called another of her films *No Fear, No Die*). This intrusion exactly doubles an unexpected intrusion into the Christ-like figure by that other mythic figure of life and death, Dionysus (whose name is echoed in 'Denis'). Once he has read the letter to the 'beloved son' in the cabin in the forest, that other home where the father does not await him, the 'real' son finds and picks up a crown made of leaves and flowers. It was braided and worn by the wild girl who haunts the woods, who has no relation to the protagonists

except by contiguity and analogy, tied like Trébor to nature, to the sun and the lustrous water, to dogs; also like the son and the Russian thugs killed in the forest, she does not utter a single word in any of her appearances. It is quite Nietzschean, in fact: a Christ-Dionysus who, in the end, delivers the secret of life beyond all nature.

It's underscored by the editing: the Dionysian crown is braided and donned by the wild girl at the same moment when, in the cabin, Trébor and his lover are embracing.

5.

We should return here once again to the idea of passage. All the movement of the film, all its *kinetics,* is about passage. The intruder is as much the one who passes as the one who barges in. His barging in is attended by his departure, they are indiscernible from each other: that is how he remains a foreigner during his passage, why he can't be identified or assigned a home. He passes, he breaches borders or fords; when Trébor moves into the hut, two men transport a mattress – synonym of rest and comfort – by carrying it on their heads, as if holding it high above water and danger (now we are approaching the past, evoked by images from an old film showing two young men caught in a storm).

The passage does not move from a present to a future. It is not a proper quest, a progress or progression, a flight or even a story. It passes from a present to its past and does not come back to the present except to watch it pass again. Trébor's obscure Russian past pursues him; meanwhile he is trying to make amends with a lost son who doesn't want to see him again, who will lead him, in any case, nowhere but back to his own youth, the better to deliver him to his imminent and final decline, unless everything gets suspended in the immobile time of an endless passage on a boat we will never see dock, carrying the father and the two sons, one dead and the other false, having embarked without a destination. It's a strange trinity of the heart: one man has lost his, another is running on empty (as the Russian woman has said to Trébor earlier), the third takes care of the others as if only he, a stranger, understands everything that the rest of us don't understand.

In an analogous manner, the film passes from one hemisphere into another, from the West to the East first and then from the North to the South – only to return *in extremis* to the winter in Jura. There has been no progress, no more than that Polynesia cannot be taken for a kind of paradise. Of course, it is not only enchanted in Trébor's fantasy; it delivers, in the long, luxurious shots of quivering trees and emerald seas. And yet, one of the first shots of Tahiti shows a large sign above a shop that reads 'Tahiti Quincillerie', a commentary that needs no explication.

This uninterrupted passage that drives the film takes place under the sign of the *traversal*: Trébor traverses a lake swimming, traverses mountains on his bike, meticulously cares for his tires; borders are traversed, passports are burnt, a stretch of snow is traversed by a body cruelly tied by the hair; oceans are traversed, a *bra de mer* is forded; until, finally, a sled pulled by vigorously whipped dogs trails off in the distance, bringing the film to an end at the edge of the screen. And, in the hysterical laughter of the dogsled driver there is an echo of the explosion of ribbons at the naval baptism, the joyous and troubling promise of an ever-renewing departure that returns, in contra-point, to a shot of a beautiful copper propeller, motionless and half-submerged. If there is a film that doesn't know how to end, this is it.

This permanent circulation, this *perpetual motion* also entails very few interiors amidst the profusion of mostly open exteriors: hills, roads, coasts, vast expanses. The interiors are often seen from outside (through windows, both the young couple's and Henri's, that echo each other from the beginning to the end of the film) or they are precarious (cabin, hut, hotel room, unspecific offices). Everything is outdoors, everything is turned toward the outdoors, one might say, recalling that *tourner* also means to shoot film. The relationship between interiority and exteriority (of the place, of the foreigner) determines itself like an exposition of the former into the latter and vice versa: as a result, places can only be supposed, never clearly presented or accessible. Who is Trébor? Who is Toni? Henri? And on and on. We understand that this is not the question; or, rather, it's the question that does not lead to any answer, that follows itself indefinitely.

Gauguin, in his Marquesas Islands, made his great painting *Where Do We Come From? What Are We? Where Are We Going?* If there is a painting that resembles a film – and in Cinemascope – this is it.

6.

The uninterrupted passage takes place in double company: that of women and that of dogs, the former linked to the latter in the figures of the customs-officer, the wild girl, the Russian woman and the dog breeder (who is credited as 'The Queen of the Northern Hemisphere').

The women don't travel or at least they aren't filmed travelling except in a royal way (the 'queen' takes her sleigh, the Russian her horse). They are not taken by the wanderings of men. Instead they tend to things – the pharmacist to her pharmacy even while she makes visits to the hermit in the forest; the dog breeder to her charges; the Tahitian mother to her house and her children – or they cure (the pharmacist, the masseuse). And if they do wander, which is the case with the wild girl and the Russian, then it's only as doubles for the

wandering Trébor: the former is in a sense his female double; she also takes refuge in the forest, though we don't learn why; the latter is the nemesis who tracks his every step. Trébor doesn't exist, in a way, except as a figure doubled from each side by these two allegories of himself.

Apart from Trébor, the wild girl is the only person to be shown almost entirely naked and in a state of pleasure – him in the sun, her in the bath (which she takes at Trébor's house, in his tub, in his absence), and it is her heart that, in a dream or hallucination, is seen torn out and found by dogs, while another image (of blood and dog hair on a bracelet) convinces us that she has been killed or at least hurt. It is suggested, if not explicitly so, by parallel of their bodies in love with themselves and with 'nature', that she is one of Trébor's feminine souls, namely, his body, his pleasure. The Russian is the other part of his femininity: his conscience, his guilt, the voice of his soul – not necessarily a moral soul but one heavy with memory, with vigilance and self-interest. The wild girl does not speak (unless she is the one whispering during the opening credits, in obscure language that includes mention of 'giving a heart' – but it could be someone else; I will return to that). The Russian, however, does speak, in a sharp, lacerating manner; or she sends electronic messages. She tortures Trébor as well as his son, while the wild girl – in reality or in a dream – is herself tortured. While the Russian declares that Trébor's heart 'is running on empty', the wild girl, perhaps, hoped for nothing more than to share her heart with him.

Two women are caretakers. The village pharmacist, who is shown performing her function in order to emphasize it, brings Trébor his medication at the same time that she comes to share his bed, coming close to his worries. The blind Korean masseuse visits Trébor in his hotel, climbs onto the bed to massage him. The multi-faceted contrast between these two women says something about their two forms of medicine and their two worlds. The passage from one to the other is also the passage from one life to another and before that from one hemisphere to another. But Trébor will not abandon Western medicine; he will continue to take his (new) meds, and he will return to the hospital (if we can say 'return', since we saw nothing of the first hospital or of the transplant). In this new hospital, in Papeete, he is observed by two nurses with sweet and young faces whose expressions betray both tenderness and something like a worried interest in this sick man, who must be exceptional here. But their faces also signify, in this brief distraction from their medical tasks, that medicine is not the point here...

Heart sickness is the province of the man; the treatment – if not cure, which may be impossible – and care is the province of women. But at the same time, their doubling signifies that it has less to do with medical technique than with the impossible 'technique' of a true change of heart, of an interior metamorphosis for Trébor, of the conversion or revelation that the 'beloved

son' might represent. Because the whole world of which he is capable is tied up in this 'beloved' – all the love that might after all be nothing, or nothing but these very words, nothing but this nearly silent incantation.

Two of the women are mothers – the customs officer and the Marquesan. Both of them are doomed by Trébor to suffer in their maternity: his impossible paternity is the double of their damaged maternity. The other women are childless: he is their child, under their care or even under their surveillance, under their gaze – troubling, attentive or distant; mocking or even blind and consequently able to see straight into his heart.

What is the affinity shared by the dogs and the women? The pre-sentiment of intrusion. The dog trained by the customs officer knows how to sniff out illicit merchandise, the Russian's dogs know how to track Trébor the same way his own dogs intuit strange approaches in the night and the breeder's dogs excitedly sense the approach of Trébor's. His dogs (which are, not accidentally, females), once he abandons them because the breeder refuses to watch them (surely sensing his imminent flight), lose no time finding the wild girl and the body or bodies beneath the ice. At the end, when Toni approaches a house to which someone has directed him, where he will learn the truth, it is one of the Russian's dogs that barks – the ones that keep close to her when, from afar, she observes people exiting the morgue.

Dogs are at the intersection of the natural and the foreign. Trébor, lying nude in the sun, curls up with one of his dogs like he would with a women, and when his lover comes to see him she caresses his dogs with affection. Dogs are pure affect, but this affect is also what puts them on alert, whether in the night when a prowler approaches or in the frozen plains when the ice is hiding a corpse. While Trébor warms himself in the sun, one of the dogs intuits the presence of someone whose silhouette then appears between the trees.

The kinship between dogs and women intensifies in the well-appointed carriage the breeder drives – amidst loud snaps of the whip and cries of encouragement – with alacrity through the snowy forest. It speeds ahead toward other strangenesses, toward other possible intrusions; it speeds ahead, the ultimate irony of fate and the undecidability of pathways and passages resounding in the driver's manic laughter, which also betrays the jubilation of a director who has thrown her film *a grandes guides* toward the depths of her own strangeness.

The obscurity of the closing shot resembles that of the opening, as we return to the woman with a barely audible voice – and a face one can only guess at – whispering over the credits. Among the words and phrases we think we discern are 'I hear you' and 'give a heart'. Is this woman the Russian? Nothing is confirmed. But it could be that the ultimate ambiguity, the enigma of intrusion, is at play here in a strange love act between this avenger and her sworn enemy.

But this secret, like all the others, this real or merely simulated secret – simulated between the characters whose relationships with each other will never be clearly established and simulated by the filmmaker for us (our relationship with her also unclear) – is carried off, along with the whole film, by the most secret one of all, the woman who trusts in nothing but the furious running of her dogs.

17 Still from *L'Intrus*

18 Still from *L'Intrus*

Part IV
Within Film

Part IV
Within Film

11

Delivering: Claire Denis's Opening Sequences

By Noëlle Rouxel-Cubberly

Dark, muffled, fluid, raw, and finally eruptive. The opening sequences of Claire Denis's films share specific features that also characterize the birth process, making them the loci of a (re)naissance *par excellence*. If these very first moments of Denis's films are pregnant with the films' substance, they also exhibit common traits with the gestation process, such as muffled sounds, cave-like background shades, an intruding sense of intimacy and, finally, the vivid colours of an emerging life.

Opening sequences have been compared to genesis and ontogenesis.[1] In her book on opening sequences, Laurence Moinereau devotes a chapter to this comparison. Alexandre Tylski, in *Le Générique de Cinéma* (Opening Sequences in Cinema), mentions these lexical 'neighbours' – *générique, généalogie, génération, genèse* – and quotes Thierry Kuntzel's designation of the opening sequence as the 'generating matrix of the text' (*matrice génératrice du texte*). He also refers to André Gardiès's comparison of the opening sequence with an embryo (2002:13). The films of Claire Denis invite the critic to push this analogy a bit further, as spectators are physically involved in their first moments of encounter with each of her creations. Every title sequence could actually be described as a cinematographic birth: first of all, the spectator slowly comes out of the initial darkness through a very long process (with opening sequences that sometimes last over eight minutes), struggling to decipher the enigmatic sounds and images of an unknown, yet familiar, world. Just as the very first conversation between the policemen in *I Can't Sleep* is barely audible, the young woman at the beginning of *L'Intrus* is barely visible. Not only do Claire Denis's opening

scenes require the audience to 'prick up' its senses from the very beginning, but also they force an abrupt meeting with the characters, as happens in a birth. From *Trouble Every Day* to *White Material*, from *No Fear, No Die* to *35 rhums*, characters appear at a personal, intimate moment of their lives: a woman meeting a sexual victim (*Trouble Every Day*), young people meeting while dancing in a club (*Beau Travail*), a man, 'le Boxer', meeting death (*White Material*). Finally, the overarching (musical) theme of fluidity and movement is omnipresent in these introductions, either with a body of water (the sea in *Chocolat*, the swimming pool in *Nénette et Boni*, the river in *Trouble Every Day*) and/or a road (*Trouble Every Day, No Fear, No Die, 35 rhums, White Material*). This symbolic element facilitates the crossover, the entrance into this 'other' world, the world of fiction – or, as Odin puts it, 'l'entrée du spectateur dans la fiction' (1980: 208).

Beyond the numerous references to a symbolic gestation, Claire Denis's opening sequences see the collision of various sensory elements that engender trademark scenes, often detached yet coherent with the rest of the film (the phone card scam in *I Can't Sleep*, the mysterious young woman in *L'Intrus*). In Claire Denis's films, and more so in her title credits, the intellectual process is hindered by this overwhelmingly sensory process – as it is during a birth. Before making sense of the story, the spectator is thrown into a world of new sensations, as suggested by the title of Rémi Fontanel's book, *Le Cinéma de Claire Denis ou l'Enigme des Sens* (*sens* means both 'sense' and 'meaning' in French). This double birth, the spectator's through the film's, allows Claire Denis to leave, in turn, her imprint in a perceptible artistic filiation.

This analysis is divided into four main parts; the salient characteristics of these title scenes – obscurity/silence, fluidity/transportation, corporeality and filiation – will be closely examined. Simultaneously, examples from Denis's opening sequences will illustrate these birth-related traits as the film first unfolds. This chapter seeks to demonstrate the power of these key moments in Claire Denis's cinema, their signature role and, beyond the trademark, the mark they leave in the history of cinema.

Obscurity/Opacity

No Fear, No Die, Beau Travail, Trouble Every Day, Friday Night, L'Intrus and *White Material* all emerge from the dark – these titles appear against a black backdrop, echoing the sombre connotations they display. In her book on opening sequences, Laurence Moinereau mentions specific examples of striking black-screen beginnings, from Renoir's *Boudu* to Godard's *Alphaville* (2009: 206). These opening seconds of the film, these moments of 'non-vision', as Metz put it, work as punctuation signs (2003: 134), the end of a previous life

and the passage into another one. In most of Claire Denis's opening sequences, the dark screen dissolves into a succession of obscure scenes, either because of the dark shades of the picture itself or because of their unclear relation to one another. In *Nénette et Boni*, for instance, the spectator struggles to find a coherence between the very first scene, where a man tries to sell phone cards to African immigrants and that of Nénette swimming in the pool.

This figurative or concrete night hypnotizes and invites the spectator to access a new world. Sheltered a bit longer than usual in this obscure cocoon – these opaque scenes extend the darkness of the screening room – the spectator then labours to decipher the film. As Barthes puts it, 'Inclusum labor illustrat: because I am locked in, I work and shine with all my desire' (1957: 104).[2] There is, indeed, a particular communion between the spectator and the opening scenes, a sort of 'forced marriage', where each side searches for the projection of his/her own shining reflection – the film appeals to the past experience and knowledge of the spectator while the spectator uses his/her background to read the film.

Moreover, Claire Denis's opening sequences tend to evacuate the written and spoken word that would shed too crude a light on to this deciphering process. Even her titles, behind their apparent straightforwardness, represent cryptic clues. Snatches from trivial conversations, Denis's film titles (e.g., *S'en fout la mort, J'ai pas sommeil*) add to the complex perception of the film's visually and aurally enigmatic tones and rhythmic pace, more than they point at possible diegetic directions.

This semantic obscurity plays a crucial role in the unfolding of the film. Puzzled by the Denisian film title – this 'lost fragment of the diegesis' (Odin 1980: 200) – the spectator now tries to solve this mysterious element. The desire for fiction is triggered and the spectator strives to make sense of this opaque mirror. In fact, opening sequences could be compared to Plato's cave with distorted shadows, since they usually intensify and magnify certain key aspects of the film. But unlike the chained and duped individuals of the cave, the spectators feel their senses become unleashed, allowing them to better see what is at stake. Paradoxically, the obscurity is necessary to shed light on to the overlooked trivial aspects of our lives that actually reveal deep changes (e.g., Laure packing to move in *Friday Night*).

Silence

Matching the sombre and plain tones of *L'Intrus*'s opening cave or *Trouble Every Day*'s nocturnal kiss scene, the soundtracks accompanying these opening scenes are bare. As opposed to the distinctive sounds of conventional opening scenes (e.g., orchestrated music, the blowing whistle of a train), Claire Denis opens her films either with barely audible noise, soft songs or mumbled speeches against

a black background. This muffled auditory entry into the fiction mimics the child's first auditory apprehension of the world from the womb – subdued sounds, more than clearly articulated speeches, offer another sensory perspective into the 'outer-cocoon' life. As Tylski writes, quoting Denis Vasse's *L'Ombilic et la Voix* and Michel Chion's 'Toile Ombilicale': 'If so many films first start with sound, before any real image, aren't they replicating the prenatal stage when the child can hear before seeing and being born?' (2008: 60).[3] In Claire Denis's opening sequences, the sound seems to arrive by consecutive waves, reinforcing the impression of discovering new shores. Such is the case with *Beau Travail*: after a few notes, the sound of the sea becomes more and more audible before the song of the 'Légionnaires' emerges, as the camera pans over a colourful fresco.

Music obviously represents a crucial element of these title sequences' soundtracks.[4] Many include scores composed by the Tindersticks, with whom Claire Denis collaborates very closely. Indeed, their haunting music has become a recognizable feature of Claire Denis's cinema. Distinctive musical features for these title sequences include these long intriguing chords (*Friday Night*, *L'Intrus*, *White Material*). Claire Denis fully explores the potential of this initial setting, allowing her spectators to vibrate (*entrer en vibration*, as Odin puts it (1980: 213)) with the film. This comparison also fits Deleuze's reflexion on harmonics that resonate on to other sensory faculties. In *Chocolat*, the written credits unfold just like the waves of this opening scene, as the sound of the ocean gradually arises, submerging the viewer into a meditative state. Conversely, fear becomes palpable as the viewer of *White Material* hears the haunting and ominous first chords of the soundtrack while the handheld camera, moving slowly forward, captures a pack of dogs crossing a rural road in the night.

Undeniably, the viewing of Denis's title sequences represents a full multisensory experience. Fontanel suggests that this minimalist music makes the spectator 'hear' the images (2008: 151). Indeed, the senses merge into one another, once again putting the spectator in the position of a newborn using all her senses to identify her surroundings. Interestingly enough, whether mumbled or sung, the first words are barely understandable, as if to put, once again, more emphasis on the visual dimension.

Reflecting the mystery of birth, Claire Denis's opening sequences, like much of her cinema, remain opaque (as Bergstrom asserts). As Jousse pointed out about *Chocolat*, 'one of the strengths of the film is precisely that it explains nothing' (1998: 132–3). Right from the very beginning, a non-verbal communication is established between the spectator and the film, following the lines of the Kristevian 'chora' or 'semiotic' (1974: 22–3), the pre-linguistic symbiosis with the mother. The credits traditionally appear in print in the opening sequence. However, Claire Denis tends to cinematize her titles; for instance, the letters

of '35 rhums' appear in glowing yellow letters inside a train tunnel, whereas 'Trouble Every Day' shimmers on the surface of the river. And indeed, throughout these opening sequences, an opacity, pregnant with unleashed meaning, floats, shaping from the very beginning 'the dreamlike irreality of the film' (Bergstrom 2003: 99). In Claire Denis's opening sequences, obscurity represents the passage into new life, as opacity denotes its depth.

Corporeality

Much has been written on the corporeality in Denis's cinema (for example, in works by Beugnet, David, Fontanel, Mayne), on its physicality, on the raw quality of these filmed bodies. She actually declares: 'Capturing bodies in film is the only thing that interests me' (Jousse and Strauss 1994: 25).[5] Indeed, this assertive statement corresponds to a specific way of inscribing the body at the very heart of her opening sequences. In fact, her title sequences, first and foremost, capture private bodies. Whether filming cops laughing at raunchy jokes (*I Can't Sleep*), a girl swimming in a pool (*Nénette et Boni*) or a dying man (*White Material*), Claire Denis offers, as mentioned previously, an extremely intimate depiction of human energy but without ever being intimist. Her camera observes these bodies but never pries into them. In fact, these initial raw cuts into her characters' everyday privacy touch upon much wider socio-political realities – the police's inability to catch a murderer, a girl's unwanted pregnancy, a soldier victim of ethnic conflicts.

However, this physicality is also deeply felt by the spectator. Among the non-narrative pleasures of the opening sequence (Allison 2001: 10), songs, images, and unexpected cuts also stimulate the viewer, eliciting at times 'a visceral response' (Allison 2001: 75). From the catchy rhythm of Tarkan's song in *Beau Travail* to the nocturnal perambulation on an African path in *White Material*, Claire Denis certainly shapes our narrative pleasure (anticipation, excitement, fear). As Fontanel writes, in Claire Denis's cinema, the image itself is 'considered as fertile, boisterous, active...alive and can (must) be mixed, kneaded, penetrated...' (2008: 142–3).[6] He then suggests reading her title sequences as overtures, opening on to time, diegesis and image. These openings of Denis's title sequences also announce the birth of her characters on to the screen as we feel for their predicaments without ever knowing or caring to know about them.

These bodies we follow are enclosed in restricted environments (a woman in a cave, policemen in their helicopter, Daiga in her car), often analogous to a womb. Denis is actually famous for the 'strong spirit of collaboration' of her film crew (Mayne 2005: 18). In an interview, Claire Denis actually explains how she and her actors would prepare for a film as if in 'a kind of a womb' (Romney

2000: 4); she also mentions the 'very erotic relation' she has with her actors (Mayne 2005: 144–5). It's no wonder a tremendous sense of intimacy emanates from all her films. In *Friday Night*, the use of montage creates a feeling of intimacy, all the more interesting as 'cold colours', such as blue, black and darker tones, dominate the film palette. This peculiarity creates an interesting 'feeling of memory within the present instant' (Archer 2008: 256). As David states, 'For a long time, there were no bodies in cinema' (2008: 128).[7] I would suggest that not only does Claire Denis give birth to these ignored bodies, but also revels, right from the very first scenes of her films, in their cinematographic birth.

Fluidity

Not only do many of Denis's films start in or near water, a highly maternal element (David and Fontanel 2008: 88), but also they convey a sense of fluidity. As a matter of fact, critic Anne Diatkine compares the fluidity of *35 rhums* to the fluidity of jazz, comparing the film to a never-ending opening sequence.[8] Rémi Fontanel, in his analysis of Denis's opening sequences, notices the fluidity of the written credits in *Chocolat* and their tearing up the time of a still photograph (he actually italicizes the verb *déchirer*) when the son and the father emerge from the water and the film starts (Tylski 2008: 145). Interestingly enough, France, the young woman, does not belong to this symbolic birth – later on, the little boy is seen in the water playing with clay-like sand. This female protagonist appears after, as if in an inverted birth; the film can be born and unfold only without France. What is more, the name 'Claire Denis' appears last as the camera starts panning over towards France, 'flowing' out of the credits. Claiming the maternity of her film, she also separates the protagonist, France, from the two African males, at the same time that she bonds to them. This reverse Birth of Venus[9] also stresses the importance of the gaze within the making and watching of the film – mirror-character France not only belongs to the film (with her, the film can start), but also represents the fiction that her African past has become.

In the same vein, Nénette revels in the water before being violently extracted from this reverie (and reborn) to the harsh reality she faces: a teenage pregnancy. Closing this opening sequence, the letters of the title, *Nénette et Boni* (who are themselves motherless), ripple like the water of the next shot. Judith Mayne has compared Nénette to Ophélia (2005: 72), which, here again, evokes this problematic relationship to maternity – in fact, her brother, Boni, ends up being a mother to the child. Boni, sexually aroused by the baker's wife, exchanges a conversation with her about these 'invisible fluids' that attract two people to one another. Frederic Strauss suggests that 'the "secret chemical dialogue" of which she speaks is also what Claire Denis aims to achieve in the relations between images' (1997: 65). I would, in turn, suggest that this dialogue is

also a relationship she builds between her film and her spectator, allowing the latter a symbolic rebirth through the former. Fluids, indeed, also belong to the vocabulary of magic and, just like mothers, have the mysterious power to conjure up new forms.

The Road/Transportation

The impression of fluidity conveyed by Denis's opening sequences also come from her recurrent use of movement (Mayne 2005: 10, 20, 30) and, more specifically, of cars or trains, a conventional beginning for fiction films. However, Denis's roads never represent a starting or ending point. In a video interview about *35 rhums*, she comments on the RER (the train that connects Paris to the suburbs) and explains her interest in the back-and-forth movement rather than the exploratory aspect of the road. She says:

> Transportation, that's what speaks to me... in other words, maybe the comings and goings sometimes... everything that gives me time, that allows me to see – again and again – the same landscape at different times, in different lights, during different seasons, rather than hitting the road. Maybe because, fundamentally, I'm someone who dwells upon things more than I follow the road. That's it. The shuttle between... the RER, that really speaks to me.[10]

This fluid movement is also adopted by the camera itself, as movement and passage are key in Denis's work (Mayne 2005: 61). Mayne comments on the opening sequence of *Nénette et Boni*, with its 'tight shot of a man selling cards [before the] camera moves around the room' (2005: 70). As she explains, 'We are close to the individuals, but we really cannot tell who they are (there is no establishing shot)' (2005: 70). The same directorial choice actually applies to most of her opening scenes. The meandering camera moves around (Durham 2003: 122), gazing in *Friday Night,* hypnotizing in *35 rhums*, inquisitive in *White Material*. Interestingly enough, the camera, as it hovers over Laure's moving boxes in *Friday Night,* pauses on a box where she has written 'A DONNER MAMAN' *(to give Mum)*. Since Claire Denis uses words so sparingly, even in her credits, this inscription raises a series of questions: the obvious (is it, though?) meaning is 'things to give to Mum', but one can also understand that a Mum is given away, which is, in a way, Laure's likely bourgeois fate, unless she decides to 'mother' her own fate (as she does later in the film), mirroring the act of creating one's own film. In fact, the last box shown in this panning movement is marked 'CD'. An obvious reference to music (so inspiring for Claire Denis), these initials are also underlined, unlike all of the other inscriptions, allowing the director to sign, acknowledge or 'mother' this opening scene of her film.

Throughout her opening sequences, this meandering camera figures the birth of Denisian characters that are delivered by the camera more than they are constructed with psychological traits. The camera performs the artistic birth of 'bodies in motion, approached as objects of wonder and curiosity' (Mayne 2005: 81). From the opening scenes, Denis's characters appear as Protean, in osmosis with her 'travelling films' (Hall 1992: 47). In fact, her characters personify a 'world of movement, of migration, of the dissolution of boundaries, of national borderlines' (Hall 1992: 47).

Denis's film beginnings catch her characters on a floating stage. The timelessness of the credits (Odin 1980: 206; Archer 2008: 248) make Claire Denis's opening sequences look like ukyio-e[11] prints, these 'pictures of the floating world', since they represent a transient stage, an 'intermediary zone ... providing a focus that allows for a transition into the movie' (Stanitzek 2009: 44). But unlike the traditional opening sequence, which allows the spectator to slip into fiction, Claire Denis's opening sequences allow the spectator to slip into reality and, what is more, his/her own reality. As Stanitzek puts it, the opening sequence represents the 'switch from the outer to the inner side of fiction – a 'crossover' (2009: 57), a mandatory stage to reach one's own and true identity.

This floating moment, in Denis's films, also bears some resemblance to the labour that precedes the birth. Often long and slow (more than eight minutes long in *L'Intrus*), Denis's credits also initiate a reflexion on time, a non-linear time stressed by never-ending, and never really beginning, title sequences (Fontanel 2008: 151). If opening sequences set a pace, Claire Denis's title credits impose a decelerated rhythm on to the spectator. Along with long chords (*White Material*, for instance) or slow music (*Trouble Every Day, Friday Night, 35 rhums*), uncommon technical choices, such as extreme close ups or erratic camera movements, force the spectator into the film's own pace. Only through this visual and aural 'breathing' can the spectator fully experience the Denisian film. This floating moment seals his/her bonding with the artistic work and, more deeply, with his/her own understanding of the renewed self through the cinematic experience.

Filiation

Claire Denis also reveals an acute sense of the artistic filiation from the very beginning of her films. A film such as *Beau Travail* not only refers to Melville's *Billy Budd, A Sailor*, but also refers to her appropriation of a literary monument. Through the expression *belle trouvaille* (nice find) used to qualify Sentain, the catalyst element of the story, she also feminizes her own title, both acknowledging and twisting her literary heritage. With this filmic masterpiece,

she could almost chant 'the king is dead, long live the king'. And if she does not mention Melville as a source of inspiration in the credits, she does, and more efficiently so, through her directorial choices.

Her opening scenes, like her films in general, stylistically owe much not only to Renoir, Bresson and Godard, but also to Oshima, Fassbinder, Friedkin, Imamura, Ozu, Wong Kar-Wai, Hong Sang-Soo, Kurosawa and Wim Wenders (David 2008: 65–67). However, she also often refers in her interviews to literature and to the influences of her readings. This is particularly tangible through the 'christening' of her characters. Caroline Durham traces the filiation between the driver, 'William J. Park', who is first seen in *Chocolat* with his son and is later called 'Mungo' (2003: 126–7). Durham explains that Mungo Park was an eighteenth-century Scottish explorer and demonstrates that, through him (a character not from Cameroon, but from the United States), Claire Denis talks about false homecomings, 'confirming that her film functions explicitly as an allegory of *nation* [Durham's emphasis]' (2003: 128). In fact, if Mungo cannot find himself in Africa, how could the daughter of ex-colonizers do so? Mungo Park tells her to leave Africa.

Another example is Maria Vial. First seen in a light summer dress, she also reveals a thin, yet strikingly powerful body. Later on in the film, a child soldier picks up a gold-plated Dupont lighter with her husband's engraved initials 'A. V'. Read in French, these letters correspond to the past tense of the verb 'to have' (*avait*); these two sole letters describe exactly what Maria is afraid to become – one who 'used to own', just like a colonizer forced to surrender. This lighter is also a direct reference to the title as, in Pidgin English, it is 'white material', which is a dismissive term for the superfluous goods belonging to the Whites – it also obviously refers to the Africans' plight as a result of the colonization. The pidgin filiation of the title certainly resonates throughout the film, giving it an ever-darker meaning while avoiding any sordid form of realism. Through her films, Claire Denis not only pays tribute to her inspiring predecessors, but she also reshapes various forms of filiations with gender and generation reversals (David 2008: 191) and with unexpected off-centred perspectives.

Claire Denis's opening sequences relate to both the human and artistic birth, carefully staging the spectator's rebirth through the film and the film's birth itself. Thanks to a carefully crafted osmosis with the film, the spectator discovers always-renewed perspectives that make each Denisian film a regenerating experience. Her treatments, both raw and soft, of these opening scenes reveal a never-ending reflexion on the status of the filmic representation, its inscription in our cinematic experiences and on to the screen of our fantasies. Through obscure, but traceable, filiations, embodied by these atypical credits, Claire Denis engenders and signs an uncompromising approach to the film experience.

Sharing with her viewers a uniquely perceptual understanding of the opacity of (the human and artistic) birth, she places her cinematographic work at the core of the human experience. More precisely, her opening sequence, while paying tribute to its contributors, places the spectator's multi-sensory gaze into its epicentre. This redefined, liberated spectatorship, purposefully disorienting, also brings us closer to a fascinating, birth experience.

Notes

1. The development of an individual organism, from embryo to adult.
2. 'C'est parce que je suis enfermé que je travaille et brille de tout mon désir'. All translations are mine.
3. 'Si tant de films débutent d'abord par du son, avant toute image proprement dite, ne réitèrent-ils pas le stage prénatal lorsque l'enfant entend avant de voir et de naître?'
4. On this subject, see Fabrice Fuentes's chapter, 'La Fibre musicale', in *Le Cinéma de Claire Denis ou l'énigme des sens*, David, S. and R. Fontanel (eds.) Lyon: Aléas, 2008.
5. 'La prise du corps est la seule chose qui m'intéresse'.
6. My translation of Fontanel's words: 'L'image est considérée comme fertile, remuante, active...vivante et peut (doit) être malaxée, pétrie, pénétrée, traversée...ouverte...'
7. 'Longtemps au cinéma il n'y eut pas de corps'.
8. 'Fluidité des images et beauté des acteurs obligent, *35 rhums* coule comme une musique de jazz [mais] donne le sentiment de ne jamais vraiment commencer. Comme un générique qui n'en finirait pas'. (Because of the fluidity of the images and the beauty of the actors, *35 rhums* flows like jazz music [but] gives the impression that it never really starts. Like an opening sequence that would never end.)
9. Sébastien David also comments on another reverse and transgender birth: in *L'Intrus*, the son gives a second birth (and his life) to his father through a heart transplant in *Le Cinéma de Claire Denis ou l'énigme des sens*, Lyon : Aléas, 2008.
10. 'Ce qui me correspond, c'est les transports, c'est-à-dire peut-être les va-et vient parfois. C'est tout ce qui me laisse du temps et me permet de voir et revoir un même paysage à plusieurs heures, sous plusieurs lumières, sous plusieurs saisons, plutôt que de tracer la route. Peut-être parce que fondamentalement, je suis quelqu'un du ressassement plus qu'une tailleuse de route. Voilà. Ça me correspond bien la navette entre...que fait un RER'.
11. Ukiyo-e is a Japanese art movement that spanned from the seventeenth through the nineteenth centuries. It depicted the everyday life of artisans, merchants, actors and geishas.

19 Still from *Nénette et Boni*

20 Still from *Friday Night*

12

Rhythms of Relationality: Denis and Dance

Laura McMahon

> *Because cinema has its centre in the gesture and not in the image, it belongs essentially to the realm of ethics and politics (and not simply to that of aesthetics).*
>
> Giorgio Agamben, 'Notes on Gesture'[1]

In *Alliterations* (2005), a collection of conversations about dance between Claire Denis, the philosopher Jean-Luc Nancy and the choreographer Mathilde Monnier, Monnier comments on the fact that Denis's films are often described as 'a choreographic treatment of the image, of movement'.[2] While perhaps the most persuasive example of this can be found in *Beau Travail* (1999), Denis reveals that the first of her films to be described in terms of choreography was *S'en fout la mort* (*No Fear, No Die*) (1990), with reference to the scenes of dance between Jocelyn (Alex Descas) and the cockerels that he trains to fight. Emphasising the dance-like dimensions of *S'en fout la mort*, Martine Beugnet reads the balancing movement of Descas's gestures and the 'whirl of beating wings and feathers' in terms of 'the seductive choreography binding man and animal that the camera records'.[3] Denis recounts that during the test shots, when she and her director of photography, Agnès Godard, realised that they themselves 'had to be moving in order to accompany the actors', they decided to use a handheld camera for these scenes.[4] *S'en fout la mort* details the experiences of Jocelyn and Dah (Isaach de Bankolé), who arrive in France from Bénin and the West Indies, respectively, and struggle to make a living there. Denis explains that, given that the film was dealing with underground spaces and clandestine bodies, she felt unable to use conventional modes of film composition, such as a static frame or a travelling shot:

We had to be clandestine with the camera, we had to *accompany* them and walk next to them, into their 'cupboard under the stairs' where they trained. At that moment, we no longer had any doubts about the handheld camera – it sealed something between us, between Agnès Godard, Alex Descas and me. The reason for our choice wasn't aesthetic at all but visceral.[5]

Privileging the affective rather than aesthetic dimension of this relation, Denis goes on to suggest that 'the movements of the actors and of the camera were linked by a temporal and spatial decision and, I'd also say, by a solidarity with the characters of the film'.[6] While film traces the gestures of dance here, filmmaking itself becomes a form of dance, opening to modes of accompaniment and commonality, between beings both on screen and off.

In this chapter, I explore dance in film and filmmaking as dance, in an attempt to address the rhythmic forms of commonality and accompaniment – or solidarity, as Denis puts it – that these intermedial relations might engender. In order to avoid treating scenes of dance in Denis's work simply as dance rather than dance mediated by film, I seek to emphasise the specifically *filmic* contours of these particular forms of movement.[7] Reminiscent of Maya Deren's concept of 'chore-cinema', in which, as Sherril Dodds notes, 'dance and the camera are inextricably linked',[8] the scenes that I discuss here act to elaborate tensions of relationality – between bodies on screen yet also between viewer and film – as cinematic time and space are rhythmically reconfigured via a focus on the gestures of dance. In resonance with Giorgio Agamben's observation in the epigraph shown previously, the filmic choreographies explored here are not only aesthetic, but ethical and political, too. The rhythms of commonality ushered in by these filmic accompaniments of dancing bodies can be seen to articulate an ethical and political model of syncopated togetherness that it is Denis's concern to emphasise throughout her work. Though my focus remains on scenes of dance throughout this chapter, I wish also to suggest a broader understanding of choreographic cinema that extends beyond the literality of dance and engages with a more implicit structure of inter-rhythmic resonance between images and sounds.[9]

Working closely with choreographer Bernard Montet on *Beau Travail*, Denis orchestrated the stylised scenes of the Legionnaires moving together in order to give the impression of what she calls 'a single body...a military ideal'.[10] In the early scene in which the Legionnaires, standing apart, raise their arms to the sky in unison, a seamless vision of sameness is constructed through the harmonious formation of bodies,[11] the aestheticised fraternity and unity of which is emphasised by the all-male operatic chorus of 'O heave!' from Benjamin Britten's *Billy Budd*. As Beugnet and Sillars suggest, these scenes configure the *corps d'élite* in a space of timelessness, invoking age-old connections

between dance and war, exploring both the mythic dimension of the Legion and a progressive exhaustion of that myth.[12] Underlining the choreographic elements at play, Beugnet observes:

> Agnès Godard's camera work functions as a relay to the movement created by the choreography. Via the editing, it creates an alternation of brief shots of straining individual bodies and ensemble shots where the unity of the group is recomposed and reaffirmed, the singular subsuming behind the rule of discipline.[13]

Beugnet's comments highlight the ways in which the dance-like dimension of *Beau Travail* works through filmic form as well as on-screen gesture. Through framing, the alternation of shots (slow pans, medium and long shots) and recomposition, the rhythm of the film adopts a form of ceremoniality in response to the movement of bodies on screen, creating a 'relay' of choreographic exchange – a form of 'chore-cinema'.

Such sequences of ritualistic, harmonised movement emphasise the logic of the self–same underpinning the Legion – a logic that is not only aesthetic, but also political. These images (accompanied by Britten's opera) recall what Jacques Rancière, writing on Plato's designation of aesthetic regimes of the political, describes as 'the *choreographic* form of the community that sings and dances its own proper unity.'[14] As a symbol of the ideal of fraternity central to the conjoined myths of French nation and military, the Legion seeks to establish a network of harmonious, homosocial bonds, producing a collective identity that would override any racial and religious difference between its members.[15] For Nancy, *Beau Travail* explores a particular theologico-political order in which the Legion remains imbued – an 'a-religious', closed, hierarchical system invested in replaying its own image (or icon) of sacred power back to itself.[16] As in Rancière's reading of Plato, here in *Beau Travail*, choreographic movement aesthetically conditions and configures a partitioning of political forms, rhythmically inscribing collective identity and communal sense.

However, *Beau Travail* builds this vision of sameness, only to undercut it. Central to the film's unravelling of the Legion's myth of communal fusion is the progression from scenes focusing on the idealised unity of the *corps d'élite* towards scenes showing the fracture of that collective body. The 'dance' sequences are key in tracing this shift from fusion to fission, moving from 'a rapturous but undifferentiated vision of physical sameness and choreographed movement' towards 'images of clasping, contact, rescue and conflict...'.[17] Given the retrospective framing of the narrative in terms of the fetishistic investments and melancholic attachments of Galoup (Denis Lavant), which focus increasingly on his destructive obsession with Sentain (Grégoire Colin), this move towards fission may be read in terms of a subjective, idealised vision

that progressively falters.[18] At the same time, the framing of the narrative is never securely anchored in Galoup's subjectivity – as the iconicity of the Legion choreographically unravels, the film weaves complex relations between the subjective and the collective, between the singular and the plural. The scene in which bare-chested Legionnaires repeatedly collide marks out the spacing of singularities, and the limits of collective fusion, through the reiterative thud of skin-to-skin contact. Such scenes suggest a rhythming of more disjunctive forms of relationality, which are simultaneously aesthetic (moving from integration to aggregation), affective (ambiguously filtered through Galoup's fantasmatic investments) and political (as the harmonious logic of homofraternity unravels).

Yet integral to *Beau Travail*'s probing of this a-religious order is its emphasis on the Legion's encounters with the Djiboutian community, as the film maps out instances of intercultural contact and post-colonial tension.[19] In one of the opening scenes of the film, the Legionnaires are shown dancing with a group of Djiboutian women. Flickering disco lights and the pulsating rhythms of a pop song, Tarkan's 'Simarik', render the scene sensual and tactile, as the close-up, handheld camera movement shifts between the uniformly starched shirts and shaven heads of the Legionnaires and the varied patterns, fabrics and hairstyles of the women.[20] Here 'the stark contrast between the closed economy of the legion and the open exchange of the Djiboutians'[21] explored throughout the film is condensed into a set of visual, aural, tactile rhythms. Julia Dobson points to 'a complex dynamic between spectacle and agency' here, which works to interrupt both the male neo-colonial gaze within the *mise en scène* and spectatorial modes of objectification.[22] The indeterminate sexuality of the Legionnaires contributes further to an ambiguous positioning of the dancers, engendering a subtle queering of relationality.[23] As the dancers intertwine, the uniform(ed) (queer) body of the Legion is shown to be dispersed by the racial and sexual difference of the Djiboutian women, in a form of co-exposure and contact or what we might call, drawing on Nancy, *being-with* – that is, a mode of commonality without communion, without hypostatisation into any one collective identity.[24]

Thus, in *Beau Travail*, dance configures different modes of commonality, shifting from the harmonised movement of a closed, a-religious order reliant upon a logic of the same towards a set of disharmonious yet open rhythms of togetherness, in which forms of relationality are realigned and reconfigured – between bodies on screen and between viewer and film. The close-up, haptic dimension of the disco scenes, subtended by a resistance to viewerly purchase and possession,[25] invokes the issues of accompaniment and solidarity of which Denis speaks in relation to *S'en fout la mort*. Drawing on Denis's own use of the term 'solidarity' in discussion of her work,[26] Forbes Morlock suggests that Denis is interested in ways in which her films 'may engender unforeseen

connections or solidarities', whereby '[s]olidarity would not be a solid relation but instead a relation with the solid, an alliance with that which resists'.[27] This non-appropriative dimension of 'solidarity' offers a way of thinking through the rhythmic, yet resistant, interplay between filmmaker and filmed subjects, between bodies on screen, and between viewer and film. As film becomes a mode of envisaging *and* engendering forms of solidarity, Denis weaves choreographic forms of alliance to that which elides categorisation, to that which eschews totalising orders of knowledge. This recalls Agnès Godard's description of her camera work as not voyeuristic but rather as a mode of looking and loving – even dancing – without exhaustive knowledge.[28]

The issue of dance thus connects more broadly here with the question of how relationalities may be *rhythmed* through film. In her reading of *Beau Travail*, Beugnet develops concerns of rhythm beyond literal figures of dance, referring, for example, to the melodic flow of the voiceover of Galoup and to Nelly Quettier's 'symphonic' editing, which combine in non-linear forms 'to pattern the rhythm and framework of a primarily sensual vision'.[29] This formal emphasis on rhythm can be viewed in the broader context of Denis's investment in the intermediality of film, as exemplified by *Beau Travail*'s hybrid mix of music, dance, theatre, opera and literature (Melville's *Billy Budd*). As Beugnet observes, Denis's emphatic engagement with other art forms allows her work to question the habitual boundaries of filmmaking.[30] Denis's aesthetics of accompaniment thus suggests not only relations to and between bodies on screen or between images and sounds – connections between art forms themselves may also be viewed as modes of (non-appropriative) accompaniment.

A dependency on rhythm as an irregular structuring device is evident, for example, in the free jazz-like composition of *L'Intrus* (2004), another hybrid text that draws in influences from philosophy (Nancy, Deleuze), painting (Gauguin) and music (Johnny Cash), among other forms. Erratically structured through the repetitive guitar loop on the soundtrack that seems to mime the beat of Louis's failing heart, *L'Intrus* progresses like a Deleuzian *bal(l)ade* through a series of points of flight and unexpected correspondences (e.g., between Louis and the vagabond girl).[31] In anticipation of the syncopated image–sound structure of *L'Intrus* or the subtly balladic dimensions of *Friday Night*, the opening scenes of *Beau Travail* orchestrate a set of visual, aural and tactile rhythms that respond and correspond to one another (I note only a few of them here): the percussive disco beat and play of pulsating light in the nightclub scene; the hum of voices and clatter of a train as it carries Djiboutian passengers through the desert; the quivering of tufts of grass in the wind; the rising murmur of 'O heave!'; the almost imperceptible swaying of ceremonial bodies; the undulating travelling shot along the water's edge; Galoup hacking away at branches of a tree in Marseille; the scurry and scramble of a series of military exercises. Bodies,

objects, sounds and movements emerge as intimately linked across divergent times and spaces, through a non-metrical relay of corresponding rhythms that reverberate in excess of causal logic, engendering the kind of 'unforeseen connections' and unspoken solidarities described previously by Morlock. In *Beau Travail*, this dynamic of choreographic commonality incorporates images of dance and musical sounds, yet it also extends beyond such literal instances, towards a more general aesthetics of inter-rhythmic resonance.[32]

Beau Travail's rhythming of relationality reaches its apotheosis in Galoup's irruptive performance in the deserted nightclub, to the sound of Corona's dance hit 'Rhythm of the Night'. The scene recalls Lavant's acrobatic performances in Léos Carax's *Bad Blood* (1987) and *The Lovers of the Bridge* (1991).[33] Denis decided to position Galoup's dance *after* rather than before the scene of his possible suicide (in which Galoup lies with a gun) in order to 'give the sense that Galoup could escape himself'.[34] The pulsating beat of the soundtrack acts as an auditory continuation of the close-up focus on the pulse of Galoup's arm in the previous shot. As this transition between shots binds vitality to the death drive, resisting any binary opposition of life and death,[35] non-causal connections are intimated once again through an aesthetics of inter-rhythmic correspondence. In resonance with the lyrics of the song, Galoup 'abandons himself to a kinetic pattern whereby he seems to lose control of everything except his ability to be immersed in the rhythm'; as Elena del Río notes, this constitutes not a 'smooth or consistent rhythmic pattern' but rather a form of 'kinetic fragmentation' signalled by 'a hesitant pattern of fits and starts and of abrupt, deliberate stops.'[36] As kinetic fragmentation proliferates through the fractured mirror reflections of the empty nightclub space, the dance scene stages a radical dispersal of the identity of Galoup and, by extension, the collective identity of the Legion. Susan Hayward reads this scene in terms of the dislocation of the post-colonial body;[37] James S. Williams interprets it as a 'decentring, centrifugal' set of gestures that lift the film out of the 'centripetal vortex' articulated most forcefully earlier by the circling movement of the face-to-face confrontation between Galoup and Sentain.[38] As Galoup's elastic movement threatens to overflow the filmic frame, his dance acts as a figure of unmasterable excess unravelling the closed structure of the Legion, spiralling outwards in a movement from the centripetal to the centrifugal.

Such a moment (a single figure dancing) is one that Denis evokes elsewhere in her work – for example, in the performance of Camille (Richard Courcet) in *J'ai pas sommeil*. Yet Lavant's excessive movement recalls in particular Grégoire Colin's scene as the teenage Alain, dancing alone in his bedroom in Denis's *U.S. Go Home*, a film shot for television in 1994. There, filmed in one long take, to the sound of the Animals's 'Hey Gyp' blasting out from Alain's bedroom radio, Colin's movement builds frenetically towards a fever pitch, where his body,

like that of Lavant in the final scene of *Beau Travail*, stretches beyond the limits of the filmic frame. Alone in his bedroom, Alain's dance has a masturbatory dimension, yet it also conveys what Angela McRobbie, writing in the context of young adulthood and dance, describes as 'the possibility of some mysterious transformative power ... a fantasy of change, escape, or achievement ...'.[39] The dances of Colin and Lavant mobilise a contrasting range of meanings – youth, desire, rebellion for Alain; life/death, dislocation, escape for Galoup. However, bodily movement here remains mysteriously transformative; it both engenders and exceeds symbolic meaning, evoking what Nancy calls, in discussion with Monnier, 'the transmission of a gesture and not of knowledge', configured as 'a gesture detached from finality'.[40]

In a conversation with Monnier and Nancy, Denis reflects on the role of the solo dance in her films:

> I've always chosen dance to express solitude, a moment when the character is very alone. It takes the form of a monologue. I have never used dance as a moment which would reunite the characters of the film, as is often the case at the end of musicals. This solo dance is addressed to the viewer; it's like a look to camera. The idea of the solo is also an appeal, a solitary appeal to the empathy of the viewer, a cry, an outstretched hand.[41]

This vocabulary of the address or the appeal intimates an ethics of dance, or, more specifically, an ethical relation that film might enable between dancer and viewer. Rather than a spectacle of union between bodies on screen, as classically encoded by the musical genre, what Denis privileges here is a mode of empathy between dancer and film viewer that appears to precede or exceed identification. Film viewer and dancer come into contact via an ethics of relationality that takes place through the appeal or address issued by the dance on screen. This is reminiscent of Philippe Lacoue-Labarthe's thinking of the connection between rhythm and ethics:

> Rhythm manifests and reveals, gives form and figure to, makes perceptible, the *ethos* ... To this extent, then, it should perhaps be recognised that rhythm is not only a musical category. Nor, simply, is it the figure. Rather, it would be something between beat and figure that never fails to designate mysteriously the 'ethical'. ...[42]

Transposing Lacoue-Labarthe's rhythm onto the beat of Galoup's bodily dispersal, for example, suggests an ethos of gesture made perceptible to the viewer before or beyond identification with a particular shape or figure.

181

At the end of Denis's documentary on Monnier, *Towards Mathilde* (2005), Monnier takes centre stage in a performance. At stake here once more is 'the transmission of a gesture and not of knowledge', that is, 'a gesture detached from finality'. As hovering camera movement accompanies the dance, the ambient sound, projected images and split screen emphasise a dispersal of identity, the plurality of the body and a transmission of the unknown. Monnier's gestures here speak to Nancy's discussion of dance in *Allitérations* in terms of a trance, traversal or passage.[43] Nancy evokes a memory of the movement of Lucinda Childs in a performance of Philip Glass' opera *Einstein on the Beach* (1976), directed by Robert Wilson. Referring to a moment when Childs crossed the stage diagonally, Nancy recalls how this movement impinged upon him: 'I felt taken into the movement of a slanting passage, of an oblique traversal through which the body of Childs communicated a sensation which was distinct and designed'.[44]

Here, for Nancy, the mysterious rhythm of dance sounds out both an oblique traversal and a distinct beat. Yet in its oblique traversal, its slanting passage, dance remains a set of gestures through which we might come into contact with something unknown. Invoking memories of trances and ritualistic dance witnessed while she was growing up in Africa, Denis recalls:

> I had the impression that it was something which would always be refused to me – an unknown world for me. But I understood one day that, in a nightclub, you can approach these correspondences: you're dancing alone and suddenly you sense someone dancing. You don't need to see that person, you don't need to recognise them, you sense a dance, a form... and it happens in a similar way during a show, when you close your eyes and you can prolong an image or a dance.[45]

For Denis, then, viewing, feeling and imaging the gestures of dance offer ways of coming into contact with something unknown and unmasterable – a way of sensing unspoken 'correspondences'. In *Towards Mathilde*, this is how Denis approaches the subject of dance, and the subject of Mathilde – as subjects to be accompanied in their unfamiliarity or unknowability. This recalls the mode of ethical relation between filmmaker and documentary subject described by Sarah Cooper: drawing on Emmanuel Levinas's thinking of ethics as a relation to irreducible alterity, Cooper suggests that documentary subjects in particular works 'might be seen to resist reduction to the vision of the filmmaker who fashions them...'.[46] Indeed, at times the handheld camera (of Agnès Godard and Hélène Louvart) moves in close to the bodies of the dancers, particularly the body of Monnier, yet proximity yields not appropriation of Monnier's movement or discipline but rather a filmic form of coming into contact with

that which remains unknown. In discussion with Monnier, Denis says: 'I filmed you without a priori, I approached you, I tried to enter into your work'.[47] Such an act of entry might be understood here in terms of an encounter without assimilation. Hence the title of the documentary, *Towards Mathilde* – the 'towards' denotes a movement of approach rather than appropriation.

Film can thus be seen to accompany Mathilde, just as it accompanies the solo dancing bodies of Colin and Lavant or bodies in contact in *No Fear, No Die* and *Beau Travail*. Such a mode of accompaniment is also at stake in the pivotal scene of dance in *35 rhums*. In a restaurant late at night, to the sound of the Commodores' 'Nightshift', familial bonds and erotic tensions are mapped out between Lionel (Descas); his former lover Gabrielle (Nicole Dogué); his daughter, Joséphine (Mati Diop); and her prospective lover, Noé (Colin). 'Nightshift' was written as a tribute to the singers Marvin Gaye and Jackie Wilson; as Darren Hughes points out, the song is 'a remembrance of loss and tragedy', apt here for a scene that explores what Denis calls 'a sort of tragedy, in a family sense',[48] the loss of a daughter, perhaps, as she moves from father to lover. While the intimate dance shared by Joséphine and Noé is framed in a medium shot, suggesting Lionel's point of view, the camera moves in close when Lionel dances with Gabrielle (to an earlier song) and then with the restaurant owner (to 'Nightshift'), recalling the choreographic accompaniment of Descas in *No Fear, No Die*. Denis describes this close-up mode of filming the actors (particularly from behind) in *35 rhums* as 'a way of being *with* them';[49] her phrasing clearly resonates with Nancy's own notion of *being-with*, gesturing to modes of fragile commonality both on screen and off. As we have seen, such forms of relationality are not only aesthetic and affective, but ethical and political too. In *35 rhums*, the intimate logic of the same upon which the relation between father and daughter is tenderly built opens to encounters with others.[50] This recalls the disco scenes of *Beau Travail* in which the disharmonious relationalities of dance signal a resistance to any one fusional, collective identity. Disjunctive modes of commonality extend also to the reworking of actors' roles, as the dancing body of Colin appears, as we have seen, in *U.S. Go Home*, *Beau Travail* and *35 rhums*, or as Descas dances in *No Fear, No Die* and *35 rhums* (and also in *J'ai pas sommeil*), allowing, via Denis's regular community of actors, for such dances to be intertextually inflected by a shared history of gestures.

Recalling the mode of accompaniment invoked by Denis in relation to *S'en fout la mort*, dance can be seen in her work, then, as a privileged figure of syncopated commonality or solidarity, between bodies on screen, between filmmaker and actors, between viewer and film. Dance acts as a dynamic of non-possession and non-assimilation, opening Denis's cinema to an aesthetics, ethics and politics of accompaniment. In *Beau Travail* and *L'Intrus* in particular, filmic events are reconfigured beyond a logic of linear causality, creating networks of

inter-rhythmic resonance. Denis forges her own 'chore-cinema', as her films usher in forms of choreographic commonality between images and sounds across divergent times and spaces. Via a non-appropriative mode of *being-with*, filmmaking here – what Denis herself describes as a movement 'towards' – accompanies the world and accentuates its rhythms.

I am indebted to the conference organisers of 'Film-Philosophy III' (University of Warwick, UK, 15–17 July 2010) and 'Women's Filmmaking in France 2000–2010' (Institute of Germanic and Romance Studies, London, UK, 2–4 December 2010) for the opportunity to present earlier versions of this chapter and to delegates for their useful comments. My thanks in particular to Martine Beugnet and Sarah Leahy for their helpful suggestions and to Edward Holberton and Anne-Sophie Kaloghiros for their kind assistance.

Notes

1. Agamben, Giorgio, 'Notes on Gesture', in *Means without End: Notes on Politics*, trans. Vincenzo Binetti and Cesare Casarino (Minneapolis, 2000), pp. 49–60 (p. 56).
2. Monnier, Mathilde, and Nancy, Jean-Luc, *Allitérations: Conversations sur la danse. Avec la participation de Claire Denis* (Paris, 2005), p. 123; translations are my own.
3. Beugnet, Martine, *Claire Denis* (Manchester, 2005), p. 69.
4. Monnier and Nancy: *Allitérations*, p. 123.
5. Ibid., p. 124; my emphasis.
6. Ibid.
7. For an introduction to the relation between film and dance, see Dodds, Sherril, *Dance on Screen: Genres and Media from Hollywood to Experimental Art* (Basingstoke, 2001).
8. Ibid., p. 7. See, for example, Deren's film *Study in Choreography for the Camera* (1945).
9. This echoes Deren's conception of the broader rhythmic, poetic dimensions of 'chore-cinema' beyond literal images of dance, as explored in her film *Ritual in Transfigured Time* (1946). Ibid., pp. 7–8.
10. Monnier and Nancy: *Allitérations*, p. 126.
11. Beugnet, Martine and Sillars, Jane, '*Beau travail*: Time, space and myths of identity', *Studies in French Cinema* i/3 (2001), pp. 166–73 (p. 170).
12. Ibid, pp. 166–73. See also Hayward, Susan, 'Claire Denis' films and the post-colonial body – with special reference to *Beau travail* (1999),' *Studies in French Cinema* i/3 (2001), pp. 159–65. Hayward's analysis also focuses on the central role of dance in *Beau Travail*.
13. Beugnet: *Claire Denis*, pp. 108–9.
14. Rancière, Jacques, *The Politics of Aesthetics: The Distribution of the Sensible*, trans. Gabriel Rockhill (London, 2006), p. 14; original emphasis.
15. Beugnet and Sillars: '*Beau travail*', p. 168.
16. Nancy, 'A-religion', *Journal of European Studies* xxxiv/1–2 (2004), pp. 14–8.

17 Beugnet and Sillars: 'Beau travail', p. 170.
18 Ibid.
19 Hayward: 'Claire Denis' films', pp. 159–65.
20 Beugnet: *Claire Denis*, p. 112.
21 Ibid.
22 Dobson, Julia, 'Sequels of engagement: From *Le Petit Soldat* to *Beau Travail*', paper presented at the conference 'Cinéma et engagement', Nottingham Trent University, UK, 12 September 2002; cited in Beugnet: *Claire Denis*, p. 113.
23 Cooper, Sarah, 'Je sais bien, mais quand même...: Fetishism, Envy, and the Queer Pleasures of *Beau travail*', *Studies in French Cinema* i/3 (2001), pp. 174–82 (pp. 180–1).
24 Nancy, *The Inoperative Community*, trans. and ed. Peter Connor et al., with a foreword by Christopher Fynsk (Minneapolis, 1991).
25 On haptic visuality, see Marks, Laura U., *The Skin of the Film: Intercultural Cinema, Embodiment and the Senses* (Durham, London, 2000).
26 Romney, Jonathan, 'Claire Denis interviewed by Jonathan Romney', *The Guardian*, 28 June 2000. Available at: http://film.guardian.co.uk/interview/ interview-pages/0,,338784,00.html.
27 Morlock, Forbes, 'Solid cinema: Claire Denis's strange solidarities', *Journal of European Studies* xxxiv/1–2 (2004), pp. 82–91 (p. 88; p. 90).
28 'I don't like feeling like a voyeur. The most inexhaustible landscapes for me remain faces and bodies: I like to *look* at people, to look at them in order to love them. It's like dancing with someone, except with a camera you don't touch them. I just want to tell them that I'd like to put my hand on them'. Vincentelli, Elizabeth, 'Agnès Godard's Candid Camera', *Village Voice*, 4 April 2000; original emphasis. Available at: http://www.villagevoice.com/2000-04-04/film/agnes-godard-s-candid-camera/
29 Beugnet: *Claire Denis*, p. 118.
30 Ibid., p. 33.
31 See Damon Smith, '*L'Intrus*: An interview with Claire Denis', *Senses of Cinema* (2005). Available at: http://www.sensesofcinema.com/2005/35/claire_denis_interview/. Smith also mentions the rhythmic 'jazz' style of Denis's filmmaking. On the *bal(l)ade* form of Denis's films, see also Beugnet: *Claire Denis*, p. 33.
32 Noting *Beau Travail*'s 'emphatic choreographic dimension', Elena del Río suggests a Deleuzian aesthetics of affective reverberation between times and spaces. See del Río, 'Body transformations in the films of Claire Denis: From ritual to play' *Studies in French Cinema* iii/3 (2003), pp. 185–197 (p. 193).
33 Beugnet: *Claire Denis*, p. 120n55.
34 Darke, Chris, 'Desire is violence' (interview with Denis), *Sight and Sound* ix/7 (2000), pp. 16–18 (p. 17).
35 Del Río: 'Body transformations', p. 193.
36 Ibid., p. 194–5.
37 Hayward: 'Claire Denis' films', p. 166.
38 Williams, James S., '"O Heave! O Heave away, Heave! O Heave!": Working through the author in *Beau Travail*', *Journal of European Studies* xxxiv/1–2 (2004), pp. 44–59 (p. 51).

39 McRobbie, Angela, '*Fame, Flashdance*, and fantasies of achievement', in Jane Gaines and Charlotte Herzog (eds), *Fabrications: Costume and the Female Body*, (New York, London, 1990), pp. 39–58 (p. 41). On Denis's recollections of dancing in her bedroom as a teenager, see Romney: 'Claire Denis interviewed by Jonathan Romney'; see also Hughes, Darren, 'Dancing reveals so much: An interview with Claire Denis', *Senses of Cinema* (2009), http://www.sensesofcinema.com/?p=2524.

40 Monnier and Nancy: *Allitérations*, p. 52; p. 55. On the non-finality of gesture, see also Agamben: 'Notes on Gesture', pp. 58–9.

41 Monnier and Nancy: *Allitérations*, p. 126.

42 Philippe Lacoue-Labarthe, 'The Echo of the Subject', in Christopher Fynsk (ed), *Typography: Mimesis, Philosophy, Politics* (Cambridge, MA; London, 1989), pp. 139–207 (p. 202).

43 Monnier and Nancy: *Allitérations*, pp. 58–62. Nancy appears in *Towards Mathilde*, reading as part of a performance choreographed by Monnier.

44 Ibid., p. 131.

45 Ibid., p. 130.

46 Cooper, *Selfless Cinema? Ethics and French Documentary* (Oxford, 2006), p. 5.

47 Monnier and Nancy: *Allitérations*, p. 125.

48 Hughes: 'Dancing reveals so much: An interview with Claire Denis'.

49 Ibid.; original emphasis.

50 For Williams, the song's focus on shifting (from life to death) 'corresponds to the structure and function of this scene where relationships are reconfigured and desire safely channelled [...]'. See Williams, 'Romancing the Father in Claire Denis's *35 Shots of Rum*', *Film Quarterly* lxiii/2 (2009), pp. 44–50 (p. 47). Drawing on Williams's reading, Andrew Asibong argues persuasively that the affirmative dimensions of this scene diverge from a general logic of destruction or rejection signalled by dance elsewhere in Denis's work (Asibong cites the final scene of *Beau Travail* and 'the painfully awkward dance between Camille, Théo and their mother' in *J'ai pas sommeil*). See Asibong, 'Claire Denis's Flickering Spaces of Hospitality', *L'Esprit Créateur* li/1(2011), pp. 154–167 (p. 164; p. 167n16).

21 Still from *Beau Travail*

13

That Interrupting Feeling: Interstitial Disjunctions in Claire Denis's *L'Intrus*

Firoza Elavia

The Nervous System of the Interstice

One critical process that generates the relations and connections between two film images is the interstice.[1] Configuring a film's internal relations, speeds and affects, the interstice creates a rhythm or an internal pulse of what is true to that film. In Claire Denis's *L'Intrus* (2004), such pulsation moves beyond the maternal grammar of action-affection-reaction of the movement-image.[2] In the movement-image, causes lead to actions, presenting continuity in the spatio-temporal relations between images, which fortify a knowability and understandability to the plot and narrative. In *L'Intrus*, to the contrary, there is spatio-temporal discontinuity, which flusters and dislocates the return of the same image. Discontinuities in space and time bring about breakages in thought, inducing aporetic states of perplexity, haltingness and ungraspability in the connection between two images. Such rupturing is brought about by interstitial repetition, which becomes a fundamental process in producing the disjointed space-times in the film, generating perpetual disjunctions in the continuity of a thought. Enabling variable movement, which continually deregulates the charge and direction of thoughts, their presence produces heterogeneous temporalities and virtual multiplicities in the film.

In *L'Intrus*, we find a regime in which the links between images are irrational. The irrationality between two images make up the time-images that have disconnected space-times randomly connected together in what Deleuze

calls an 'any-space-whatever'.[3] Time-images may be connected to each other without logic or reason, disrupting the spatio-temporal continuity found in movement-images. In movement-images, the cut, which connects one space-time (or image) to another, establishes the film's unidirectional movement, its associations, meanings and purposes. In time-images, however, the chain of disconnected shots disorients the spectator, whose bearings in space and time can become a confusing experience. As a result, the any-spaces-whatever of the time-image may leave the experience of images and events indeterminable and unlocatable.

The movement-image and time-image produce experiences that are remarkably dissimilar. Rather than producing the return of the same, brought about through the convention of continuity editing, which reproduces the order of known quantities, in *L'Intrus* we find ourselves experiencing unknown qualities and intellectual challenges by virtue of the difference in the succession of images. Interstitial repetition, producing interruptions and dissonance between images, induces a shock to the automatic sensory-motor schema of the movement-image. Instead of the continuous movement from action-affection-reaction, an irrational cut disrupts the 'sublime' flow of such a motorized movement and thought.[4] Introducing a gap between the preceding and succeeding image, which no longer sustain the same spatio-temporal continuity, the irrational cut creates dissonance within the narrative, presenting an experience of shock to the (habitual) continuity of a thought. The interstice, displacing one image with another, forces the spectator to think a new image. The destruction of one thought by another is necessary for the renewal of thought itself, which generates not only a new image, but also the conditions of change to occur, and such a new thought also disturbs the boundaries of what is a given (prior) order. The aporias created by interstitial repetition in *L'Intrus* thereby come to generate the heterogeneous times of the film. They also multiply difference by the expansion of unknown qualities, creating diverse ways of seeing through unexpected associations in the movements of thought.

In the succession of discontinuous images in *L'Intrus*, the image that follows, as Deleuze writes in *Cinema 2: The Time Image* (1989), is the image that materializes from the void, presenting thought from the outside. A different image cutting into a sequence of events presents a shock to thought as it breaks the sequence and inserts its own presence. The chain of interstitial repetition not only allows for the production of different images to appear, producing the changing relations, speeds and affectivity between images, but also continually modulates and generates the virtual connections between two images. The interstice, which occurs between two images, is where the virtual time of the event unfolds. These virtual events in *L'Intrus* become the sites of my examination. Interstitial time being measureless, its importance is vital as it

generates the force and propulsion that moves the work along. Such a force not only propels physical matter, but also activates the virtual dimension of the work, including the movements of thought.

Virtual Event – Actual Scar

I will proceed to what I constitute to be a critical interstitial moment in the film revealing a singular event. The nature of this event is such that it unfolds within the interstitial moment, making it incorporeal and virtual. Nonetheless, the singularity of this event is powerful, as it distributes its echoes and resonance throughout the film. In this echoing and resonance that occur among images, we have the time-image, which presents the relations occurring between images rather than to an action, as in movement-images. The time-image presents a dispersionary movement where images relate to other images, forming chains of associations and memories.[5] In this sense, echoes of an image are repetitions with difference. In the movement-image, the main event becomes central within a chain of minor events in a chronological plot. In the time-images of *L'Intrus*, however, the event itself is incorporeal, and we feel its presence in the film as its images multiply and proliferate. The chains of memories in *L'Intrus* are distributed through interstitial repetition, which disperses the echoes and resonances of this incorporeal event.

If the continually occurring disjunctions generate the film's spasmodic effects, then the great chasm forged right into Trébor's body transmits tremors that echo throughout the film. It is that immense silent scar extending in a straight line on his torso travelling on the skin, a hardened, sewn-up surface. The scar that lines the body is an actual image in the film, a visible sign; the event of the heart transplant, however, becoming incorporeal, is its corresponding virtual movement in the film, which is never seen. While we see a massive scar, we do not see the actual operation. We do however see a woman appearing suddenly with x-rays, who disappears as suddenly as she arrives, in addition to money exchanging hands. We are also presented with inklings as to who might serve as possible donors in the illegal underground market of buyers of body parts, which by inference could be Slavic accents, expressing a somewhere in Eastern Europe. Thus, as one of the defining moments in the film, the heart transplant's invisibility is striking for its ability to orient the viewer towards this event. We only see the operation's traceable effects, quite suddenly, when a blind masseuse stumbles her withering hands over what is a massive scar, and, subsequently, throughout the film we notice Trébor continually stroking it, as if a reminder of both the depths of that surface and also of its untraceable depth.[6] However, we only see fleeting glimpses of this scar, which lines the body's surface. When we see the scar we trace that scar to an operation, but we do not see the

moment of the operation, which is a discrete moment in the film. We instead endure what precedes and succeeds it, the event of the operation itself becoming incorporeal.

This pivotal event of the operation intersects with the interstitial period. The event is immersed in the interstice, in that all-pervading depth of what is invisible, and is all the more cogent for being a potential. The event occurs between two different images, a measureless period in the 'nothing really happens' of a gap, but in which we find the greatest movements occurring. The event becoming incorporeal is implied, circulating on the horizon and functioning in a circuit with images that do appear. While dissimilar from each other, the images and the event are partial objects, which remain non-totalisable, as they are unable to exist without each other. In this sense the actual and the virtual cannot be considered separately; rather than being two partial objects, the actual and virtual should be understood to make up the total object.[7] The circuit between the film's events and virtual images is the continual pure movement between actual-virtual images, which reveals bodies and things. Yet, there is also another movement in the film of disjunctive presents, which forces the movements of thought.

Folding of Time: 8

I will first delve further into the actual-virtual movements of the scar, which not only lies on the surface of Trébor's body, but also on the body of the film. The scar's marking is a visible sign and, as a visible sign, it functions as a remainder (we see how much is *actually* left to heal) and also a reminder of the real crack in the body that it once was (this function is *virtual* and operates here through memory). The actual operation of the heart transplant, which is the invasive penetration into the body, constitutes a real event that we never see. We only see the operation through its dual references, as something that is about to occur and as that which has already occurred. In its post-operational state, we see it by the scar that has marked the body, as something that occurred in the near past, as a 'has been'.[8] In its pre-operational state, we see it when Trébor anticipates the heart operation's future moment, as something that is yet to come. Much as the memory of the operation is drawn out (signalled through the healing scar), tracing the movements of Trébor in search of his lost son, the anticipation of the event itself is also drawn out in the first half of the film. While we see the multiple activities occurring between Trébor and various parties, which seem unconnected and unrelated, including e-mail negotiations, bank transactions, endless waiting in hotel rooms, hands exchanging money, x-rays and medical reports, the event itself occurs in a flash – so much of a flash that the operation in this sense has no present. This pivotal event instead splits the present into two

streams of past and future and advances two questions: 'what will happen?' and 'what has just happened?'[9]

Experienced only through its invisibility, the event presents itself as echoes of memory in Trébor's journey across the oceans. In its anticipation and in its memory, the operation, in its continual virtual presence, enacts reverberations throughout, its powerful forces spreading along the film's entire time span. *L'Intrus*, one might say, is arranged around this virtual event. We experience or know about the operation through its anticipation and its pain – as a virtual movement arising in circuit with the film's actual images. As Deleuze notes, the actual and virtual make up a double series constantly in circuit with each other. And while they are correlates and cannot exist without each other, they do not resemble each other.[10] In this way, the interstitial moments in *L'Intrus*, which link different images randomly together, enact this constant play between the actual images and the virtual event.

However, the event is virtual, and its presence is felt throughout the film in that virtual state. What is the present of the film is constantly haunted or in a circuit with the virtual event. The film's present, where the actual images unfold, forms a circuit with the always present virtual. In this sense, the present is to be understood as the mobile frontier of the film. The present of the film, inhabited by the virtual, thereby operates through the various *states* of the operations as anticipation/memory (virtual) and through the different *stages* of the healing scar that marks Trébor's body (actual). Expressed in another way, the present is the intersecting point of the figure '8' in continuous circuit with actual images and the virtual event.[11] In this sense, it must be understood that the present is not merely the actual image; it is that which forms an intersecting point *between* what is actual and virtual. The present is thus a mobile frontier situated at the limits of what is actual and virtual *continually* splitting the film on the vertical axis. It occurs at the (mobile) fold between the two perpetual movements. The actual images of the scar[12] are always in circuit with the virtual event (in anticipation of the operation or as its memory), making up the present of the film.

Disjunctive Presents: Pasts ⟵⟶ Futures

To be sure, there is yet another movement of the present that occurs transversally to the actual-virtual circuits. This is the disjunctive and horizontal movement of time in the film that operates bi-directionally rather than uni-directionally.[13] As noted earlier, in its constant aspect, the present of the film continuously splits the film on its vertical axis into its actual-virtual relations, virtual pasts and futures bringing into the mix questions such as 'what will happen?' and 'what has just happened?'[14] Yet, each present constituent to an image is temporally disjunctive, the assembly of all the variegated presents

constituting the different images in the film. Rather than continuous presents unfolding, the film is a series of discontinuous presents, which rupture the film's spatio-temporality.

In a chronologically ordered film, causes lead to actions and reactions, the present of the film becoming thick with action. The present, in which the action unfolds, is distinctly separated from the past and future. In the movement-image, interruptions to the present occur through the use of narrative techniques such as flashbacks, dream sequences or subjective shots. All of these occur as recollection images that restore the narrative continuity and causality within the film's linear time structure, which, as Rodowick notes, remain within the regime of the sensory-motor schema.[15]

However, in *L'Intrus*, while we experience the bi-directional, horizontal movements of time from the anticipation of the operation to its memory, they are temporally disjunctive. The interstice regularly disrupts the narrative's spatio-temporal continuity, and shots linked to each other as the any-spaces-whatever break up the film's surface of time. Each shot becomes a part in the disjunctive chain of unfolding presents, each present splitting further into pasts and futures, rather than being distinct, as in movement-images. Each of the actual images making up the mobile and disjunctive chain of presents resonate in turn with virtual pasts and futures. The images arriving disjunctively in *L'Intrus* induce spatio-temporal and conceptual aporias.

In the time-image, the incorporeal event, as Conley writes, 'is coextensive with a state of extenuation, a condition of being beyond oneself [where] nothing is contained in an event'.[16] An event such as the operation is not satiated with the present; in fact, it has no present at all, and it is only felt through a virtual presence moving in circuit with images, haunting the surface of things. Its affects reverberate into the many folds of the film, forming its multiplying echoes and resonances. Pasts and futures fold into and reverberate in the time of the present, and such a structure destroys the possibility of the discreteness of space-time, which lays claim to the present as real, distinct and dense with action. The operation becomes exhausted by all actual and virtual possibilities, cutting up the words and actions of a typical chronological plot, in which events and causes propel the narrative. In this cutting up, time-images move beyond language – into an outside, thus, Deleuze writes, 'now to be done with words'.[17] Actions become indecipherable and ambiguous when words evaporate, moving in amorphous ways.

Trébor's journey from France to the South Pacific moves through such an outside beyond words or actions. We see that the disjunctive presents are never that of the now but always in the 'folds and creases',[18] moving constantly between pasts and futures to follow; presents unfold as Trébor is frequently looking out of windows or pensive in bed, thinking about what is to follow

or what came before. Every disjunctive present is always a remote field of activity, without action, in which Trébor feels the 'effect of the effect'.[19] The scar's multiple images produce echoes of the event every time he rubs it or, when he hopes to find his lost son, the scar becomes a virtual, incorporeal one. Each present has, in this way, 'lost its hold and faded' into the future.[20] Virtual pasts and futures unfold into these distanced and fading presents, while Trébor observes young Asian men who laugh at him, when he collapses in his shack by the sea or while convalescing in his hospital bed caught in their resonant tremors, and as he anticipates a future to come in his hotel bed in Switzerland or by the lake where he rests and swims with his Huskies.

What we are left with are pure images and visions, the any-spaces-whatever of Trébor's anticipation and wandering to the South Pacific. This is a bi-directional horizontal movement of time, of disjunctive presents folding into virtual pasts that have been and of futures to come. Strung out in a broken chain, images of Trébor's wanderings present the two-limit conditions of their present: actual-virtual and disjunctive. Each shot is an unfolding present carrying two transversal movements, one vertical and the other horizontal and bi-directional, making up the mobile and disjunctive chain of fading presents.

Moments of Fabulation

In *L'Intrus*, we have no way of knowing whether the wild woman laughing on the dog sled is real or imaginary, whether Trébor being dragged by the couple to his death is actual or fantasy, whether the head frozen in ice is real or not, whether the heart dripping with blood in the snow is imaginary, whether the dead torso wrapped in tarpaulin is real, or whether the many encounters with the different intruders that watch Trébor through the woods, in his cabin or on the streets are part of his imagination. Neither are we certain whether the bizarre interviews conducted for finding a substitute son for him were real or not. Cues that would distinguish the real from the imaginary are unavailable and, as Deleuze muses, we no longer even have a place from which to inquire what is real or imaginary. The reactive and mechanical actions of the sensory-motor regime of the movement-image that present plots, actions and reactions have been replaced by purely visual time-images whose real–imaginary relations have become obscured.

In the random connections between pasts and futures occurring through actual-virtual circuits in disjunctive presents, we have arrived at what Deleuze has called the crystal image of time, where there is no way of orienting ourselves between what is real and what is imaginary. Temporally indiscernible images dissolve the progression of successive presents, and they do not offer a method by which it would be possible to say that the actual follows the virtual or

vice versa. As Rodowick points out, these are not merely subjective illusions but rather genuine chasms – one fades in, and the other fades out. Interstitial repetition presents such an inability to distinguish between what is real and imaginary, yielding a paradox, making the choice between two possible, yet mutually contradicting, narrative explanations equally likely.[21]

The empty, disconnected any-spaces-whatever of the time-image[22] express the banality and idleness of the characters' lives who are seen but whose intentions are revealed only by the amorphous signs of their bodies.[23] Trébor's physical presence is forceful, and this physical sense denotes all possibilities in the spectator's impressions of him. What is seen of the characters or locations proceeds with a familiarity that, at best, sheds dim light on the situation. We see the familiar forms of characters wandering around in the woods or in city streets; what we cannot understand are their connections, relationships or encounters with each other (who is the woman who breeds the Huskies? Who are the young East Asian men?). In what could have been the development of a plot, action or events of chronometric time, we now find purely visual time-images that show the aftermath or a before of what makes up an event. The spectator follows Trébor roaming around city streets, country roads or journeying across continents, and we never quite know the nature of what is unfolding before us. In fact, we are at a point where we are uncertain as to what is real and imaginary, physical and mental.

Disrupting the film's spatio-temporal continuity and linking together the any-spaces-whatever interstitial repetitions do not reproduce the same identities, ideas or concepts, as they are not bare repetitions. In movement-images, their occurrence would generate ordinary repetitions, bringing about a continuous spatio-temporality and producing thought of the same. In *L'Intrus*, instead, images linked to each other in any-spaces-whatever enact a disjointed chain dispersed throughout the film. Connected through the interstice, heterogeneous images produce differential spatio-temporal relations and also differentials in thought. Each image or sequence thus propels its particular line of flight.[24]

Left to our own devices, we fabulate through the interstices that link different time-images together. In fabulating, movements of thought are produced. Our thoughts fabulate connections among people, animals and things materializing on the film's visible surface. The interstices that generate the disjunctions between shots give rise to what is paradoxical, contradictory or unfathomable and thus, simultaneously, become the moments for fabulation. The pure visual and optical images realized in the any-spaces-whatever create the spatio-temporal disjunctions, not only between images, but also between virtual pasts and futures in circuit with them. This constant modulation executes the film's spiritual automation – it connects the conscious and unconscious in thought and creates, in turn, psychic and emotional connections in the spectator's

internal monologue.[25] In the perpetual repetition of the interstice, there is simultaneously also a continual fabulation of events, people and things. In fabulating, we respond emotionally, psychologically and psychically to the actual images in the film, where the spectator invariably creates connections between the spatio-temporal gaps and dissonance. In fabulating, the spectator generates virtual times, which come to proliferate the film. Interstitial repetition therefore constantly enacts the virtual multiplicity in the film.

Conclusion: Virtual Multiplicity and the Image of Thought

As I have tried to show, the interstice makes possible the continual drift of disjunctive images into the film-space, opening the film up to the whole outside. The flux of images stream and vanish into the void from which it arises, generating aporetic states and unfamiliarity. Continually moving beyond what is knowable, visible and conscious, each shot pushes Denis's film to its limit, becoming inexplicable, inscrutable, exhausting. In the repetition of the interstice the image returns as an unknown, unrecognized quality, forcing the limits of our intellectual engagement with it. This unrecognizability in the flow of images forces us to think. In the midst of such strain, the different faculties are heightened to perform a transcendent exercise as the spectator's senses grasp at the streaming images. Faced with indeterminable, unknown images, the faculties break down rather than correlate to form what is a determinable or known identity of an object or an idea. Indeed, when the faculties are in states of disarray, they operate with extraordinary potential. Unexpected ways of perceiving, remembering or understanding can occur when a given faculty operates in an unusual capacity. Without intending to, memory might become useful for seeing, just as vision might function for operating cognition.[26]

Showered by the endless repetition of the interstice, which generates paradoxes, disrupts the flow of thought and multiplies unknown factors, the spectator is left in a whirlwind of heterogeneous time flows, struggling to cope cognitively and psychically. Each different image arising forces the limits of the intellect, propelling the heterogeneous movements of thought. Interstitial repetitions, which connect images, enable the production of ideas. Ideas by themselves, however, do not possess an actuality and are purely virtual, as they are brought about by numerous differential relations that compose them.[27] As Deleuze writes, ideas themselves are the thoughts of the *cogito*, and the fractured 'I' of the *cogito* make them indeterminate. The multitude of thoughts generated in the fracturing 'I' exist in their different aggregated ways. Ideas, therefore, necessarily subsist in these fractures, in the interstice, and 'emerge on their edges', indeterminate and ceaselessly forming and disappearing.[28]

Thus, we come to see how ideas existing in the interstitial fracture between two time-images reside in states of pure virtuality, in their multiple, indeterminate forms.[29] This indeterminate state of pure virtual relations is manifest in the concluding sequence of *L'Intrus*. The shots move through interstitial ruptures, by their pure virtual connections to each other. We fabulate through the different time-images linked together where, out of the blue, we see the same woman who stalks Trébor in Europe. Pursuing him somewhere in East Asia and then to the Pacific Islands, she intrudes upon him again when he is severely ill in hospital. A close up of her peering face is cut to the scene in a morgue, where a huge scar reveals a corpse's chest. Following only what could be our speculation as to who the intruder is, or the image of the scar on the corpse (the identity of which remains unrevealed but which we venture to guess), we come to the film's conclusion. With the infirm Trébor returning home, we see shots of the coffin being loaded onto a ship, accompanied by piercing, invasive noises of machinery; these are followed by images showing the dark presence of expansive waters. A ship sways as it veers away. The image then cuts to a young man, ostensibly the substitute son, giving the ailing Trébor some water. Last, we see the nameless woman's unrestrained laughing as she pulls away in her sled, drawn by excited Huskies in the snowy wilderness, presumably somewhere in the Jura Mountains.

In this concluding sequence, heterogeneous images are linked together by movements of thought. Ideas, as pure virtual entities, exist in an inexhaustible state in the interstice. And being indeterminate, James Williams writes, ideas 'can only ever be approximated through constructs that reveal aspects of its internal relations'.[30] An idea can express only aspects of an actual image. The image of the scar circulates with its multiple virtualities, of which four of its reciprocal virtual relations may been noted – as the expression of pain for the lost son, the intrusive presence of the foreign heart that is snatched from the bodies of others, as the borderline of inside/outside and as the mobile frontier that splits the film into its two streams of past and future. By virtue of the scar's expression in something, it reveals the other through a reciprocal relation whereby they come to configure each other. The scar reveals pain, the lost son, the illegal trade in body parts, Trébor's self-estrangement and more. And just as an equation in differential calculus can never be exhausted, ideas cannot be either. Deleuze shows how ideas and problems are relatable to equations and their differentials. Ideas, he writes, are the 'differentials of thought' in which each idea, being available to a differential calculus, means that its imaginative qualities move beyond the utilitarian subordination of thought to things or to a purpose. The important point here is that an idea can be viewed in endlessly different ways, which, in turn reveals its endless significant reciprocal points. But with respect to qualitative multiplicity, these endless differential points of

view cannot be reduced to mere numbers and, even more important, to some identifiable unity. Rather, a multiplicity is to be understood more through its positive differences, through its continuous variations rather than through its negative difference, which arises from quantitative or numerical values.[31]

Through these relations between ideas and their qualitative variations, we understand the relations between two time-images brought together through the interstice generating their virtual multiplicity. An idea emerges in the interstitial moment between two images expressing virtual multiplicity and revealing its many reciprocal points in the two images connected to it. The ideas of 'pain' or 'lost son' or 'illegal trade in body parts', which are never articulated in the film as such, come to be generated in the interstices connecting images. In this sense they are never determinate and always on edges – forming, adding, eliminating, reforming. The sign of the scar operates as a structure of elements in continuous variation, as positive difference, and is resistant to identification as such. The scar functions as a visible sign always in different stages of recovery corresponding to virtual potentials throughout the film. And, by the film's conclusion, it functions fully outside of Trébor's body, revealing what may be his son's dead body. The relations now between the two actual scars, on two bodies, connected through the interstice, produce in turn their own different virtual multiplicity. The two actual forms that are now two different scars subsequently produce their own virtual relations. The two scars extend and multiply into a relation between two things that spreads into the world. The virtual is also the totality of ideas and intensities that circulate between the actual images; the actual images, however, operate by the things that they incarnate in the physical manifestation of objects and things, in signs.[32] Thus, just as experience is not possible outside of thought, a film is not possible outside its actual-virtual circuits.

Notes

1. This is barring single-shot films made famous by Andy Warhol, Michael Snow or Aleksandr Sokurov.
2. Deleuze, Gilles, *Cinema 1: The Movement-Image*, trans. Hugh Tomlinson and Barbara Habberjam (Minneapolis, 1986), pp. 61–6 (henceforth *MI*).
3. Deleuze, Gilles, *Cinema 2: The Time-Image*, trans. Hugh Tomlinson and Robert Galeta, (Minneapolis, 1989), p. 33 (henceforth *TI*).
4. Deleuze: *TI*, p. 40.
5. Rodowick, David, *Gilles Deleuze's Time Machine* (Durham, 1997), p. 90.
6. Deleuze, Gilles, *The Logic of Sense*, Mark Lester with Charles Stivale (trans), Constantin V. Boundas (ed), (New York, 1990), p. 87 (henceforth *LoS*). Depths, being mixtures of things, are formless and chaotic and cannot be traced.

7. Deleuze, Gilles, *Difference and Repetition*, trans. Paul Patton (New York, 1994), pp. 100–1 (henceforth *DR*).
8. Ibid., p. 159.
9. Ibid., p. 63.
10. Deleuze: *DR*, p. 100.
11. Ibid., p. 100.
12. The absence of the scar in the first half of the film must be understood, therefore, as a positive difference.
13. This bi-directionality will be taken up further in the next section, in the crystal image of time.
14. Deleuze: *LoS*, p. 159.
15. Rodowick: *Gilles Deleuze's Time Machine*, p. 91.
16. Conley, Tom, 'The film event', in Gregory Flaxman (ed.), *The Brain is the Screen* (Minneapolis, 2000), p. 308.
17. In Conley: 'The film event', p. 308.
18. Conley: 'The film event', p. 306.
19. Deleuze: *LoS*, p. 159.
20. Ibid., p. 159.
21. Rodowick: *Gilles Deleuze's Time Machine*, p. 95.
22. Deleuze: *TI*, p. 8. The images are emptied of action.
23. Except in rare moments, the spectator is not privy to the characters' intentions.
24. Deleuze: *DR*, p. 88.
25. Deleuze: *TI*, p. 165.
26. Deleuze: *DR*, pp. 165–6.
27. Ibid., p. 279.
28. Ibid., p. 169.
29. Ibid., pp. 169, 199.
30. Williams, James, *Gilles Deleuze's Difference and Repetition* (Edinburgh, 2003), p. 143.
31. Williams: *Gilles Deleuze's Difference and Repetition*, pp. 6–7, 143–6. Williams explains that qualitative states of difference are constituted, for instance, by allowing various shades of a colour to drift through rather than in counting the actual number of shades a colour has. Thus, he writes that we must connect to the pure variations in ideas and sensations (which are finite and affirmative) rather than connect to the actual objects themselves (which are infinite and negative in their differences).
32. Williams: *Gilles Deleuze's Difference and Repetition*, pp. 144–6.

22 Still from *L'Intrus*

14

Points of Flight, Lines of Fracture: Claire Denis's Uncanny Landscape

Henrik Gustafsson

> There is an image from my childhood. I am on a ship, I am arriving in Africa with my mother.... There was the sea, the sky, that little line which made up the coast.... We were approaching the coast, we were going towards something, and what was just a little line would come closer and closer and become solid land.
>
> Claire Denis[1]

> He looked at her with the expression common to African labourers: a blank look, as if he hardly saw her, as if there was an obsequious surface with which he faced her and her kind, covering an invulnerable and secret hinterland.
>
> Doris Lessing, *The Grass Is Singing* (1950)[2]

In 1983, Claire Denis travelled through the American Southwest scouting for locations, working as an assistant director to Wim Wenders, who was making *Paris, Texas* (1984) at the time. She has later described this as the formative experience for her own filmmaking:

> [W]e weren't just searching for locations. Wim Wenders was searching for his film. It was a moving experience for me to discover this landscape and to watch a man looking for himself.... I asked myself, Do I have a landscape? With Wim Wenders, I was travelling across the territory of cinema.[3]

The question, 'Do I have a landscape?' doesn't seem to refer to a given location as much as to a kind of vision, an inaugural scene for the creative process, that

sets off a chain reaction: Wenders is scouting for locations, for a film, for himself, while Denis recognizes in the deserts of the American West the deserts of the West Africa of her childhood. For Wenders, this is where the two dominating themes of his work intersect – his commitment to location shooting, on the one hand, and his exploration of the impact of American culture on post-war German life, on the other, as famously aphorised in his film *Im Lauf der Zeit* (Kings of the Road, 1976): 'The Yanks have colonized our subconscious'. Maybe the return to the physical terrain then marks an attempt to reverse the process, to exorcise screen memories and to decolonize imagination?

Not merely of anecdotal interest, this episode provides us with a highly evocative point of departure to consider landscape in the films of Claire Denis. As with Wenders's films, it presents an interface where a number of themes converge: the legacy of colonialism, the issue of borders and the quest for personal and national identity. This quest, in turn, straddles the border of imaginary geographies and tangible locations. Whereas the landscape pursued by Wenders is derived from the images forged by the likes of John Ford, Walker Evans and Edward Hopper, Denis has cited an equally resonant landscape of colonial imagination as her inspiration, the maritime adventures of Herman Melville, Joseph Conrad and Robert Louis Stevenson as well as the epics of David Lean. Beginning on the Mexico/United States border, the title *Paris, Texas* itself confuses borders, reflecting the split biography of its male protagonist, Travis. In Denis's directorial debut, *Chocolat*, instead of Paris/Texas, we have France/Cameroon, France being the name of the semi-autobiographical protagonist who revisits the former colony where she grew up as the daughter of a colonial governor. Thus, it is clear that borders cross characters as well. Like Travis, a man in search of an erased past within the immense presence of the landscape, France's relation to the past is a form of self-inflicted amnesia – indicated by the scar tissue on the palm of her hand, left from a burn mark that also marks the last, traumatic memory from her childhood in Cameroon. When a fellow traveller, William 'Mungo' Park, reads her fortune, he observes: 'Your hand's strange. I can't see anything. No past, no future'. Finally, the location of Paris/Texas is encountered only as a photograph of a vacant desert lot, while France's flashback is mediated by a pencil drawing of the Mandara Mountains (the prime scenic attraction of Cameroon), made by her father, depicting a desert skyline sculptured by volcanic plugs. The image spreads across two pages in the open notebook that France clutches in her hands while travelling through Cameroon. As she looks up from the drawing and out the side window, we are transported from the contemporary roadside of corrugated metal shacks to the mud huts on the savannah in 1957, the last year of French colonial rule. The landscape thus enables a transition, a leap across a temporal divide. However, my argument in this chapter will be that landscape in Denis's

films, in fact, does the very opposite; that it stalls and interrupts such attempts to overcome a distance, to form a bridge or bond with the past and the land. As the two epigraphs opening this chapter suggest, landscape oscillates between a vision materialized and a vision withheld, between entry and exile, between 'solid land' and 'secret hinterland'.

A Change of Scenery

My analysis will be framed by two of Denis's films shot in Cameroon, *Chocolat* and *White Material*. I will also briefly draw from two more films by Denis that deal with the aftermath and continuity of colonialism through characters who, like France in *Chocolat* or the French landowner, Marie Vial, in *White Material*, either fail to return from or fail to remain in former colonies: namely, the Legionnaire, Galoup, in *Beau Travail* (1999), who is dishonourably discharged and exiled from a Foreign Legion patrol in Djibouti; and Louis Trébor, in *L'Intrus*, who travels to French Polynesia in search of his son.

In this sense, these films would seem to corroborate cultural geographer Denis E. Cosgrove's definition of landscape as 'a distanced way of seeing, the outsider's perspective', by which he is referring to a privileged viewing position of enjoying the scenery withdrawn from any lived, social reality.[4] Over the past couple of decades, it has become commonplace in post-colonial theory to expose landscape as a whitewash of the colonial agendas of territorial aggression and land grabbing. Associated with the retro mode of the heritage film, *Chocolat* has been criticized for perpetuating such a visual stereotype of a radiant, timeless country open to claims of possession.[5] The sheer visual pleasure offered by the landscape in *Chocolat*, its panoramic sweep and lucid cinematography, renders it ideologically susceptive, relishing a nostalgic myth of the golden age of the French empire. Denis herself has made the following reflection: 'The attraction of beautiful landscape is something dangerous for film. You must know exactly what you want to express with a landscape because if the camera is hypnotized, then it's dangerous'.[6] Denis is not primarily referring to the danger of unreliable conditions on location here but rather to some mesmerising or digressive power that landscape exerts. However, there is also an ethical implication to this danger, as becomes evident when put in context with another comment made by the director:

> When I was young, and I was reading *Out of Africa*, by Karen Blixen, I used to choke with rage. This nostalgia for the land, that land, that culture, that farm... That expression of love was infamous because none of this belonged to her... By loving it, I appropriate it, and I have no right to do so.[7]

As this would suggest, the 'outsider's perspective' can be turned around in a manner that invites us to consider the danger of *not* keeping the distance, which brings us to an alternative context for considering landscape in Denis's work. The director's thoughts concerning the fatal attraction of beautiful landscape were made in relation to *L'Intrus*, her most ambitious film to date in terms of locations, as it was shot in France, Switzerland, South Korea and Tahiti. *L'Intrus* was inspired by an autobiographical essay by the French philosopher Jean-Luc Nancy, concerning his experience of having undergone a heart transplant. Over the past decade, Denis and Nancy have engaged in an ongoing dialogue, resulting in films, essays, books and conversations. Lately, this exchange and collaboration between filmmaker and philosopher has been the subject of a number of cross-readings.[8] In light of this recent interest, it may seem surprising that one of their shared preoccupations has not warranted closer scrutiny, namely, that of landscape, a subject to which Nancy devoted a brief essay entitled 'Uncanny Landscape'.[9] Not only does Nancy's essay, and his writing on the image in general, touch on a number of connected themes and motifs that inform landscape in Denis's films – the notion of foreignness and intrusion, the imagery of horizons and borders – but also pertains to her signature elliptical style. The original title of 'Uncanny Landscape' (*Paysage avec Dépaysement*) itself comprises an ellipsis, conflating landscape (*paysage*) with disorientation and exile (*dépaysement*). More specifically, the term *dépaysement* denotes the strategy of displacement in surrealist art. It is this unsettling experience, then, to which the Freudian concept "uncanny" in the translation refers.

The essay begins by invoking a historical shift and a process of estrangement from the land brought on by urbanisation and industrialisation. Thus, at first, Nancy's take on landscape seems to corroborate a familiar plotline of the origin and evolution of this pictorial genre. According to this narrative, landscape serves as a kind of compensatory fantasy that indicates a rupture or a wound, referring us to a state of innocence and unity to which we cannot return. However, Nancy is referring to another kind of rupture or scar that directly ties into the surrealist legacy of *dépaysement*. Landscape is neither diagnosed as symptom nor decoded as a sign but is identified with a force and a capacity to estrange and render uncanny. Not subordinated to any external value or authority, nor circumscribed by the assuring borders of homeland, nation-state, country or community, not even nature as such, landscape is not the representation of a location but the presentation of dislocation. Nancy states that 'we could say that landscape begins when it absorbs or dissolves all presences into itself'.[10] A landscape does not contain any other presence nor does it refer to anything beyond itself. Still, Nancy maintains that it 'opens to the unknown'.[11] Indeed, landscape is the taking place of this unknown, 'a withdrawal of all divine presence and thereby of all presence in general; what is henceforth present is

the immensity itself, the limitless opening of place as a taking place of what no longer has any determinate place'.[12] With no proper place for a social, moral or metaphysical order, what remains is 'a land occupied only with opening in itself'.[13] What, then, defines this agency that Nancy confer to landscape?

The single most identifiable feature of a landscape is the horizon, which is emblematic of the withdrawal and suspension of presence through which Nancy defines landscape: 'The division itself is nothing: it is the separation, the interval, the insubstantial line of the horizon that joins and disjoins earth and sky'. It is 'at once a closure of space', the outer limit of earth, depth and presence and 'a flight into infinity...which never stops drawing back'.[14] Thus, the horizon performs a double operation of joining and disjoining, of bringing together and pulling apart, of closing and opening. In *The Ground of the Image*, the collection in which 'Uncanny Landscape' is included, the horizon also serves as a metaphor for the image in general. The image, according to Nancy, is not a bond but a cut separated from the invisible ground that surrounds it. This uprooting releases a hidden force that makes the image stand out, clear-cut against this background, discontinuous with the world and remaining always at a distance. The line that sets it apart is also referred to by Nancy as a mark, or a scar.[15] The image, like the horizon, simultaneously rises from the ground and recedes from us: 'The pulling away raises it and brings it forward: makes it a "fore", a separate frontal surface, whereas the ground itself has no face or surface. The cut-out or clipping creates edges in which the image is framed'.[16] Though Nancy's writing style can be challengingly enigmatic, I hope to bring specificity and resonance to his argument by staying close to the sensory, earthy surface of Denis's equally enigmatic visual style.

Framed and Fractured

Horizons feature prominently in Denis's directorial debut, *Chocolat*, often in carefully composed shots containing all the formal beauty of the genre – airy perspectives, restful horizon lines, sunrises and sunsets, and few signs of physical labour. Or, as a variation of this, the camera repeatedly pans away from the road ahead, making sideways excursions to track the horizon. Long shots of the horizon, long both in terms of distance and duration, also open and close the film. The first, near-monochromatic image introduces an elemental, landscape distilled into sand, sea and sky. The shot is held in suspense in a freeze frame as the first credits unfold then set in motion: first, the motion of the breaking surfs and then, after nearly two minutes, the motion of the camera turning inland in a half-circle pan. It is a curious shot, for we realize that it begins as a point of view shot only after it has completed its arc, now directed towards France, the source of this viewpoint. Thus, a rupture takes place within this measured

movement, unnoticeably loosening itself from the character's line of sight. A similar detaching from France's point of view also precedes the last image in the film. As her plane takes off, the camera remains with the three baggage carriers whom she previously had been observing. Walking to the edge of the landing strip, they face a green field with their backs turned to us, engaged in a lively discussion that we do not hear, followed by a sudden burst of rain. These two shots that frame *Chocolat* are exemplary of the elliptical quality of space in Denis's work in general: unmoored from point of view, distanced yet highly attentive and bisected by the line of a horizon.

The horizon is also a topic of the film's dialogue. Halfway through *Chocolat*, France asks her father to explain what the horizon is. Eventually, he responds:

When you look towards the hills, where there are no houses or trees, precisely where the land meets the sky, that's the horizon. Tomorrow when it's light, I'll show you. The closer you get to that line, the farther it moves. If you walk towards it, it moves away. It flees from you. I have to explain that to you too. You can see the line. You see it, but it doesn't exist.

The monologue is followed by a shot of the sun-drenched desert framed by the dark doorway and the shadowy interior of the house. This threshold between interior and exterior is a recurring image in Denis's films: in *Beau Travail*, the stark contrast between inside and outside, light and dark, is amplified in the way three volcanic islands are framed by Galoup's seafront veranda; in *L'Intrus*, a view of a forested lake is cut out by the square frame of the dark walls of Trébor's mountain cabin. Like a *passe-partout*, the image is enhanced through the importance given at once to the frame, the cutting out of a section of land, and to the off-screen space from which it is separated and stands out. Once more, these images speak of Denis's work in general – of the way shots are extracted and isolated from continuity. Cut out and suspended in midair, the landscape lingers as a pause or a question mark. What commonly serves as a background, as a stage for events to unfold, instead asserts the absence of background, in the sense of background stories and historical context, psychological depth and driving forces. Landscape also distinguishes itself through silence or, as a variation of it, in the way that ambient sound, rather than creating continuity between shots, isolates shots, emphasising the singularity of each instance. This is another way, then, in which the background rises to the fore.

The final point to make about horizons in *Chocolat* is also the most obvious one. The imaginary nature of the horizon upon which France's father ruminates has an evident geopolitical and biopolitical dimension, referring to the dividing lines, the colour lines and geographical lines, through which colonialism

operates. In all of these films, Denis highlights the performative aspect of these borders as spaces to enforce ideas of belonging and non-belonging, of inside and outside. There is an overall profusion of territorial markers – of walls, gates, fences and checkpoints, of lines of division that differentiate and domesticate space – like the rocks painted white and arranged in straight lines and square grids on the undifferentiated desert ground in *Chocolat* and *Beau Travail* as well as the rituals of raising and saluting the flag performed within these demarcations.

My claim here is that the ruptures that occur on the formal level of these films are integral to the post-colonial critique that they raise. And, conversely, that the recurring visual tropes of barriers and boundaries invite us to think about other borders. In narrative cinema, we may say that fiction acts as a border and that cinematic space is enclosed by cause-and-effect- driven narratives and psychologically rounded characters. In Denis's films, however, this border is suspended simply through the scarce supply of narrative information to dominate space. Not being circumscribed by the subject's goals and desires, nor resolved into symbolism or metaphor, settings retain their condition precisely as *exteriors*. We have no access to an inside but merely to surface phenomena, acts and appearances. Thus, landscape does not serve as establishing shots or transition shots. On the contrary, it causes what Nancy refers to as 'the suspension of a passage',[17] whereas, according to the logic of borders, if you cross one, you are someplace else. In this sense, the arbitrary nature of borders is reflected in the arbitrary connections between the images.

To take this point further, the imagery of physical scars in Denis's work – the scar tissue on France's hand, the surgical scar carved across Louis's chest – invites us to think about other kinds of scars. In formal terms, we may say that Denis follows a logic of 'scars' rather than 'suture'. Instead of the invisible editing techniques of mainstream cinema, which erase the stitches between shots to create a seamless, coherent space, Denis exposes the seams in the editing, fracturing the relation between shot-reverse-shot, reaction-shots and eye-line matches. Cues for fusing together seeing and setting – the first-person narrative structure, flashbacks, voice-over, and point-of-view shots – are instead used to inflict a cut that breaks up the link between subjective viewpoint and physical environment. Tied neither to an individual character nor to an omniscient narrator, it often remains uncertain where the images come from. This formal strategy of mismatches and non-alignment also makes us conscious of ourselves looking, whereas suture, conversely, aims to make us forget that we are doing so.

I want to conclude this section by considering 'uncanny landscape' in the light of Nancy's writings on cinema more specifically. In his first commentary on Denis's work, a short piece on *Beau Travail* entitled 'A-Religion', Nancy

calls attention to how the film sets the rigorous ritual order of the Foreign Legion in stark relief against a primordial terrain of black volcanic rock, white salt crystals and turquoise sea – virgin territory also in the sense that this was the first film ever made in Djibouti. Nancy argues that the film's majestic beauty 'holds the narrative at bay, in favour of an ostentation of the image'.[18] In another context, he has referred to *Beau Travail* as a film 'aiming somewhere beyond any "point of view," with a look devoid of subjectivity'.[19] These two observations – the holding at bay of narrative and the voiding of subjectivity – are related, a point that is further elaborated on in Nancy's book on the Iranian filmmaker Abbas Kiarostami, *The Evidence of Film* (2001). For Nancy, landscape enables a certain kind of looking – what he refers to as *regard*. Usually translated as gaze, I propose that we retain the original phrase, since 'regard' has the double meaning in English of looking upon something and of honouring something, of paying attention and showing respect, which is precisely the double meaning that Nancy's wordplay with *regard* and *égard* expresses.[20] In cinema, the fixed glare of the static long shot, lingering in moments of observation and delay, is particularly prone to resist immersion and therefore to promote regard. Most emphatically, 'regard' manifests itself in 'the steadfastness of landscapes . . . in all-encompassing shots [where] these wide presences meet our gaze'.[21] The regard does not aim to penetrate and explain what it sees. It does not attempt to suppress or sublimate distance and discontinuity. On the contrary, it insists upon this distance.

In the films by Denis considered here, the resolute presence and persistence of the landscape draws attention to the passage of time, allowing this passage to take place and to pass on the screen. The stillness of the landscape renders visible the currents and rhythms of curtains and clotheslines swaying in the breeze, of dust stirred up in the wind and ripples through grass and water, or of veins pulsing beneath the skin. These movements challenge the surface by suggesting a passage between inside and outside, yet they also hold this passage at bay. They do not take us from one point in space and time to another but offer glimpses, fleeting impressions and uncertain temporalities. Such encounters are further initiated by the process of shooting on location, which in itself invites intrusions – like the unexpected snowfall in Busan, South Korea, a chance occurrence that came to transform the entire structure of *L'Intrus*.[22] In this sense, we may say that landscape promotes another idea of continuity.

It would be reductive, however, to address Denis's films exclusively from the perspective of their lyrical, sensuous qualities, for this transient beauty is encountered within contexts that are anything but soothing or reassuring. In the next section, we turn once more to this dissonance that resounds along the dividing lines retraced in Denis's exploration of the failing of systems of colonialism, codes of honour, and family ties.

Keeping the Distance

There is half a century of post-colonialism between what takes place in *Chocolat* and then in *White Material*. Stylistically, they are markedly different, from the elegiac tableaux of the former, to the unsteady, handheld camera of the latter, which often remains directed towards the ground. There is little sky to be seen in *White Material* – a landscape is scattered rather than laid out through the course of the film, in clouds of red dust, smouldering fields and off-tilted horizons. Though Denis herself has denied that the films share a connection, *White Material* in many ways appears to be a companion piece to *Chocolat*, mirroring and distorting several of its key motifs.[23] The two films are book-ended not only by the location of Cameroon, but also by the colonial products that inspired their titles: chocolate and white material, the latter a slang expression for ivory. Both titles furthermore share a similar ambiguity, as 'chocolate' has the additional double meaning in French of 'to be Black' and 'to be had' or 'to be cheated', whereas 'white material' is used for White people, who, in the film, are reduced to a foreign object to be discarded. Finally, the films are linked by the French plantation owner in *Chocolat* who lectures about the proper way to serve coffee and the coffee grown by Marie Vial in *White Material*. This bond between commodities and colonialism is taken to its logical conclusion with the international trade of organ transplants in *L'Intrus*, making the ironic point that, while the movement of bodies are impeded, organs effortlessly cross the borders of nations and bodies alike.

As Marie struggles to bring in the harvest amidst the outbreak of civil war, several familiar tropes from Denis's previous films return in a distorted form. There is the improvised flag made out of a pair of red shorts and carried away by two child soldiers, travestying the flags raised and saluted in the outposts of the Legion and the Empire; and there is Vial's son, Manuel, who literally goes local and joins the rebels, fashioning himself as a caricatural version of the Legionnaires in *Beau Travail*. We also find the twin figure of the border and the horizon. As social hierarchies break down, borders at once rapidly collapse and multiply. Marie, however, is determined to maintain them – locking and unlocking the gate chain, inspecting the torn fences around the plantation. Halfway through the film, she passes a group of rebels blocking the road with a rope, which serves as an ad-hoc tollgate. As she returns on the same road, it has been dropped to the ground, and the camera pans the slack rope from one roadside to the other. This image, literal and concrete within the context of the film, resonates with another obscure line that concludes the film. In the final scene, the camera tracks through a field in the fading twilight, and a lingering, out-of-focus shot of the horizon at dusk abruptly brings the film to an end. This line, then, already blurred out, is about to dissolve into the night.

There are no horizons, so to speak, in *White Material*, no lines of distinction along which joining or disjoining, meeting and separation, would be possible. There is merely rejection and abjection. If Denis calls attention to the constructed nature of dividing lines, she also cautions us not to overlook them. Just because these lines are imaginary doesn't mean that they don't exist. In this sense, *White Material* is about the *lack* of regard. Insisting on her belonging and right to the land, Marie refuses to perceive her own foreignness.

This is the danger of beautiful landscape of which Denis has spoken: opening up before us, inviting us to be hypnotically drawn in, suggesting a hidden unity that soothes over and solicits claims to 'discover' or 'deserve' the land. This is another sense, then, in which Denis's landscapes are 'uncanny'. On the one hand, they mobilize a whole repertoire of colonial fantasies – palm-fringed islands, mountains shrouded in mist, pristine deserts and lonely wanderers. On the other, they disrupt aspirations to form a bond, to set roots or leave a mark. Instead, characters are themselves marked, scarred or cut off from the object of their proclaimed love (the love of the land, of the Legion, or of a son). Landscape distinguishes itself; that is, it refuses to be assimilated. It does not bring about a closure but a fracture. It does not suture us into identification but leaves us outside. However, in doing so, it also enables another viewing position. The question raised by landscape in these films concerns how to relate to the foreignness and intrusion of others as well as our own. Rather than bridging or filling the gap, it makes room for discontinuities to emerge, suggesting that, in order to see the fractures that run across the globe, we may need to keep a distance.

Notes

1. Renouard, Jean-Philippe, and Wajeman, Lise, 'The weight of the here and now: Conversation with Claire Denis, 2001', *Journal of European Studies* xxxiv (2004), pp. 19–33 (pp. 32–3).
2. Lessing, Doris, *The Grass is Singing* (London, 1950/2007), p. 118. I'm grateful to Imogen Plouviez at HarperCollins *Publishers* for granting permission to use this quote as an epigraph.
3. Mayne, Judith, *Claire Denis* (Urbana and Chicago, 2005), p. 15.
4. Cosgrove, Denis E., *Social Formation and Symbolic Landscape* (Madison, 1984/1998), p. 161.
5. See, for example, Murray, Alison, 'Women, nostalgia, memory: "Chocolate", "Outremer", and "Indochine"', *Research in African Literatures* xxxiii/2 (2002), pp. 235–44; Watson, Ruth, 'Beholding the colonial past', in Vivian Bickford-Smith and Richard Mendelsohn (eds), *Black and White in Colour: African History on Screen* (Oxford, 2007), pp. 185–202.
6. Special Feature: Interview with Claire Denis on *L'Intrus*, Tartan DVD edition.

7 As quoted in Beugnet, Martine, *Claire Denis* (Manchester and New York, 2004), p. 11.
8 See, for example, the special issue 'Claire Denis and Jean-Luc Nancy' of *Film-Philosophy* xii/1 (2008). Available at: http://www.film-philosophy.com/index.php/f-p/issue/view/11.
9 Nancy, Jean-Luc, 'Uncanny landscape' [2002] in *The Ground of the Image* (New York, 2005), pp. 51–62.
10 Ibid., 58.
11 Ibid., 59.
12 Ibid., 59.
13 Ibid., 59.
14 Ibid., 61.
15 Nancy, Jean-Luc, 'The image – The distinct' in *The Ground of the Image*, pp. 1–14 (p. 4).
16 Ibid., 7.
17 Nancy: 'Uncanny landscape', p. 61.
18 Nancy, Jean-Luc, 'A-religion' [2001] *Journal of European Studies* xxxiv/1–2 (2004), pp. 14–8 (p. 16).
19 Nancy, Jean-Luc, *The Evidence of Film: Abbas Kiarostami* (Brussels, 2001), p. 52.
20 'The image... is this outside of the world where the gaze loses itself in order to find itself as *gaze* (regard), that is, first and foremost as *respect* (égard) for what is there, for what takes place and continues to take place'. See Nancy: *The Evidence of Film*, p. 64.
21 Nancy: *The Evidence of Film*, pp. 55–6.
22 Denis talks about this in the interview featured on the Tartan DVD edition.
23 'Claire Denis: "For me, film-making is a journey into the impossible"', *The Observer*, Sunday, 4 July 2010. Available at: http://www.guardian.co.uk/film/2010/jul/04/claire-denis-white-material-interview.

23 Still from *L'Intrus*

24 Still from *L'Intrus*

15

Arthouse/Grindhouse: Claire Denis and the 'New French Extremity'

Adam Nayman and Andrew Tracy

In an influential 2004 article for *ArtForum,* James Quandt groups Claire Denis's *Trouble Every Day* with films by Bruno Dumont, Philippe Grandrieux, Gaspar Noé and others as representatives of what he labels the 'New French Extremity', which refers to '[a] recent tendency to the wilfully transgressive [that brings] [i]mages and subjects once the provenance of splatter films, exploitation flicks, and porn – gang rapes, bashings and slashings and blindings, hard-ons and vulvas, cannibalism, sadomasochism and incest, fucking and fisting, sluices of cum and gore – [to] the high-art environs of a national cinema whose provocations have historically been formal, political, or philosophical (Godard, Clouzot, Debord) or, at their most immoderate (Franju, Buñuel, Walerian Borowczyk, Andrzej Zulawski), at least assimilable as emanations of an artistic movement (Surrealism mostly)'.[1] Quandt contrasts this new wave of 'shock tactics' with the more 'traditional virtues' of French art cinema; for example, Dumont betraying the 'raw, dauntless corporeality' of his earlier work for the horror show of *Twentynine Palms* (2003), contradicting critics' hopes that he would be 'the standard-bearer of a revival of humanism – indeed, of classic neorealism – in French cinema'; or Denis's 'disdain[ing] [of the] clear-eyed empathy and sociological insight' of *Chocolat* and *S'enfout la mort* in the blood-spattered cannibal holocaust of *Trouble Every Day*.[2]

Despite his lamenting that these films manifest 'a failure of both imagination and morality', Quandt is no political-aesthetic conservative nor, indeed, is he a dewy-eyed optimist. The range of 'traditional' forebears he marshals against the Extremists includes the 'uncomfortable truths' of Fassbinder, 'the elliptic violence of Bresson's *L'Argent*, the emotional evisceration of Eustache's *The*

Mother and the Whore [and] the bitter sexuality of Pialat's *À nos amours*, or even the 'authentic, liberating outrage – political, social, sexual – that fueled such apocalyptic visions as *Salò* and *Weekend*'.[3] Nevertheless, the different varieties of despair that Quandt cites against the scorched-earth nihilism of the New French Extremity (hereafter referred to sans quotation marks) do contain a profound connection to the vaguely defined 'humanism' that has so often been accepted as the basis of French art cinema – not a Renoirian continuity or persistence but the possibility of regeneration based upon a remorseless and pristine clarity. By contrast, the films of the Extremists (varied and dissimilar as they are) are marked by a rather extraordinary insularity, a confinement to the realm of the body and the pleasures/injuries wrought upon it that often posits little but (often bloody) dead ends. While the films of Pialat or Eustache might have been comparably unsparing, and those of Fassbinder and Pasolini have touched upon similar depths of pessimism and despair, none of them (not even Pasolini's repellently symmetrical Sadean riff) have the same kind of neatness as the work of the Extremists, even as the latter wallows in humid baths of blood, sweat, spittle and semen. These films share a tendency towards gaseous grandiloquence that derives directly from their elevation of the helplessly self-centred world of bodily sensation to sovereign status, an evacuation of history and social reality through the vividness of corporeal being.

Considering the place of Denis in this company, on the one hand her films have consistently demonstrated a topicality and socio-political engagement that puts her at odds with the Extremists, most notably, in the colonial/post-colonial thematics of *Chocolat* and *Beau Travail*. And whereas Noé or Grandrieux have pursued their dark, increasingly narrow visions ever further down the rabbit hole, after her most pronounced excursion into Extremity Denis returned, seemingly untroubled, to her earlier mold in *35 rhums* – a revisitation of the social networks, family dynamics and *banlieue* setting of *J'ai pas sommeil* and *Nénette et Boni* – and *White Material*, which recalls both *Chocolat*, in its tale of a die-hard French plantation owner in an unnamed African nation caught up in an encroaching civil war, and *Beau Travail*, in its depiction of a stubborn white outsider clinging to some bygone illusion of proprietorship. Yet, at the same time, Denis has explored an inner-directed sensual world, a world of immersive sensation (and assorted viscous fluids) that, especially after the artistic and career-turning point of *Beau Travail*, has shown a marked tendency to apparently become unmoored from the social, in the lovely nocturnal tone poem *Friday Night* (2002) or the elliptical journey of *L'Intrus* (2004) no less than the gory provocation of *Trouble Every Day*.

There is no cause, of course, to inscribe the social and the sensual as diametrically opposed terms and, apart from Luc and Jean-Pierre Dardenne, whose intensely corporeal cinema occasioned a powerful re-invigoration of

social realism in both the European art film and American independent cinema, Denis, more than any other contemporary filmmaker, has shown how these two forces may not only be bound up with but may even articulate the other. However, Denis's unique aesthetic also aligns itself with pronounced trends in contemporary art filmmaking – an evacuation of subjecthood, a refutation of psychology in favour of an intense materialism and an assertive yet oblique invocation of charged political subjects – which reflects a considerably altered state in both the production and reception of the art film. As opposed to the unsentimental clarity or earned nihilism of earlier European art filmmakers, the boundary-pushing films of Denis and the Extremists touch upon an enveloping quiescence ('an aggressiveness that is really a grandiose form of passivity', as Quandt dubs it)[4] yoked to the supposedly liberatory properties of the body in either carnal delight or violent transgression. These tropes not only link them to the shock tactics of exploitation cinema, but also find resonance in certain prevailing currents of cultural theory that have reciprocally accorded both 'high' and 'low' manifestations of these tendencies a considerable amount of interpretive attention. Despite (or because of) Denis's pronounced singularity, her work has proven an uncanny bellwether of certain significant changes in European art cinema over the past three decades: its progressive incorporation of genre elements; the terms of its reception in criticism and academia and its reflection in (and of) wider cultural attitudes; and an intensive focus on the body that results, quite often, in an evasion of the world in which that body moves.

It is thus that Quandt's partly tongue-in-cheek label seems to apply so perfectly to what he himself confesses is an otherwise highly incongruous grouping of filmmakers: 'for all their connections (shared actors, screenwriters, etc.), the recent provocateurs are too disparate in purpose and vision to be classified as a movement'.[5] If New French Extremity has since gained currency as both a critical term and a marketing brand, it is only the recent example of a series of critical rubrics that have attempted to classify the pronounced aesthetic swings in the country's cinematic output despite the fact that these 'movements' are rarely as cohesive (or coherent) as their names would suggest. That France seems to have occasioned more of these catchy appellations than other European film-producing countries clearly relates to the centrality of the Nouvelle Vague in the mythology of the European art film and the relatively cohesive institutional-philosophical-polemical affiliations of the group itself. Most of the subsequent 'groupings' of French art cinema (and French art cinema in general) have been discursively organized by critics and commentators in relation to the Nouvelle Vague, either as indices of its continued influence, evidence of its waning or laments for its passing – elegies that are as much about the diminished stature of film critics since the 1960s as about the erosion of an ideologically or aesthetically coherent filmmaking movement.

As is so often the case when art inevitably enters the realm of rhetoric, the relative truth of these groupings is less important than the fact that they are generally held to be true. The late eighties and early nineties saw a particularly influential, if retrospectively short-lived, dichotomy emerge between two much-discussed cinematic 'movements': the so-called *cinéma du look*, associated with the glossy Parisian fantasies of Jean-Jacques Beineix, Luc Besson and Leos Carax; and the *cinéma de banlieue,* a cycle of films set against the gritty, multicultural backdrop of the city's underprivileged suburbs.[6] While both of these urban-oriented groupings were regarded as a break from the prestigious 'heritage films' of the 1980s – lavish, star-studded and easily exportable exercises in rural nostalgia that evoked earlier ages of French literary and cinematic humanism, exemplified by Claude Berri's Pagnol diptych *Jean de Florette* and *Manon des Sources* (1986) – they were also positioned against each other in a rhetorical duel between stylized, escapist fantasy and gritty, socially engaged realism, an opposition more apparent than real.

With their outlandish plots, romantically alienated characters and focus on urban youth culture, the films of the *cinéma du look* were derided by French critics for a 'pure and simple forgetfulness of the principle of reality'[7] while being routinely feted in overseas markets (Beineix's outlandish, opera(tic) 1981 thriller, *Diva*, led the way, winning an audience award at the Toronto International Film Festival and receiving extravagant praise from such high-profile American reviewers as Roger Ebert and Pauline Kael). What these critics and audiences were responding to was arguably as much an idea of a rejuvenated French art cinema as the thing itself. Filtering high-art manoeuvres through the narrative syntax and ostentatious style of Hollywood genre filmmaking – *Diva* is a gangster picture, Besson's *Le dernier combat* (1983) a *Mad Max* riff and *Subway* (1985) a tricked-out chase movie – filmmakers like Beineix and Besson were godsends for North American critics looking for a *nouvelle* Nouvelle Vague (while largely ignoring and dismissing the contemporaneous films from the many still-active members of that original cohort, particularly Godard) and canny producers chasing foreign grosses.[8]

In contrast to the crossover ambitions of the *cinéma du look*, the subsequent *banlieue* cycle ostensibly sought to confront the social, racial and economic disparities of the disadvantaged Parisian suburbs with graphic, unsparing verism, as signalled by the nervous black-and-white cinematography (that innate signifier of cinematic truth) of Mathieu Kassovitz's sub-genre standard-bearer, *La Haine* (1995). However, Kassovitz's aggressively stylish debut demonstrated that the *banlieue* films could be just as aestheticised, market driven and genre derived as their supposed antitheses in the *cinéma du look*. *La Haine's Taxi Driver*-quoting scene of Vincent Cassel cocking his fingers like a gun at his mirrored reflection indicates just how much international art cinema at the time was taking the lead

from prior American models, a nicely ironic inverse of the 'New Hollywood' generation's Europhilism. Rather than a diametric opposition, both the *cinéma du look* and the *cinéma de banlieue* gave evidence of a post-Nouvelle Vague inclination towards the flash and dazzle of American genre cinema though more in the spirit of globalized commerce – as per Besson's, Kassovitz's and Jean-François Richet's forays into American studio productions[9] – than the Nouvelle Vague's celebration of American speed and energy in its rhetorical battles with the so-called *cinéma de papa*.[10]

It was in between these mo(ve)ments that Denis made her first films and, beyond their own individual merits, they are enlightening for what they reveal about the cross-pollinating streams of French art cinema at the time. Despite her cinephilic apprenticeship with such directors as Jacques Rivette, Wim Wenders and Jim Jarmusch, in her early films Denis steers far clear, in content as well as budget, from both the baroque Nouvelle Vague homages of Carax and the Amerophile efforts of Beineix and Besson. And while *S'enfout la mort* and *J'ai pas sommeil* echo the *cinéma de banlieue* in their focus on immigrant characters struggling to assimilate into French society, Denis's typically oblique approach to character and narrative also signals her inheritance from a long-established tradition of modernist art cinema. While Denis's early development can thus be placed within overlapping yet familiar cinematic provenances, she quickly complicated the terms of this reading with *Beau Travail*, which marked her breakthrough not only to wider international recognition, but also to a significant advancement in her aesthetics – as Jonathan Rosenbaum rather stridently put it, 'the difference between Claire Denis' early work and *Beau Travail* . . . is quite simply the difference between making movies and making cinema'.[11] While, to a certain extent, a continuation of Denis's concern with the interaction between the French metropole and its former colonies that began with *Chocolat* – as well as a cinephilic salute to her Nouvelle Vague forebears in its utilization of actor Michel Subor and his character Bruno Forestier from Godard's *Le petit soldat* (1963) – *Beau Travail* was far more assertively a film of surfaces rather than politics (or characters): of bodies in motion and at rest and of the coiled potential within them.

This was visual spectacle of a kind qualitatively different from that of the *cinéma du look*. Where the montage-driven tradition out of which the latter evolved used bodies as elements within the frame – fragmenting or spectacularising the body as a purely plastic object, an assemblage of parts to be utilized according to the sovereign needs of the image – Denis, in *Beau Travail*, employs the body as the 'frame of the action' (to quote the Dardennes), the body and its movements serving rather as the *determinants* of the image. This transmutation is neatly signified in the film's famous final scene, wherein Denis Lavant's taskmaster, Sargent Galoup, does a spectacular solo dance in

a discotheque to 'Rhythm of the Night', echoing, and subtly altering, the exhilarating dance sequence set to David Bowie's 'Modern Love', which Lavant had performed in Carax's *Mauvais sang* (1986) a decade earlier. Where Carax's sudden arresting of Lavant's acrobatics through a hard image-and-sound cut confirms the sequence as a bravura, self-contained unit (within a film made up of self-contained units), Galoup's DeBarge-assisted dance into oblivion in *Beau Travail* is the culmination of the corporeal velocity that has been gathering until this point – an explosive culmination of the body's potential, at which, in substituting for the sergeant's narratively signalled suicide, also abstracts the physical end of that body.

Yet, if Lavant-the-performer's defiance of Galoup-the-character's dictated end can be read as a refutation of mortality and the fatalism of narrative, it is also pervaded with a formalistic chill. Where Denis's Nouvelle Vague forebears, Godard and Rivette, also created emotion formally rather than narratively, through the defiance of traditional fictional constructs like character and plot, that emotion was also bound up with the revelation of the person of their actors; no less than the fluidity and ceaseless improvisation of Rivette's chameleons, the flatness and automation of performance in Godard only attests to the solidity of the people performing. In *Beau Travail*, by contrast, Lavant's triumph is that of externalized virtuosity rather than inner subjecthood; he is a study in animal locomotion, the pantomiming of Godard/Rivette rendered as a kinetic spectacle that would not be out of place in the pop environs of the *cinéma du look*.

Denis's most celebrated film thus already contained the seeds of the seemingly drastic right turn of *Trouble Every Day*, which takes her prior aesthetic/thematic preoccupation with the body to extreme lengths, both graphically and narratively. A distended version of a scenario originally conceived as part of an anthology film (which was also to have featured episodes from Atom Egoyan and Olivier Assayas), *Trouble* utilizes a hackneyed horror-movie plot – a genetic experiment gone awry that has rendered the chief researcher (Vincent Gallo) and his colleague's wife (Béatrice Dalle) blood-craving, day-walking nymphomaniac vampires – but treats it with arthouse occlusion. Instead of explaining how these characters have been transformed into predators whose sexual urges have lethal consequences, Denis plunges us deep into a heightened and, as it is gradually revealed, monstrous subjectivity, her tactile sensitivity to bodies – at all times, across virtually all characters, major and minor – radically emphasized to suggest the unbridled desires of her half-reluctant predators. The film's astonishingly sensual charge, even in mundane moments (like Gallo's gaze crawling all over the bobbing calves of the hotel maid as she leads him and his wife to their room) forces us inside the dreadful immanence of their desires; the lattice of wooden boards meant to keep Dalle's voracious succubus safely trapped in her room – and any hapless intruders safely out her reach – is a visual metaphor that exists for

the sole purpose of being impulsively torn down. If Denis makes us complicit in the characters' erotically violent urges, we are also uncomfortably complicit in their bloody fallout, the intimate attention lavished on skin and sinew making its eventual and spectacular violation (in a pair of sequences that rocket to the most extreme fringe of the Extremity) all the more horrifying.

While Denis, at times, sardonically comments on her film's genre bases (at one point, Gallo jokingly acts the part of Frankenstein's monster for his young bride), there is much less of a distance between her 'low' content and high-art inclinations than in, for example, Godard's gangster riffs, Rivette's Langian thriller plots or even Carax's heist-movie fantasia in *Mauvais sang*. *Trouble Every Day* functions equally as a *film d'auteur* and an unusually refined but easily classifiable (and marketable) genre piece – a grey area that other members of the Extreme coterie, from the more reticent Grandrieux to the aggressively self-promoting Noé, have adeptly exploited. Reciprocally, a new generation of French-language exploitation filmmakers, such as Alexandre Aja (*Haute tension*, 2003), Pascal Laugier (*Martyrs*, 2008), Fabrice Du Welz (*Calvaire*, 2004; *Vinyan*, 2008) and Alexandre Bustillo and Julien Maury (*À l'intérieur*, 2007), have aped some of the signifiers of art cinema – stylish cinematography, name stars and calculatedly elliptical narratives – to add a gloss to their fence-swinging depictions of gore, sexually charged violence and ostentatious taboo breaking.[12]

This recent cross-pollination between 'high' and 'low' filmic forms – which is hardly a phenomenon restricted to French-language cinema[13] – has also benefited considerably from academic theory's trickle-down effects on the wider culture, as well as the latter's trickle-up influence on the former. If the slick, audience-friendly 'art' films of Beineix and Besson helped to domesticate and familiarize the arthouse for North American consumption, the anti-evaluative, anti-hierarchical orientation of much cultural theory helped give these manoeuvres intellectual legitimacy. No less than the North American film critical community – which, as Rosenbaum has tirelessly pointed out, is often no more than the vanguard of a passively receptive, aesthetically and politically quiescent mass audience – North American academia is all too willing to vaunt the most readily available products (American genre cinema) and most readily recognizable imports ('art' films that play by or lightly tinker with the rules of American genre cinema) as the benchmarks of cultural importance, particularly when they can be dismantled to reveal their real or attributed social/political/sexual/racial 'discourses'. Accordingly, both 'art' and 'genre' filmmakers, possessed of a wised-up, post-academic awareness of the underlying structures of the exploitation film – 'discourses' of gender, family, social disparity, colonialism and so forth – have foregrounded these structures in their own films, tapping into an ever-expanding 'cult' cinema sensibility that has incorporated and popularized the language of certain currents of academicized analysis.[14]

One of these currents, and the one most germane to a discussion of the New French Extremity, is a loose agglomeration of cultural attitudes, as opposed to thought or theory – let's call it Foucauldian-Buterlian-Deleuzo-Guattarianism – deriving from a series of influential works that sought to resituate a left-wing language of political liberation as an innate property of the body rather than the vehicle of a directing will. In this calculus, the body's physical freedom of movement – and the concomitant freeing of that body's desires – is read as a site of 'resistance' within an ossified public sphere and a corrupting, guilt-obsessed Freudian psychologism, thus hitching post-modern/post-structuralist semantics to a kind of resuscitated vitalism.[15] One of the effects of this shift has been to make the personal political by handily removing it from the field of actual political engagement, making of it a rhetorical shadow (or shell) game whose stridency is matched only by its impotence. Where Foucault at least had the humility or the self-awareness to define his remarkably agile thought exercises as 'fictions' (as Barthes had previously dubbed his 'mythologies'), the tendency since has been to treat these allegorical narratives of political defiance as if they were the thing in itself, a solipsistic *fait accompli*.

Along with its genre borrowings (and a residual strain of *épater le bourgeois*), it is this accumulated cultural-intellectual baggage that underlies the provocations of the New French Extremity and perhaps explains their penchant for the windily allegorical. The film titles themselves, even when implicitly ironic, bespeak stark opposition, finality, all-encompassing significance: *La vie de Jésus* (Dumont, 1997), *Seul contre tous* (Noé, 1998), *L'humanité* (Dumont, 1999), *La vie nouvelle* (Grandrieux, 2002), *Irreversible* (Noé, 2002) and *Enter the Void* (Noé, 2010); even the anodyne titles of *Sombre* (Grandrieux, 1998), *Twentynine Palms*, *Flandres* (Dumont, 2006) and *Hadewijch* (Dumont, 2009) evoke cosmic certitude by their very neutrality. Deprived of articulation, happily helpless slaves of their animal drives, Dumont's rutting, po-faced lumps, Grandrieux's viciously carnal nightlifers and Noé's hyperbolic limit cases all stand as pre-set figures in an equation that has already been solved. Further, by their tendency to pointedly yet vaguely evoke charged political situations – Le Pen and the rise of the Front National (*Seul contre tous*), the Balkan Wars (*La vie nouvelle*), the invasions of Afghanistan and Iraq (*Flandres*) and fundamentalist terrorism (*Hadewijch*) – the films inscribe allegorical finitude upon subjects that are still painfully complex, painfully open.

Just as Dumont progressively moved away from the intense specificity of *La vie de Jésus* and *L'humanité* towards the more nakedly symbolic and abstract, Denis made this move towards the allegorical in *Beau Travail* before winnowing that abstraction down to the bone in *Trouble Every Day* and *Friday Night*, and peeling it back to the very marrow in *L'Intrus*, which follows Michel Subor's aged soldier of fortune (Bruno Forestier under yet another alias?) as

he embarks on a globe-trotting journey to replace his failing heart with a new one. Yet, while some have chosen to read the contrast between Subor's effortless exterior peregrinations and inexorably deteriorating physique as an allegory about Occidental tourism, this is ultimately more provisional than truly purposeful; the film's intriguingly exploratory form never attains the ephemeral, yet incisive, insight of *Beau Travail's* brilliant post-colonial pantomime. Whether or not the mixed reception of *L'Intrus* proved disheartening for its maker is hard to know, but there's no question that Denis has somewhat resurfaced from her headlong plunge into bodily textures into a wider social world. *35 rhums*, a touching family drama patterned after Ozu's *Late Spring* (1949), includes perhaps the most explicit (and therefore slightly discordant) instance of political commentary in her work thus far, in a classroom debate on the impact of IMF policies. *White Material*, though maintaining Denis's tendencies towards the allegorical by withholding the name of the war-torn African nation in which it takes place and weighing down certain characters – most prominently the nameless 'Boxer' (Isaach de Bankolé) and the wastrel son (Nicolas Duvauchelle) of Isabelle Huppert's plantation owner – with some rather strenuous symbolic baggage is nevertheless too plainly urgent in its concern for Denis's childhood home to be as philosophically abstract as Dumont's *Flandres*.

There is, has always been, a fundamental empathy in Denis's work that counters her evidently powerful attraction to (and skill with) the disturbingly sensual depiction of violence. Unlike the iconoclasm and aesthetic-rhetorical gauntlet-dropping of Noé, Grandrieux and Dumont (as well as such transnational provocateurs as Michael Haneke and Lars von Trier), Denis's aesthetic is not built upon and does not necessitate a strident, wilful challenge to the audience's tolerance and sensibilities; she has instead cultivated an authorial gaze that is unmistakable even as it shifts in focus and intensity from film to film. In this, she resembles the Dardennes, who are also difficult to 'place' in terms of national cinema movements or key influences (apart from their beloved Bresson) even as their work feels so uncannily familiar in its subjects and concerns. Unlike the Belgian brothers, however, who have accomplished the Benjaminian feat of founding a genre of which they are the only true practitioners, Denis has a flexibility that allows her to adapt to the contours of genre – the serial-killer film (*J'ai pas sommeil*), whimsical romantic fantasy (*Friday Night*), the family drama (*35 rhums*) and the horror movie (*Trouble Every Day*) – and to echo, incorporate or utilize the traits of contemporary cinematic sensibilities (more so than 'movements') such as the *cinéma du look*, the *cinéma de banlieue* or even the New French Extremity, all of which she has outlasted, to say nothing of having artistically outstripped. If Denis has not yet achieved the Dardennes's remarkable fusion of stylistic refinement and social concern, she nevertheless has earned pride of place in a more amorphous French cinematic lineage irreducible

to labels either adopted or applied, one that extends from the Nouvelle Vague to such non-aligneds as Pialat or Eustache and later-arriving figures like Andre Techiné, Olivier Assayas, Jacques Nolot and Arnaud Desplechin – a tradition defined not by formal or thematic similarities but rather by an underlying determination to feel out and push past the limits of movements or categories, to find the fissures and gaps that lead out beyond.

Notes

1. Quandt, James, 'Flesh & blood: Sex and violence in recent French cinema', *ArtForum* xlii/6 (February 2004), p. 126.
2. Ibid.
3. Ibid., p. 132.
4. Ibid.
5. Ibid.
6. The term *cinéma du look* was coined by critic Raphael Bassan in *Revue du Cinema*, no. 448, in May 1989, eight years after the premiere of *Diva*. Interestingly, Bassan's taxonomy coincided with the movement's perceived dissolution – Besson's *La Femme Nikita* (1991) and *Léon/The Professional* (1994) are not generally classified as examples of *cinéma du look*.
7. Greene, Naomi, 'Representations 1960–2004: "Parisian images and national transformations"', in M. Temple and M. Witt (eds.), *The French Cinema Book* (London, 2004), p. 251.
8. Carax stands somewhat apart from Beineix-Besson in his apparent lack of crossover ambitions and in his far more studied obeisance to the Nouvelle Vague in *Boy Meets Girl* (1984) and *Mauvais sang* (1986), with his enormously expensive *Les Amants du Pont-Neuf* (1991) a financially disastrous attempt to blend the *film d'auteur* with the mega-production. Like Denis, Carax also later touched upon the shores of Extremity with the graphic, unsimulated sex scenes in *Pola X* (1999).
9. Besson made the first move with the English-language, French–American–Italian co-production *The Big Blue* (1988), followed by *Léon/The Professional*, *The Fifth Element* (1997) and *The Messenger: The Story of Joan of Arc* (1999). Kassovitz, after courting a crossover audience with the serial-killer mystery *The Crimson Rivers* (2000), soon after made the American suspense-horror film *Gothika* (2003) and the sci-fi film *Babylon A. D.* (2008). Richet, who had won acclaim for *Ma 6-T va crack-er* (1997), later came to the United States to direct the lamentable remake of *Assault on Precinct 13* (2005) before returning to France to direct the big-budget, two-part gangster epic *Mesrine* (2008).
10. *Cinéma de papa* was the much quoted, and perhaps apocryphal, term supposedly coined by the 'young Turks' of *Cahiers du cinéma* (most often accorded to François Truffaut) as a derogation of the classical pre-war French cinema exemplified by such directors as Julien Duvivier, Marcel Carné and the screenwriting team of Jean Aurenche and Pierre Bost.

11 Rosenbaum, Jonathan, 'Unsatisfied men', *Chicago Reader*, May 25, 2000.

12 The sharing of star actors between the films of the New French Extremity and the new French exploitation – *Seul contre tous*'s Phillipe Nahon in *Calvaire*, *Trouble Every Day*'s Béatrice Dalle in *À l'intérieur* – is only the most evident affinity between the French arthouse and grindhouse. Further, like their *cinéma du look* and *cinéma de banlieue* forebears, the new exploitation filmmakers made inroads to American and English-language films: Aja directed the horror remakes *The Hills Have Eyes* (2006), *Mirrors* (2008, a remake of the 2003 South Korean film *Into the Mirror*) and *Piranha 3-D* (2010), and Laugier was briefly attached to a remake of Clive Barker's *Hellraiser*, while Du Welz's *Vinyan* (2008) was made in English with British actor Rufus Sewell and French superstar Emmanuelle Béart.

13 Other notable examples include the "J-Horror" cycle of Japanese thrillers, which afforded idiosyncratic filmmakers like Kiyoshi Kurosawa and the more hyperactive Takashi Miike entrée to arthouse appreciation, and recent, genre-oriented South Korean films by such directors as Park Chan-wook (who took the Grand Prix at Cannes for his baroque 2004 revenge thriller, *Oldboy*, and the festival's Jury Prize for the 2009 vampire film *Thirst*) and Bong Joon-ho. One could also cite the collected works of Mexican director-producer Guillermo del Toro, who has moved seamlessly back and forth between blatantly commercial fare such as *Blade II* (2002) and the *Hellboy* films and 'arthouse' efforts like *The Devil's Backbone* (2001) and *Pan's Labyrinth* (2006), which mix their spooky effects with a po-faced veneer of historical gravity. Overlooking all these latter-day developments is the remarkable critical and academic embrace of David Cronenberg, one of the first horror filmmakers to attract not only critical acclaim but also considerable academic attention.

14 A prime example would be George A. Romero, whose reliably strident old-guard leftism in the increasingly topical zombie sagas *Diary of the Dead* (2007) and *Survival of the Dead* (2009) have made him sympathetic to reviewers and academics alike despite his diminished capacity to produce effective genre entertainments. Meanwhile, the chatter around the *Hostel* films of Eli Roth is instructive in demonstrating how easily zeitgeist-inclined commentators can be co-opted. Roth's wholly disingenuous claims for his grotesquely violent neo-grindhouse films – that they are vessels channelling contemporary American anxieties about torture and the resentment of the international community or that the thoroughly clichéd female-victim-turning-on-her-tormentors denouement of the second film constitutes some kind of 'feminist' twist on the genre – are, if not accepted wholesale, nonetheless accorded undue seriousness by critics and duly integrated into 'think pieces' about the films. This would seem to be an example of the tail wagging the dog.

15 Even Foucault's panoptic fatalism is shot through with intimations of a future emancipation deriving from the pre-discursive essentialism of the body: 'It is the agency of sex that we must break away from if we aim – through a tactical reversal of the various mechanisms of sexuality – to counter the grips of power with the claims of bodies, pleasures and knowledges in their multiplicity and their possibility of resistance'. Foucault, Michel, *The History of Sexuality – Volume I: An Introduction* (New York, 1990), p. 157.

25 Still from *Trouble Every Day*

Bibliography

Agamben, Giorgio, 'Notes on Gesture', in *Means without End: Notes on Politics*, trans. Vincenzo Binetti and Cesare Casarino (Minneapolis: University of Minnesota, 2000), pp. 49–60.

Allison, Deborah, "Promises in the Dark: Opening Title Sequences in American Feature Films of the Sound Period" (University of East Anglia Ph.D, 2001).

Ancian, Aime 'Claire Denis: An interview', *Senses of Cinema* (2002). Retrieved June 2, 2009, from: http://archive.sensesofcinema.com/contents/02/23/denis_interview.html.

Archer, Neil, 'Sex, the city and the cinematic: The possibilities of female spectatorship in Claire Denis's Vendredi soir'. *French Forum* xxxiii/1–2 (Winter/Spring 2008), pp. 245–60.

Arroba, Álvaro (Ed.), Claire Denis, Fusión Fría. (Festival Internacional de Cine de Gijón, 2005).

Asibong, Andrew, 'Viral women: Singular collective and progressive infection in Hiroshima Mon Amour, Les Yeux Sans Visage and Trouble Every Day', in H. Vassallo and P. Cooke (eds), *Alienation and Alterity: Otherness in Modern and Contemporary Francophone Contexts* (Bern: Peter Lang, 2009), pp. 93–114.

—— 'Claire Denis's Flickering Spaces of Hospitality', *L'Esprit Créateur* li/1(2011), pp. 154–167.

Azalbert, Nicolas, 'Terre d'asile', *Cahiers du Cinéma* dcliv (March, 2010), pp. 17–18.

Barthes, Roland, 'En sortant du cinéma', *Communications* xxiii (1957).

—— *Image Music Text*. (Ann Arbor: University of Michigan, 1977).

Baudrillard, Jean, *Le Système des Objets. La consommation des Signes / The System of Objects* (Paris: Denoël-Gonthier, 1968).

Bell, James, 'All in the family', *Sight and Sound*, xix/8 (2009), p. 44.

Bergstrom, Janet, 'Opacity in the films of Claire Denis', in T. Stovall and G. Van Den Abbeele (eds.), *French Civilization and its Discontents. Nationalism, Colonialism, Race* (Lanham: Lexington Books, 2003).

_____ *Claire Denis*. (Manchester: Manchester University Press, 2004).

Beugnet, Martine, *Cinema and Sensation: French Film and the Art of Transgression* (Edinburgh: Edinburgh University Press, 2007).

Beugnet, Martine and Sillars, Jane, 'Beau travail: Time, space and myths of identity', *Studies in French Cinema* i/3 (2001), pp. 166–173.

Bresson, Robert, *Une Femme Douce/A Gentle Woman* (1969).

Carter, Mia, 'Acknowledged absences: Claire Denis's cinema of longing', *Studies in European Cinema* iii/1 (2006), pp. 67–81.

Conley, Tom, 'The film event', in Gregory Flaxman (ed.), *The Brain is the Screen* (Minneapolis: University of Minnesota Press, 2000).

Cooper, Sarah, 'Je sais bien, mais quand même...: Fetishism, envy, and the queer pleasures of Beau travail', *Studies in French Cinema* i/3 (2001), pp. 174–182.

_____ *Selfless Cinema? Ethics and French Documentary* (Oxford: Legenda, 2006).

Darke, Chris, 'Desire is violence' (interview with Denis), *Sight and Sound* x/7 (2000), pp. 16–18.

David, Sébastien, and Fontanel, Rémi, *Le Cinéma de Claire Denis, ou, l'Enigme des Sens* (Lyon: Aléas, 2008).

Davis, Robert, 'Interview: Claire Denis on 35 Shots of Rum', *Daily Plastic* (2009). Retrieved June 2, 2009, from: http://www.dailyplastic.com/2009/03/interview-claire-denis-on-35-shots-of-rum/

Deleuze, Gilles, *Cinema 1: The Movement-Image*, trans. Hugh Tomlinson and Barbara Habberjam (Minneapolis: University of Minnesota Press, 1986).

_____ *Cinema 2: The Time-Image*, trans. Hugh Tomlinson and Robert Galeta (Minneapolis: University of Minnesota Press, 1989).

_____ *Difference and Repetition*, trans. Paul Patton (New York: Columbia University Press, 1994).

_____ *The Logic of Sense*, Mark Lester with Charles Stivale (trans), Constantin V. Boundas (ed), (New York: Columbia University Press, 1990).

Denis, Claire, 'Noir désir': interview with Serge Kaganski, *Les Inrockuptibles* 57 (July, 1994), p. 74 (reprinted May 12, 2000).

_____ 'Interview with Claire Denis' (2009) [video]. Retrieved June 20, 2010 from: http://www.allocine.fr/video/player_gen_cmedia=18866960&cfilm=111438.html.

_____ 'Close-up: Claire Denis': Interview with Dave Calhoun, *Time Out* (2010a), July 1–7, p. 69.

_____ 'White Material': Interview with Sarah Cronin (2010b). Retrieved December 29, 2010, from: http://www.electricsheepmagazine.co.uk/features/2010/07/01/white-material-interview-with-claire-denis.

_____ 'Trois femmes puissantes': Interview with Stéphane Delorme and Nicolas Azalbert, *Cahiers du Cinéma* dcliv (March, 2010c), pp. 19–23.

―――― 'Le territoire s'oppose au paysage' (Territory is the opposite of landscape): Interview with Nicolas Azalbert and Vincent Malausa, *Cahiers du Cinéma* dclxv (March, 2011), p. 17.

Diatkine, Anne, Review from Elle (October 1, 2009). Retrieved June 20, 2010 from: http://www.allocine.fr/film/revuedepresse_gen_cfilm=111438¬e=2&ccritique=19274771.html.

Dobson, Julia, 'Sequels of engagement: From Le Petit soldat to Beau Travail', paper presented at the conference 'Cinéma et Engagement', Nottingham Trent University, UK, 12 September 2002.

Dodds, Sherril, *Dance on Screen: Genres and Media from Hollywood to Experimental Art* (Basingstoke, 2001).

Durham, Carolyn, 'More than meets the eye. Meandering metaphor in Claire Denis's Chocolat', in E. Rueschmann (ed.), *Moving Pictures, Migrating identities* (Jackson: University Press of Mississipi, 2003).

Eisenstein, Sergei, 'Methods of montage', in Jay Leyda (ed. and trans.), *Film Form: Essays in Film Theory* (San Diego: Harvest Books, 1949), pp. 72–83.

Fanon, Frantz, *Peau Noire, Masques Blancs (Black Skin, White Masks)]* (Paris: Seuil, 1952).

Fontanel, Rémi. '"Ouvrir" le film' in A. Tylski (ed.), *Les Cinéastes et Leurs Génériques* (Paris: L'Harmattan, 2008).

Gégauff, Paul, *Le Reflux* (1965).

Godard, Jean-Luc, *Le Petit Soldat* (1961).

Gonzales, Yann, Arte France. (2001) Retrieved April 10, 2009 from: http://archives.arte.tv/cinema/cannes2001/ftext/1505.htm#b.

Hall, Stuart, 'European cinema on the verge of a nervous breakdown'. In D. Petrie (ed.), *Screening Europe: Image and Identity in Contemporary European Cinema* (London: BFI, 1992), pp. 45–53.

Hayward, Susan, 'Claire Denis' films and the post-colonial body—with special reference to Beau travail (1999)', *Studies in French Cinema* i/3 (2001), pp. 159–165.

Henderson, Brian, 'Towards a non-bourgeois camera style', in Bill Nichols (ed.), *Movies and Methods: An Anthology* (Volume One; Berkeley: University of California Press, 1976), pp. 422–38.

Horeck, Tanya, and Kendall, Tina, *The New Extremism in Cinema: From France to Europe* (Scotland: Edinburgh University Press, 2001).

Hughes, Darren, 'Dancing reveals so much: An interview with Claire Denis', *Senses of Cinema* (2009). Retrieved March 15, 2011, from http://www.sensesofcinema.com/?p=2524.

Jousse, Thierry, 'Jeux africains', *Cahiers du Cinéma* cdvii-iii (May, 1998), pp. 132–33.

Jousse, Thierry and Strauss, Frédéric, 'Entretiens avec Claire Denis' [Interviews with Claire Denis], *Cahiers du Cinéma* ivcvxxix(May, 1994), pp. 24–30.

Kristeva, Julia, *La Révolution du Langage Poétique* [*Revolution in Poetic Language*] (Paris : Seuil, 1974).

Kuntzel, Thierry, 'Le travail du film, 1 [The Film Work, 1]', *Communications* xix (1972), pp. 25–39.

——— 'Le travail du film, 2 [The Film Work, 2],' *Communications* xxiii (1975), pp. 136–189.

Lacoue-Labarthe, Philippe, 'The Echo of the Subject', in Christopher Fynsk (ed), *Typography: Mimesis, Philosophy, Politics* (Cambridge MA; London, 1989), pp. 139–207.

Lang, Fritz, *Metropolis* (1927).

Latour, Bruno, 'Some experiments in art and politics', in *E-Flux*, vol. 23 (March 2011). Retrieved July 7, 2011 from: http://www.e-flux.com/journal/some-experiments-in-art-and-politics/

Lessing, Doris, *The Grass is Singing* (Harper Perennial Modern Classics 2000 [1950]).

Lübecker, Nikolaj, 'The dedramatization of violence in Claire Denis's I Can't Sleep', in *Paragraph* xxx/2 (2007), pp. 17–33.

Marks, Laura U., *The Skin of the Film: Intercultural Cinema, Embodiment and the Senses* (Durham, London, 2000).

Martin, Adrian, 'Ticket to ride: Claire Denis and the cinema of the body', *Screening the Past* (2006). Retrieved June 2, 2009, from http://tlweb.latrobe.edu.au/humanities/screeningthepast/20/claire-denis.html.

Martin, Adrian, 'In a foreign land', *Sight and Sound*, xx/7 (2010), pp. 50–1.

Mayne, Judith, *Claire Denis*. (University of Illinois Press, 2005).

McMahon, Laura, 'The withdrawal of touch: Denis, Nancy and L'Intrus', *Studies in French Cinema*, viii/1 (2008a), pp. 29–39.

——— 'Deconstructing community and Christianity: 'A-religion' in Nancy's reading of Beau travail', *Film-Philosophy* xii/1 (2008b), pp. 63–78.

McRobbie, Angela, '*Fame, Flashdance*, and fantasies of achievement', in Jane Gaines and Charlotte Herzog (eds), *Fabrications: Costume and the Female Body* (New York, London, 1990), pp. 39–58.

Metz, Christian, 'Ponctuations et démarcations'[Punctuations and demarcation], in *Essais sur la Signification au Cinéma* [*Film Language : A Semiotics of the Cinema*]. (Paris: Klincksieck, 2003).

Moinereau, Laurence, *Le Générique de Film. De la Lettre à la Figure* [*The Title sequence. From the Letter to the Figure*] (Rennes: Presses Universitaires de Rennes, 2009).

Monnier, Mathilde and Nancy, Jean-Luc, *Allitérations: Conversations sur la danse. Avec la participation de Claire Denis* (Paris, 2005).

Morlock, Forbes, 'Solid cinema: Claire Denis's strange solidarities', *Journal of European Studies* xxxiv/1–2 (2004), pp. 82–91.

Morrey, Douglas, 'Open wounds: Body and image in Jean-Luc Nancy and Claire Denis', *Film-Philosophy* xii/1 (2008), pp. 10–30.

Nancy, Jean-Luc, *The Inoperative Community*, trans. Peter Connor, Lisa Garbus, Michael Holland and Simona Sawhney, ed. Peter Connor, with a foreword by Christopher Fynsk (Minneapolis, 1991).

───── *L'Intrus [The intruder]* (Paris: Galilée, 2000).

───── 'A-religion', *Journal of European Studies* xxxiv/1–2 (2004), pp. 14–18.

Narboni, Jean, Sylvie Pierre and Jacques Rivette, 'Montage', in Nick Browne (ed.), *Cahiers du Cinéma Vol. 3, 1969–1972: The Politics of Representation*, trans. Tom Milne (London: Routledge, 1990), pp. 21–44.

NDiaye, Marie, 'Revoir l'Afrique': Interview with Nicolas Azalbert, *Cahiers du Cinéma* dcliv (March, 2010), pp. 24–5.

Odin, Roger, 'L'entrée du spectateur dans la fiction' [The entrance of the spectator into fiction] in Jean-Louis Leutrat (ed.), *Théorie du film* (Paris: Albatros, 1980), pp. 198–213.

Oyono, Ferdinand, *Une Vie de Boy (House-boy)* (Paris: Pocket, 2006 [1956]).

Perrault, Charles, *Histoires et Contes du Temps Passé, avec des Moralités / Tales and Stories of the Past with Morals* (Paris: Claude Barbin, 1697).

Rancière, Jacques, 'Aesthetic separation, aesthetic community,' in Gregory Elliott (trans.), *The Emancipated Spectator*. (New York and London: Verso Books, 2009), pp. 51–82.

───── 'The method of equality: An answer to some questions', in Gabriel Rockwell and Philip Watts (eds.), *Jacques Rancière: History, Politics, Aesthetics* (Durham and London: Duke University Press, 2009), pp. 273–88.

───── *The Politics of Aesthetics: The Distribution of the Sensible*, trans. Gabriel Rockhill (London, 2006).

Río, Elena del, 'Body transformations in the films of Claire Denis: From ritual to play' *Studies in French Cinema* iii/3 (2003), pp. 185–197.

Rodowick, David, *Gilles Deleuze's Time Machine*, (Durham: Duke University Press, 1997).

Romney, Jonathan, 'Alien Heart', *Sight and Sound* xv/9 (2005), pp. 40–2.

───── 'Claire Denis interviewed by Jonathan Romney', The *Guardian*, 28 June 2000. Retrieved March 15, 2011, from http://film.guardian.co.uk/interview/interviewpages/0,,338784,00.html.

Sachs, Ira, 'Awakenings', *Filmmaker* vi/1 (1997), pp. 36–8, 77–81.

Shephard, Alex, 'Isabelle Huppert, beloved actress', *Plastic* (2010). Retrieved July 20, 2011, from: http://www.planet-mag.com/2010/features/alex-shephard/isabelle-huppert-interview/

Smith, Damon, 'L'Intrus: An Interview with Claire Denis', *Senses of Cinema* (2005). Retrieved June 2, 2009 and March 15, 2011, from: http: http://sensesofcinema.com/2002/23/denis_interview/

Stanitzek, George, 'Reading the title sequence (vorspann, générique)', *Cinema Journal* xlviii/4 (2009), pp. 44–58.

Stevenson, Allen Johnson, "A vampire in the mirror: The sexuality of Dracula." *PMLA / Publications of the Modern Language Association*, ciii/2 (March 1988), pp. 139–49.

Stoker, Bram, *Dracula* (Westminster: Archibald Constable & Co., 1897).

Strauss, Frédéric, 'Miam-Miam', *Cahiers du cinéma* 510 (February 1997).

Tarr, Carrie, with Brigitte Rollet, *Cinema and the Second Sex: Women's Filmmaking in France in the 1980s and 1990s* (London and New York: Continuum, 2001).

Tylski, Alexandre, *Le Générique de Cinéma. Histoire et Fonctions d'un Fragment Hybride [The Cinema Opening Credits. History and Functions of a Hybrid Fragment]* (Toulouse: Presses Universitaires du Mirail, 2008).

Vincentelli, Elizabeth, 'Agnès Godard's candid camera', *Village Voice*, 4 April 2000. Retrieved March 15, 2011, from http://www.villagevoice.com/2000-04-04/film/agnes-godard-s-candid-camera/

——— *Gilles Deleuze's Difference and Repetition* (Edinburgh: University of Edinburgh Press, 2003).

Williams, James S., '"O Heave! O Heave away, Heave! O Heave!": Working through the author in Beau Travail', *Journal of European Studies* xxxiv/1–2 (2004), pp. 44–59.

——— 'Romancing the father in Claire Denis's *35 Shots of Rum*', *Film Quarterly* lxiii/2 (2009–10), pp. 44–50.

Witt, Michael, 'Montage, my beautiful care, or histories of the cinematograph', in Michael Temple and James S. Williams (eds.), *The Cinema Alone: Essays on the Work of Jean-Luc Godard* (Amsterdam: Amsterdam University Press, 2000), pp. 33–50.

Wood, Robin, 'Only (dis)connect and never relaxez-vous, or I Can't Sleep', in *Film International* (Jan. 27, 2011). Retrieved July 5, 2011 from: http://filmint.nu/?p=243.

Index

35 rhums/35 Shots of Rum 4, 5, 9, 29, 32, 33, 35, 37, *39*, 46, 51, 55, 57, 64, 70–2, 75n, 76n, 99–105, 136, 142, *145*, 164, 167–70, 172n, 183, 185n, 186n, 212n, 216, 223
35mm film 14

accompaniment 176, 178, 179, 183
actual-virtual 192, 193, 195, 199
Africa xiii, xxii, 9, 41–4, 73, 91, 103, 104, 111–21, 121n, 123n, 131n, 139, 143, 171, 182, 203, 204, 205
African/Africaine xii, xv, 5, 26, 66, 73, 98, 99, 100, 103–5, 106n, 113–15, 117, 119–20, 121n, 122n, 136, 139–140, 142, 143, 165, 167, 168, 171, 203, 212n, 216, 223
African-American 26, 100, 117
Agamben, Giorgio ix, 175, 176, 184n, 186n
AIDS 83, 93, 127, 128–9
Ancian, Aimé 66, 75n
animal xiv, 43, 93, 103, 122n, 175, 180, 196, 220, 222
any-spaces-whatever 190, 194–6
Arthouse 215–24, 225n

Bankolé, Isaach de 26, 47, 77, 92, 96, 98, 105n, *107*, *124*, 136, 137, 152, 175, 223
The Bastards xv
Baudrillard, Jean 130, 132n
Bazin, Andre 80

Beau Travail 6, 13–15, 19, 21, *24*, 67–68, 69, 75n, 94–5, 103, 137–9, 153, 164, 166, 167, 170, 175–181, 183, 184n, 185n, 186n, *187*, 205, 208–11, 216, 219–20, 222–3
Beineix, Jean-Jacques 218-9, 221, 224n
Bell, James 21n
belonging 91, 97, 111, 112, 115–8, 209, 212
Besson, Luc 218–9, 221, 224n
Beugnet, Martine ix, xv, 3, 63, 65–7, 70, 75n, 84–5, 167, 175, 176–7, 179, 184, 185n, 213n
Billy Budd 16, 69, 94, 153, 170, 176, 179
birth 67, 68, 69, 112, 163–4, 166–72, 172n
border/borderline ix, xv, 98, 104, 113, 149, 155–6, 170, 198, 204, 206, 209, 211
Boulter, David 9

Cain and Abel 69
Cameroon 26, 41–2, 44, 67, 73, 103, 111–9, 122n, 171, 204, 205, 211
Cameroonian 64, 99
cannibal/cannibalism 97, 125–31, 215
Carax, Leos 13, 15, 180, 218–21, 224n
Carter, Mia 63, 64, 75n, 229n
Chevalier, Pierre 14, 23
children xv, 10, 47, 48, 70, 75n, 76n, 92, 140, 149, 156

233

Chocolat xxii, xxiii, 6, 26–7, 42, 64–6, 73, 77, 94, 98, 99, 103, 105n, 111–21, 121n, 122n, 123n, *124*, 126, 135, 136, 139–41, 143, 164, 166, 168, 171, 204–9, 211, 215, 216, 219, 212n
choreographic/choreography 99, 175–80, 183–4, 184n, 185n
Christ 69, 148, 153–5
Christianity/Christian 12, 75n, 106, 153, 154
cinema de banlieue 216, 218–9, 223, 225n
cinéma du look 218–20, 223, 224n, 225n
Colin, Grégoire *24*, 55, 67, 69, 70, 71, 77, 96, 98, 99, 138, 142, 177, 180–1, 183
colonial 74, 93, 94, 98, 103–5, 106n, 111–6, 118–20, 121n, 122n, 128–31, 142, 143, 204, 205, 211–2, 216, 212n
colonialism 25, 104–5, 111, 113, 116, 118–121, 121n, 129, 136, 140, 143, 204, 205, 210–1, 221
colonialist 65, 66, 72, 120, 204
commonality 97, 102, 176, 178, 180, 183–4
community xv, 42, 63, 64, 66, 72–3, 75n, 76n, 79, 86–7, 87n, 97, 99, 101, 127, 135, 136, 142, 177, 178, 183, 185n, 206, 225n
consumption 130, 221
corporeality/physicality 164, 167, 215
Cosgrove, Denis E. 205, 212n
Courcet, Richard *90*
Crusoe, Robinson 42

D-Day 44
Dalle, Béatrice 36, 54, 88n, 96, 97, 126, 220, *133*, *160*, 225n
dance 20, 32, 55, 65, 68, 72, 73, 99, 106n, 137, 175–84, 184n, 186n, 219–20
Dardenne, Jean-Pierre 216
Dardenne, Luc 216, 219, 223
Darke, Chris 76n, 185n
daughter 32–3, 35–6, 55, 64, 66, 70–2, 75n, 97, 100–3, 142, 171, 183, 204
death 27, 46–7, 54, 71, 94, 101, 102, 120, 122n, 151, 153–4, 164, 180–1, 186n, 195
Deleuze, Gilles x, 80–2, 88n, 166, 179, 189–90, 193–5, 197–8, 199n, 200n

Descas, Alex 13, 14, 25, *39*, 47, 55, 96, 97, 99, 136, 137, 141, *145*, 175–6, 183
desire 68, 70, 73–74, 76n, 80, 95, 96, 98–101, 104–5, 112, 114, 126, 130, 140–1, 150, 154, 165, 181, 185n, 186n, 209, 220, 222
diaspora 97, 104
differential calculus 198
differentials of thought 198
digital ix, 14, 23n
Dionysus 148, 154–5
Diop, Mati 36, *39*, 99, 142, 183
disjunctive present 192–5
dissonance 190, 197, 210
Ducasse, Cécile *xxiii*, 77, *124*
Dumbo 44
Dumont, Bruno 215, 222–3
Dupont, Vincent *90*
Duvauchelle, Nicholas 54, *76*, 91, 223

employment 135–44
ethics 36, 137, 175, 181–3, 186n
European Graduate School vii, x, xvi, 59
exile 5, 68, 74, 97, 121, 205–6

fabulation 195–6
family xiv, xv, 43–4, 49, 56–57, 63–74, 75n, 83–4, 92, 93, 96–9, 101, 112, 119–21, 143, 149, 183, 210, 216, 221, 223
Fanon, Frantz 104–5
Fargeau, Jean-Pôl 26, 83n, 93
father 33, 35, 36, 38, 41, 43–4, 47–8, 55–6, 57, 64, 66–73, 91, 97, 90, 99–102, 105n, 112, 115–6, 119, 120, 128, 142, 148–50, 153–5, 168, 172n, 183, 186n, 204, 208
filiation 95–6, 148, 149–50, 164, 170, 172
fluidity 164, 168–9, 172n, 220
folding of time 192–3
Fontanel, Rémi xv, 164, 166–8, 170, 172n
foreign 17, 75n, 76n, 100, 103, 153, 158, 198, 210, 211, 218
Foreign Legion/Legionnaires 16–17, 19, 23, 103, 176, 178, 205, 210, 211
foreigner 103, 128, 137, 140, 142, 149, 155–6

foreigness 103, 135–44, 154, 206, 212
frame 14–15, 42, 67, 80, 96–105, 113, 115–6, 121–2n, 149, 153–4, 175, 179–81, 183, 207–8, 218
framing 98, 106n, 177–8

Gallo, Vincent 56, 141, 220–1, *226*
gay 83, 96
Gégauff, Paul 95, 149
gender xv, 69, 74, 92, 171, 172n, 221
gesture xiv, 3, 33, 68, 69, 86, 95, 98, 102, 118, 139, 148, 154, 175–7, 180–3, 184n, 186n
globalization 14, 87, 128, 130
Godard, Agnès 14, 29, 92–3, 106n, 175–7, 179, 182, 185n
Godard, Jean-Luc xii, 48, 50, 51, 81–2, 88n, 95, 164, 171, 215, 218–21
Golubeva, Yekaterina 55, 136, 140, *201*
gore 215, 221
grafting 91–105
Grandrieux, Philippe 215, 216, 221–3
Guiana 126–8

heart transplant 70, 95, 147–59, 172n, 179, 191–2, 206, 223
Hepburn, Audrey 44
heterogeneous time 190, 197
heterosexual 67, 70
Hinchliffe, Dickon xv, 3–6
Hollywood ix, xx, 6, 180, 131, 184n, 218, 219
home 44, 47, 49, 52, 56, 67–74, 93, 100, 101, 103–4, 112, 115–20, 126–7, 131, 139, 148, 150–2, 154, 155, 171, 198, 223
homosocial 96, 177–8
Horeck, Tanya 74n
horizon 115, 122n, 192, 206–8, 211–2
horizontal 193–4, 195
horror film 54, 128–9, 224n, 225n
Houri, Alice 67, *173*
Huppert, Isabelle *cover image,* 72, 75n, 76n, 91, 94, 103, 105n, 106n, *124*, 139, 143, 223

identity xiv, 91, 97–8, 111–2, 115–7, 119–20, 148, 151, 170, 177–8, 180, 182, 183, 184n, 197–8, 204
IDHEC, L' (L'Institut des hautes études cinématographiques) 50–2, 58
image of thought 81, 197
immigration xv, 143
incest 65, 67, 215
interiority 31, 156
interstice 189–9
interstitial repetition 189–91, 196–7
intimacy xiv, xv, 5, 56, 68–9, 74, 96–7, 99, 101, 105, 113–4, 163, 168
intruder 95, 119, 139, 143, 148, 154, 155, 195, 198, 220
L' Intrus/The Intruder 4, 5, 7, 13, 46, 55, 64, 70–1, 75n, 79, 94, 95, 106n, 142, 147–59, 160, 163–6, 170, 172n, 179, 183, 185n, 189–99, 201, 205–6, 208, 210, 211, 212n, 214, 216, 222–3

J'ai pas sommeil/I can't sleep 13, 32–3, 36, 64–7, 73, 79–87, 88n, 89n, *90*, 97–8, 126, 136–7, 140–1, 164–7, 180, 183, 186n, 216, 219, 223
Jarmusch, Jim xiii, xv, 219
Jesus 153
Jeunet, Jean-Pierre 129

Kendall, Tina 74
Kiarostami, Abbas xi, 210, 213n
Kinnell, Galway xiii
kinship 63, 65–9, 72–4, 94, 95, 96–7, 99–102, 105, 147, 150, 158

Lambert, Christophe 92
landscape xiv, 9, 66, 71–2, 96, 148, 169, 185n, 203–12, 212n, 213n
Lauterbach, Ann xiii–xiv
Lavant, Denis 20, 139, 177, 180–1, 183, 219–20
Lemercier, Valérie *173*
Lessing, Doris 93, 94, 105n, 113–5, 122n, 203, 212n
Loiret-Caille, Florence *226*

Man No Run 137
Marquesas Islands 149, 156
Martin, Adrian 63, 73, 75n, 76n
Martinique 28, 47, 64–5, 73, 83–4, 142
masculine 92, 93, 95, 103
maternity 158, 168
Mayne, Judith xv, 63–4, 66, 74n, 75n, 88n, 129, 132n, 144n, 167–70, 212n
McMahon, Laura 63, 75n, 106n
Melville, Herman 69, 94–5, 153, 170–1, 179, 204
Monnier, Mathilde 175, 181–3, 184n, 186n
montage 79–85, 88n, 92, 168, 219
Montet, Bruno 16, 176
mother 32–3, 41–3, 46, 56–7, 64–5, 68, 73, 75–6n, 97, 99, 100, 106n, 112, 114–7, 121, 149, 156, 158, 166, 168–9
motherland 65, 121
Mugel, Jean-Paul 15–16
music xiv, 3–10, 14, 16, 20–21, 23, 47, 71, 84, 96, 98, 112, 163–72, 172n, 179–81

Nancy, Jean-Luc xv, 41, *59*, 69, 75n, 95, 106n, 118, 143, 147, 175, 177–8, 179, 181–3, 184n, 185n, 186n, 206–7, 209–10, 213n
narrative xiv, 4, 5, 6, 64, 70, 80–2, 86, 92–5, 98, 102–3, 106n, 119, 126–8, 131, 137–8, 167, 177–8, 189–90, 194, 196, 206, 209–10, 218–22
NDiaye, Marie 93–4, 103, 106n, 112, 118–20
Nénette et Boni 3, 4, 6, 8, 63, 64, 67–8, 70, 74, 77, 96, 98, 142, 164, 165–9, *173*, 216
neo-colonial 87, 104, 106n, 118, 121n, 125, 130–1, 178
New French Extremity 215–7, 222, 223, 225n
Noé, Gaspar 215

obscurity 158, 164–5, 167
opacity 89n, 102, 164, 167, 172
opening sequences 163–72
Oyono, Ferdinand 94, 113
Ozu, Yasujiro 37, 101–2, 106n, 171, 223

parents xv, 41, 43, 49, 53, 64–73, 100, 118
Paris, Texas xii–xxi, 203–4
patriarchal 71, 102
Peck, Raoul 25, 26
Perrier, Mireille 26
Pésery, Bruno 35
photography xii, xxi, 92, 143, 148, 175
Pola X 15, 224n
politics x, xii, xiv, xv, 66, 74, 79, 86–7, 88n, 89n, 98, 111, 175, 183, 184n, 186n, 219
post-colonial 5, 63, 96, 97, 104, 106n, 111–4, 117–9, 121, 121n, 122n, 126, 127, 129–30, 135–6, 140, 142–3, 178, 184n, 205, 209, 211, 216, 223

queer 178, 185n
Quettier, Nelly 13–23, 179

race xv, 92, 99, 101, 104, 111–2, 115, 117–8, 120, 122n, 148
real-imaginary relations 195
Realm of the Senses 54
regard (gaze) 210, 212, 213n
relationality 79, 92, 99, 105, 175–6, 178, 180–1, 183
resonance 69, 176, 180, 184, 191, 194, 207, 217
Riefenstahl, Leni 13
road 43, 118, 156, 164, 166, 169, 196, 207, 211
Rollet, Brigitte 71, 75n
Romney, Jonathan 167, 185n, 186n
Rossellini, Roberto 80

S'en fout la mort/No fear, no die 25, 27–9, 47, 64–70, 73–4, 137, 140, 154, 164, 165, 175, 178, 183
Sachs, Ira 75n
scar xiii, 116–7, 151–3, 191–3, 195, 198–9, 200n, 204, 205–7, 209, 212
Schirmacher, Wolfgang xvi
score 8, 95, 96, 166
sex xiv, 67, 70, 75n, 101, 125, 224n, 225n

sexual 63, 67, 68, 70, 72, 74, 95–6, 105n, 114, 116, 127–8, 136, 140, 164, 178, 216, 220–1
sexuality 45, 74, 101, 125, 132n, 178, 216, 225n
Shepard, Sam xix, xx
Shephard, Alex 76n
siblings xv, 63, 64, 67–70, 75n
silence 28, 47, 48, 122, 164, 165, 208
Smith, Damon 70, 75n, 185n
solidarity 69, 96, 102, 176, 178–9, 183
son 36, 38, 48, 64, 65, 67, 70–3, 75n, 91, 92, 95, 103, 116, 118, 120, 148–58, 168, 171, 172n, 192, 195, 198–9, 205, 211–2, 223
song 3, 6, 8–10, 20, 99–100, 165–6, 167, 178, 180, 183, 186n
Staples, Stuart xv, 3, 5, 6, 7, *11*, 95
Subor, Michel 54, 69, 70, 91, 93–6, 106n, 149, *160*, 218, 222–3
suburban 5, 112, 127
swimming 48, 151, 156, 164–5, 167

tactile 7, 125, 178, 220
Tarr, Carrie 71, 75n
Tarzan 44–45
time-images 189–91, 194–6, 198–9
Tindersticks xv, 3–5, 93, 95, 166
Tintin 44–45
titles 164–6, 211, 222
Toussaint, Julieth Mars *145*
transplant 70, 95, 148–51, 153–4, 157, 172n, 191–2, 206, 211

transportation 164, 169
Trouble Every Day 4, 6, 9, 10, 13, 46, 54–5, 63, 70, 96–7, 125–31, *133*, 141–2, 164–5, 167, 170, 215–6, 220–3, 225n, *226*

U.S. Go Home 180, 183
Ughetto, Jean-Luis 11n, 35
uncanny 203–12, 213n, 217
urban xiv, 136, 206, 218

vampire 54, 126–9, 131, 132n, 220, 225n
Vendredi Soir/Friday night 4, 6, 11n, 13, 70, 96, 106n, 142, 164–6, 168–70, 173, 179, 216, 222–3
Vers Mathilde 137
Vers Nancy 143
virtual event 190–1, 193
virtual multiplicity 197, 199

Walt Disney 44
War and Peace 44
Wenders, Wim xii, xiii, xv, xix, 171, 203, 204, 219
White Material cover image, 4, 5, 9, 10, 46, 64, 70, 72–4, *76*, 91–4, 96–9, 102–5, 105n, 106n, *107*, 111–2, 119–21, *124*, 126, 139, 143, 164, 166–7, 169–71, 205, 211–2, 213n, 216, 223
Wings of Desire xii, xxi

Young, Neil 16